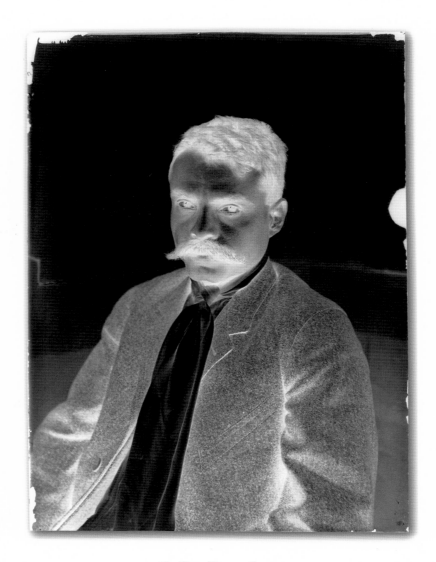

Emiliano Zapata. *Ca.* 1914.

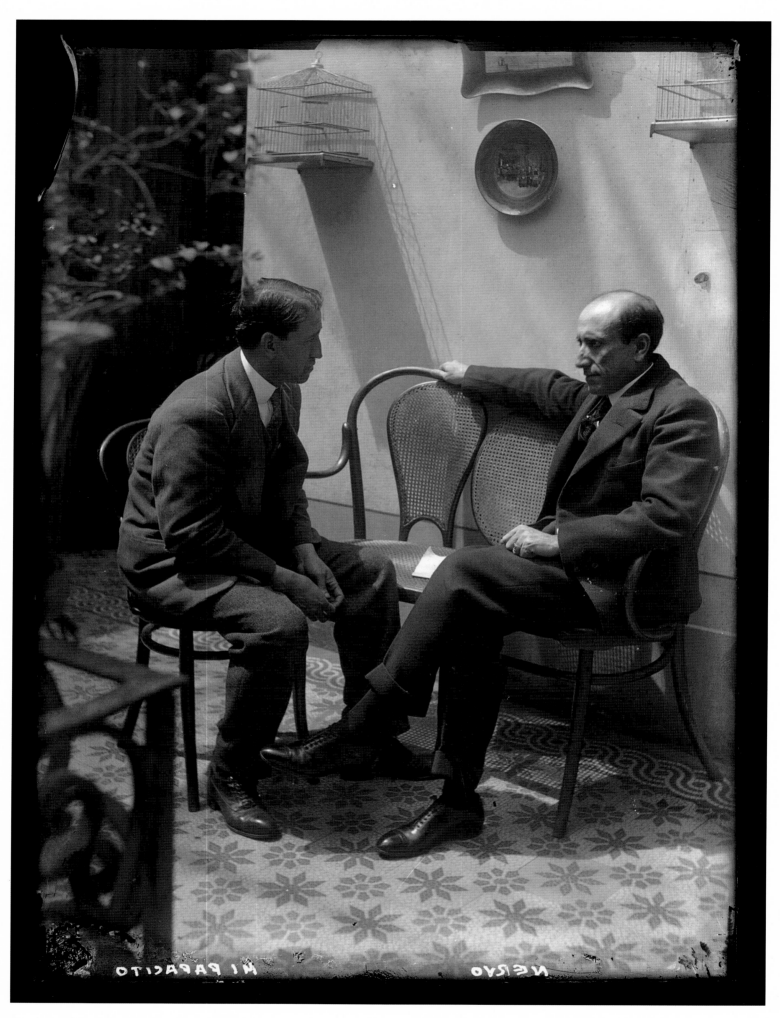

Agustín Víctor Casasola interviewing the modernist poet Amado Nervo in his house. Mexico City, *ca.* 1915. [23146]

MEXICO
The REVOLUTION *and* BEYOND

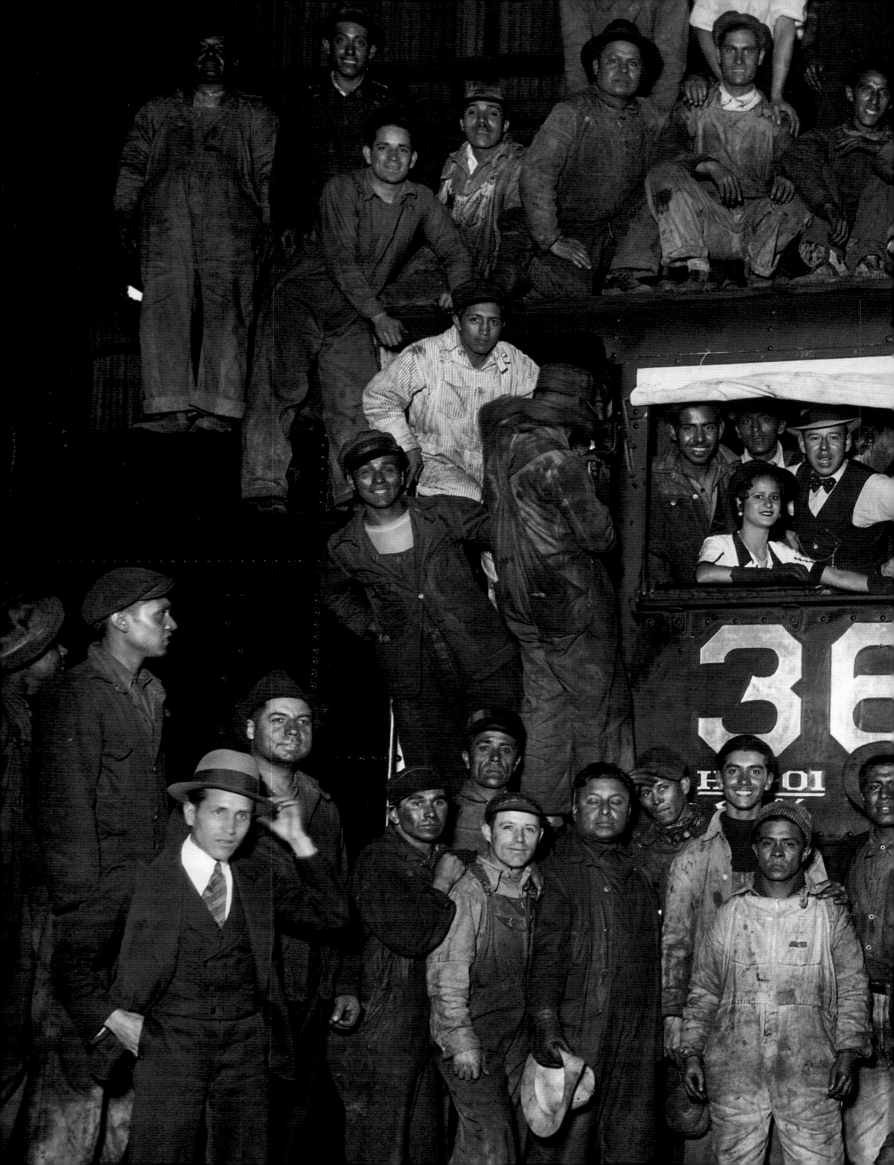

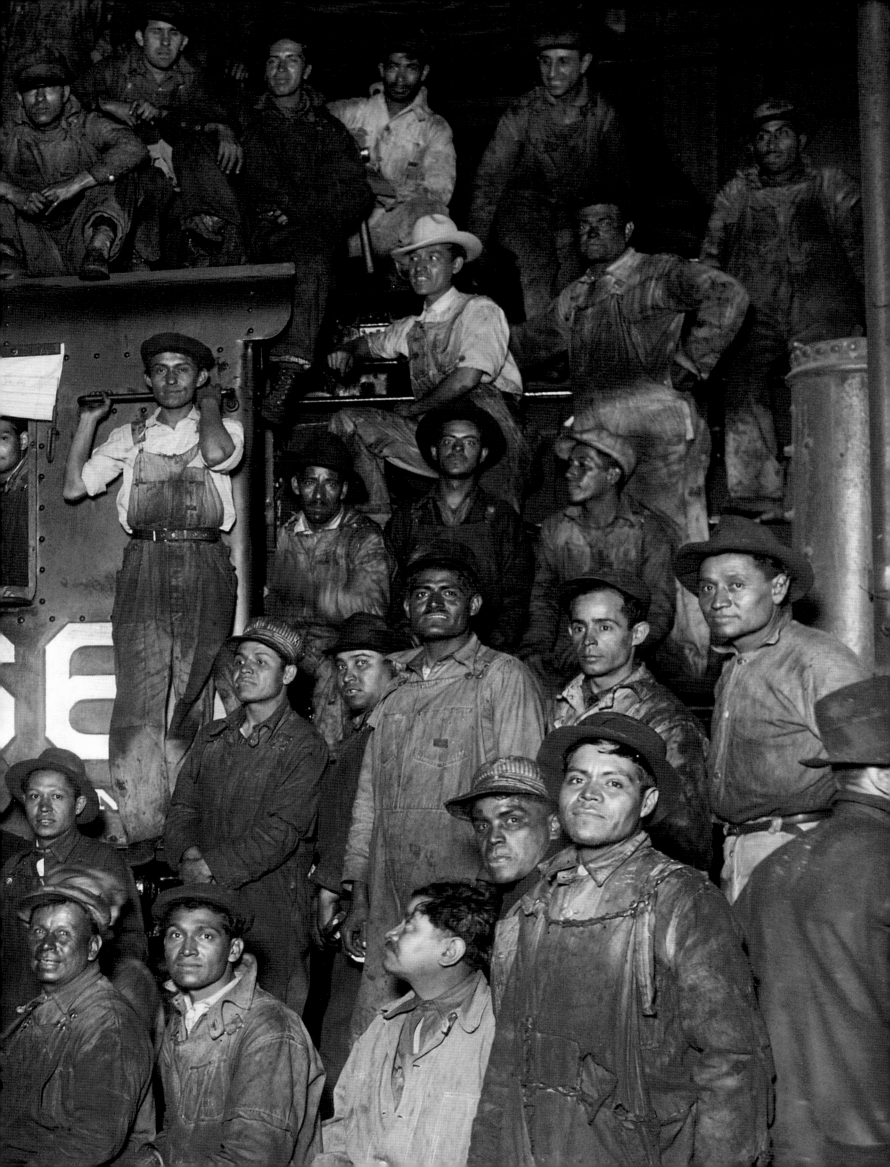

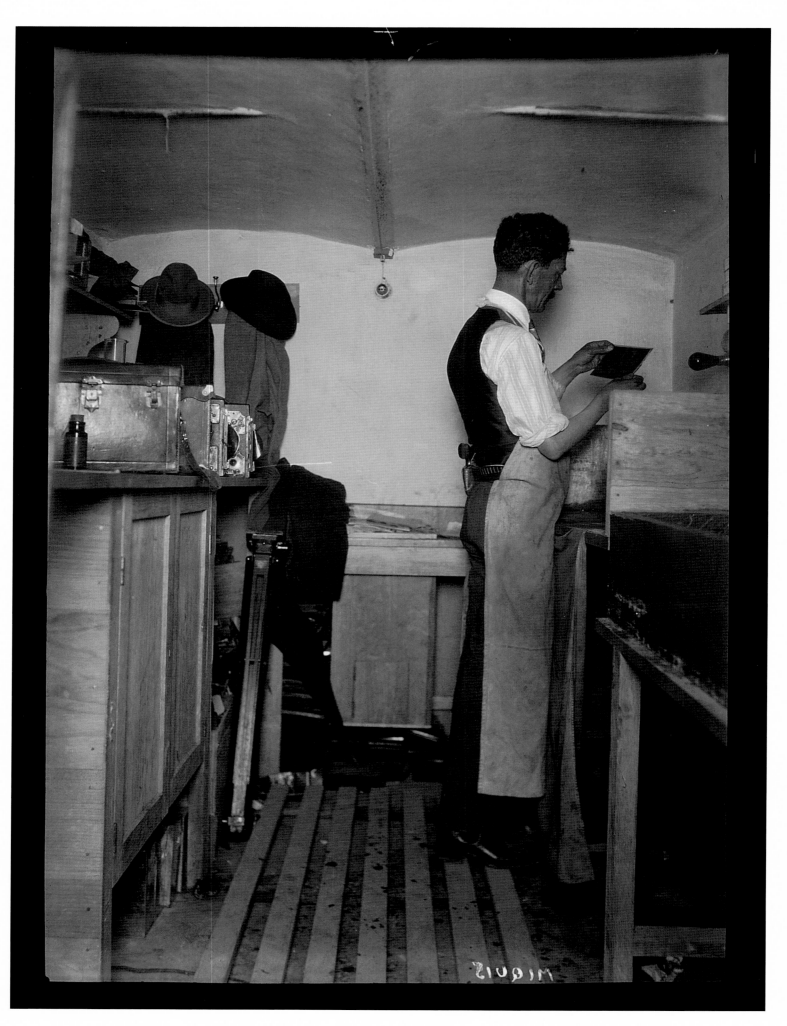

Miguel "Miquis" Casasola, armed, in the darkroom of his studio. Mexico City, *ca.* 1925. [197450] The plate reads: Miquis.

MEXICO
The REVOLUTION *and* BEYOND

Photographs by Agustín Víctor Casasola 1900–1940

Edited by Pablo Ortiz Monasterio

Essay by Pete Hamill

Afterwords by Sergio Raúl Arroyo and Rosa Casanova

Published in cooperation with

◖▲CONACULTA · INAH❀

APERTURE

English edition copyright © 2003 Aperture Foundation, Inc.
Introduction by Pete Hamill copyright © 2003, Deidre Enterprises, Inc.
Other texts copyright © 2003 by the authors

Photographs copyright © 2003 Instituto Nacional de Antropología e
Historia (CONACULTA-INAH), Mexico City, México

Library of Congress Control Number: 2003106591
Hardcover ISBN: 1-931788-22-7

Designed by Daniela Rocha
English translation by Carolina Clark

Originally co-published in Spanish by Turner, Madrid and Instituto Nacional
de Antropología e Historia, Mexico

The staff for this book at Aperture Foundation includes:
Ellen S. Harris, *Executive Director*; Roy Eddey, *Director of Finance and
Administration*; Lisa A. Farmer, *Production Director*; Robert Morton, *Editor-
in-chief, Books*; Andrea Smith, *Director of Publicity*; Linda Stormes, *Director
of Sales & Marketing*; Alan Yamahata, *Director of Development.*
Work-scholars: Nicola Bodman, Karen Engle, Gillian Fox,
Kim Phillips, Jeffrey Rogers, Fran Ula, Annie Wilker

Aperture Foundation, a not-for-profit organization, publishes *Aperture*
magazine, books, and limited-edition prints of fine photography and presents
photographic exhibitions worldwide. A complete catalogue is available on
request.

Aperture Foundation,
Including Book Center and Burden Gallery:
20 East 23rd Street, New York, New York 10010
Visit Aperture's website: www.aperture.org

Production: Turner, Madrid
Printed and bound in Spain

First English Edition
10 9 8 7 6 5 4 3 2 1

CONTENTS

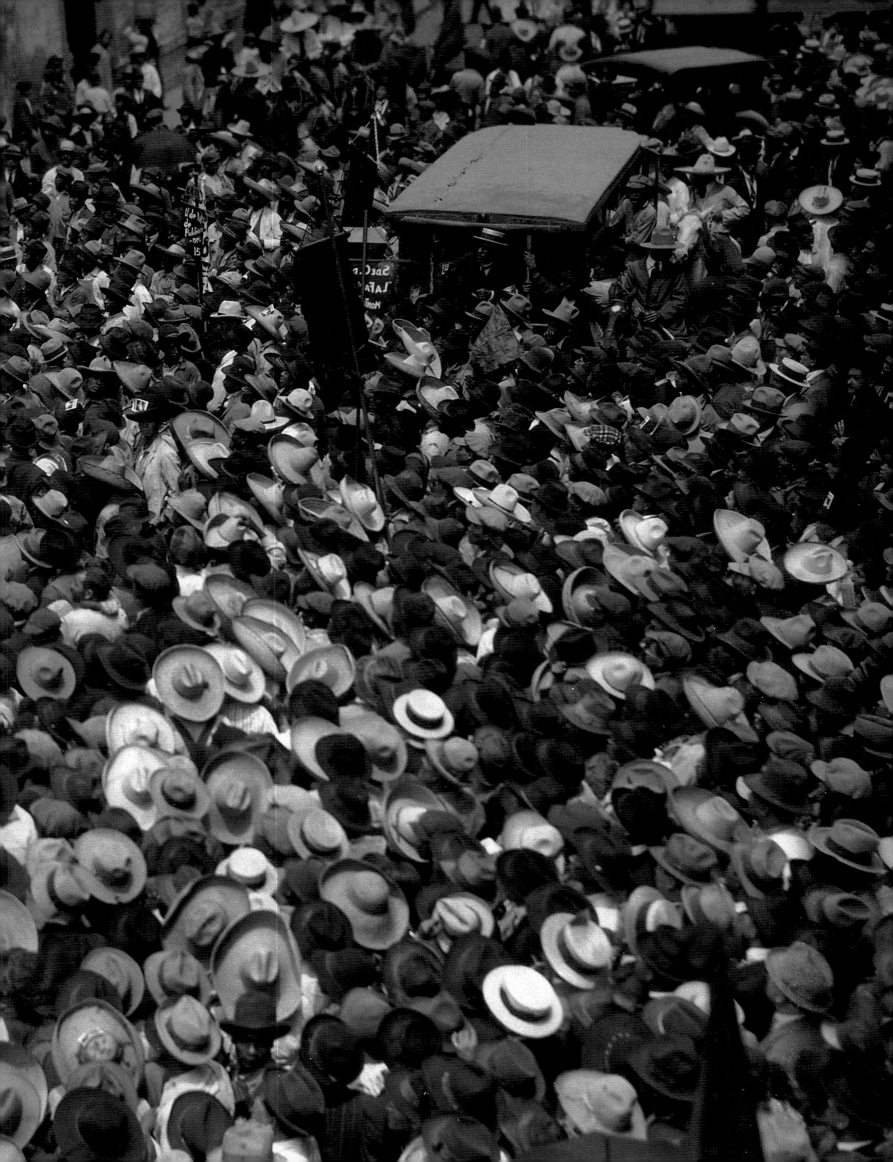

THE CASASOLA COLLECTION IN THE INAH NATIONAL PHOTO LIBRARY

The Casasola Archive, a mythic photography collection whose images have enriched the culture of modern Mexico like no other, was acquired by the federal government of Mexico in 1976. The transaction began on March 23 of that year, with the signing of a purchase agreement and the transfer of exclusive rights by then Director General of the National Institute of Anthropology and History (INAH), Guillermo Bonfil Batalla, and Agustín Casasola Zapata, the son of Agustín Víctor Casasola, founder of the archive and most visible head of the photographic dynasty that left its stamp on an entire era. The sum agreed upon for the purchase was ten million pesos.

Negotiations had been underway since 1975, under the pressure of an eventual sale of the national treasure to an entity in the United States, a transaction that would have represented an irreparable loss to Mexico's historic patrimony. At that time, the federal government decided to give the INAH custody of the collection, which was sent for safekeeping to the old San Francisco Convent in the city of Pachuca in the state of Hidalgo; the conditions in this viceroyal building, with its sturdy structure and solid walls, were favorable for the preservation of photographs. In this way, the country's first national photographic library, widely known as the Fototeca Nacional, was born. It was inaugurated on November 20, 1976, in commemoration of the beginning of the Mexican Revolution—a symbolic recognition of the archive's most widely known facet.

The Casasola Collection, or Fondo Casasola, in INAH's Fototeca Nacional is now composed of 483,993 pieces, of which 411,904 are negatives and 72,089 are positives taken between 1895 and 1972, a fertile, wide-ranging period of modern history. A total of 427,418 photographs are catalogued, and 199,018 are digitalized and available in the automated catalogue of the National Photo Library System. Thus, the old convent has been transformed into the central point in a route followed by image researchers, both in Mexico and in the world.

The Collection includes the work of approximately five hundred photographers, out of a total of more than two thousand authors with material in the Fototeca Nacional. These photos, a sweeping panorama of images and visual propositions, reflect a heretofore unknown interest in collecting photographs; this advance is one of Agustín Víctor Casasola's main contributions to the national patrimony.

Here we find the works of renowned photographers such as Hugo Brehme, Manuel Ramos, Guillermo Kahlo, Antonio Garduño, Eduardo Melhado, Amado Salmerón, Samuel Tinoco, and F.L. Clarke, as well as pieces belonging to businesses such as CIF and México Fotográfico. Cardinal figures of the nineteenth century, such as the Cruces and Campa duo and William Henry Jackson also appear here, as do the electrifying images of some members of the Casasola family.

Members of this photographic dynasty indiscriminately used glass or nitrate plates; perhaps their decisions hinged on the ease with which the nitrate plates could be transported to remote places for shooting, or perhaps on the availability of these plates on the market. It is possible that urgency in the delivery of materials in the difficult years of the armed struggle accelerated the fixing and washing processes, which, in combination with the excessive handling of some of the pieces, led to the appearance of stains or faded images. Nevertheless, temperature control in the current storage system, along with conservation procedures carried out at the Fototeca Nacional in recent years, has fully guaranteed the stability of the material.

Back in 1976, it was predicted that, with the passage of time, the old convent would be "recognized worldwide as the seat of the history of Mexico"; nevertheless, thanks to the work of the specialists in the National Photo Library System of the National Institute of Anthropology and History, it has turned out to be even more transcendent: a reference point for the international photographic community.

<div style="text-align: right">

SERGIO RAÚL ARROYO
Director General
Instituto Nacional de Antropología e Historia
(National Institute of Anthropology and History)

</div>

LO QUE HA VISTO MEXICO EN LOS ULTIMOS 30 AÑOS

ANECDOTARIO GRAFICO NACIONAL

VICISITUDES DE LA SILLA PRESIDENCIAL

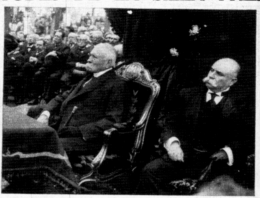

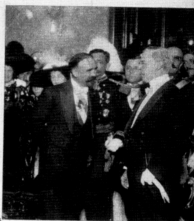

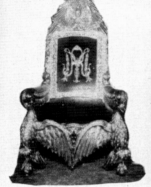

Silla del Benemérito Juárez.

El Gral. Porfirio Díaz en la silla presidencial que ocupó durante varios años.

El Lic. Francisco L. de la Barra haciendo entrega de la Silla al Presidente Madero.

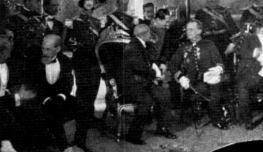

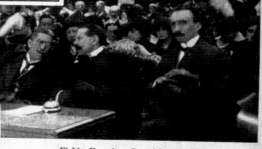

El Gral. Huerta en la primitiva silla del Gral. Díaz, durante una recepción diplomática.

El Lic. Francisco Carvajal, ocupando la silla presidencial, colocada en el hemiciclo de Juárez.

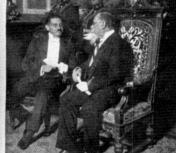

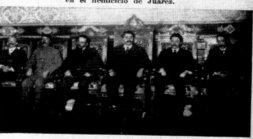

El Presidente Carranza ocupando por primera vez la silla, después de abandonar el título de "1er. Jefe."

El Presidente Provisional De la Huerta, en la silla, durante una ceremonia a la que fue llevado el codiciado mueble.

Don Eulalio Gutiérrez, Encargado del Ejecutivo, en la silla.

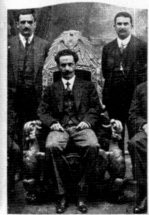

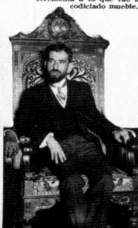

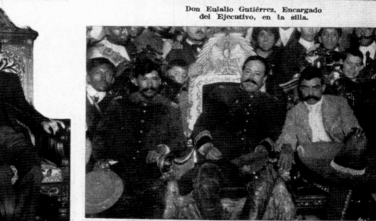

El Lic. Francisco Lagos Cházaro, Encargado del Ejecutivo, en la si-

El Lic. Roque González Garza, Encargado del Ejecutivo, en la si-

Francisco Villa y Emiliano Zapata en el Palacio Nacional.—Villa en

THE CASASOLA ARCHIVE
PETE HAMILL

I

Agustín Víctor Casasola was one of the giants of twentieth-century photography and yet his name is barely known beyond the frontiers of his native Mexico. He was one of the early masters of photo-journalism, bringing to vivid life the events surrounding that immense social cataclysm called the Mexican Revolution. As a photographer, and as the driving force behind one of the world's first professional photographic agencies, Agustín Casasola put a human face on that epic struggle.

In image after image, he showed other Mexicans and the wider world that a revolution was not a tea party. Here in the Casasola photographs were the armies swarming around the railroad trains. Here were the soldiers, some with scarred faces and rough peasant hands, drinking coffee at a bourgeois restaurant counter in the conquered capital. Here were the *soldaderas*, those valiant women who traveled with the contending armies, often fighting at the sides of their men, always providing food and warmth and other kinds of ammunition. Here too were the executions. Here, always, were the dead, lying in fields or streets, providing harvests for vultures and worms.

Those images have endured. They have helped many prose writers to imagine the passions, textures, and bitter reality of the Revolution. They have provided essential visual tools to many movie directors, from those who created films of the Revolution in Mexico itself to such Hollywood films as Elia Kazan's *Viva Zapata* (from a script by John Steinbeck) and Luis Puenzo's *Old Gringo* (based on the novel by Carlos Fuentes). The Casasola images, suitable for framing, are available in hundreds of tourist shops all over Mexico, the American Southwest, and California. They can be found in the gift shops of museums. They are emblazoned on t-shirts and on postcards and even ashtrays in the 1990s. Casasola's images of Emiliano Zapata were used as emblems of the Zapatista uprising in the state of Chiapas.

And yet Agustín Víctor Casasola remains a blurry figure. Slowly, through the research of scholars, particularly those who are cataloging the Casasola Archive for the Fototeca Nacional of the National Institute of Anthropology and History (INAH), his life and work are coming into sharper focus, like film in developer.

II

These things we know: Agustín Víctor Casasola was born in Mexico City on July 28, 1874. His father died when he was six. Miguel Casasola was his younger brother and would also carry cameras into the streets and fields of Mexico. According to Agustín's son, Gustavo, his father began his career after serving an apprenticeship as a typographer. In Mexico, as in most foreign cities, the apprenticeship system was common to many young men in a time when universities were closed to those who were born into the wrong class. For the future photographer, typography was a fine school: it demanded precision, a sense of form and style, and an understanding of the need to communicate. Casasola then followed a route that was common to many journalists in all countries in the late nineteenth century. He moved from setting type to writing the stories that would be set in type by other men. That is, he became a reporter.

The year was 1894 and like all young reporters, Agustín Casasola was surely sent out to gather news on the streets of his city. Sometimes, the news must have been shocking: terrible murders, forlorn suicides. Often it was part of that process that is a disguised form of publicity: taking notes at government functions, recording the rhetoric of captains of industry. There is a blur here, too. It's simply not yet known how and where he first worked at his new craft. His son, Gustavo, later said that Agustín worked for *El Globo*, *El Popular*, *El Universal*, and *El Tiempo* during this period. He was either a staff member on those newspapers or a freelancer who placed his stories with a variety of editors. We might never know. In

that era, in all big cities, most reporters published their work without bylines so that the newspaper itself was doing the talking, not the individual craftsman.

What is known is that around 1900 Casasola began taking photographs. At this point in the history of journalism – from Paris to New York to Mexico – photographic reproduction was entering its first great period. The halftone was developed in the 1890s, initially used on the slower presses of magazines. The first published newspaper halftone photograph appeared in the *New York Tribune* in 1897 (typically, it was a portrait of a mediocre politician). For the first time, through a system that broke the photograph into tiny dots of varying sizes, newspapers could show images that had a more subtle range of tone, from deep black to pale gray. The ability to use those halftones on relatively high-speed presses changed the graphic look of newspapers. The hard-edged line cut gave way to the subtleties of photo-engraving; it was, in its way, like the revolutionary transition from handwritten copy to the typewriter, and years later, from the typewriter to the desktop computer.

Suddenly the dashing newspaper sketch artists went out of style. They had covered wars and world's fairs, prize fights and freak shows with pen, brush, and ink, and very quickly they were gone. So were the meticulous engravers who prepared their work for reproduction. Now editors and readers demanded what they considered to be the real thing. That meant photographs. The old newspaper drawings were often brilliant, transcending the speed of their conception and execution. In Mexico, for example, José Guadalupe Posada (1852-1913) pushed his work into high and enduring art, publishing broadsides, illustrated *corridos*, posters, and hand-engraved drawings for newspapers. But the halftone drove many of these artists out of journalism. Many became comic-strip artists or magazine illustrators or full-time painters. And as they faded out of newspapers, some young people began to look hard at the camera as a means of expressing the realities of the world. Agustín Víctor Casasola was one of them.

Around 1900, he added the camera to his journalistic tools. At first, he was only supplementing his reported stories with these images, and it isn't known what specific camera he was using. Often his own early work is hard to identify. The researcher and scholar Ignacio Gutiérrez Ruvalcaba, who has been carefully examining the more than 483,993 Casasola images at the Fototeca, says that the earliest date found on a Casasola negative is 1902.

That year, Casasola traveled to the coastal city of Veracruz to take photographs of a presidential tour. The president was General José de la Cruz Porfirio Díaz, almost always referred to as Don Porfirio, and he had ruled Mexico since 1876, when Casasola was two years old. Now 72, Don Porfirio was tall, erect, a fine horseman; with his beribboned chest and stern demeanor, he exuded a kind of imperial majesty. In his own youth, Díaz had fought valiantly for the great liberal reformer Benito Juárez, a Zapotec from Oaxaca, a lawyer who believed (like Albert Camus a

century later) that it was possible to love your country and justice, too.

In his own hard way, Díaz surely loved his country but believed that justice would have to wait. First came order. He took power in a coup in 1876, and was still in power when Agustín went to Veracruz to take his photographs. When Díaz took power, he set himself the task of establishing order in the country that had been plagued by violence and chaos since attaining independence from Spain in 1821. The country had endured more than fifty different governments (including eleven headed by the comic opera scoundrel Santa Anna). It had suffered two immense humiliations: the loss of half its national territory to the United States in the disastrous war of 1846-48 and the French intervention of 1864-67 that placed an Austrian duke named Maximilian on the throne of an imaginary Mexican empire. By 1876, Mexico was a country, but only in a geographical sense; it was not yet a nation.

As a boy and young man, Agustín Víctor Casasola lived in the nation that Porfirio Díaz had made. While insisting that he embraced the liberal Constitution of 1857, Díaz was ruthless in using the iron hand against any form of disorder. He expanded and strengthened the *Rurales*, the semi-military police force created by Juárez to deal with bandits who roamed all regions of Mexico. He made arrangements with various local and regional strong men, called *caciques*, creating a federation of power that had nothing to do with democracy. He supported the anti-clerical provisions of the 1857 constitution, but made clear to powerful churchmen that he would not enforce them, unless the Church gave him problems. He created a strong bureaucracy, without which no nation can function, and made certain that its primary loyalty was to him. Above all, without any clear ideology, he began that difficult process that is loosely called modernity.

On one level, that meant welcoming American and European technologies, the most important of which were the railroads. Tracks began to stretch from the border with the United States all the way to Yucatán, and were the first step in transforming Mexico into one nation. Isolated regions were soon part of a market economy. The railroads were also part of the system of order; with them, the national army could move swiftly to quell any incipient revolts against the central authority. The modernizing process was accelerated by the spread of the telegraph. To make all this happen, Díaz had shaped a small court of advisers, bright young men who had been educated in Europe or the United States, and were determined to forge a new Mexico based on scientific principles. They were called the *científicos*, an aristocracy of technocrats, and their basic slogan was "Let us be scientific, let us be realistic." This devolved into another slogan: "Little politics, much administration." They believed, as did Díaz, that there could be no development without discipline and that the strong hand of the government must provide that discipline. All power must flow from the apex of the Mexican pyramid.

These were all aspects of an emerging modernity, but one

crucial element of modernity was not permissible: public criticism. Potential political opponents were corrupted or killed, and so were journalists. The fortunate ones escaped into permanent exile. For Agustín Casasola this smothering of dissent was most evident in the newspapers for which he worked. *El Imparcial*, for example, was the official newspaper of one faction of the regime, and was also the most successful. The last opposition newspaper, *El Monitor Republicano*, closed in 1896, to the satisfaction of the *Porfiristas*, while providing an object lesson to other journalists. Good journalism, for most publishers, was bad business. In a country where 85 percent of the population was illiterate, newspapers naturally directed their energies towards those who could read and write. These included the basic components of what was called *La Paz Porfiriana* (The Porfirian Peace): businessmen, large landowners, and the middle class that was emerging from the expanding bureaucracy.

Within the narrow frame of his craft, Casasola did what he could to move beyond what later became known as photo-ops: events staged to be photographed. Occasionally he would photograph bullfighters. Or he would make journeys to some of the haciendas where an almost feudal style of life persisted into the twentieth century. When the poor were photographed, it was usually as examples of "customs" or folklore, at regional fiestas where everyone looked content. Such photographs and stories dared not convey certain realities, among them the fact that the average lifespan outside the privileged areas of Mexico City was thirty.

The growing urban middle class wanted news that did not disturb their sleep, and Agustín Casasola was surely like almost all of his fellow reporters in providing what they wanted. Good news. Optimistic news. Stories about the opening of new paved roads and new routes for railroads. News of expanding trade. The great news in 1894 that for the first time in its history Mexico was not in debt. And news about themselves. Most of them lived in *la capital*, in the French-style mansions going up along the Paseo de la Reforma or in the districts called Colonia Roma or Colonia Juárez. Agustín Casasola saw them in his daily rounds. Their sons were going off to school in France, and that was news. Their daughters were returning with European husbands from noble families now impoverished, and that was news. They were attending art exhibits in the city, or taking in concerts and operas: all news. The latest fashions in clothing – freshly arrived from Paris, of course – were also part of the news.

But Casasola knew, as did most of his colleagues, that one subject was not fit for the newspapers: a sustained examination of the growing poverty in the slums of Mexico City. These barrios now resembled the vicious nineteenth-century slums of New York and London, places filled with people consigned to the margins of human life. Many had been forced off the land their families had worked for generations in the countryside. Now, in the city, they had no sewers, no running water, no lights, no hospitals, no schools, and very few rights. The police kept them from entering the streets of the "good" neighborhoods, lest their bare feet or ragged clothes upset the delicate feelings of the pampered loyalists of the *Porfiriato*. They must be kept out of sight, and therefore out of mind.

Later, Casasola would find himself looking at that unseen Mexico with an unshielded eye. But at the beginning, he had to stand with other photographers and photograph Don Porfirio.

III

On that 1902 journey to Veracruz, Díaz met with one of his state governors, an enlightened man named Teodoro Dehesa. He was a lover of literature and art (and subsequently an early sponsor of the painter Diego Rivera) but was loyal to Díaz, who had chosen him for the job. It is not known what they discussed, although it must have been understood that Díaz would run in 1904 for his sixth term as president, and there would be no opposition. The surviving Casasola photograph from Veracruz is as pedestrian as the event itself.

But at that moment, Casasola was approaching the subject matter of his greatest work, even if he was as unaware of what was coming as was Porfirio Díaz. In the northwest of Mexico, the troops of Don Porfirio were slaughtering the implacable, rebellious Yaqui Indians or shipping them off to literal slavery on the henequen plantations of Yucatan. In those southern jungles, remnants of Mayan warrior bands still fought skirmishes from their hideouts, and were ruthlessly killed if captured. The anarchist Flores Magon brothers were emerging from prison and would soon be circulating their subversive newspaper *Regeneración* from exile in the United States. All over the country, Mexican peasants and Mexican workers were straining under the harsh conditions of their labor. In the company towns of Cananea and Rio Blanco, they would explode into violence and be shot down for their trouble. Many hundreds of thousands of Mexicans were working for foreigners, since one of the keys to the Díaz modernization was the opening of Mexico's doors to foreign investment. Mexico needed capital, and if only a relative handful of Mexicans became rich, so be it. Díaz and the *científicos* were early believers in what was later called the "trickle-down" theory of economics.

The result of the policy was predictable. In the first decade of the twentieth century, Americans owned two-thirds of the country's railroads, and their Mexican holdings would escalate in value from virtually nothing in 1877 to more than $1.5 billion by 1910. Great hunks of the economic base were also owned by the British, Germans and French. About one percent of Mexico's people owned 85 percent of the land, and foreigners owned much of the rest. The American newspaper publisher William Randolph Hearst owned a 2.5 million acre ranch in Mexico, beyond even the wildest imagination of the fictional Citizen Kane.

The spirit of the entrepreneur was clearly in the crystalline air of Mexico City. In 1905, Agustín and his brother Miguel were both working for *El Imparcial*, edited by a man named Rafael Reyes Spíndola, with much of their work appearing in the paper's weekly supplement, *El Mundo Ilustrado*. That same year, they started a business in a street called República de Chile. It was called Casasola Fotógrafos.

At first they sold prints of some of the photographs they took for *El Imparcial* (and, most likely, images that had been rejected by the careful Reyes Spíndola). But Agustín was soon accepting photographs from others and began to shape what would evolve into one of the world's first photo agencies: the Agencia de Información Gráfica (Graphic Information Agency).

The arrangements within the agency would also create immense problems for future historians of photography in Mexico. While cataloging the Casasola Archives, Gutiérrez Ruvalcaba discovered that the 483,993 negatives in the collection were actually the work of at least 483 separate photographers. He also found evidence that Agustín Casasola had erased the names of the actual photographers from thousands of negatives and substituted his own. The majority of those photographs whose credit lines were changed seemed to have been taken by his younger brother Miguel.

Again, it's not clear if this was some obscure, inexplicable case of sibling rivalry, or a vain need by Agustín to hog all the credit. The explanation could be much simpler: Agustín saw early on that his agency was emerging into a kind of collective record of the immense changes under way in Mexico during his own lifetime. It was impossible for a single photographer to cover the vast panorama of often violent change, but there was a great need to centralize the work. After 1912, when the Revolution entered its most violent phase, the Agencia de Información Gráfica began sending the collective works of the photographic enterprise to periodicals all over Mexico, the United States, Europe and Asia. It was far simpler to use the name Casasola to give them a kind of trademark.

At that time, too, the star photographer was not yet common, particularly in Mexico. But the serious professionals were certainly known among their peers, and the excellence of Agustín Casasola was honored by the others. In October 1911, he, along with Mexico City's other cameramen, formed the Asociación de Fotógrafos de Prensa (Mexican Association of Press Photographers) and Agustín was immediately elected president.

These young men (there seem to have been no women working at the craft in those days) would exchange technical information about newer, smaller cameras and faster film. They would also discuss the work of foreign photographers. In French-influenced Mexico City, Casasola surely was aware of the portrait work of Nadar, who began his work in the 1850s, and of Éugene Atget, who in 1895 started methodically photographing the streets and neighborhoods of Paris, as a kind of Balzac with a camera. But

new work from other lands was also showing fresh ways to use the camera. Casasola must have seen the photographs of Jacob Riis, the Danish immigrant whose acerbic eye revealed the horrors of New York slum life in *How the Other Half Lives* (1890). And copies of the influential magazine *Camera Work*, started in New York in 1902 and edited by Alfred Stieglitz, must have found their way to Mexico City.

Such examples would have helped spur Agustín Casasola towards exploring the fullest possibilities of his craft, as it did for many other photographers. But he was apparently never tempted to follow the path of the "art" photographer, established in Mexico by Edward Weston in the early 1920s, and followed most intelligently by Manuel Álvarez Bravo, Graciela Iturbide, and others. Agustín Víctor Casasola was always a journalist first, and then a photographer. Someone else would have to judge whether the result was art. Journalism demanded an encounter with the real. Casasola might admire the formal genius of the art photographers or dismiss it as irrelevant to daily life, but he was fishing in a very different stream. One result was that the Casasola Agency evolved into a collective journalistic enterprise in the same sense that the cathedral of Chartres was a collective piece of religious architecture; both were the work of many hands. It would further evolve, after the shooting stopped, into the Casasola Archive.

IV

The shooting started on November 20, 1910. That fateful autumn, Porfirio Díaz was in his eighth term as president, and was celebrating the 100th anniversary of Mexican Independence and his own eightieth birthday. The implied message was simple: he and Mexico were one and the same. The celebrations were extraordinary: an entire season of parades, balls, receptions of foreign dignitaries, the opening of such monuments as the Ángel de la Independencia and the Palacio de las Bellas Artes (still not completed, but already featuring its extraordinary Tiffany curtain). Díaz was lauded by the foreign press and hailed for the great accomplishments of his regime, for such immensely important projects as the building of the hydraulic system that brought water to Mexico City (p. 29). All agreed that peace and progress were wonderful. In one Casasola photograph (pp. 40-41), made in July 1910, a month after his eighth election victory, we see Díaz at a ceremony honoring Benito Juárez, against whom he had once risen in revolt. He is seated upon a chair clearly designed to resemble a throne. He looks properly stern, in a patriarchal way, even monolithic, while the people who lived off his patronage are assembled modestly to his right in proper solemnity. In his gloved left hand, he holds a cane as if it were a scepter.

During the celebrations, there was an immense self-satisfied glow among the people who had prospered under Don Porfirio. But after promising a revolution in November 1910, a band of 130

revolutionists finally crossed the border from Texas in February 1911. Their improbable leader was a son of the *Porfiriato* named Francisco I. Madero. He was a small, intense man, something of a mystic, something of an intellectual, who wanted free elections and greater social justice for all Mexicans. Or so he said. Above all, Madero wanted to end the system of re-election, which had perpetuated Díaz in power for thirty-four years. He had been jailed for his pains, escaped in the clothes of a railroad brakeman, and then plotted an armed revolt from a refuge in San Antonio, Texas. No project seemed more quixotic.

But the fighting soon spread, driven by the rage of the people that the novelist Mariano Azuela would call *Los de abajo*. Railroad cars were blown off their tracks. Great haciendas were invaded, and sometimes destroyed, their owners fleeing to the safety of Mexico City or into exile. The convulsion had begun. We don't know Agustín Casasola's personal reactions to these events because few letters survive, and he apparently kept no diary. We do know that he remained close to Mexico City while much of the fighting was in the countryside. In the state of Morelos, to the immediate south of *la capital*, a man named Emiliano Zapata rose to the Madero cause, demanding Land and Liberty, and waged brilliant guerrilla warfare against the forces of the regime. But the decisive victory of the revolutionaries was scored in Ciudad Juárez, far to the north, near the river that formed the border with the United States. That stunning victory was gained (against the wishes of the moderate liberal Madero, who hoped for negotiations) by two men: a general named Pascual Orozco and a former bandit named Doroteo Arango, who preferred to be called Francisco Villa. As Pancho Villa, he would soon be famous all over the world.

Seven months after Madero announced the revolt, four months after he crossed the border, Porfirio Díaz was gone. In June 1911, he left the port of Veracruz on a ship called the *Ipiranga* (p. 45) bound for exile in Paris, where he would die four years later and where his bones remain interred. His departure set off celebrations in many places, with Mexicans climbing to the roofs of streetcars in Mexico City to proclaim their joy (pp. 46-47) while Agustín looked and clicked his shutter. The joy was certainly not unanimous. In the lower right hand corner of that photograph, a lone man in a business suit walks away, clearly unhappy. It was soon obvious that Madero's victory was only the curtain of the first act; infinitely more blood would be shed before the end of the great drama.

As he did during the *Porfiriato*, Casasola soon focused his lenses on the men of power. In this collection, we see (p. 45) his image of Madero entering the city in triumph, a new version of the classical man on horseback. He is hatless in an era when most men wore hats, captured by Casasola in a pose that reminds us now of various visions of V. I. Lenin that would appear after the Bolshevik Revolution in Russia, seven years later. There are boys in the crowd, some of them bootblacks, and the inevitable foot soldiers guarding the new man in Mexican history. There's a suggestion of an uneasy peace in the scene. In October 1911, Madero was elected president of the Republic.

The peace did not hold. In Morelos, Zapata thought that Madero was too slow in implementing land reform and soon rose up in arms again. The American ambassador, Henry Lane Wilson, believing that Madero was a dangerous radical, was soon conspiring to get rid of him. In 1913, Madero was overthrown in a *coup d'etat* by an old Díaz commander named Victoriano Huerta. After his election, the idealistic Madero had retained Huerta and other Díaz officers, believing that their basic loyalty was to Mexico. He was wrong. Huerta forced him to resign at gunpoint and two days later had him executed, along with his vice-president, against the wall of the Lecumberri Prison. And that double murder set off the most terrible years of the Revolution, announced by ten days of heavy fighting in Mexico City itself, an episode called *La Decena Trágica*.

An entire cast of revolutionists suddenly appeared before the lenses of the Casasolas: Venustiano Carranza, Álvaro Obregón, Pancho Villa, Emiliano Zapata. They first drove out Huerta. Then they fought each other. It is beyond the scope of this essay to chart the sustained turbulence of that ferocious combination of revolution and civil war, but Agustín Casasola was present when the combined armies of Villa and Zapata entered Mexico City, after driving out Carranza. He photographed the Zapatistas at the counter of the famous Sanborn's restaurant in Mexico City (p. 58), where they made an immense revolutionary gesture by paying for their coffee. He was present for that marvelous moment when Villa sat down in the presidential chair with Zapata to his left; they never fought each other but could not combine in a final victory either. Eventually the Casasola Archive would contain the photographs of the dead Zapata, assassinated in 1919, and Villa, assassinated in 1923. But above all, Agustín seemed to realize that this was a movement beyond a handful of men: he photographed the men who fought the war (on all sides). He photographed the armed children who joined those armies. (His own brother Miguel would give up the camera to enlist in one of the contending armies). He showed the cold faces of executioners (p. 65) and the men placed against walls to be shot down after farewell embraces from former comrades (p. 66). He showed the bodies of the dead and the casual attitudes of those who remained among the living.

He came to these scenes as a man of the city, a photographer with an urban eye. He was seeing things that few urbanized Mexicans had ever seen, but he brought to them an eye trained by the drama of the city itself. If the Villistas and Zapatistas were seeing the metropolis for the first time, he understood that for the first time city people were seeing the brave men of the North and South. His eye often recognized what Cartier-Bresson would later call "the decisive moment": the way the bodies fell after the fusillade, the primeval joy of charging cavalrymen. But he also captured the contrast between the horses of nineteenth-century wars and the railroad trains of the modern era. He caught the bold swagger of the soldadera along with the growing indifference to sudden death.

The war ground on to its inevitable end, while the attention of

the world (and the international press) shifted to the immense carnage of the Great War. The end was an inevitable acceptance of exhaustion, as it was in 1919 in Europe. When the accounts were added up, the Mexican economy was in ruins, the infrastructure largely destroyed, and about one million of the country's fifteen million citizens were dead. They died of gunshots. They died in artillery barrages. They died of disease. The old regime had been demolished. And then the men left standing faced the task of making a new Mexico.

V

The Casasola photographs after the end of the violence were suffused with a tempered optimism. His brother Miguel was back from the war and his son Gustavo was working with him as, together, they looked at the peace. In the Zócalo, the great central plaza of the city (and in its way, of the country), horsecabs mix with small trucks, and all contend with trolley cars (pp. 76-77). There has been a vast alteration in the center of the plaza: all the trees have been cut down to provide a clear field of fire for defenders of the Presidential Palace, out of the camera's sight to the right. The Cathedral remains untouched, and most people still wear the dark clothing of the years before the war. But there is no shooting. There are no bodies.

There are many images of men and women at work: building automobiles, forging iron, making shoes, sewing clothes. The lighting in these photographs is subtler, reflecting advances in the tools of photography. In 1920, the new Speed Graphic was adopted by many photographers, and five years later they began to use the new 35mm Leica from Germany. The use of flash now allows Agustín Casasola to work indoors with more efficiency and he looks at wrestlers, scientists, butchers, and bankers.

At last, he is free to record the existence of the urban poor: the voceros who delivered the city's newspapers, boys carrying chickens to the market, the clowns who made a hard living entertaining strangers on street corners. The war was over, and now the least of them could play in an orchestra (pp. 82-83). The message is a subtle one, and quite humane: every individual is worthy of attention. There are many ways to be Mexican.

His native city was again his subject and he looked at it with a loving eye. On their own, and as part of an enlightened government contract (to record the changes in Mexican life), the Casasolas moved around Mexico City. By 1925, it had 500,000 inhabitants and 20,000 automobiles. The brands of those automobiles are now long gone, artifacts of that simple era when a Mexico City motorist could have gasoline delivered to his home. Electric lights now brightened the main thoroughfares of the city, but there were virtually no stop lights and anarchy often quarreled with chaos (pp. 98-99). No revolutionary manifesto had ever predicted the coming of traffic jams.

At the same time, certain emotions were filtering into the city: loneliness, alienation, separation from others. Many newcomers from the ravaged countryside had left behind families, habits, timeless comforts of the familiar. In the photograph on page 97, almost certainly taken by Gustavo Casasola, two women murmur to each other on a streetcar that seems to have only one other inhabitant: the conductor. Outside the confined space, in the afternoon brightness, lies the city. But the intimacy of the image recalls the paintings of Edward Hopper, who was at that time discovering the poetry of urban solitude in the cities of the American northeast. In Mexico after the shooting stopped, the photograph also expresses the quiet satisfactions of peace.

So did a growing consumerism. The struggle for the bare essentials of life was no longer a grinding, hourly consideration in the city (and even during the worst days of the Revolution there was food and water for most of the inhabitants). Along came goods that were not truly essential to sustain life. In the photograph on page 100 we see a store offering formal wear for upscale consumers, or those who wanted to pretend for a night that they could look like the elegant creatures seen in the illustration in the window. This was almost certainly done by the German-born American illustrator J.C. Leyendecker, whose illustrations adorned the covers of the *Saturday Evening Post*, but whose most famous paintings were made to sell Arrow shirts. In the opposite photograph, a variety of pale-skinned women try on hats, adopting the poses of mannequins but seeming now to be frozen in a moment of a strange dance.

One assumes that most of these photographs were taken in downtown shops, not far from the altered Zócalo. On pages 102-103, we see another image, filled with mysteries. A man in a black hat hurries through traffic, stepping gingerly over the rails of trolley cars. A cigarette dangles from his lips. He is wearing a bowtie and black vest under his jacket and he looks amused. It is daylight, yet he seems a creature of the night. Is he a nightclub entertainer on his way home after a leisurely morning dalliance? Or is it dusk, and he's on his way to perform at some restaurant? He does, in fact, bear a certain resemblance to the marvelous composer Agustín Lara (see p. 193). But it's now too late to know his story or his name. In this captured moment of time, his dashing sense of amusement remains vividly alive.

There are other mysteries, now that these images have made the transition from journalism to a blurred collective memory. Why are the bathing beauties on pages 106-107 masked? Why is the hotel bellhop – who in the United States is called simply "Johnny" and peddles Phillip Morris cigarettes – seated on the hood of the huge automobile? What are they selling? What happened to them later, after the Casasola camera had moved on?

And look at the photo on pages 112-113 of many masked women seated at tables in the patio of a palatial building. There is a surreal hint here of the masked women in paintings by René Magritte. Why are they masked? And what are they doing? Are they being punished for some obscure crime? No. They are taking an examination in the use of the typewriter. That is, in the use of the machines to the left, which were rapidly changing the working methods of Mexican

businesses and bureaucracies. The steel pen was vanishing. The machine was arriving. Again, we wonder now about the lives these young women later led. And what happened to the elegant young man to the right, in his boiled collar and dark suit and impeccably barbered head?

We know from the Casasola documentary images of expanding consumerism that the Frigidaire – one of the early versions of the refrigerator – had made its way to Mexico. The rise of the department store is epitomized by "La Principal" (p. 110), which offered everything a person might need, from a hat to a bicycle, suspenders to a wrist watch, a sewing machine to a pistol. Casasola's photograph is straightforward. If it has any comment to offer it's simply: isn't this all marvelous? Look at the variety! Look at the many wonders of the world we offer you! Come in and buy and satisfy your dreams!

More important to the swiftly-changing Mexican society was the startling growth of the radio (p. 109). Here they are displayed like artifacts in a modern version of an ancient bazaar: all sizes and shapes, truly magic lamps that can deliver the wonder of the world at the owner's touch. A solid case could be made that the development of commercial radio networks – particularly of XEW – did more to create the post-Revolutionary Mexican nation than any other technological advance, including the railroad. For the first time, if they were fortunate enough to have electricity (millions did not), Mexicans in the South could hear *ranchero* music from the North. They could hear news from *la capital* and the wider world beyond Mexico. To be sure, much of the social message was controlled by the party in power, and was usually blatant propaganda. But for the first time, politicians could speak to citizens without boarding trains for distant parts, while citizens could actually hear the voices of those people whose photographs were in the newspapers or on campaign posters. Economically, radio was an essential tool for selling goods – everything from cigarettes to automobiles – and thus accelerated consumerism. Culturally, it worked even greater changes. For the first time, illiterate people could be entertained and informed without leaving home. The *radionovela*, for example, provided fictional narratives for people who could not read novels. Radio was much closer to the act of reading than either cinema or (later) television, because the listeners heard words and invented their own images. In every sense, radio was truly Mexico's first mass medium.

Agustín Casasola had the good sense and high intelligence to recognize that even straightforward documentation was part of a larger project: freezing moments of time before they drifted into a kind of generalized amnesia. He delivered prints to his clients, including the government, but saved his negatives for his larger evolving project: the Archive that now bears the Casasola name. His documentary photographs are nouns, the names of things; the verbs were all implied. Today's historians can see them as part of the even greater archive of Mexican memory, to be examined for meaning from the perspective of what is now known.

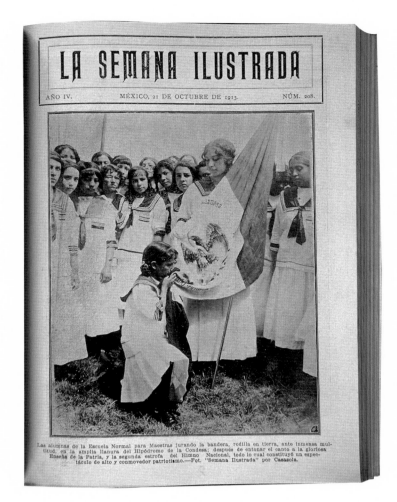

La Semana Ilustrada, magazine cover, no. 208, October 21, 1913. Hemeroteca Nacional, UNAM.

His work for newspapers and magazines was journalism, and those photographs always contain implicit verbs. Someone is always doing something. One of the largest proper nouns in Mexican society was the painter Diego Rivera, then at the peak of his international fame as a muralist, and one of the most famous communists in the Western Hemisphere. He seemed always to be doing things beyond his painting. That is, his public life was full of verbs.

In January 1929, Rivera became involved in a sensational murder case, starring the beautiful Italian-born Tina Modotti. She had come to Mexico in 1922 as the lover of Edward Weston, who made nude studies of her lush body, and taught her the craft of photography. When Weston returned to the United States, Modotti stayed on, living in the bohemian world of 1920s Mexico City, then seething with a mixture of Mexican nationalism, modernist art and left-wing politics. She had brief sexual affairs with a number of bohemia's card-carrying members, including Rivera, but then fell passionately in love with a handsome young Cuban communist named Julio Antonio Mella. He was living in exile from Cuba, a sworn enemy of the bloody Machado dictatorship.

On the evening of January 10, 1929, Tina and Mella were walking to their Mexico City apartment when two shots were fired in the darkness. Mella was hit, Modotti was not. He was rushed to a

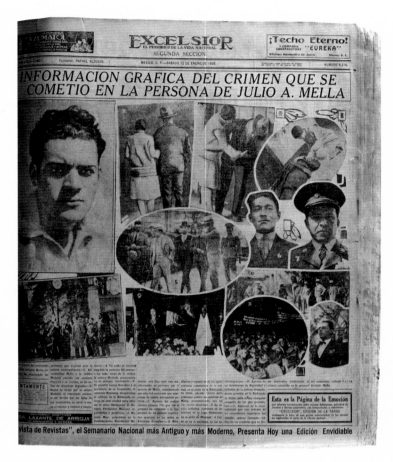

Excélsior, daily newspaper, second section, p. 1, Mexico City, January 13, 1929. Hemeroteca Nacional, UNAM.

hospital, mumbled his story, and died in the morning. Modotti told conflicting stories, lied about her name and her age, and was held by the police. They suspected, as would have almost all other policemen around the world, that Tina had murdered Mella in a lovers' quarrel. The Mexican press loved it, hauling out the Weston nudes, and filling many column inches with lurid stories about the woman one of them called "the fierce and bloody Tina Modotti."

Then Rivera got into the act. He became the most vocal defender of Modotti. He worked as a kind of detective to show that Modotti could not have killed Mella. He marched in protest rallies (pp. 124-125). Eventually, thanks in part to Rivera's efforts, Modotti was released for lack of evidence, and was soon on her way out of Mexico. She gave up photography and embraced the communist creed; in Spain, during the Civil War, she would become a fierce and bloody Stalinist. Years later, she returned quietly to Mexico and died in a taxicab in 1942.

In 1937, Rivera was also in the news when he helped persuade Mexican President Lázaro Cárdenas to grant political asylum to Leon Trotsky (p. 20). At that point, Rivera was defiantly anti-Stalinist, and Stalin's hitmen were on Trotsky's trail. Diego and his wife Frida Kahlo gave Trotsky full use of the famous "blue house" in Coyoacán, built by Frida's father, the photographer Guillermo Kahlo. Trotsky rewarded Rivera's generous help by having an affair with Frida. He was assassinated in August 1940, in another house in

Coyoacán, by an agent of Stalin. A photograph of the Trotsky funeral in the Casasola Archive is an odd reprise of earlier photographs by Agustín. Instead of the peaked rural *sombreros* of the Mexican revolutionists, taken from a high angle, we now see straw boaters, cloth caps and the fedoras of movie gangsters. The surface of the world was changing.

VI

Throughout the 1920s, and into the 1930s, the Casasolas seemed more interested in ordinary life than in the rarefied worlds of political or artistic celebrity. The contrast between ancient tradition and modernity is sometimes obvious. A streetcar is halted by a herd of goats. A figure of Judas is exploded in front of a newspaper office, while kids scour the street for fragments. Traditional musicians play instruments in a grave style that could be a thousand years old.

The circus arrives and a mustached man braids the trunks of two elephants (pp. 130-131). A huge throng of young men crowds the edges of what must be one of the city's first public swimming pools. In the shadows of the balcony there are a few women and men in suits, but there are no women at the water's edge. In another photo, layered now with time's mystery, a woman is at the controls of a locomotive while a man stands beside her dressed in vest and white shirt. Everybody else in the photograph is male, garbed in work clothes, gray with grease or grime. They all seem amused, as if the visit of a woman to their workplace was one of those amazing events they had never expected to see.

The Casasola cameras also roam the world of the urban night. As in all cities, electricity had changed most notions of time. In the countryside, many people still rose with the sun and slept after it went down. Not in the city, and a culture full of a dark glamour was emerging by the week. Cinemas opened everywhere. Dancehalls thrived. Music halls drew thousands to the multiple entertainments of San Juan de Letrán. Some of this was amusing. Look at those chubby chorus girls with their heads transformed into stars (p. 136). And why are those two women in chorus costumes standing with a crowd outside the Salón Rojo, while a man on the right of the photograph stares at their glistening flesh, and a woman on the left, in overcoat and boots, gazes at them as if they were ruining her own life?

The Casasola Archive is peopled by musicians too. Here is an eight-piece jazz band, with two female singers awkwardly awaiting their turn. Here are the winners of a tango contest. Both remind us of certain paintings by Abel Quezada in the 1970s, with their mixture of a fleeting accomplishment and a permanent innocence, here frozen forever by the camera.

The night is also the place where secret lives are played out, too often ending in the public exposure of police stations, court rooms, or the newspapers themselves. We see a dozen gay men, almost certainly under arrest, some shy, hiding behind others,

while some offer muscle-flexing parodies of the prevailing machismo. A few appear to be drunker than others, but together they convey an attitude of defiance that is at once silly, sad, and brave. We would see more of this attitude many decades later, after the social revolutions of the 1960s.

We glimpse, too, the private world of the opium smokers, where the Casasola instinct for drama seems to have succumbed to the conventions of movie melodrama. The woman with her hookah, reclining on an elaborately theatrical bed, suggests a daughter of the upper class who has fallen under the power of the white powder. Clearly the photograph is staged. But we don't know if the woman is a mere model, a counterfeit of an addict, or an actual addict. We do know that opium was part of the Mexican night.

So are the women of what the press calls *la vida galante.* They are not new to Mexico or any other city in the world. But the visiting camera is remarkably unsentimental. The woman in the doorway on page 153 has a face as tough as the world in which she lives night after night. She appears to be listening to the man in the overcoat but keeps smoking, her face alert. The pavement, and the visible sole of the man's shoe, are wet with rain. The details of the conversation are lost. So is the rest of that rainy night, long ago. The two human beings live on in this photo.

In the courts and police stations, the Casasola eye moves like a modern Daumier. There's a marvelous woman looking coldly from behind bars. She's wearing a necklace of stage jewelry. Her eyebrows are carefully clipped and drawn, her mouth shaped by lipstick into bow lips. She wears a belt that appears to be made of giant teeth. The glaze in her eyes says that no matter what she is now accused of, she is convinced she is right. She stands in rough contrast to the woman on page 164. She has just received what must have been unbearable news. Her left hand goes to her pretty face. But her heavy body seems limp in its well-made man's coat. She has been caught here in one of those decisive moments when a human being knows that life itself will never be the same. And most extraordinary of all, there in the photograph, emerging from the left, is a single human hand. It could be a hand of accusation. It could be offering help. We can't now know. What we do know is that this woman is in pain.

The man on the autopsy table on page 166 is beyond pain, but the photograph has an eerie religious quality, reminding us of all those European versions of the viewing of the dead Christ. There are many photographs of men under arrest, most of them young. We certainly would not wish to encounter the man to the left of the photograph on page 174 on a dark night. But what could have happened to that trembling young couple on page 175 or the young boys a few pages later? Like all countries, Mexico struggled to make a system of justice that was also humane. As in all countries, it was often imperfect. In image after image, we see men in suits, many of them bored, judging men without suits who knew that their lives depended upon the judgment to come.

In one remarkable scene we see an experiment in justice that failed. This was called the popular court. In some ways, it resembled the Islamic tradition of the *loya jirga*, where people prevail over individual judges. In Mexico, judgments would be shouted from the audience, expressing the thumbs-up or thumbs-down of a supposed popular will. Every row is packed, men stand to the rear, and there is no room in the balcony. Clearly, this institution contained elements of popular entertainment. Some of the men and women in the front rows are dressed as if they were going to the theater. Some surely must be relatives or lovers of the accused. They are all waiting for the curtain to rise on the drama. Today, the popular court would be a staple on daily television. But it was discontinued long ago, because the entire process was too subjective. Someone explained that if an accused murderess was beautiful, she always walked free, judged too pretty to spend the rest of her life in prison. True gallantry, after all, must contain a measure of forgiveness.

In one photograph, pp. 178-179, there is neither forgiveness nor condemnation, only acceptance. Six poor women stand outside one of the iron doors of the horrific Belén Prison in Mexico City. They resemble the drawings and sculptures of Francisco Zúñiga, wearing the eternal shawls of the Mexican poor. They are clearly waiting for glimpses of some of the men in their lives: husbands, sons, grandsons. They almost surely have no money for lawyers. They almost certainly have no political connections. They might pray for help to the Virgen de Guadalupe. They might whisper their hopes to each other. But for this moment, they wait.

They are waiting still, among the 483,993 images in the Casasola Archive. In all those frozen moments, the narrative of Mexico in the first four decades of the twentieth century lives on. Collectively, it comprises an immense work of history, one that will be examined and pondered and researched for many years to come. It is also an immense Proustian novel, in which history is meshed with ordinary lives, where great men share space with carpenters, and where the true subject is Time.

Agustín Casasola never claimed that his work was art. Few newspapermen ever make that claim. But in his own marvelous photography, and in the work of others that he assembled in the Archive, he created a collective work of art that seems today even more powerful than when it was being made. Enter that world, and you are touched by pathos, ambition, courage, laughter, tragedy, absurdity, and some abiding mysteries. Few artists anywhere have ever accomplished so much.

THE PORFIRIAN PEACE

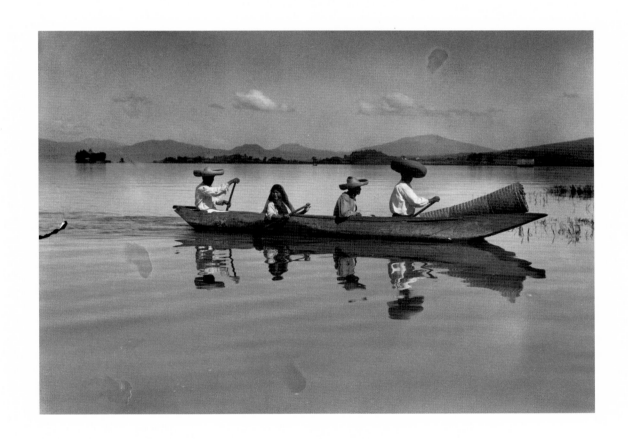

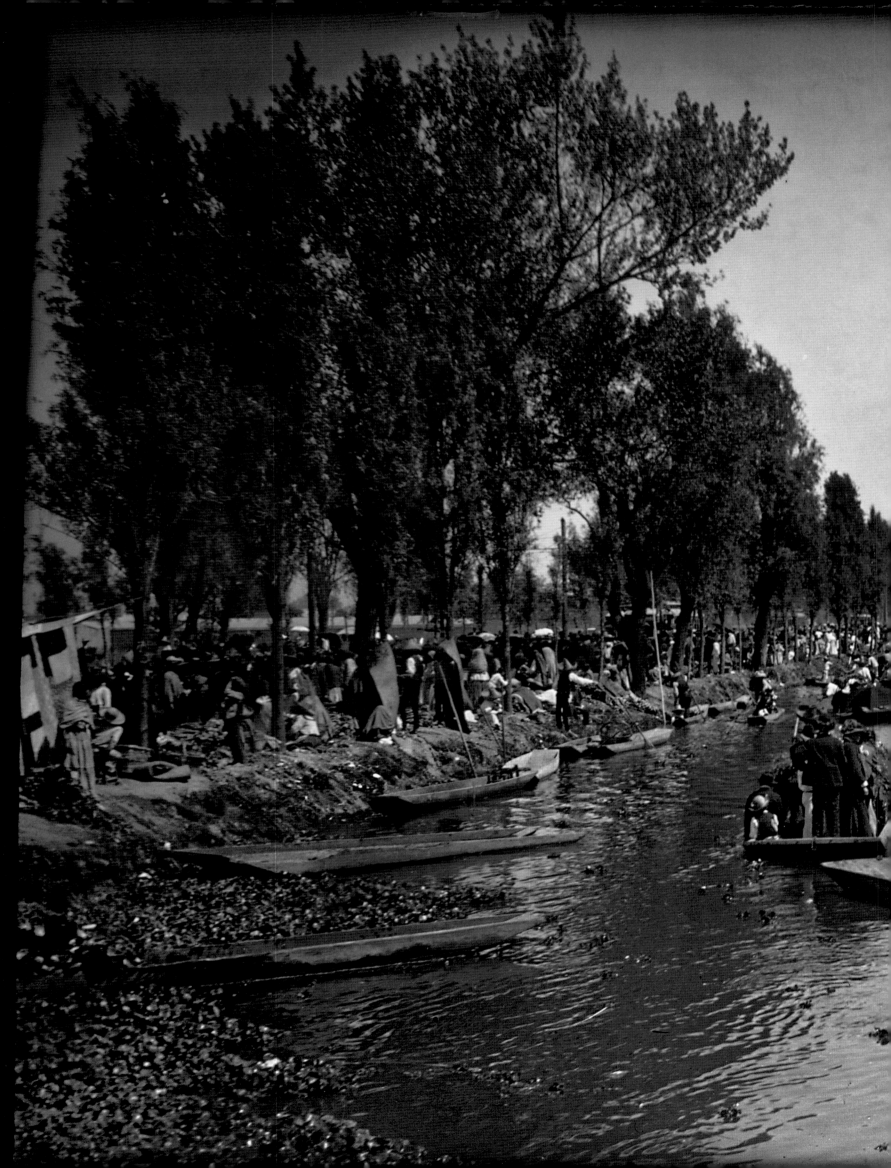

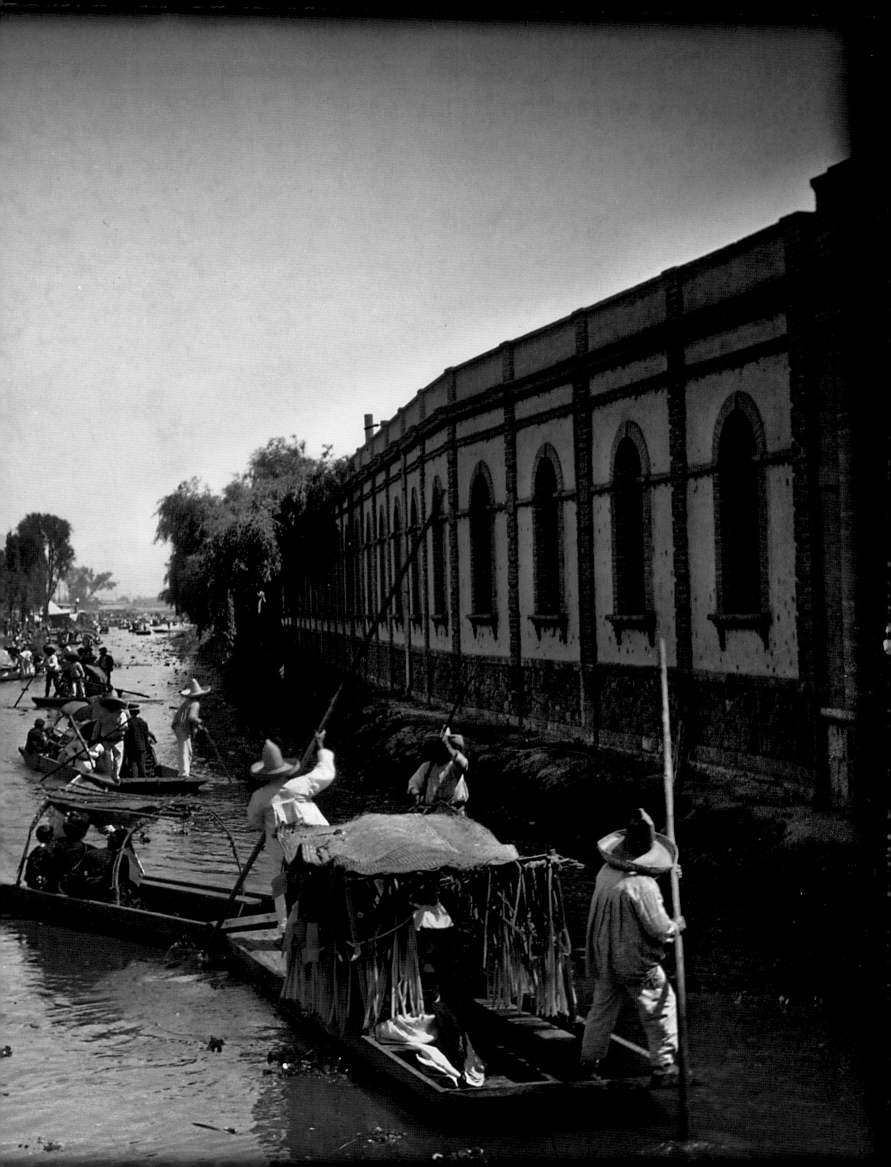

Comedies, musical extravaganzas, and ballets were performed in the Teatro Principal, located in the heart of the city. *Ca.* 1910. [196990]

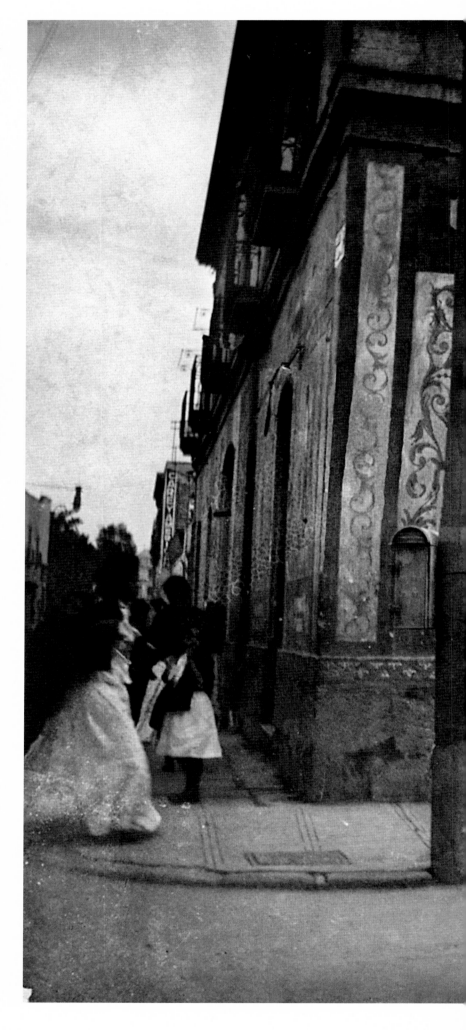

While the well-to-do classes drank European wines in luxurious restaurants and cantinas, the common people were faithful customers at establishments known as *pulquerías*, which served a thick, white, alcoholic drink made from the maguey plant: the one and only *pulque*. The façade of a downtown *pulquería* called El Vaseo appears in the photograph. [197664]

Pages 24-25
The ancient La Viga Canal was vital for communication between Mexico City and neighboring towns. Countless barges and canoes carried passengers, supplies, and merchandise. They also provided transportation for a pleasant Sunday outing during Porfirian times. In this photograph we glimpse people traveling in launches, as well as passersby along the edge of La Viga Canal. Mexico City, *ca.* 1910. [288008]

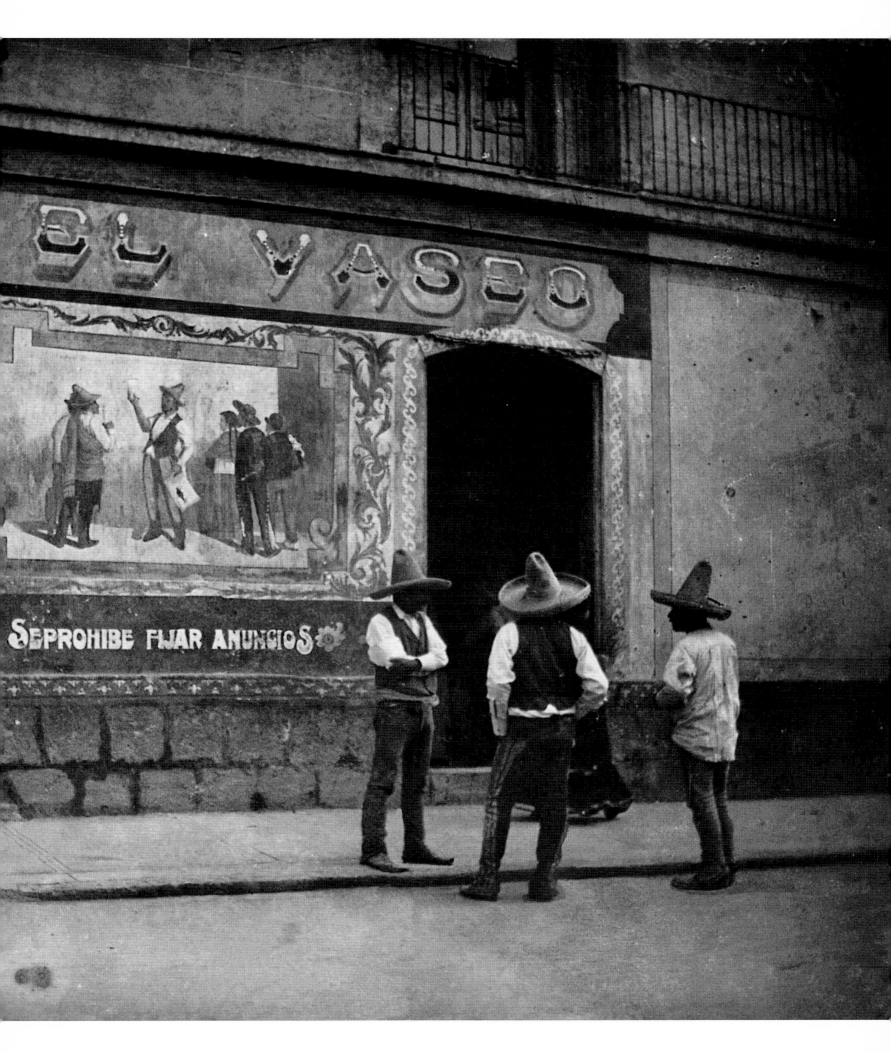

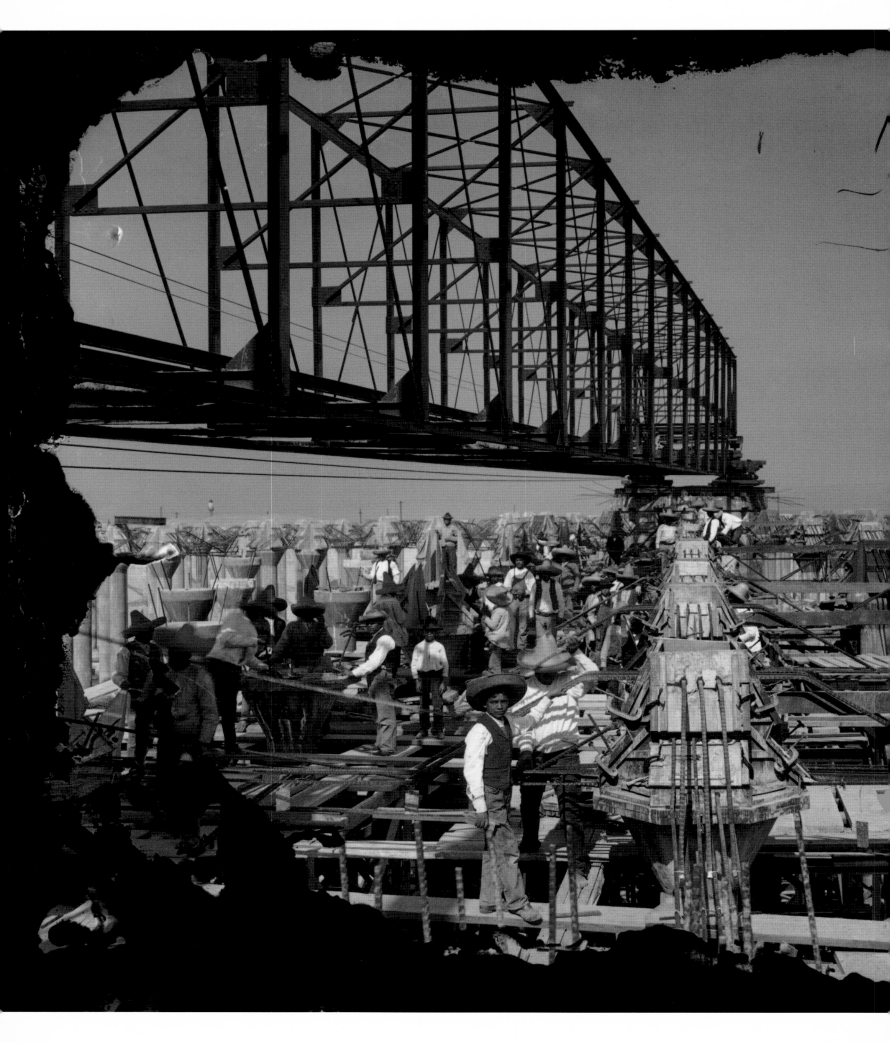

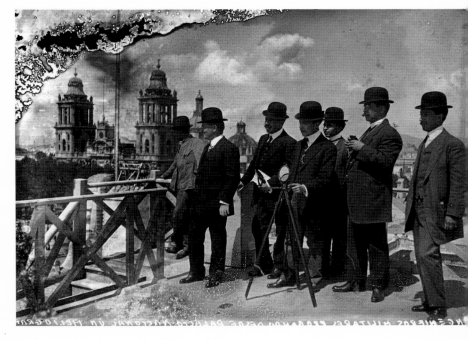

One of the aims of the Díaz regime was to encourage scientific disciplines like astronomy. This photograph shows the politician and intellectual, Vito Alessio Robles, in the company of astronomers who are analyzing solar rays from the roof of the National Palace. 1912. [201574]

General Díaz's administration sought to modernize the hydraulic infrastructure in order to provide drinking water for residents of Mexico City. The photograph is a record of one of the public works undertaken to bring spring water from Xochimilco to the city. *Ca.* 1910. [502230]

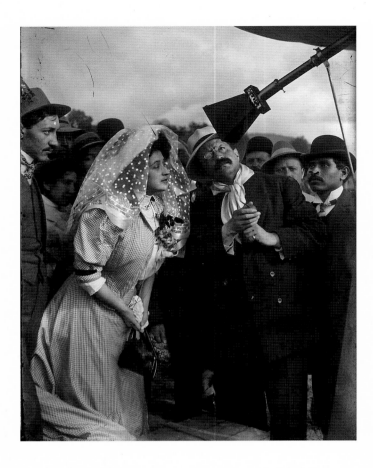

Natural phenomena like solar eclipses ceased to be seen as "omens of evil" and became "scientific curiosities." Here the camera captured an amateur astronomer setting up a telescope in the Plaza de Armas so that people could witness a solar eclipse. *Ca.* 1910. [201573]

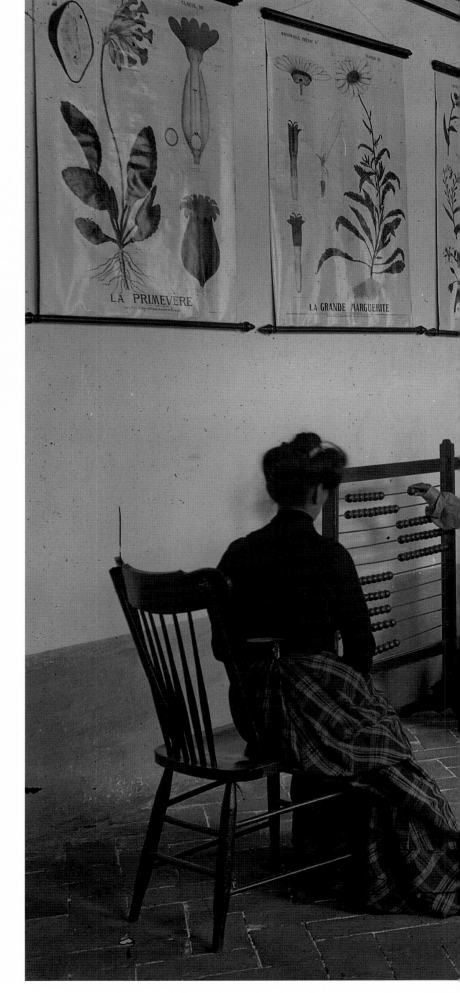

Public education was a benefit enjoyed by the urban classes. In the year 1900, primary education was obligatory. There were 12,000 schools and approximately 700,000 students. In this photograph, schoolgirls attend a mathematics class. *Ca.* 1910. [6336]

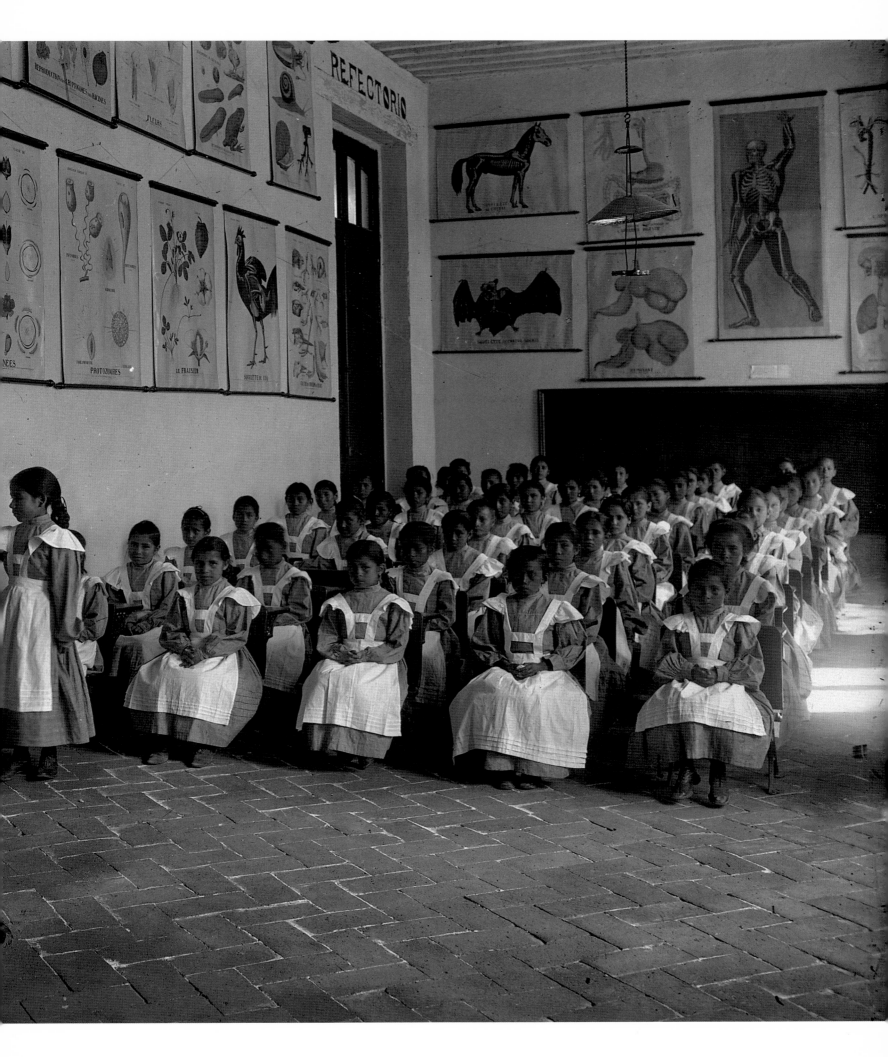

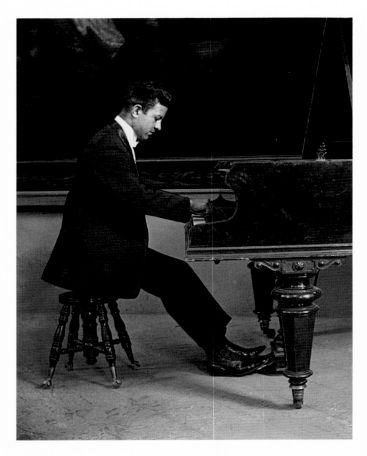

Audiences in the city's theaters experienced extraordinary events, such as the operatic performances by soprano Adelina Patti and tenor Tamagno, as well as piano concerts by Paderewski. *Ca.* 1908. [14102]

A strong European influence was noted, not only in fashionable clothing styles, but also in new social customs like the wedding in this photograph. A widow, escorted by an elegant gentleman, is part of the wedding party. *Ca.* 1912. [20351]

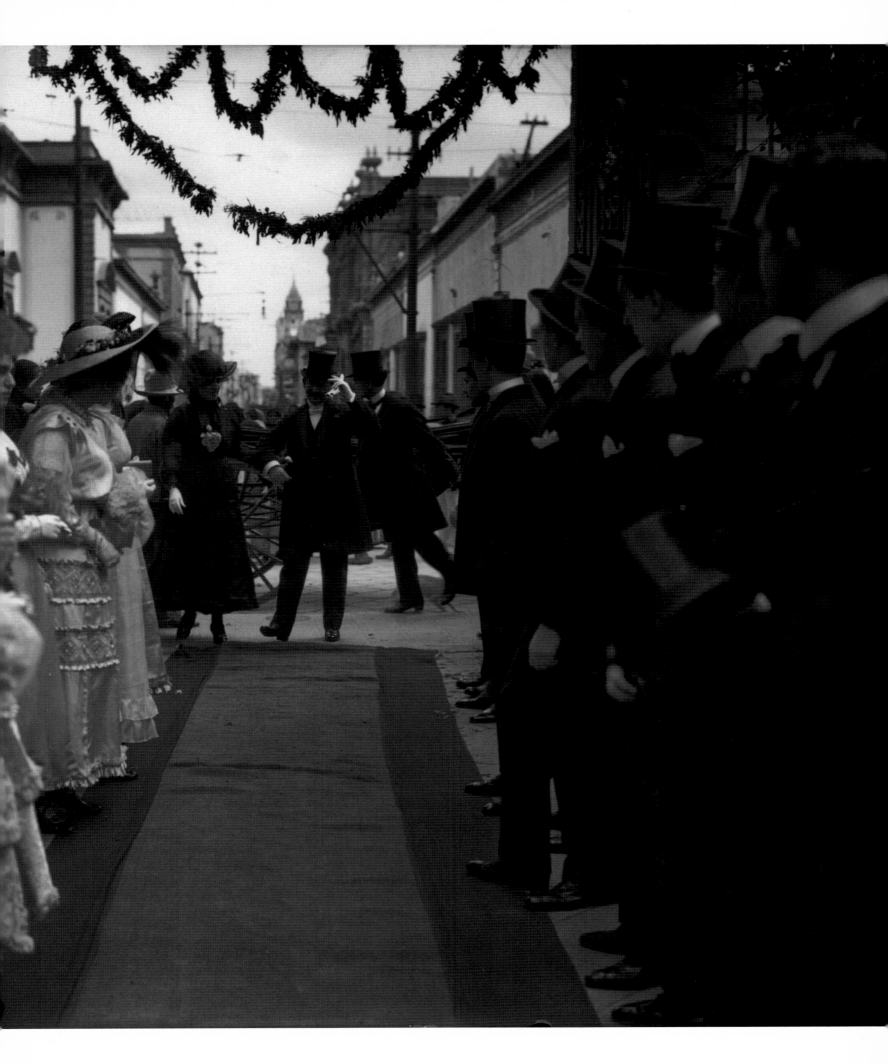

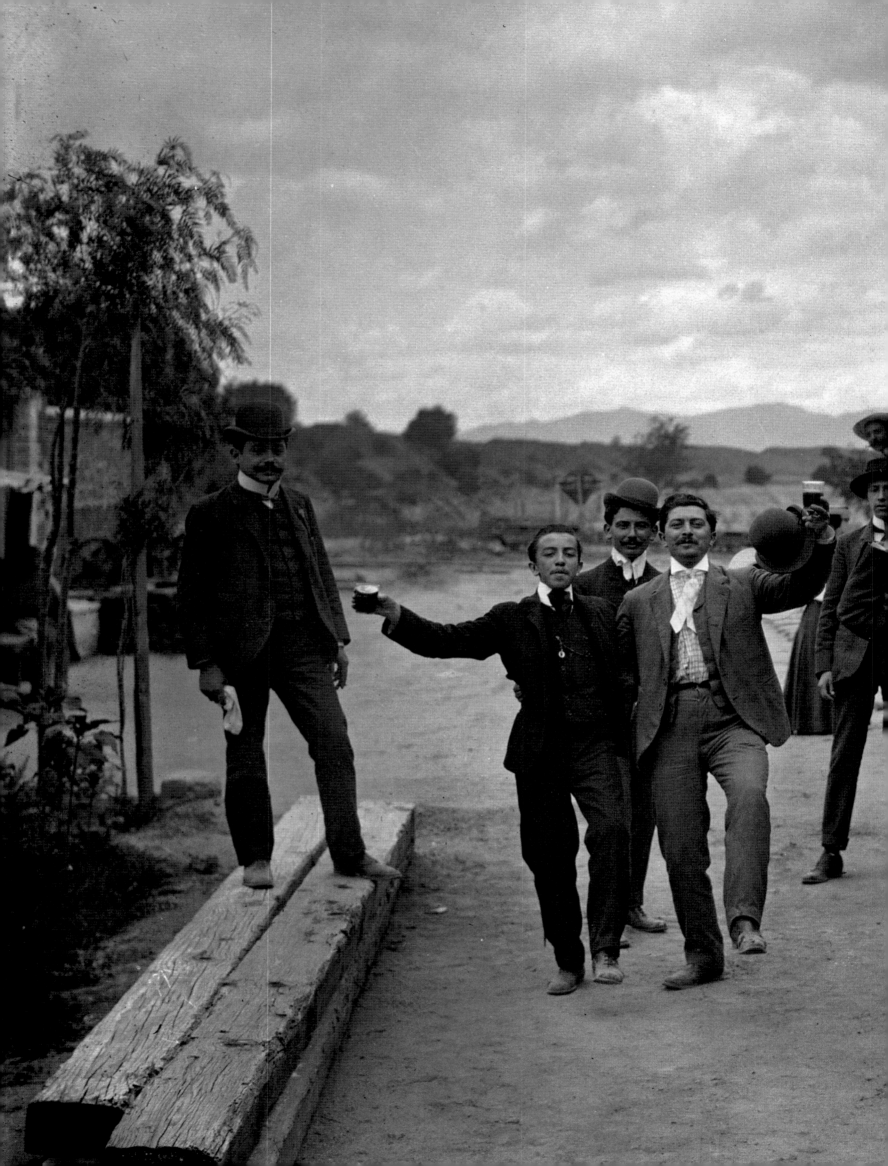

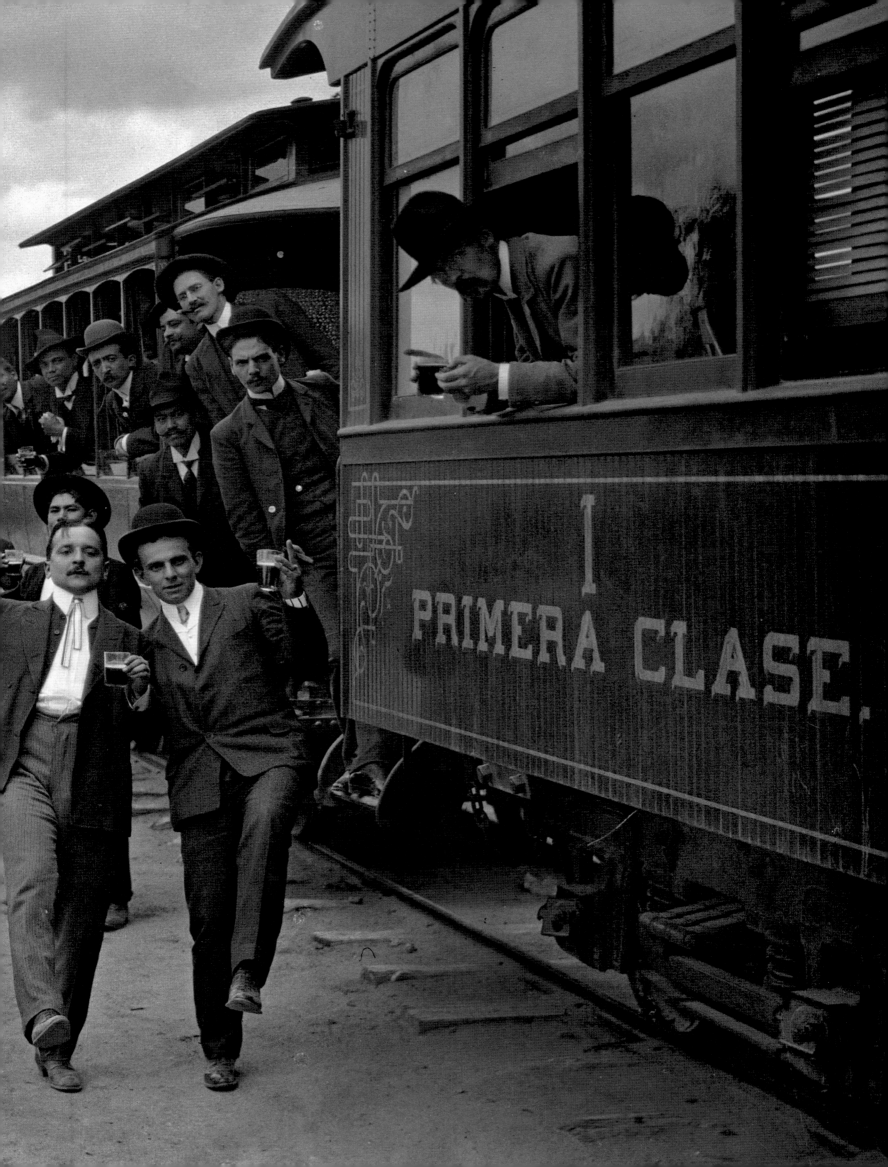

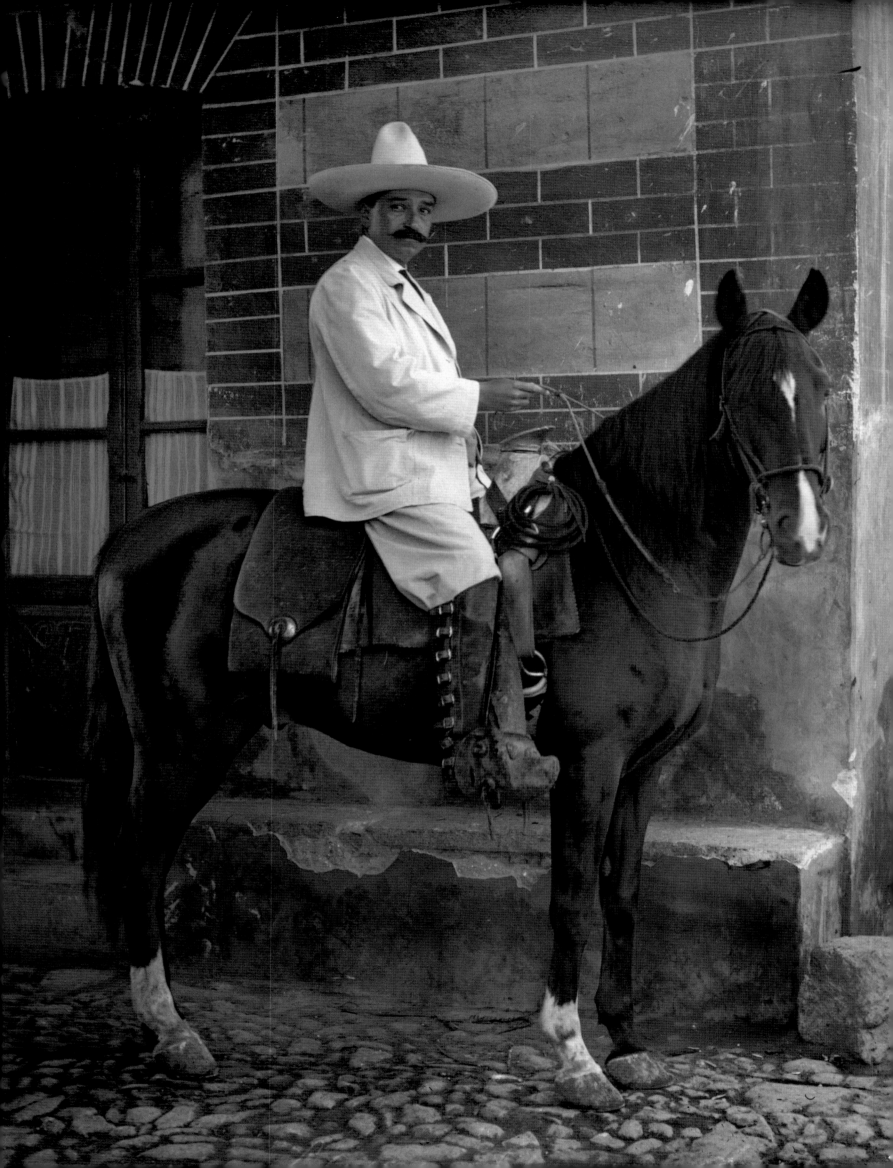

Simón Cárdenas, center, head of the bullring attendants. Ever since colonial times, bullfights had aroused great public enthusiasm. At the end of the nineteenth century, there were five bullrings in the capital. More than a few young men were anxious to make a name for themselves in the ring. *Ca.* 1910. [11859]

The *hacendados*, owners of immense stretches of farm and ranch land, lived at the top of the pyramid in rural society; at the bottom was an enormous mass of laborers living in crowded quarters at the haciendas, "working off" their eternal debts. The man on the horse is the proud hacienda owner Arcadio Lara. Mexico City, *ca.* 1910. [19365]

Pages 34-35
By laying 24,000 kilometers of railroad tracks, the government established communication between distant parts of the country. The railroads made it easier to travel long distance. Young men celebrating with beer a trip to the environs of Mexico City. *Ca.* 1911. [32022]

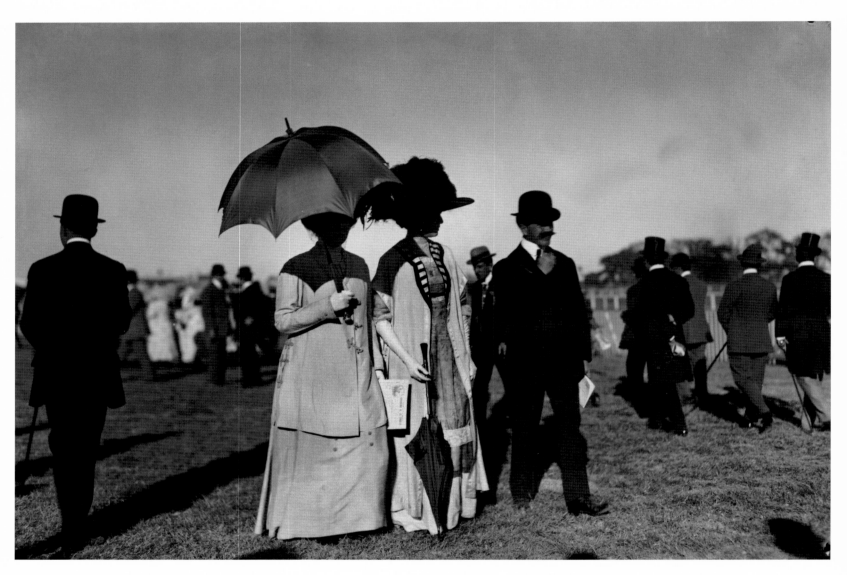

The racetrack Hipódromo de La Condesa was another of the famous gathering places for the urban bourgeoisie. *Ca.* 1905. [5869]

Every year, National Independence Day is celebrated with flashy military parades and public celebrations. This photograph portrays the parade on downtown Plateros Street, September 16, 1906, but it also reveals the nonconformity of the laboring classes. [35225]

Pages 40-41
The dictatorship of General Porfirio Díaz began in the year 1877 and lasted until 1911, when he went into exile in Europe. Thus ended the period in Mexican history known as the Porfirian Peace. Díaz appears here surrounded by his collaborators. On his left is Mexico's ambassador to the United States, Enrique C. Creel, at a ceremony honoring the republican President Benito Juárez in July 1910. [6208]

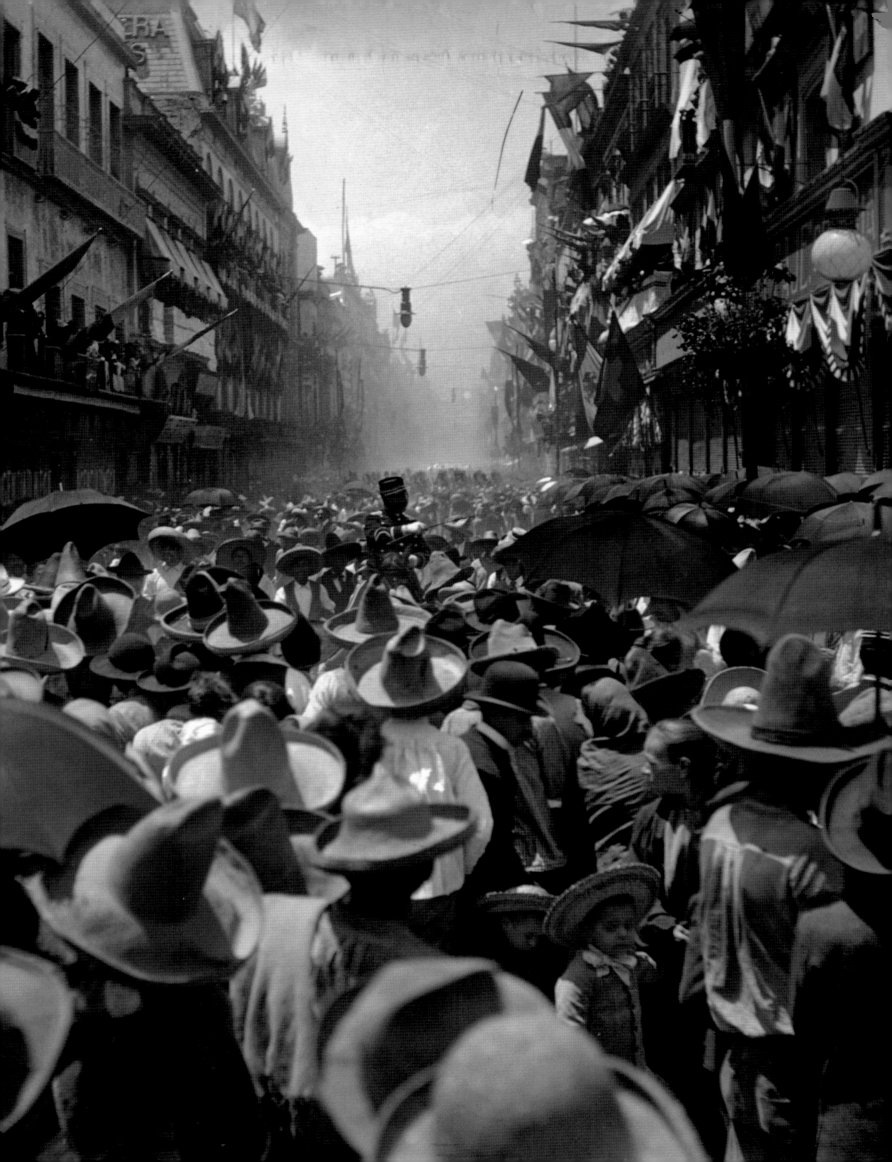

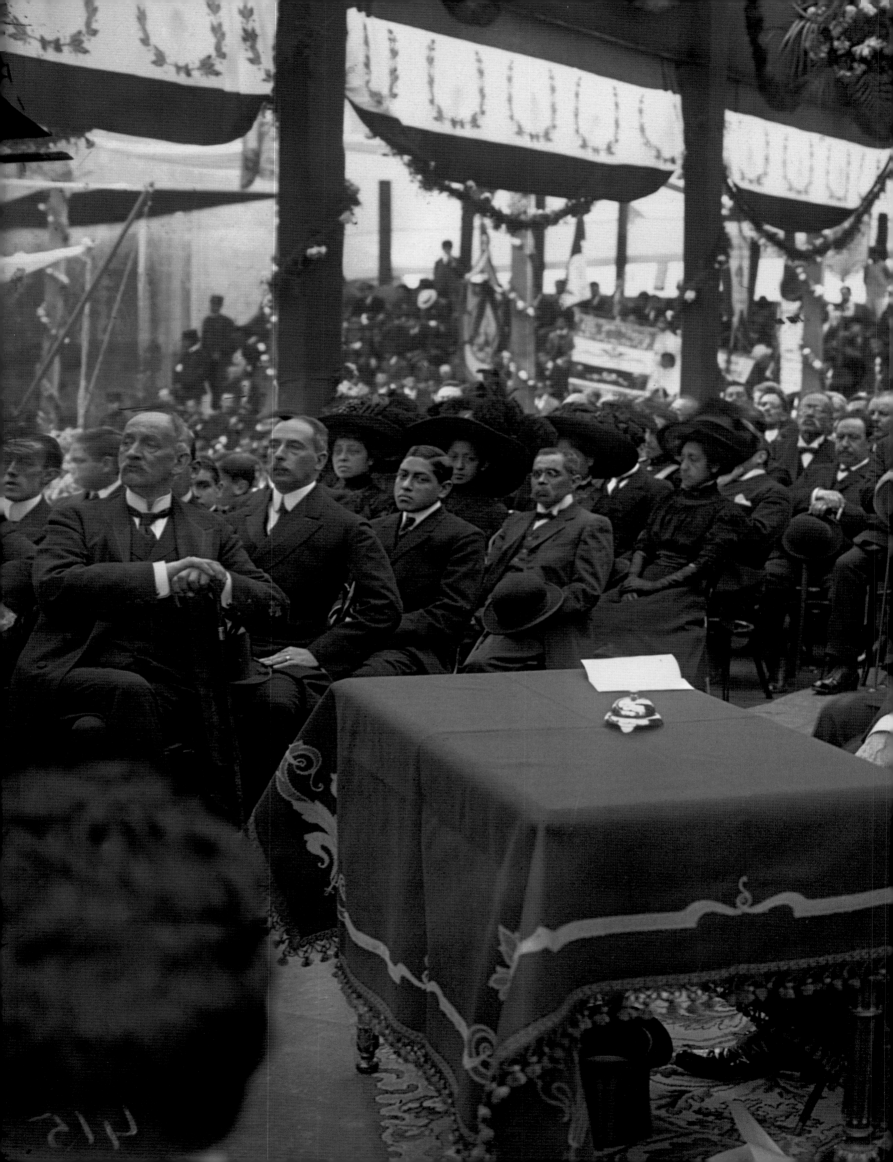

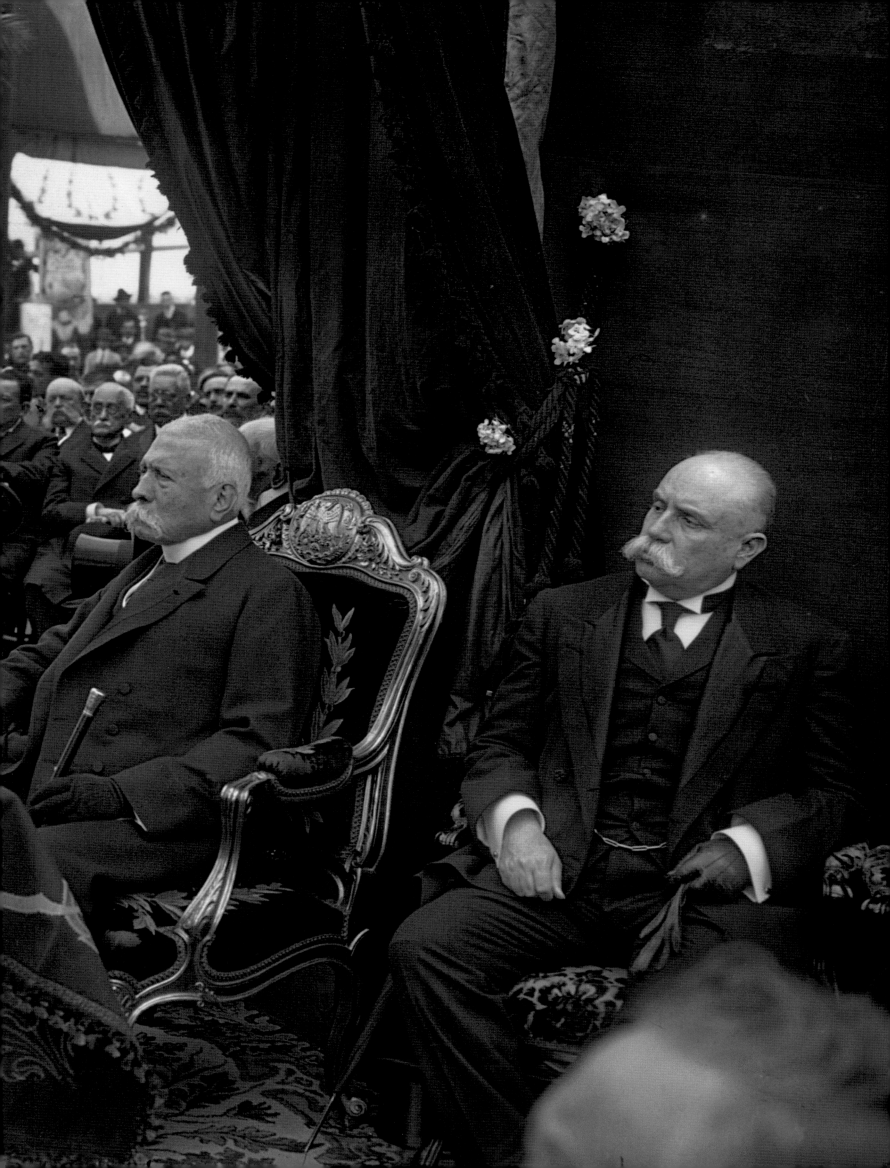

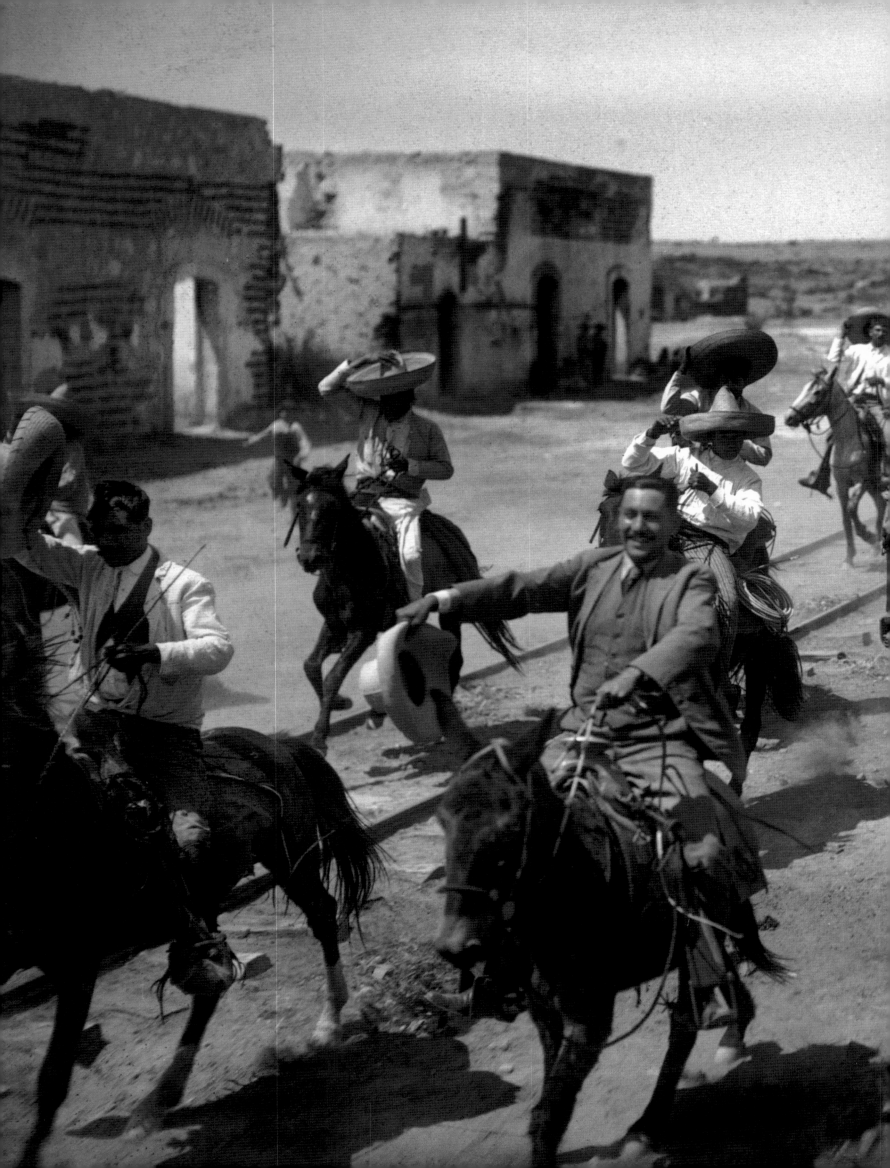

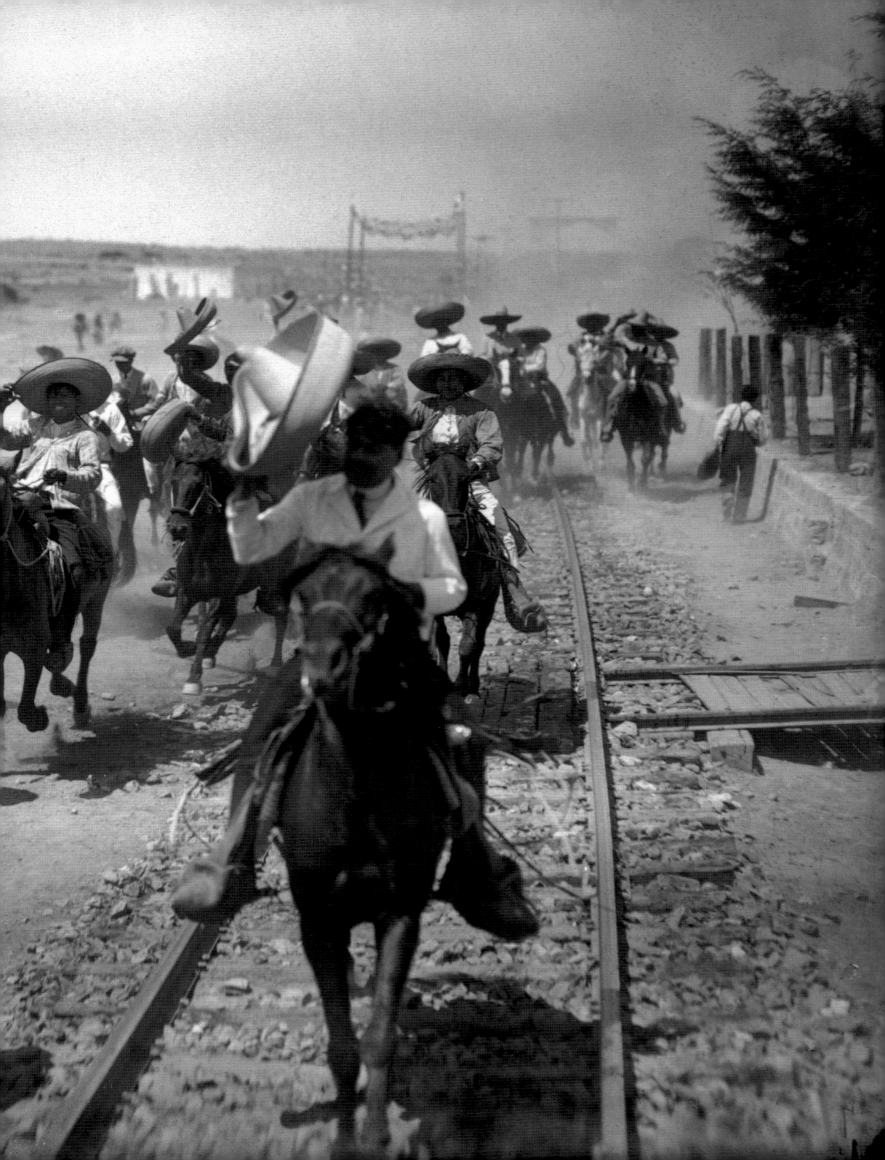

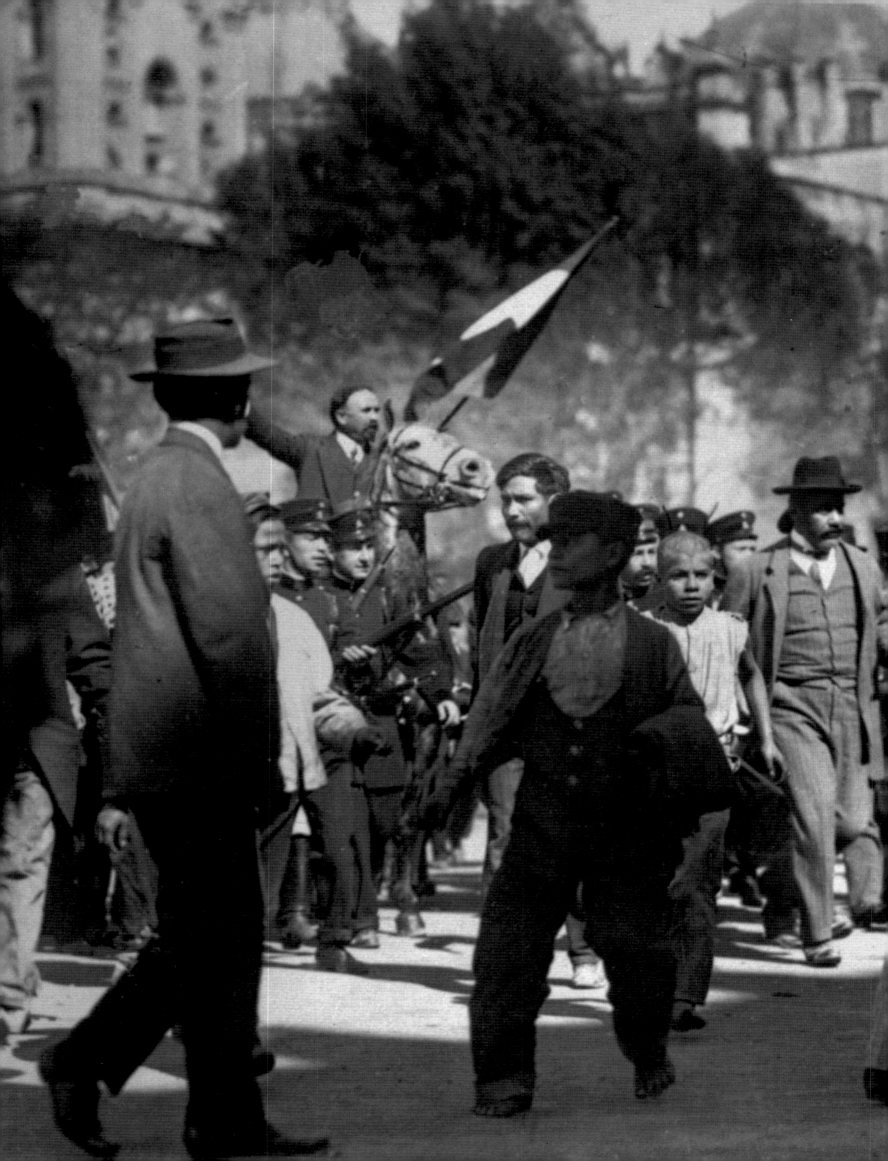

Pages 42-43
Troops loyal to Francisco Madero ride into town at a gallop. *Ca.* 1911. [5735]

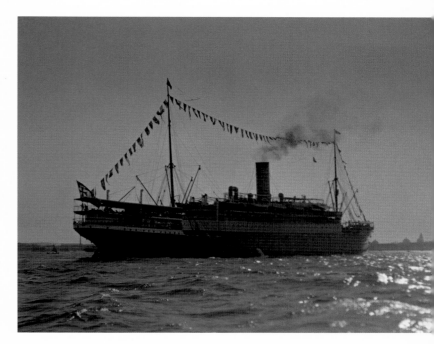

On May 26, 1911, accompanied by family members and associates, General Díaz abandoned the country on the ship named the *Ipiranga* on what turned out to be a one-way voyage. Díaz would never return to Mexico. [33501]

Loyalty march, February 9, 1913. After General Díaz was defeated and new elections were called, the democrat Francisco I. Madero was elected as the new president of Mexico. Nevertheless, in the year 1913, his government was cut short by a military coup, which precipitated a period of instability and revolutionary violence. This photograph shows Madero guarded by a loyal corps of young cadets before he was betrayed by the military officer Victoriano Huerta. [37451]

Pages 46-47
The joy with which the people celebrated the fall of General Díaz and the triumph of Francisco I. Madero was the preamble to a libertarian rebellion that cost the country more than a million deaths. In this photograph, taken on April 25, 1911, people cheer Madero and repudiate Díaz in Mexico City. [5250]

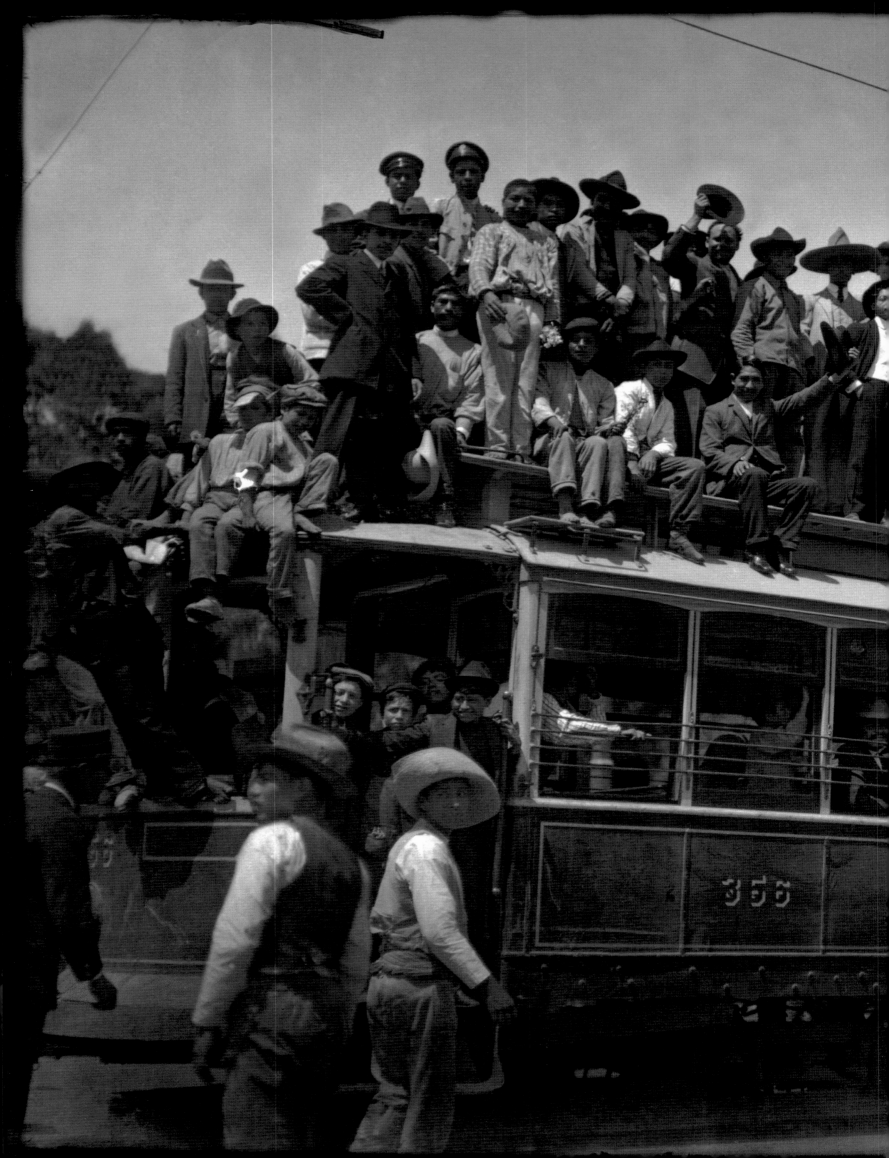

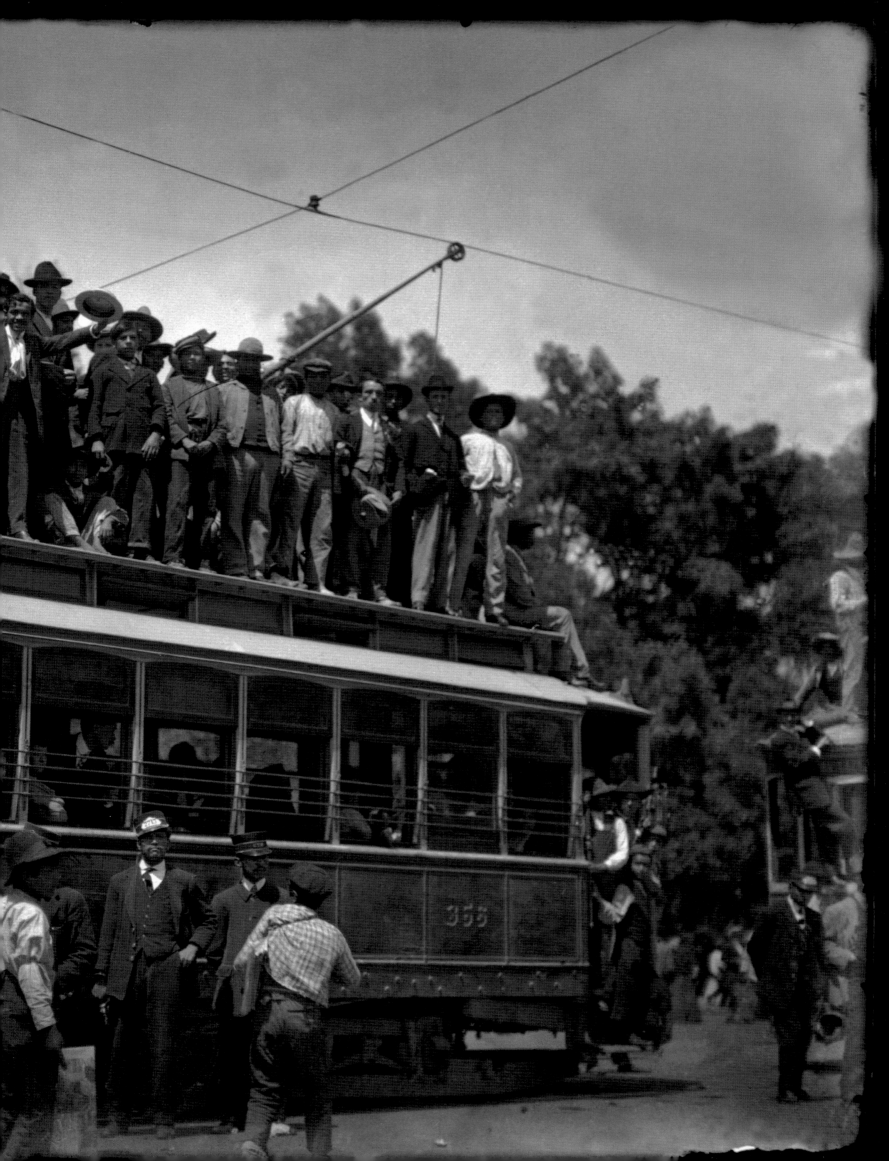

THE REVOLUTIONARY WAR

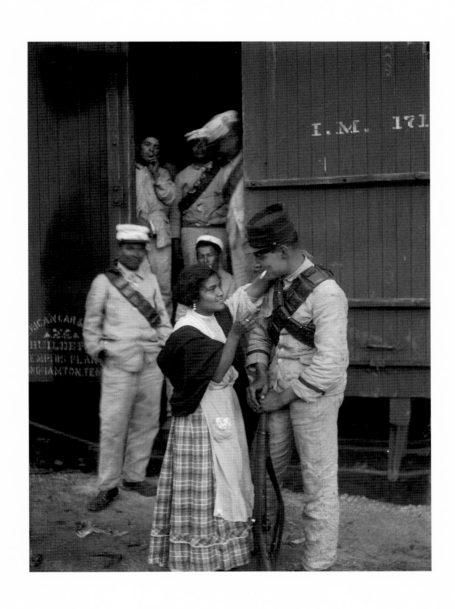

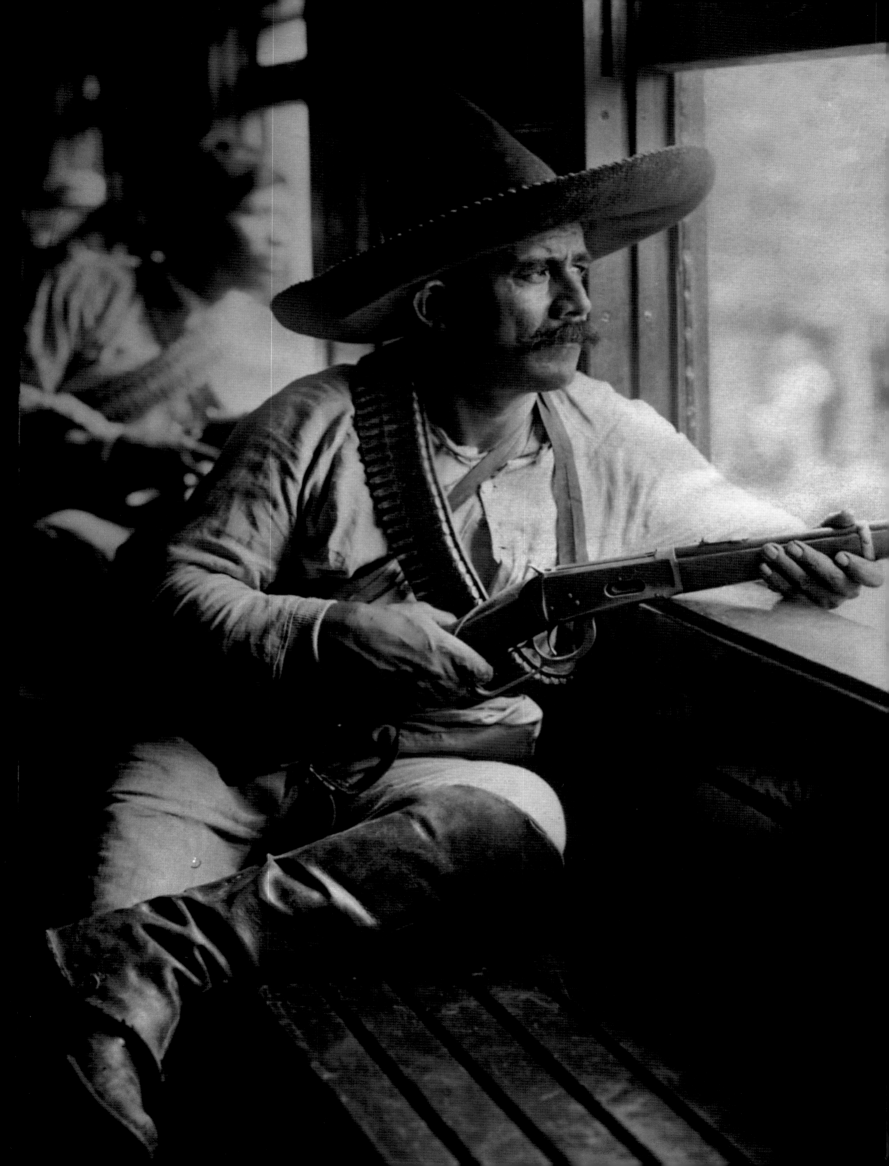

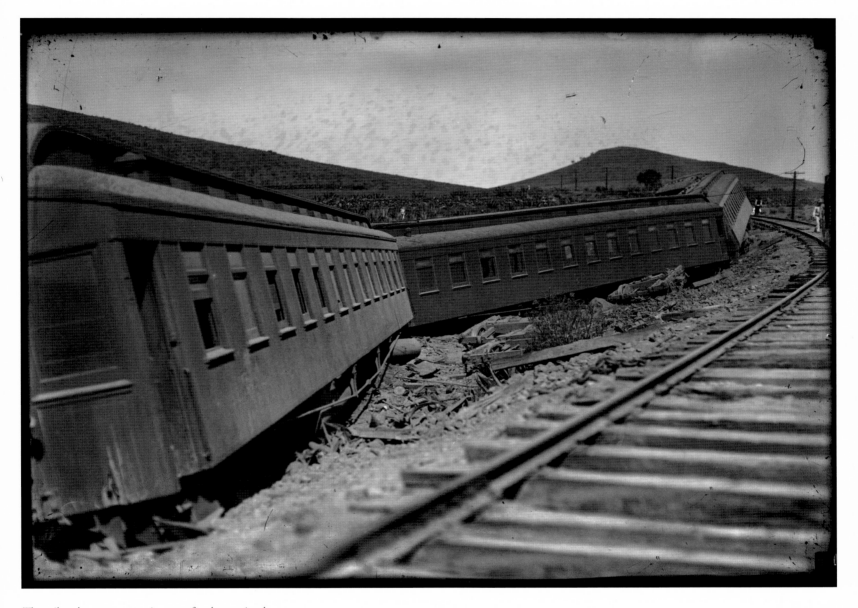

The railroads were a strategic target for destruction by the rebels, given that they transported federal troops and armament. *Ca.* 1914. [32258]

The Constitutionalist Army commanded by Venustiano Carranza rose up in arms against Victoriano Huerta in the North, while Emiliano Zapata led the fight in the South. *Ca.* 1914. [33075]

Pages 52-53
Federal troops were sent out from the Buena Vista train station in Mexico City. *Ca.* 1914. [6344]

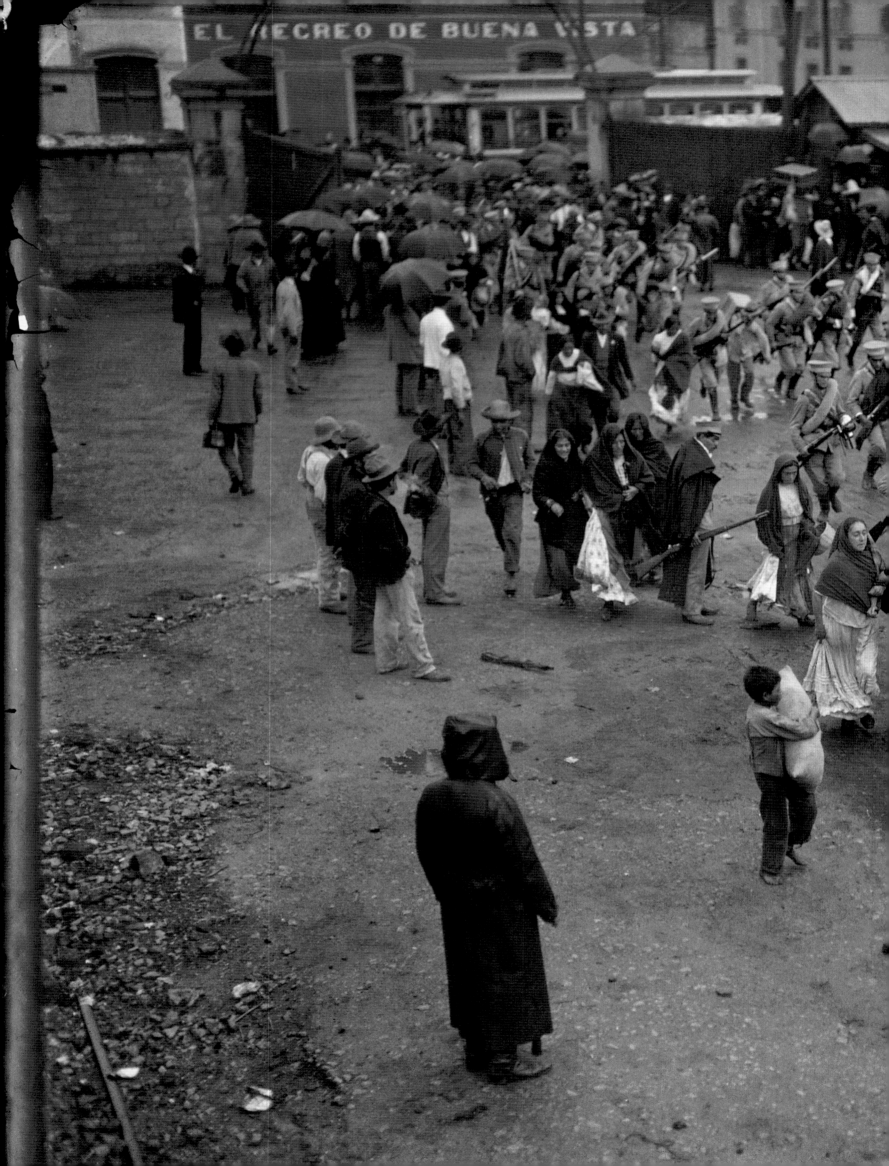

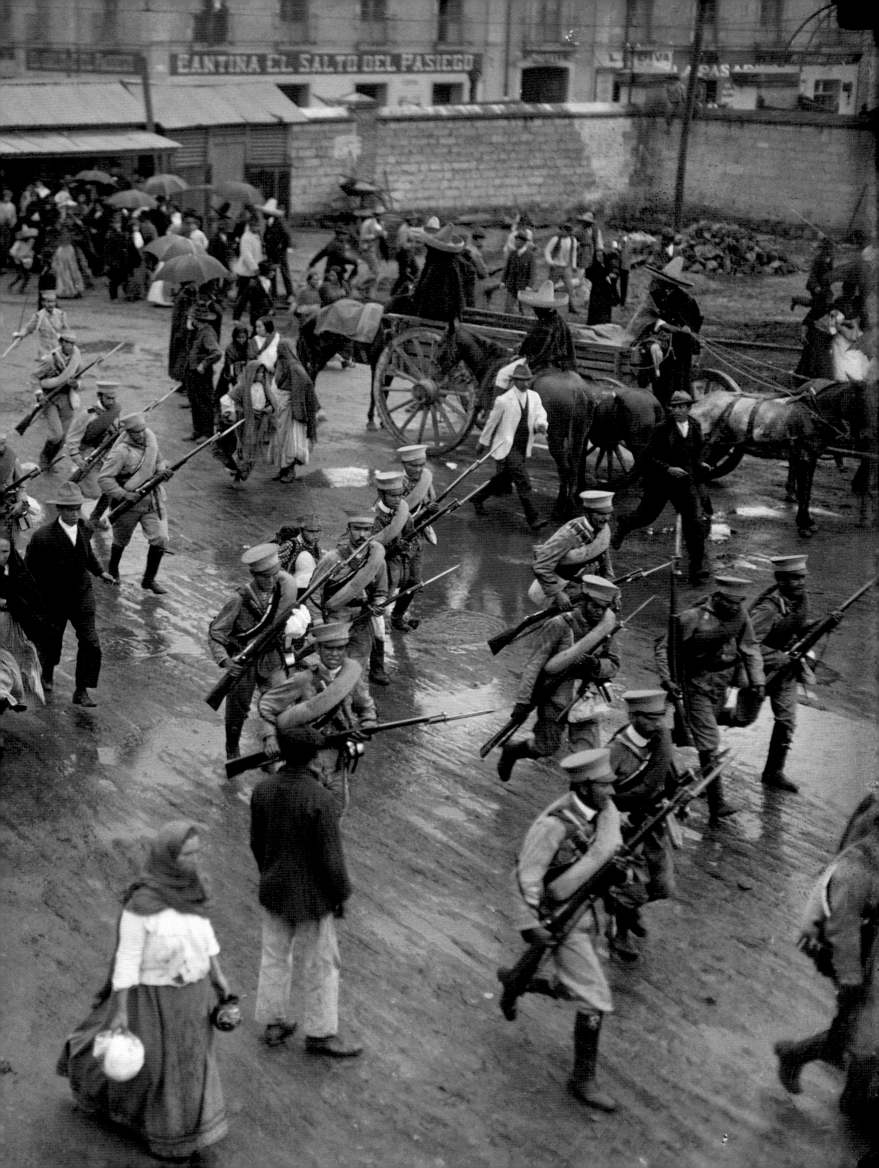

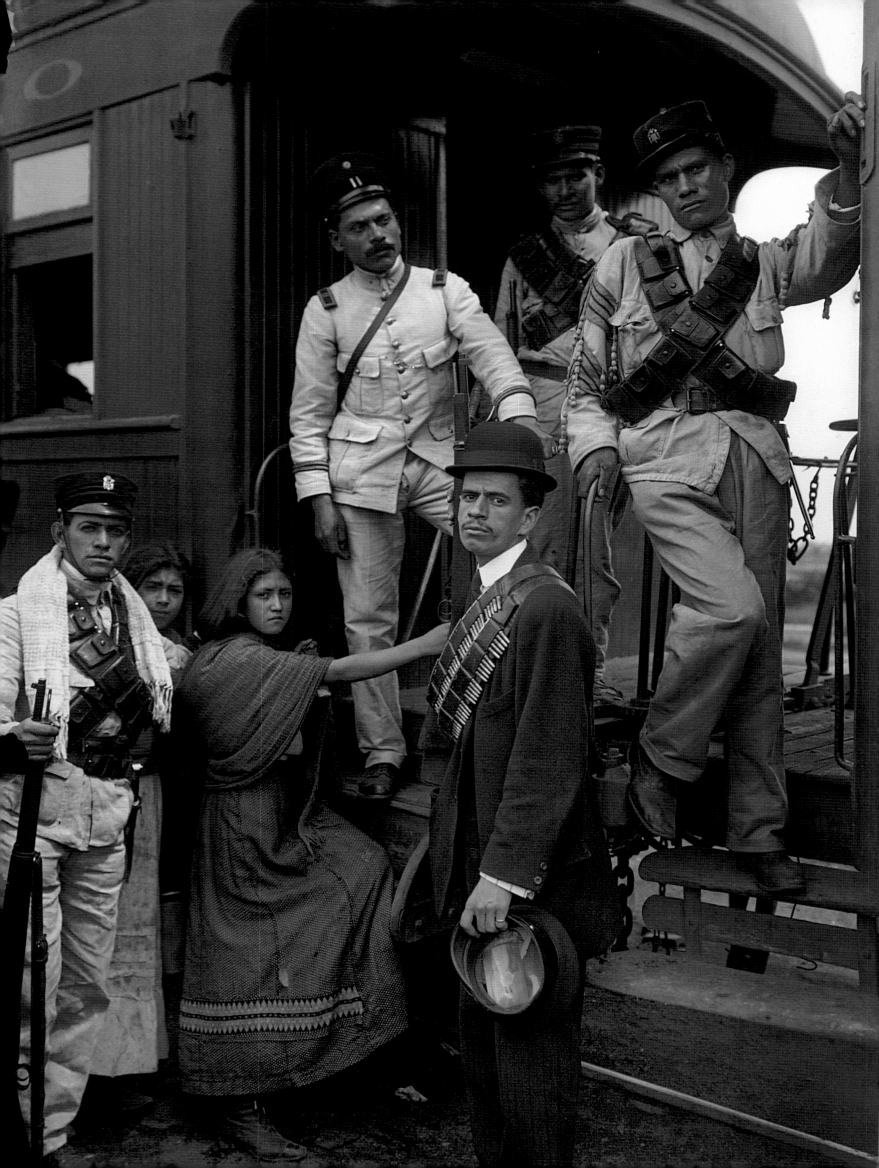

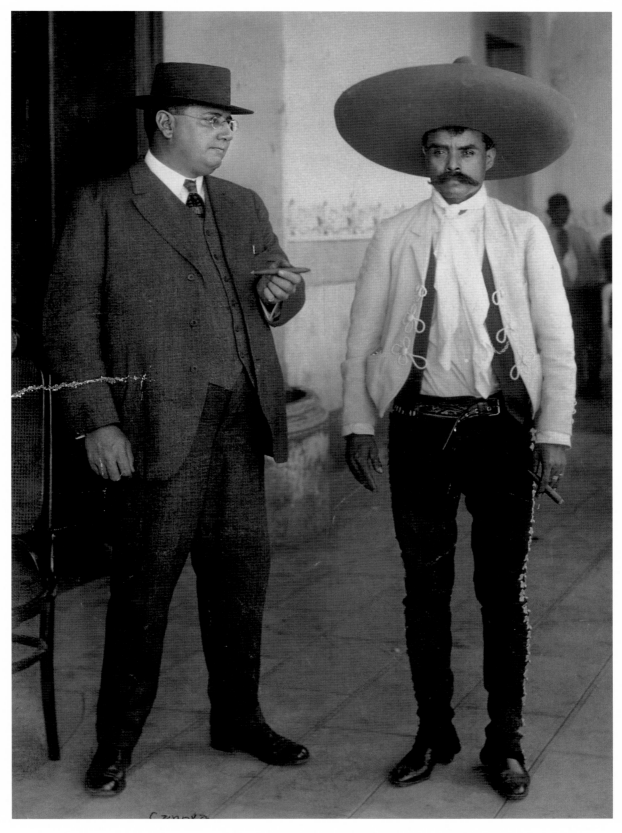

In the year 1914, the usurper Victoriano Huerta fell from power and rebel groups met in Mexico City. In this photograph are the American Consul Mr. Carothers and Emiliano Zapata in Xochimilco. [687563]

In order to maintain its illegitimate power and combat the rebels, Huerta's regime doubled the pay of federal soldiers and imported huge quantities of arms from Europe, Japan, and the United States. Here a railroad executive poses with ammunition belts and combat arms in Mexico City in April 1913. [6293]

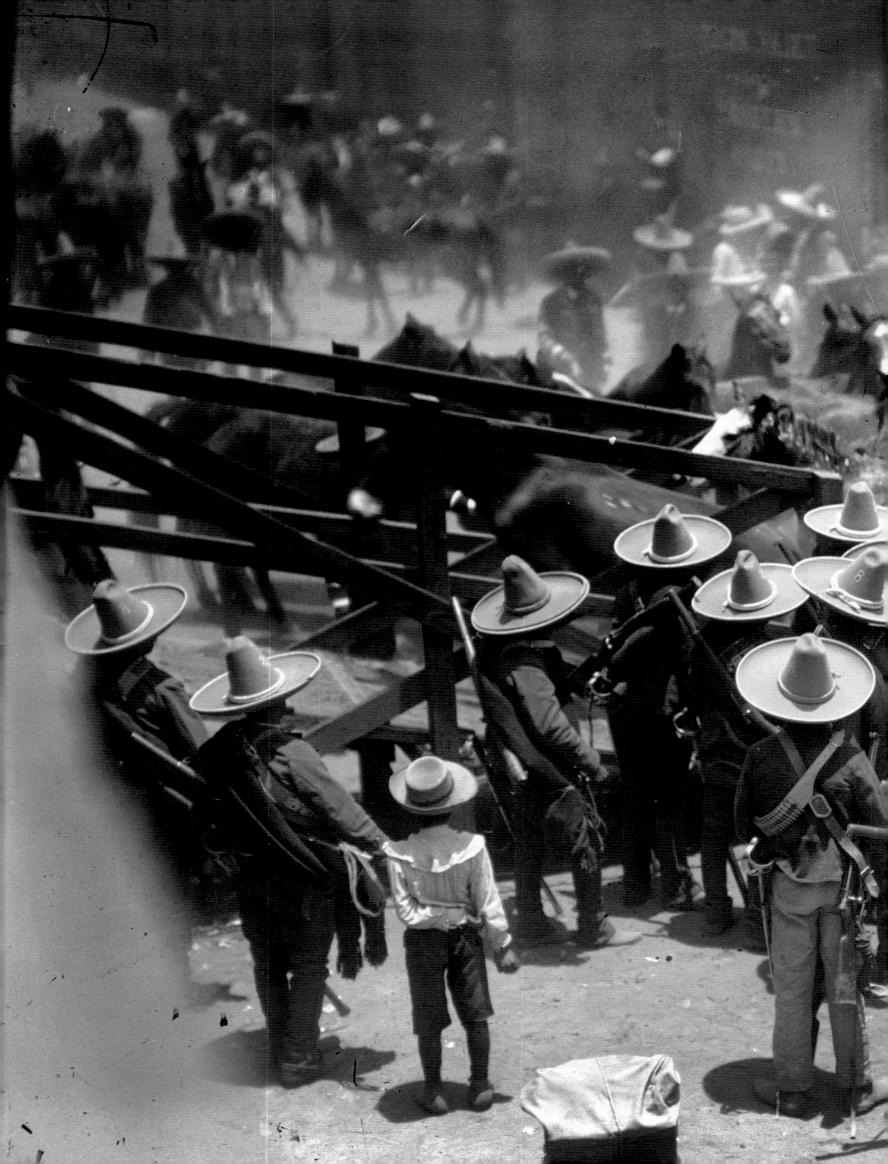

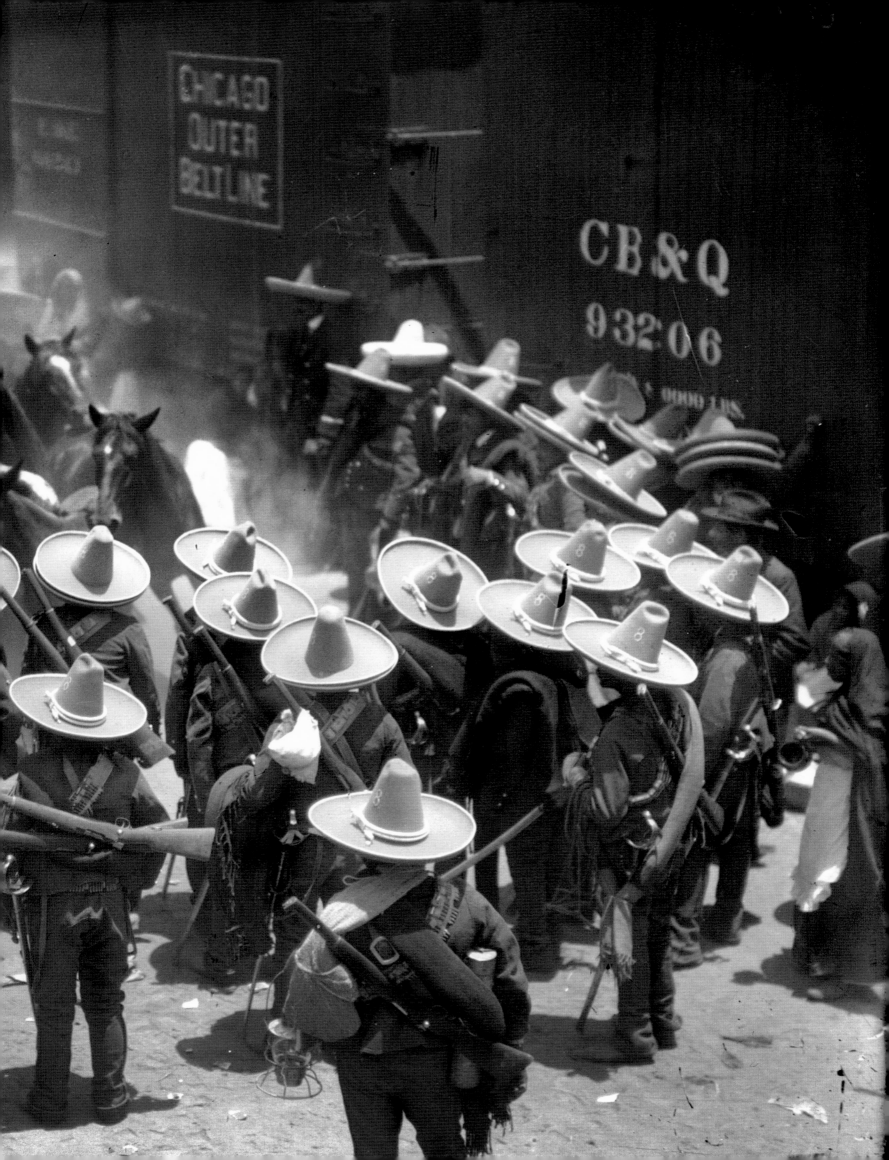

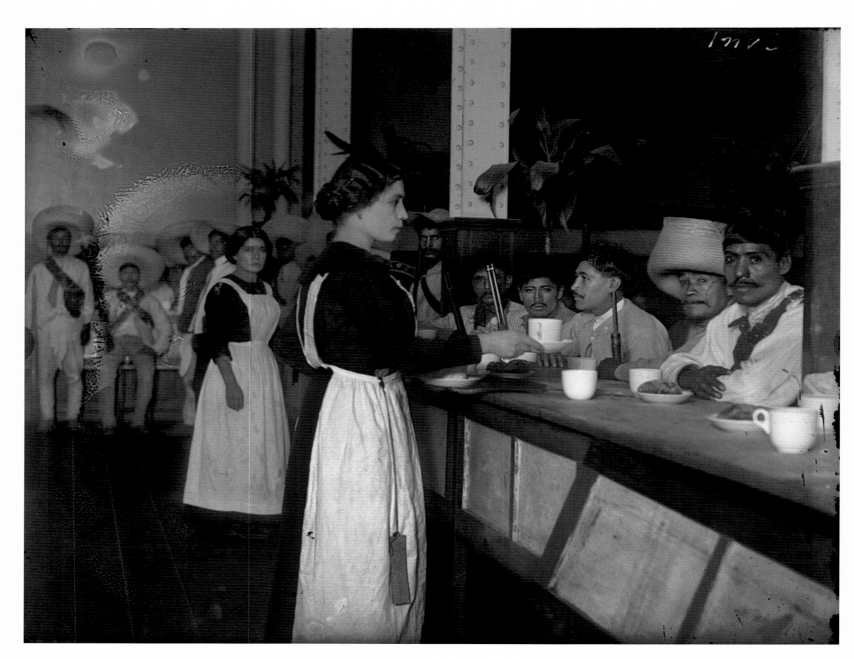

During their stay in Mexico City in December 1914, the
rebellious peasants from the South ate breakfast at the famous
Sanborns Restaurant on what was originally Plateros Street in
the downtown area. As of this date, the street no longer bore
this name because Francisco Villa had recently baptized it
Madero Avenue. [6219]

Pages 56-57
Since the mid-nineteenth century, a repressive force known as
the Rurales had existed. Victoriano Huerta incorporated this
force into the Federal Army in 1913. The photograph shows a
group of Rurales, under the command of Carlos Rincón
Gallardo, about to mount their horses and set out for
Aguascalientes on May 18, 1914. [6345]

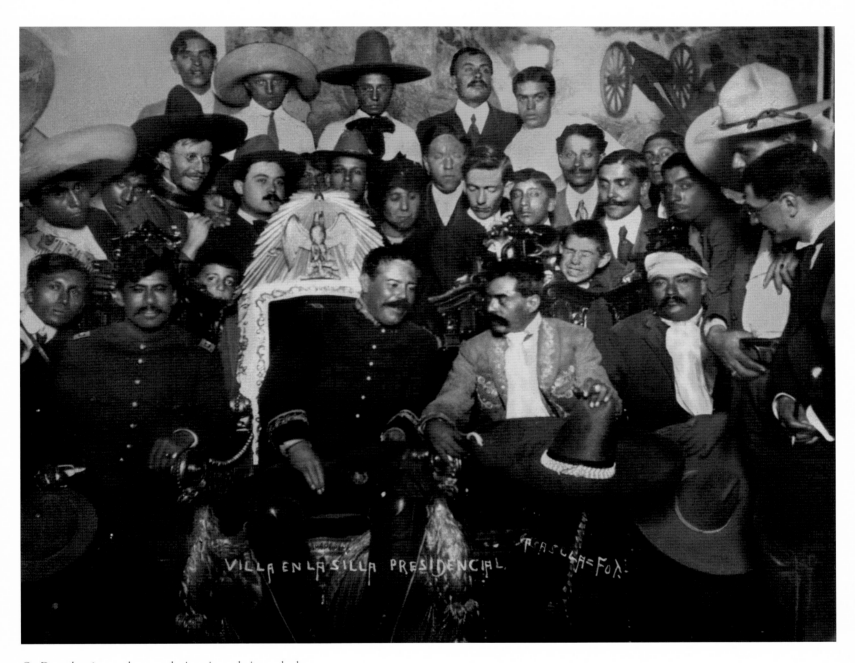

On December 6, 1914, the most charismatic revolutionary leaders, Francisco Villa and Emiliano Zapata, met in the National Palace, where they were received by President Eulalio Gutiérrez and members of the diplomatic corps. Villa agreed to sit in the presidential chair, but Zapata refused to do so. [6147]

 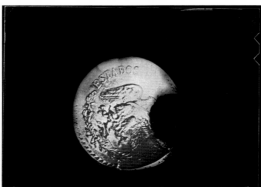

Francisco Villa was shot down along with his secretary, Miguel Trillo, in the city of Parral, Chihuahua, on July 20, 1923. The photographs show some of the assailants' bullets as well as a perforated coin from the revolutionary leader's pocket after the attack. [68187/68189]

Scene of the assassination of Francisco Villa on July 20, 1923, in Parral, Chihuahua. [68186]

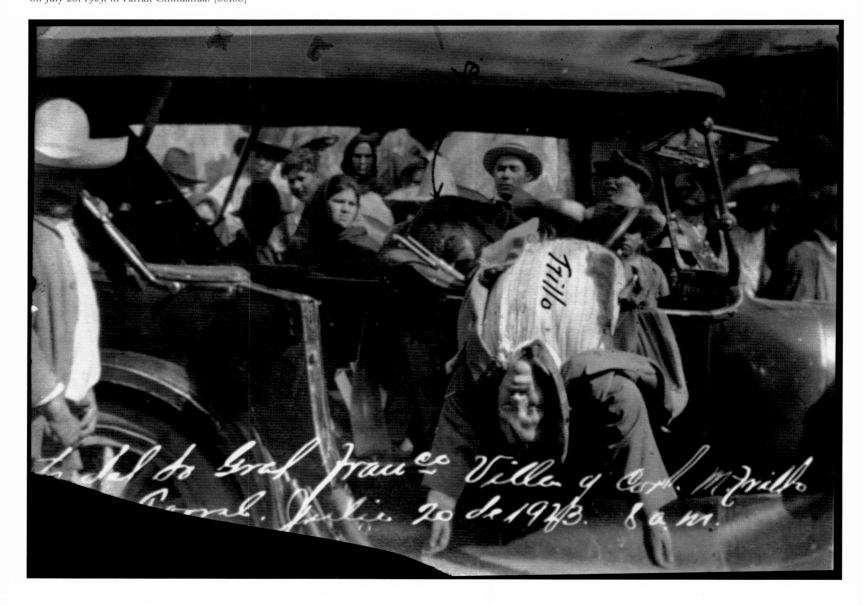

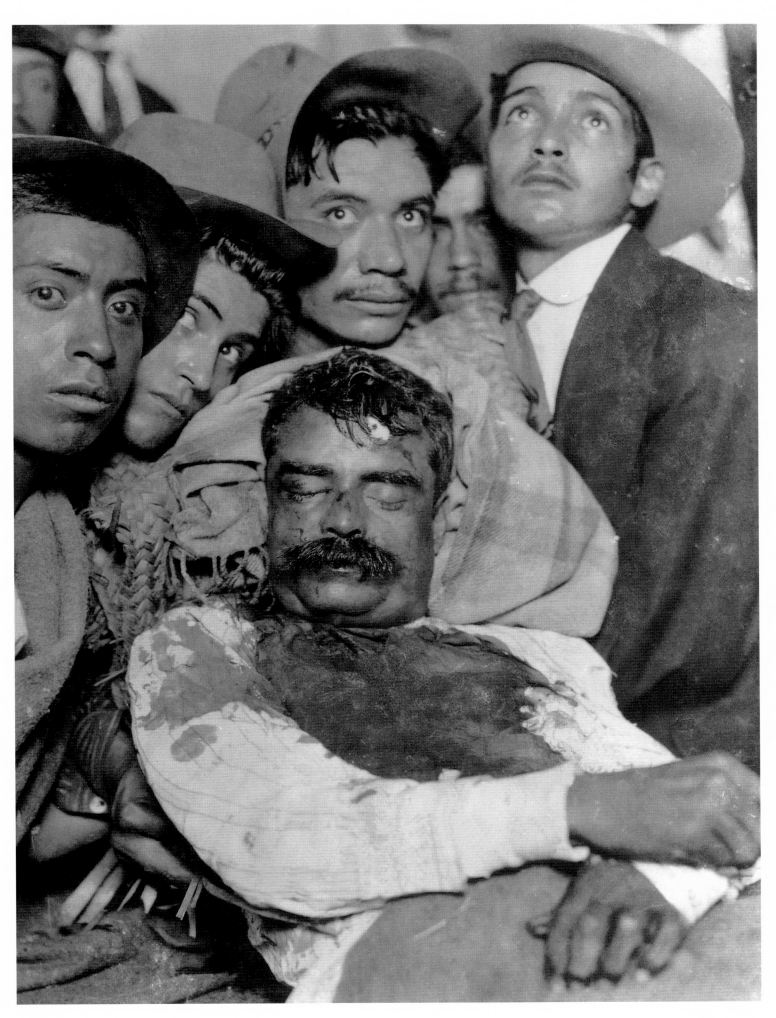

On April 10, 1919, Emiliano Zapata was riddled with bullets
at the Chinameca Hacienda. His body was taken to Cuautla,
where it was publicly exhibited. [63450]

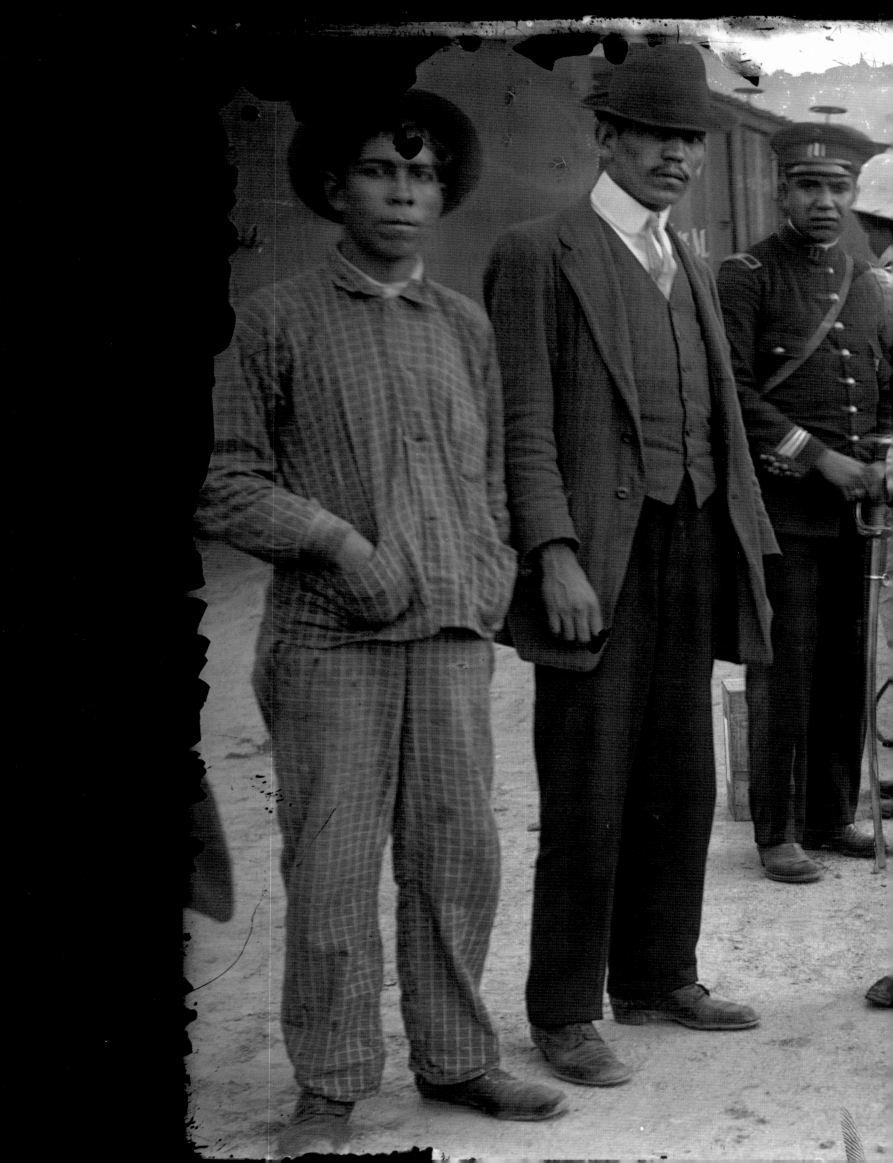

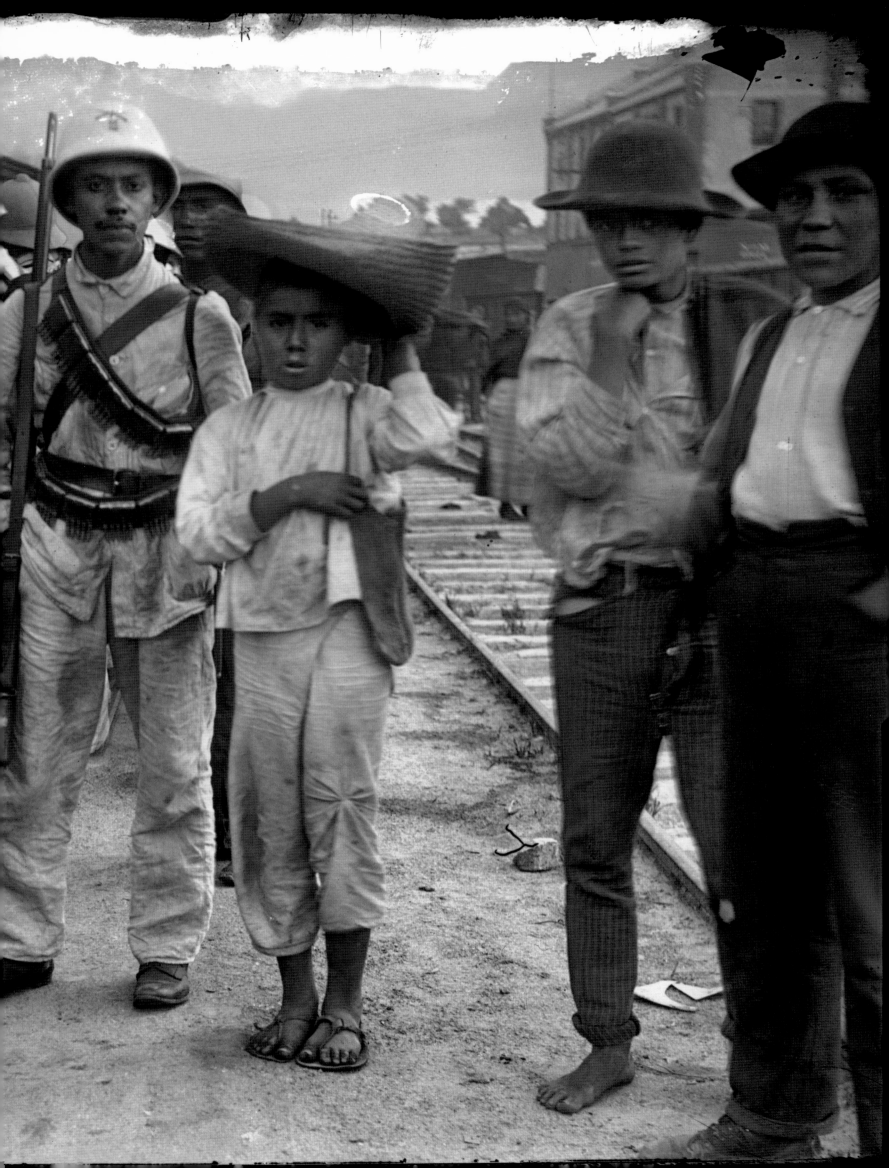

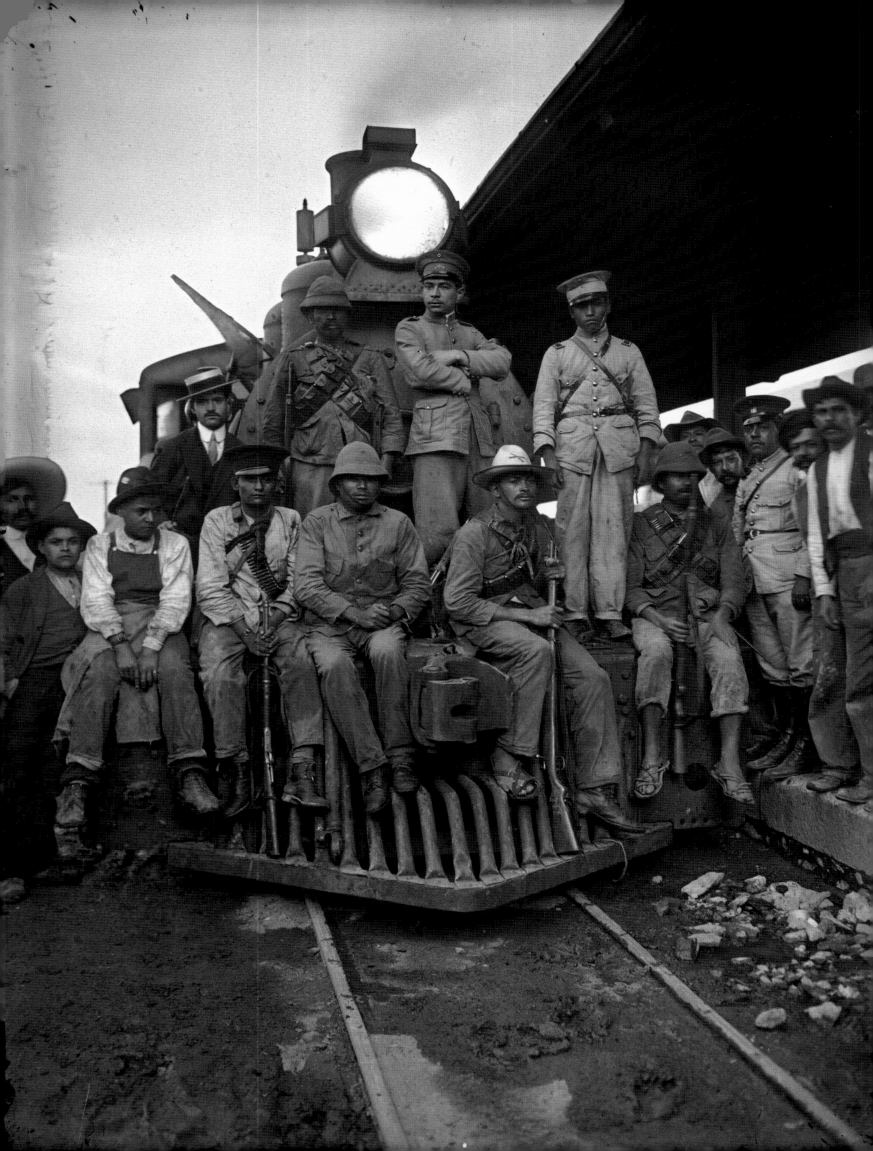

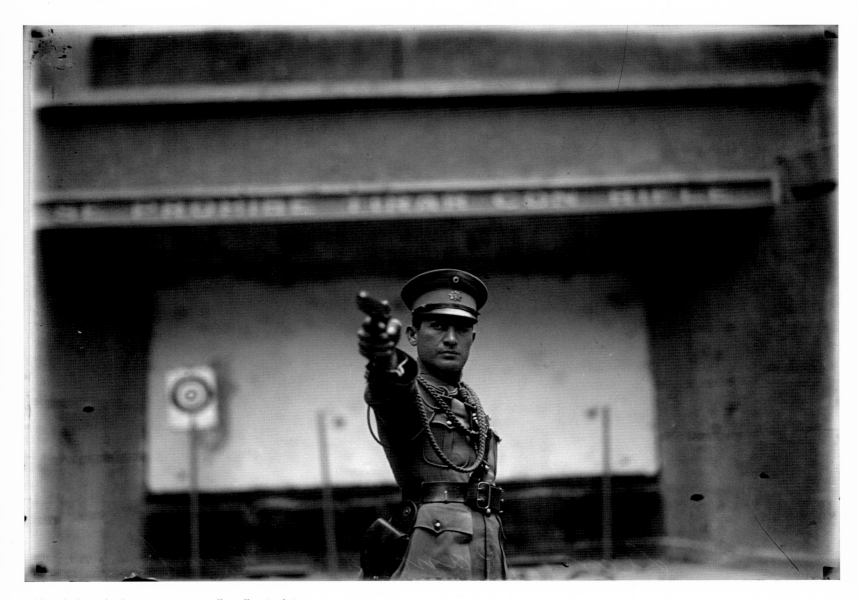

Although the Federal Army was supposedly well trained, it was incapable of putting down the revolutionary uprising. In this photograph, Colonel Román León engages in target practice in Mexico City. *Ca.* 1924. [19694]

The Constitutionalist Army was led by the military strategist Álvaro Obregón in the northern state of Sonora. In this photograph a group of *obregonista* revolutionaries pose on a locomotive. *Ca.* 1915. [32955]

Pages 62-63
In an effort to dominate the revolutionary troops, the Federal Army initiated the forced recruitment of young men and children, as shown in this photograph taken in Mexico City's train station. *Ca.* 1915. [186722]

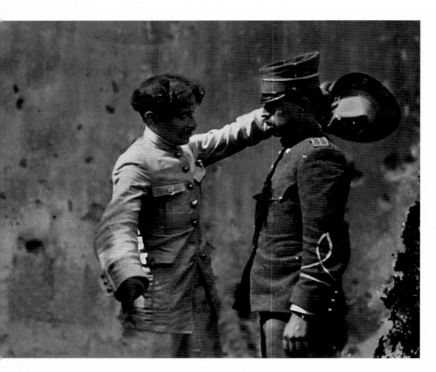

Lieutenant Felipe Acevedo says his last good-bye to his comrade-in-arms, Corporal José Aguilar, before both of them were executed on December 1, 1915, for having permitted the escape of a famous paper money counterfeiter named Leopoldo Cardona. [63674]

The insurrection generated monetary chaos in the country, a situation that was taken advantage of by counterfeiters. This crime was punishable by death before a firing squad, as shown in the photograph, in which six counterfeiters were executed on October 1, 1915, outside of the school where recruits were taught to shoot. [69107]

Pages 68-69
Peasant women in the revolutionary insurgency performed a variety of tasks that could hardly be considered inconsequential. They were known as *soldaderas* and *adelitas*. *Ca.* 1914. [6259]

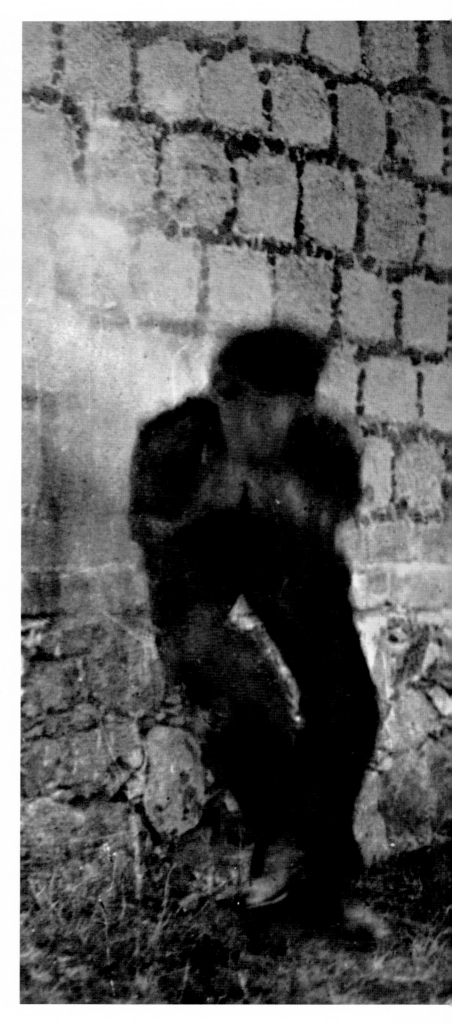

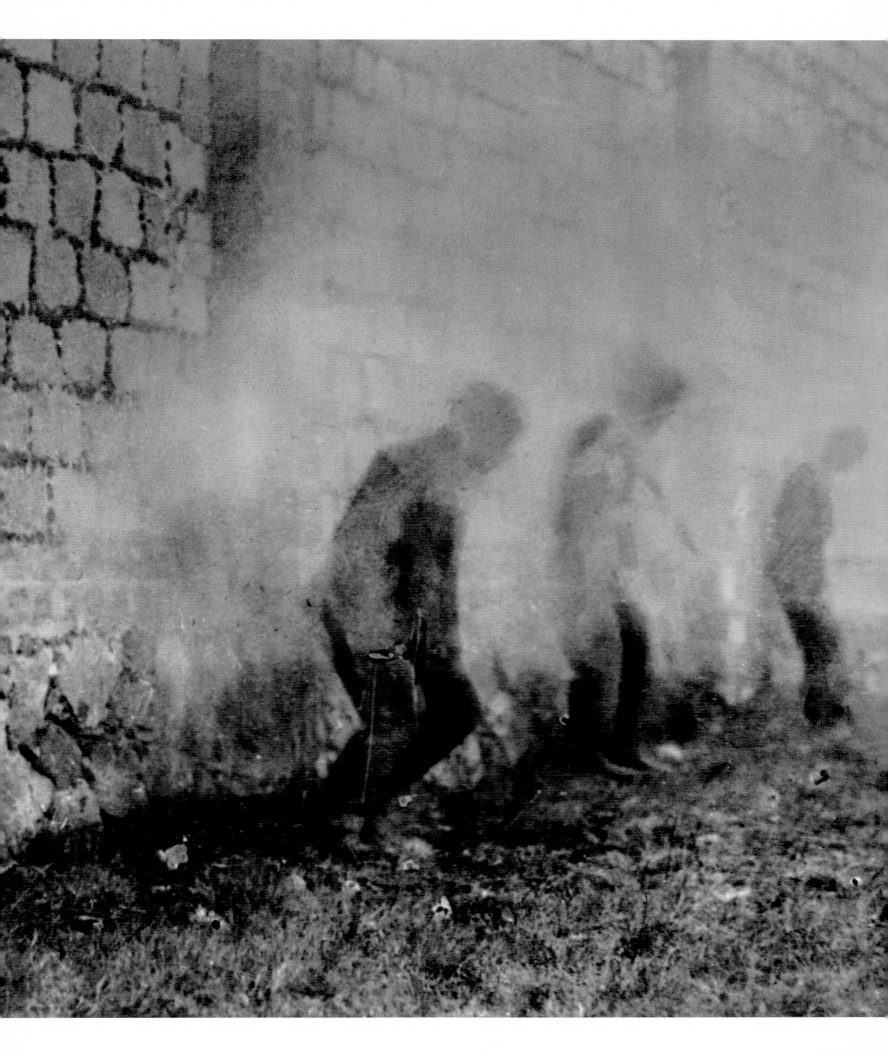

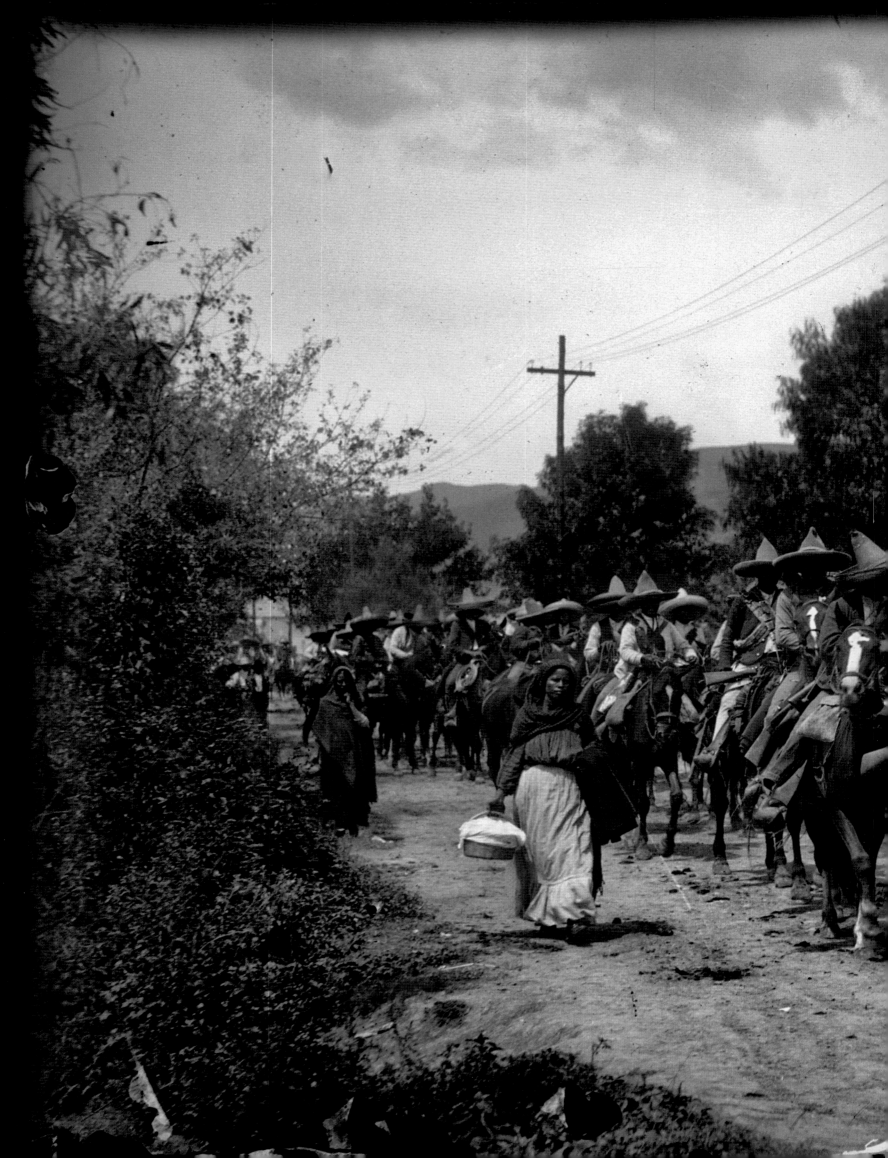

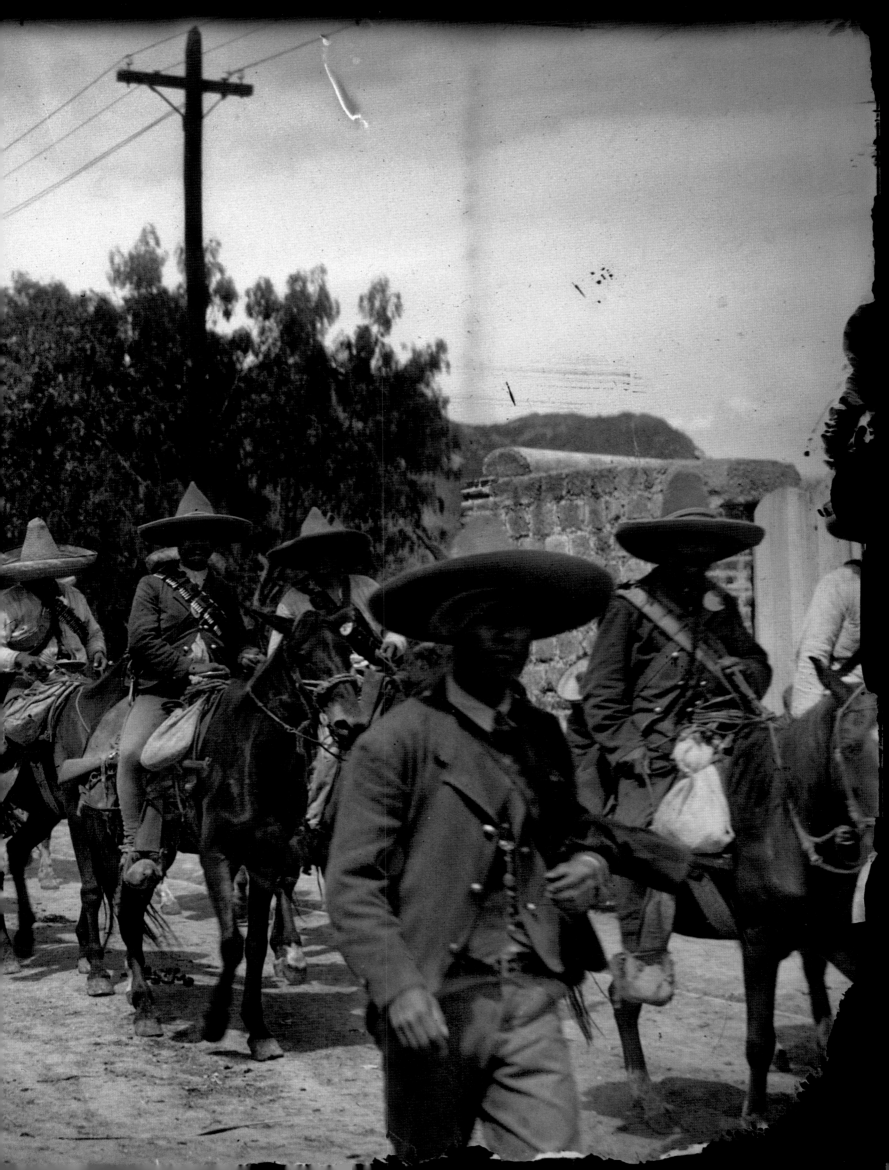

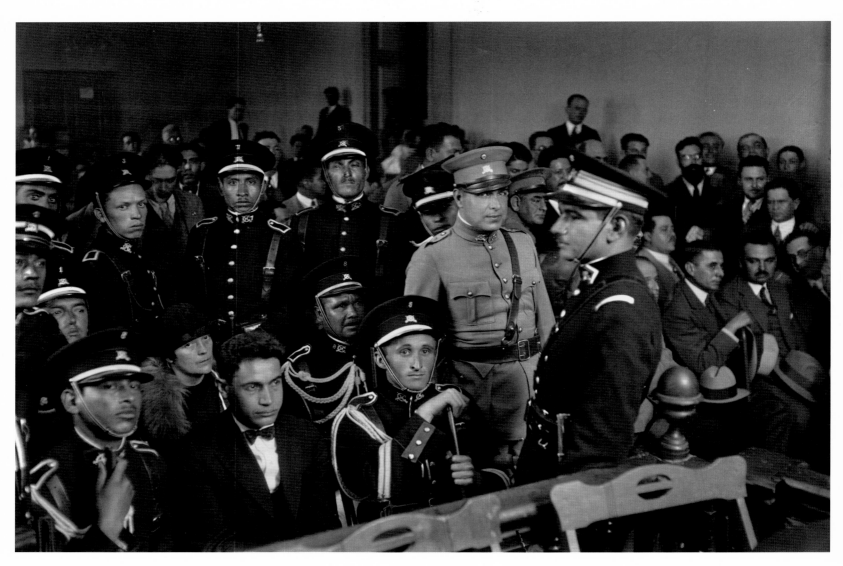

A Catholic fanatic, José León Toral assassinated General Álvaro
Obregón in 1928. This picture was taken at his ensuing trial, in
which he was condemned to death before a firing squad. [45539]

Álvaro Obregón was one of the men who assured the triumph
of the Constitutionalists and institutionalized the power
of regional leaders from Sonora. On June 3, 1914, he went to
the Santa Ana Hacienda in the state of Guanajuato, where
his group was fired upon by a column of Villa's troops;
a grenade fragment cut off his right arm. This portrait
of Álvaro Obregón, along with his wife and two sons,
was taken in Chapultepec Castle when he was president
of Mexico. *Ca.* 1921. [187125]

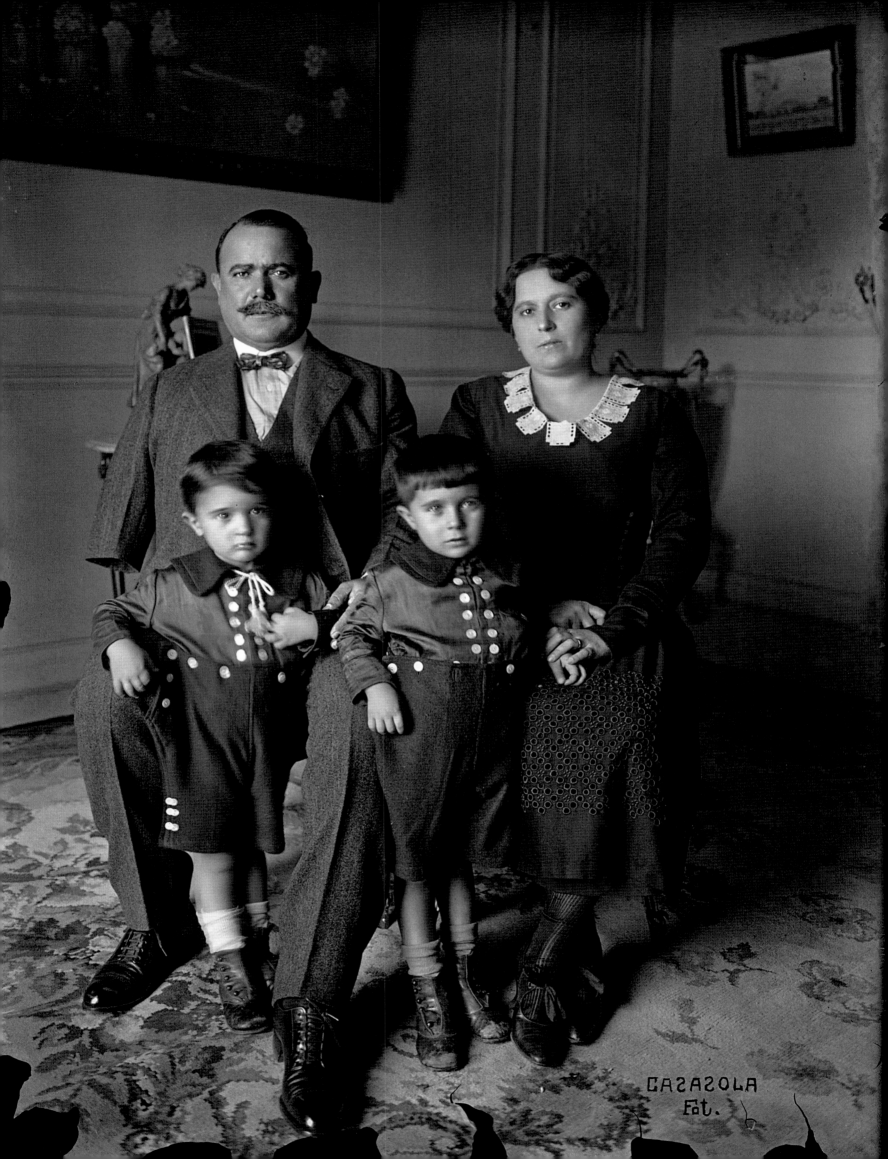

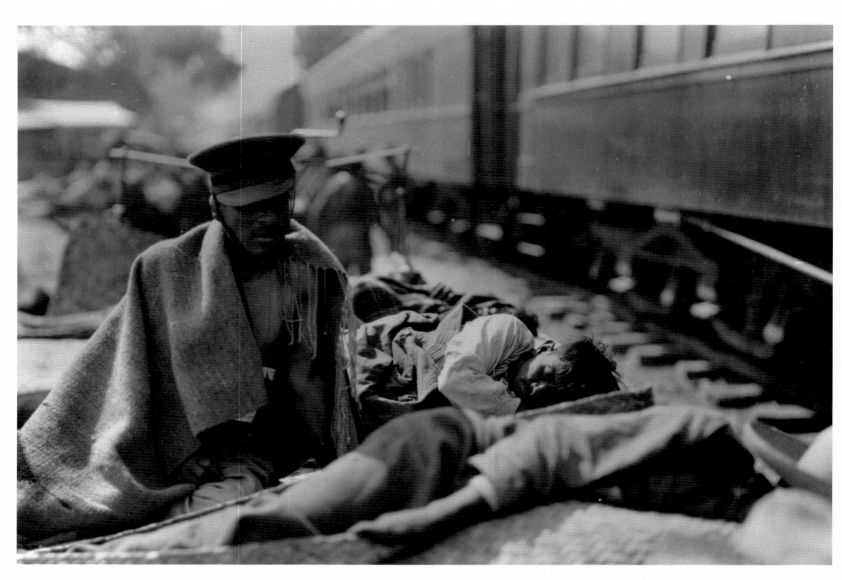

The revolutionary insurrection was long and harrowing.
Here, exhausted soldiers sleep by the train tracks.
Ca. 1918. [687569]

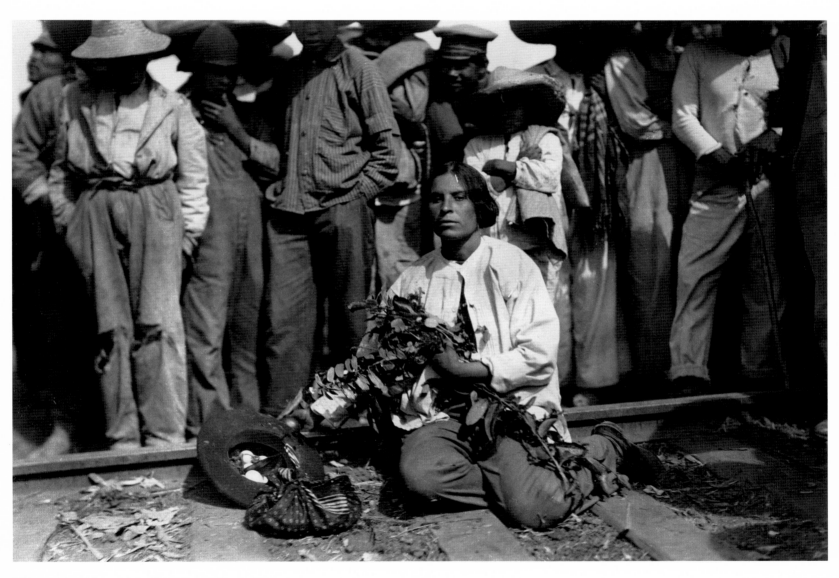

This woman, nicknamed *La Destroyer*, was famous for
helping those who had fallen in battle to die a more rapid
and less painful death. *Ca.* 1915. [687560]

THE TRADES

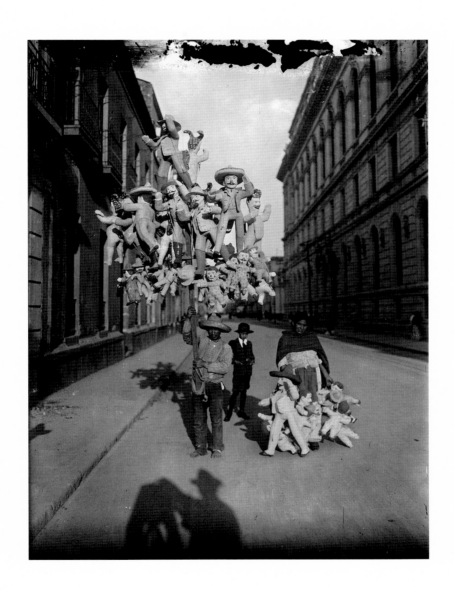

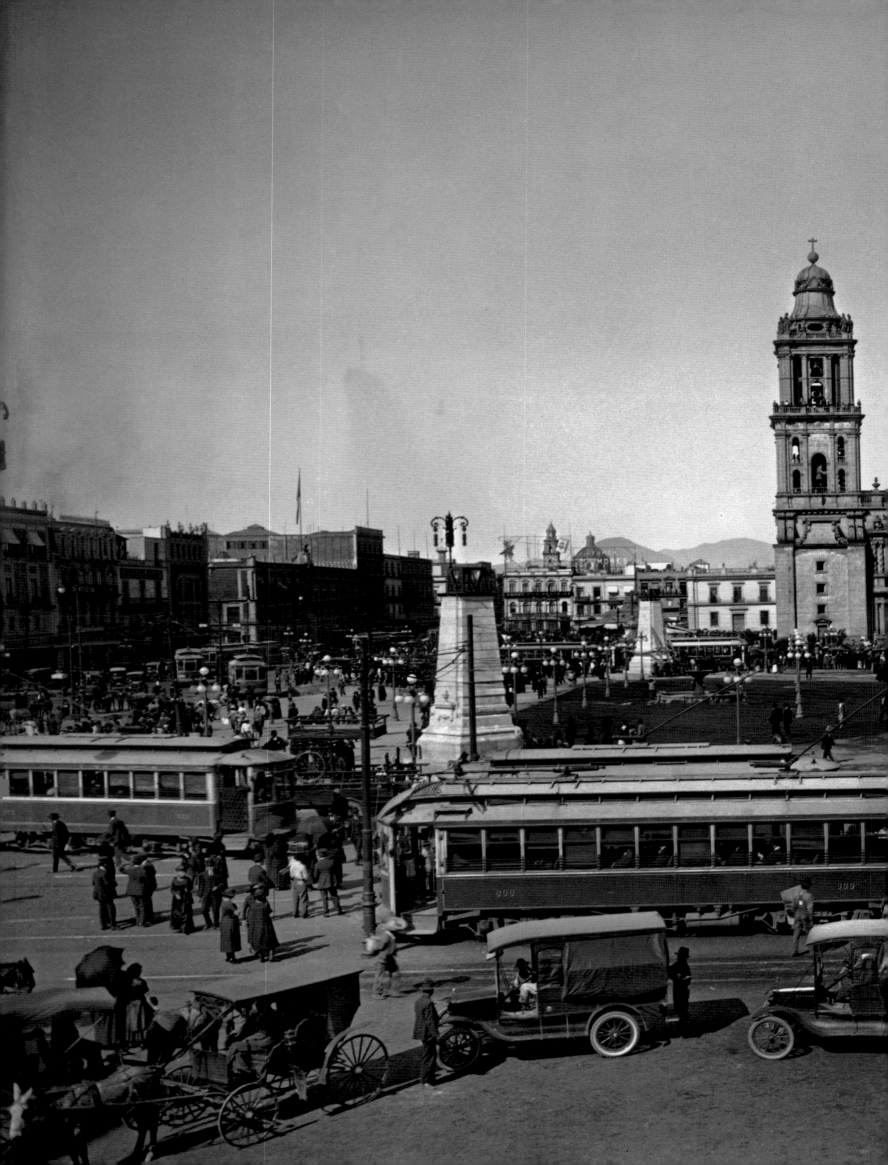

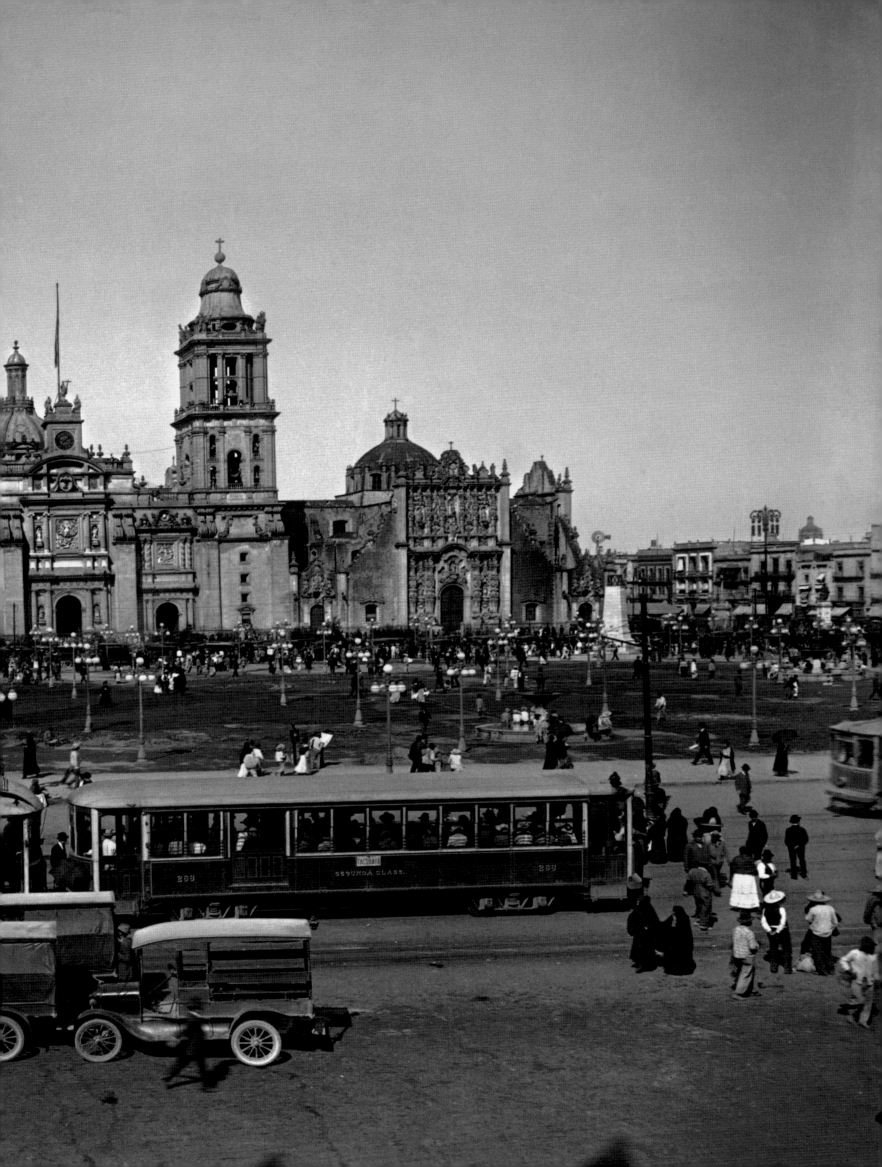

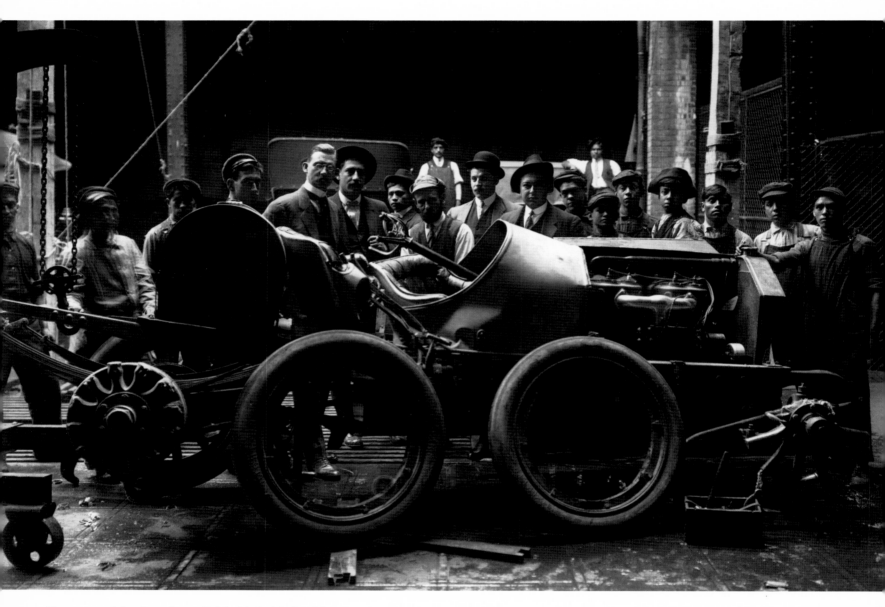

The press used the phrase "a new link in Mexico's industrial chain" to describe the country's first auto assembly plant. Located near the center of the city, Ford initiated its operations on August 25, 1926, with 260 Mexican workers. [5031]

Pages 76-77
During the first decades of the twentieth century, life in the capital city was characterized by a mixture of backwardness and prosperity, a mosaic of traditions and modern advances. *Ca.* 1920. [90683]

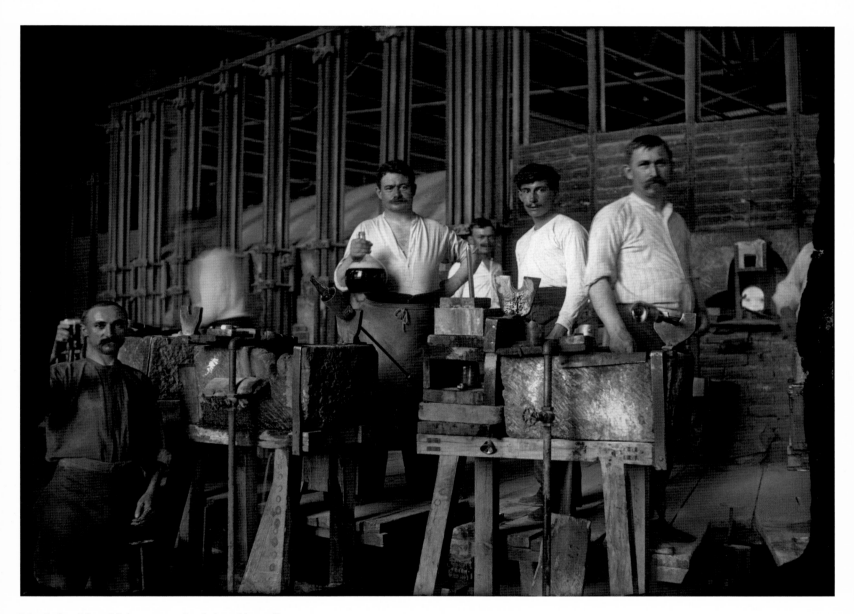

New industrial establishments coexisted alongside small artisan's shops, such as the one in this photograph that produces blown glass. Mexico City, *ca.* 1910. [5765]

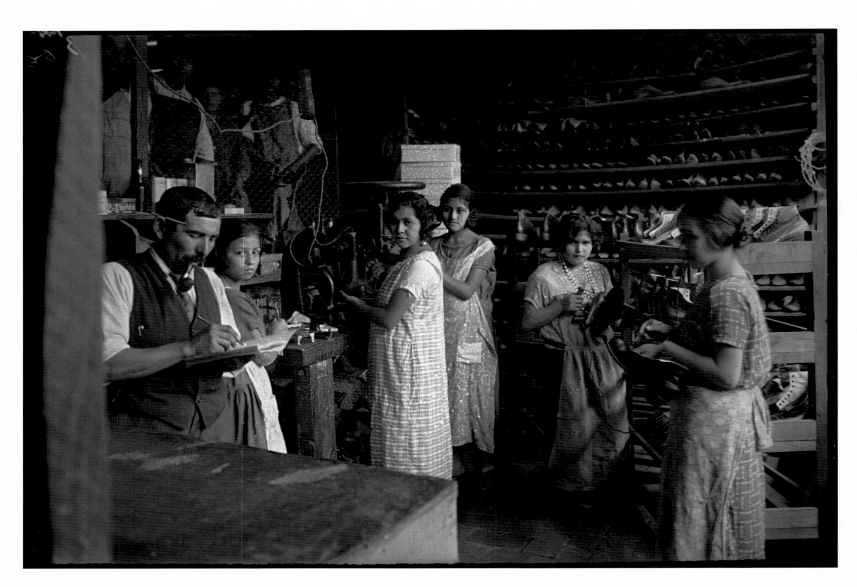

The employment of women in manufacturing became increasingly frequent and necessary. Here the inside of a small shoe factory is shown. *Ca.* 1918. [342]

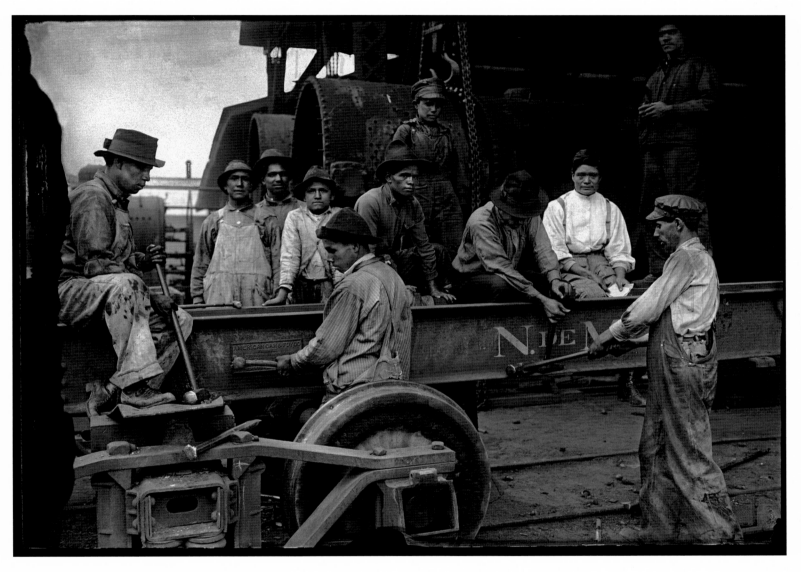

The expansion of railroads and streetcars placed demands for
specialization on the technicians and mechanics working in
garages in Indianilla, to the north of the capital city.
Ca. 1922. [33255]

Pages 82-83
Orchestras formed by blind people were a constant
feature of nineteenth-century urban life; groups like
these were also popular in the following century.
Mexico City, *ca.* 1910. [292398]

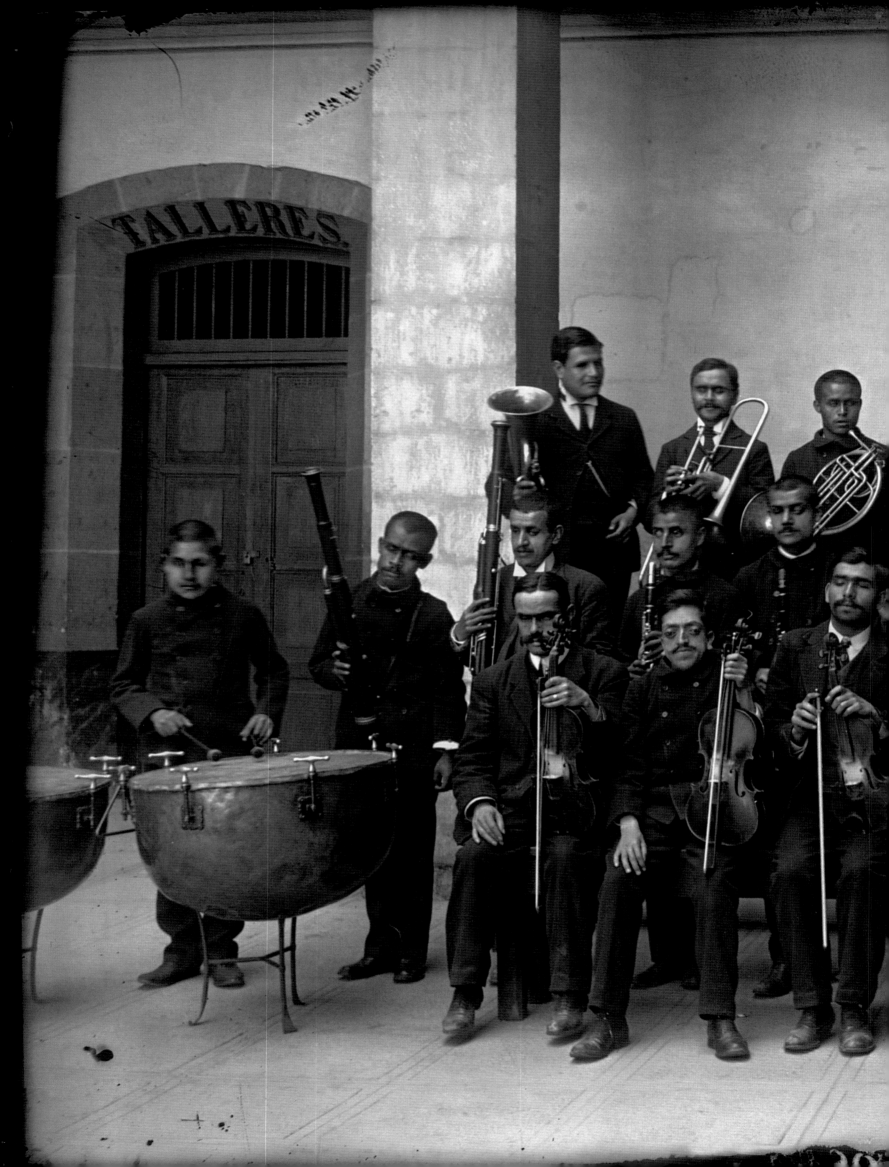

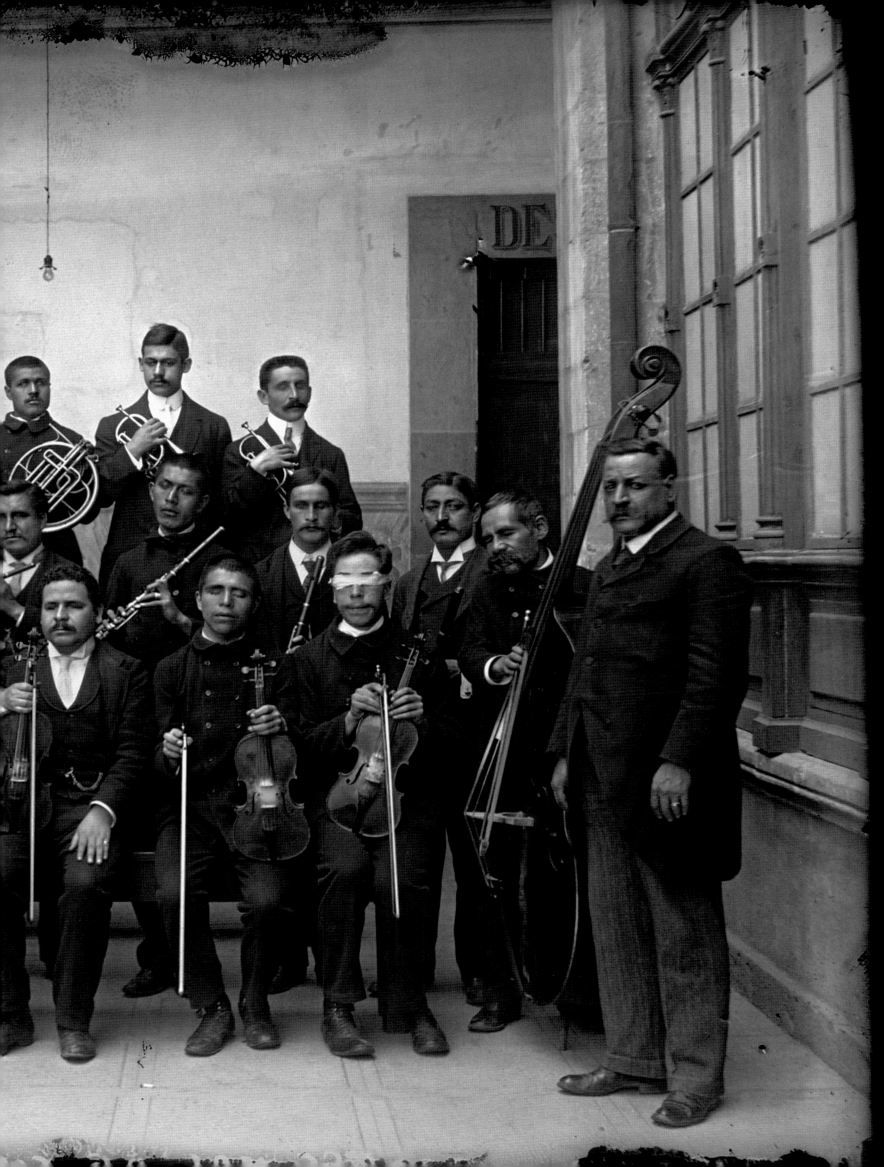

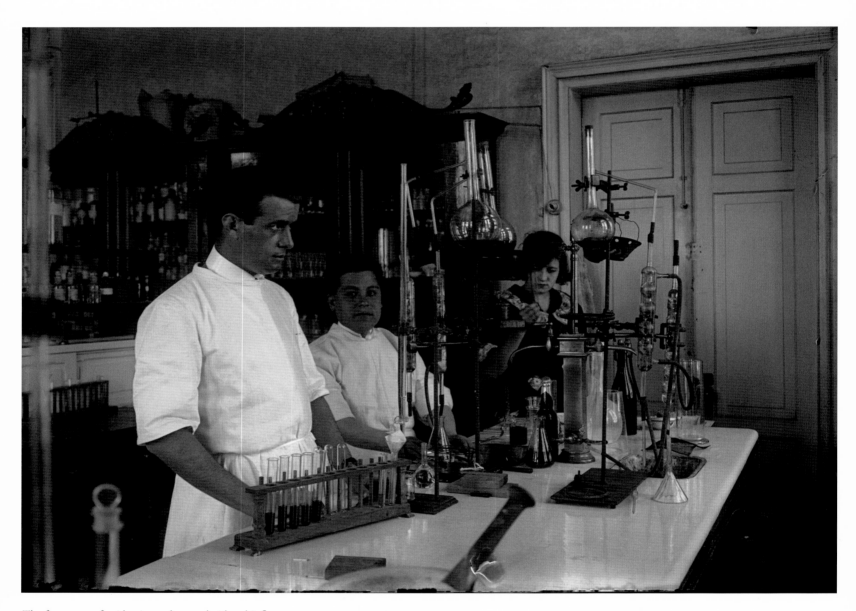

The frequency of epidemics such as typhoid and influenza
demanded the creation of a public health system and
the importation of professional diagnostic methods.
Mexico City, *ca.* 1925. [186891]

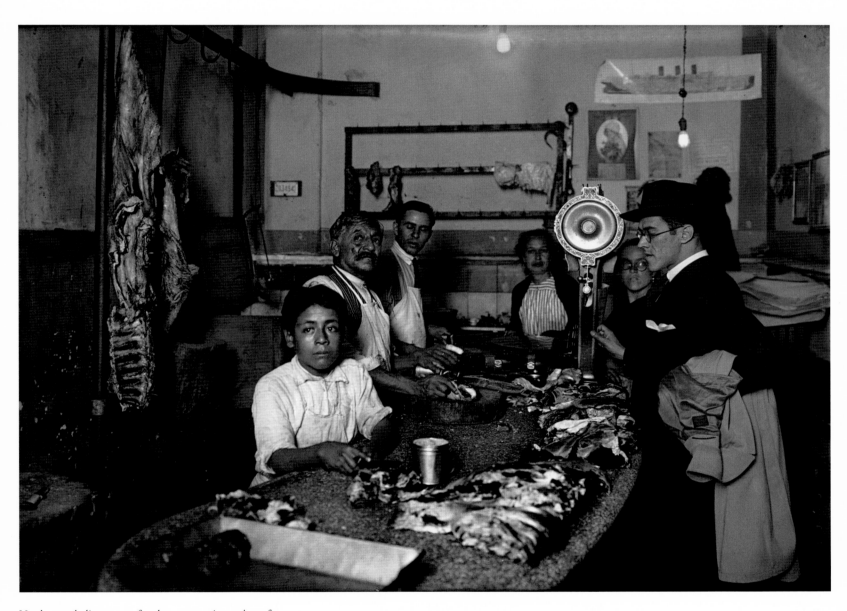

Vendors and clients pose for the camera. A number of
slaughterhouses functioning in the capital provided small
butcher shops called *carnicerías* with different cuts of meat
and viscera. Mexico City, *ca.* 1928. [292491]

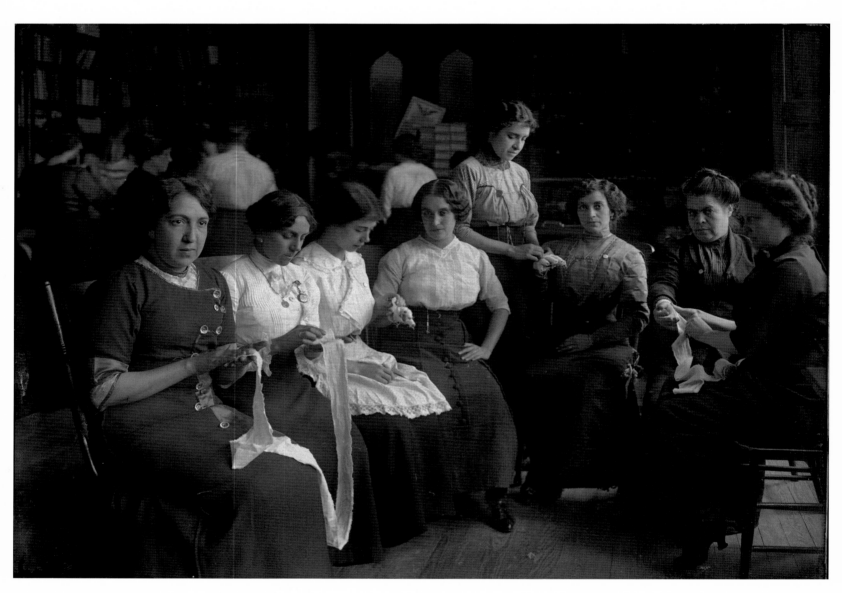

Women volunteers learned first aid, as well as the making
of bandages and tourniquets. Mexico City, *ca.* 1913. [5626]

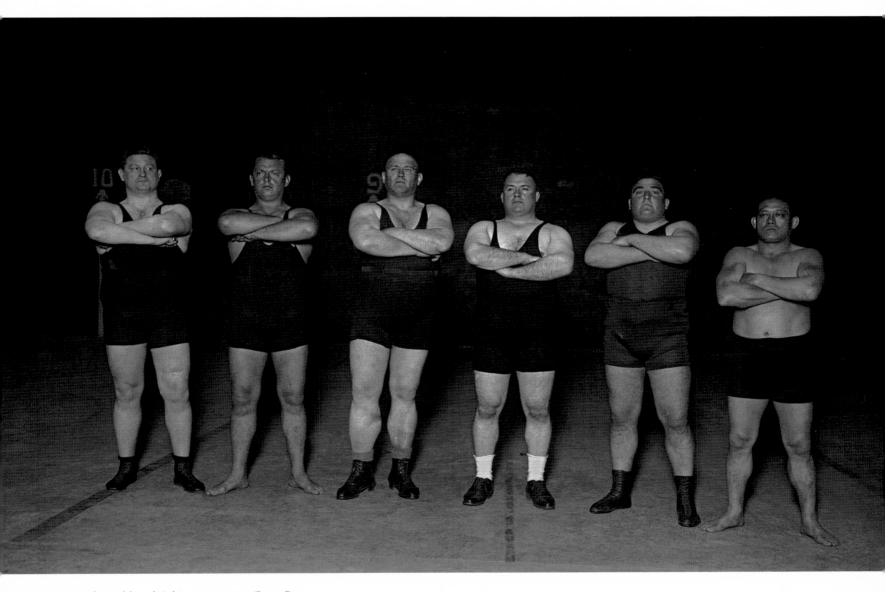

Amateur wrestlers. Although it began as a sport, Greco-Roman wrestling gradually became a spectacle and a way to make a living. Mexico City, 1925. [5756]

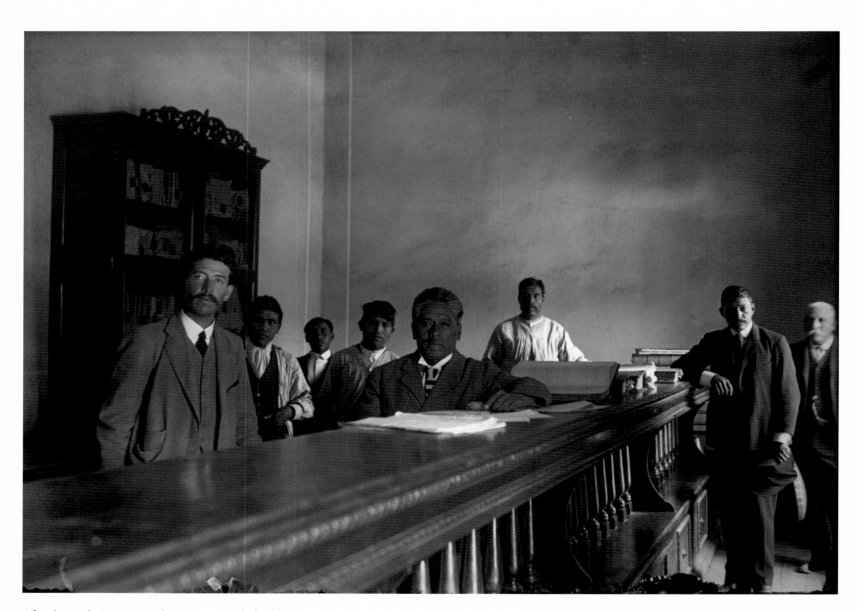

After the revolutionary struggle came to an end, the decision
was made in 1917 to formulate a new political Constitution,
one that recognized the Judicial Branch as one of the nation's
three fundamental powers. This photograph shows civil court
employees. *Ca.* 1920. [196376]

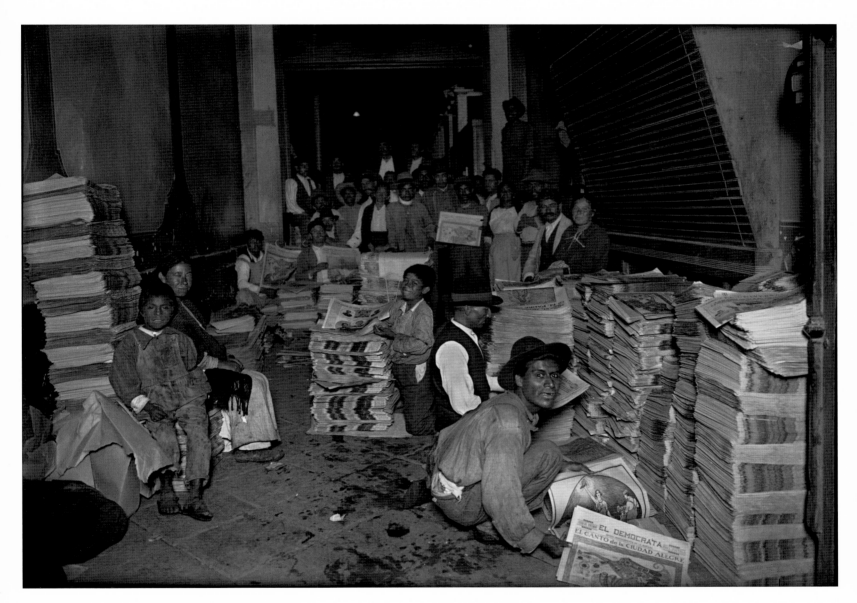

Although a good part of the population did not know how to read, more than ten newspapers were circulated in the city. They were sold on the street by hawkers called *voceadores*. Newsboys who peddled the daily paper *El Demócrata* appear in this photograph. Mexico City, *ca.* 1925. [5033]

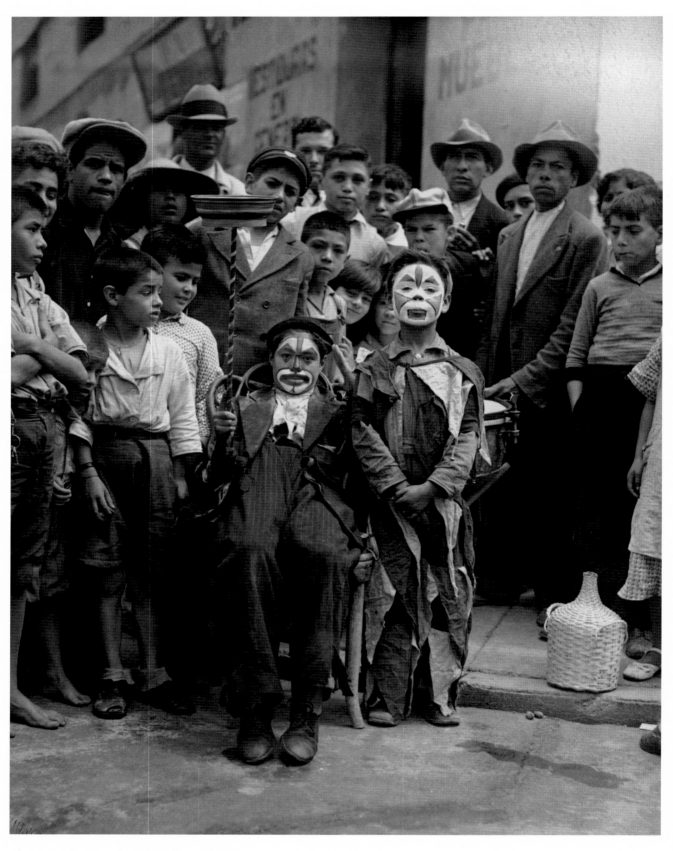

Clowns, magicians, and swindlers frequented plazas and
entertained curious city-dwellers with all kinds of shows.
Mexico City, *ca.* 1928. [72967]

Children and young people were employed in the public
markets to carry supplies and merchandise. They were known as
mecapaleros because they carried cargos on their backs by means
of a belt made of two ropes known as a *mecapal*, which rested
on the forehead. Mexico City, *ca.* 1930. [161508]

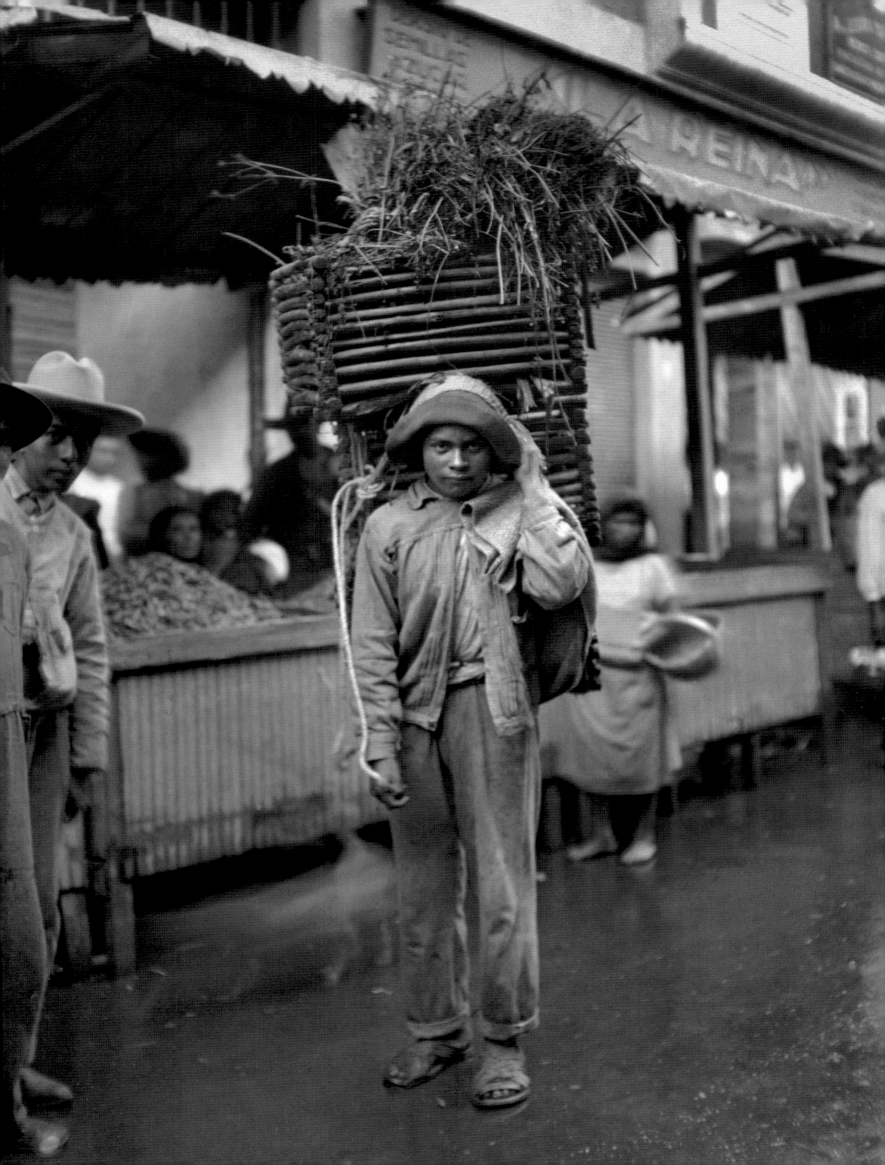

MODERNITY

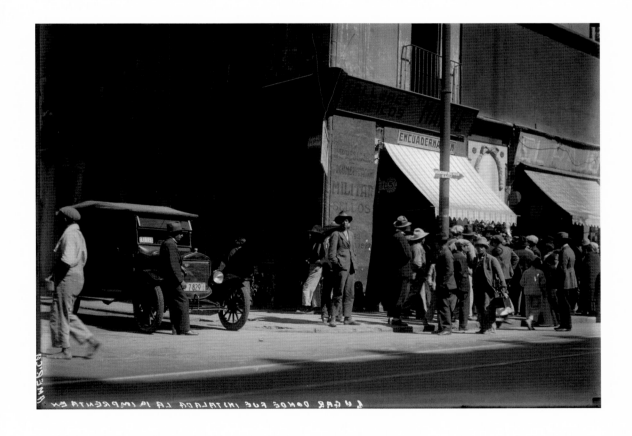

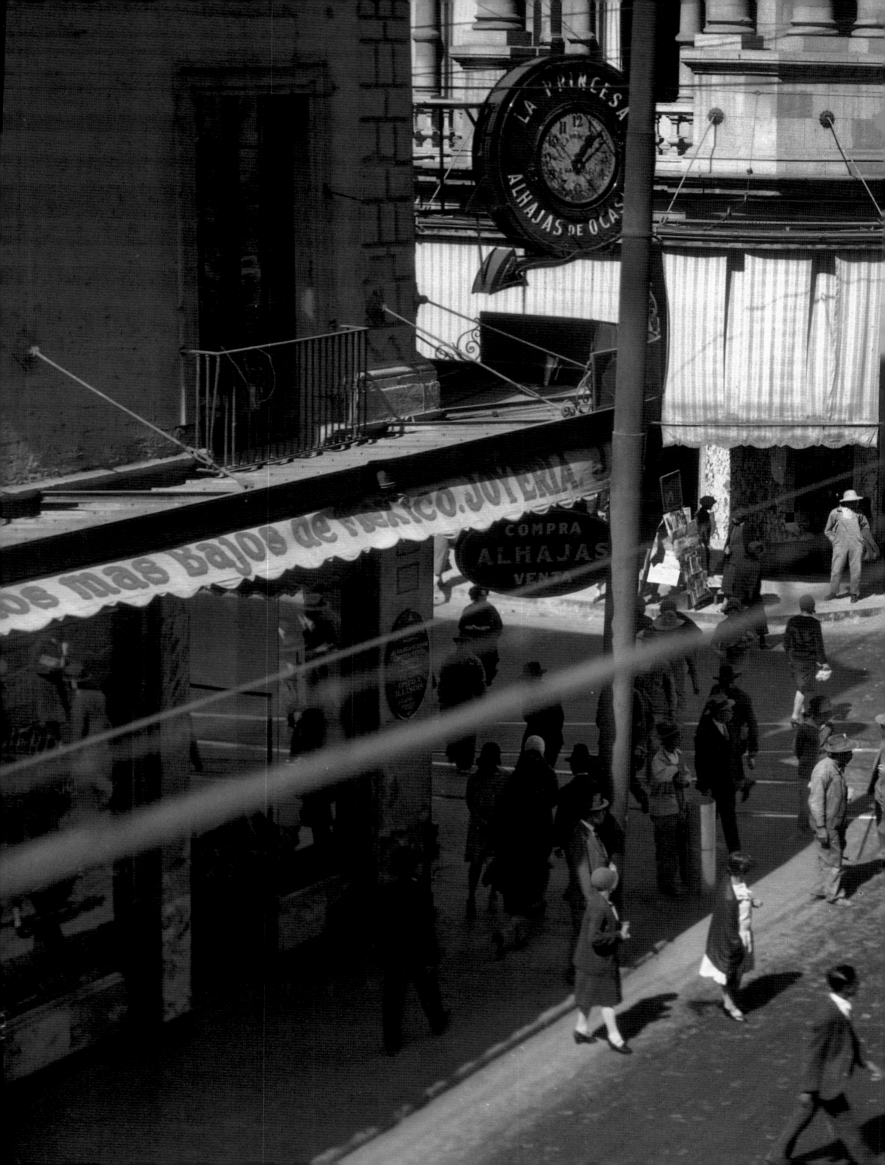

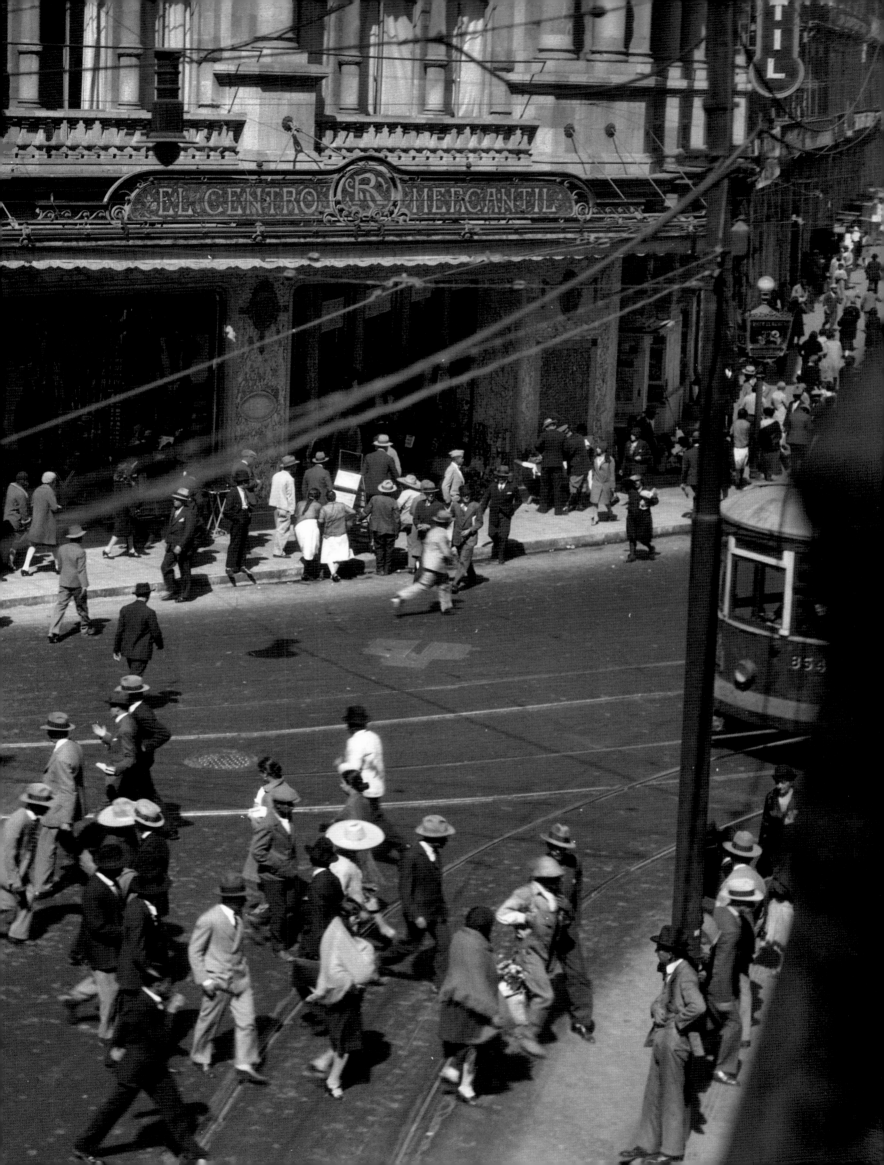

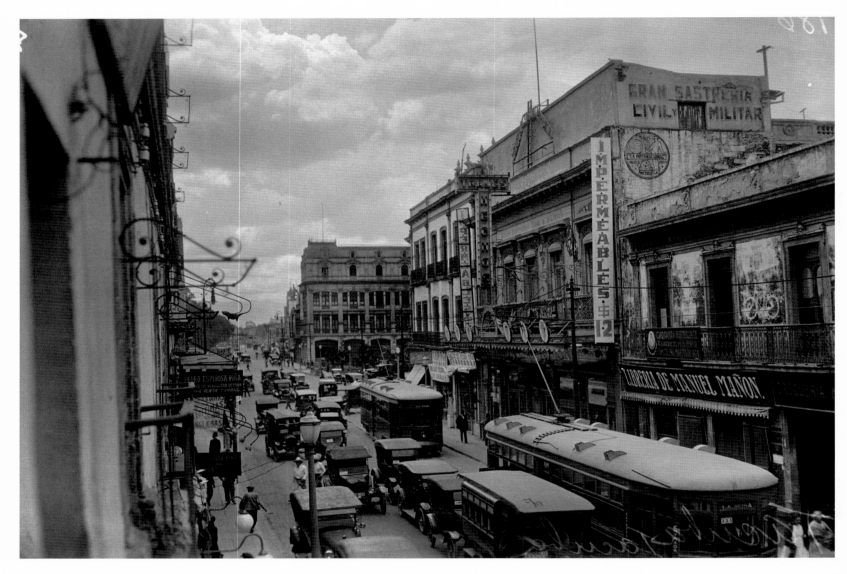

In the year 1927, when authorities prohibited the circulation
of horse-drawn vehicles, cable cars and automobiles dominated
the urban landscape. Mexico City's provincial air disappeared
within just a few decades, as shown in this photograph of a
downtown avenue. [196219]

Pages 94-95
Active modernization of the country was undertaken during
the period of the consolidation of a new political regime
(1917-1934), especially in Mexico City. [196262]

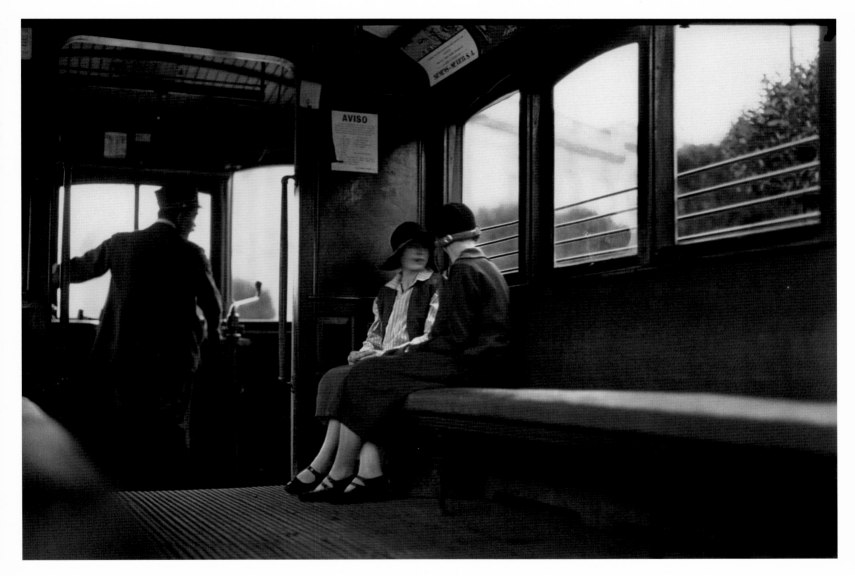

Fashionable young ladies riding in a cable car. Mule-drawn
streetcars were replaced by electric streetcars at the end
of the 1920s. [7298]

Pages 98-99
By 1929, more than 20,000 automobiles, passenger buses, and
cargo trucks circulated throughout the city and outlying areas.
This is a picture of one of the first protests of the chauffeur
and taxi-drivers' union. [196308]

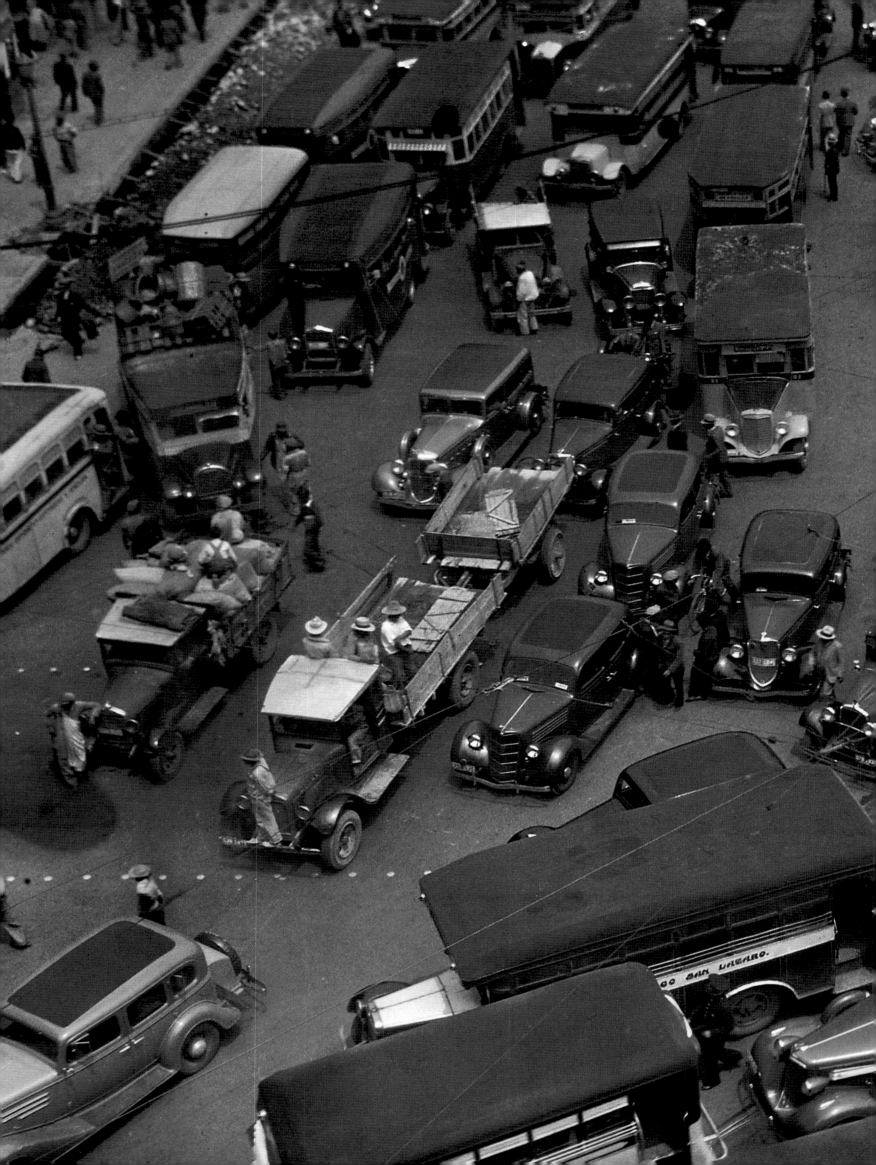

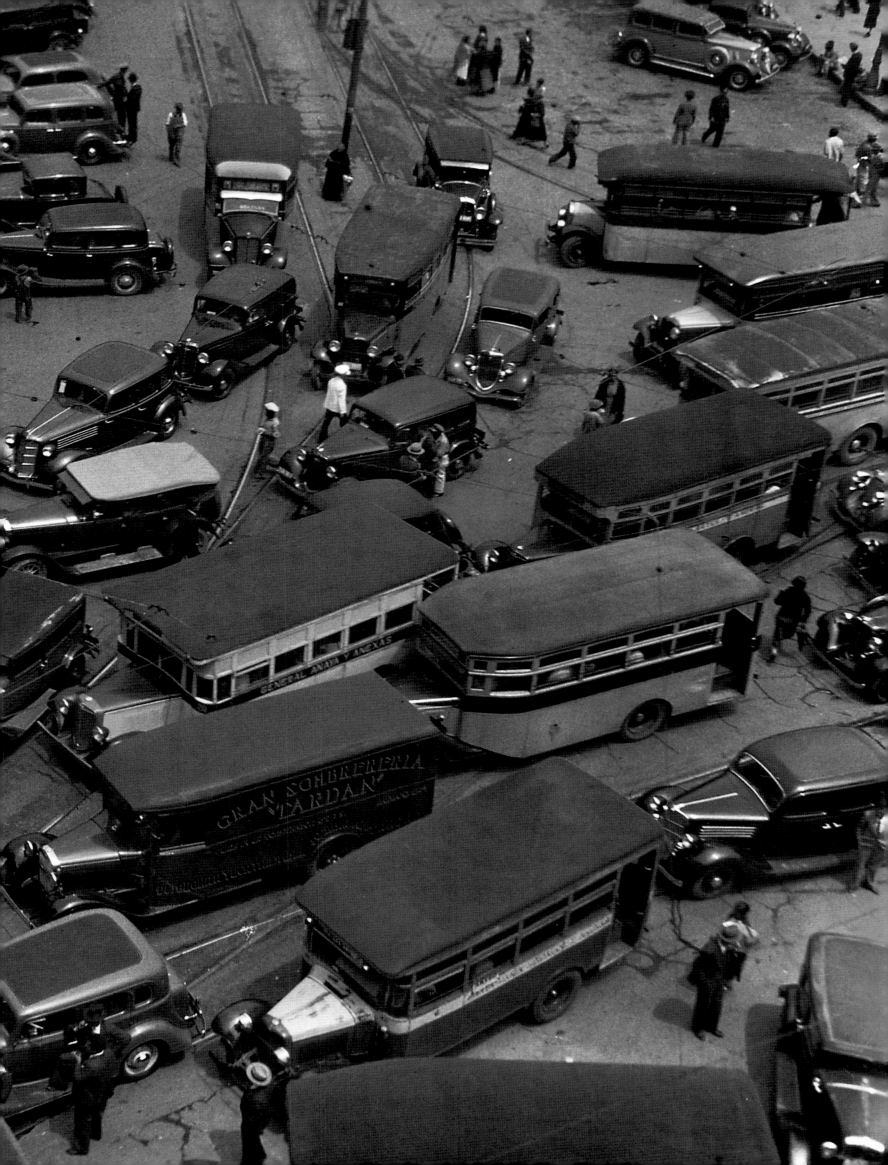

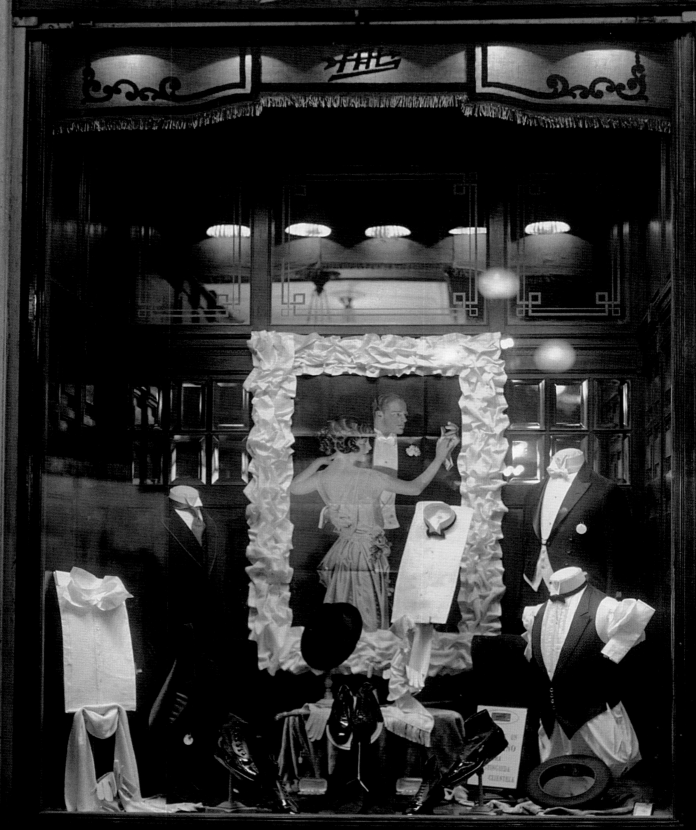

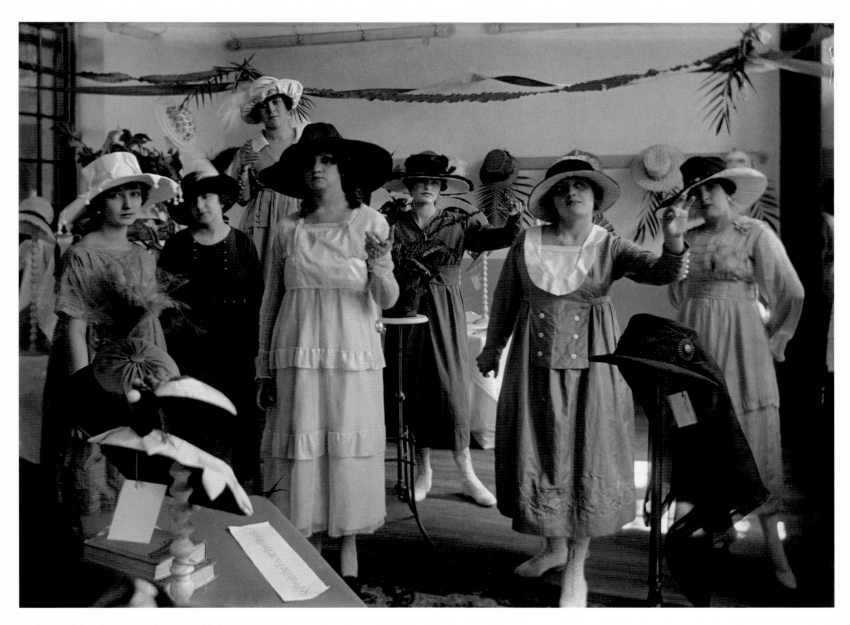

Ladies modeling hats in an elegant establishment
of Mexico City. *Ca.* 1920. [96436]

In addition to numerous small businesses and a few big
department stores, the city boasted six tie factories, five
corset and girdle makers, twenty-one belt and shoestring
manufacturers, and forty-six shoe producers. The
photograph is of a display window at the FAL
department store. Mexico City, *ca.* 1925. [165987]

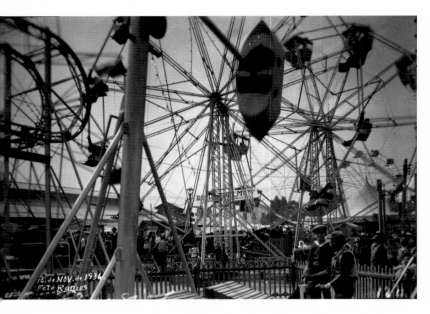

Amusement parks gradually replaced town fairs and eventually became one of the most popular forms of public entertainment during the 1930s. Movement and vertigo detonated a whole new gamut of emotions. [276136]

Authorities in the nation's capital frequently had to reform transit regulations in an effort to impose some order on the unrestrained boom in automobiles. For some, the challenge of modernity was evaluated in terms of movement. Mexico City, 1922. [136464]

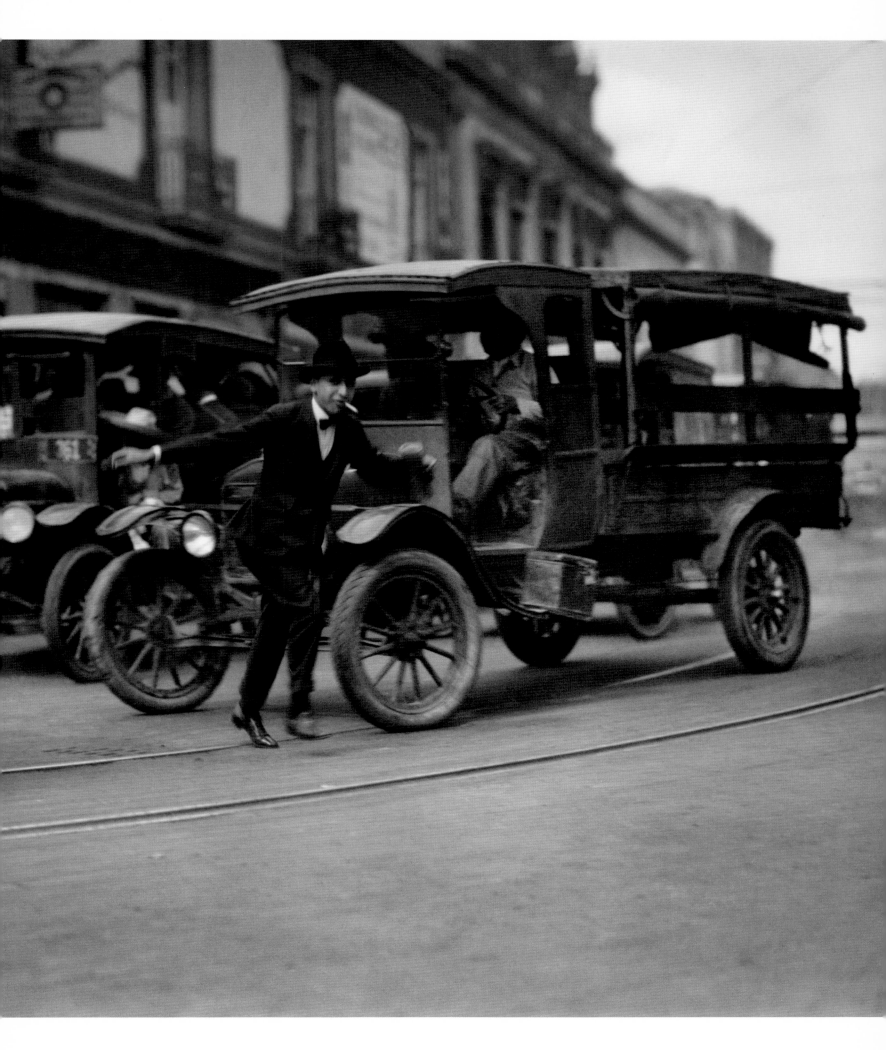

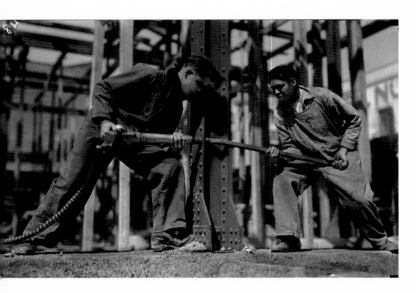

Hundreds of laborers, as well as tons of iron and glass were used to finish the Teatro Nacional. *Ca.* 1925. [196265]

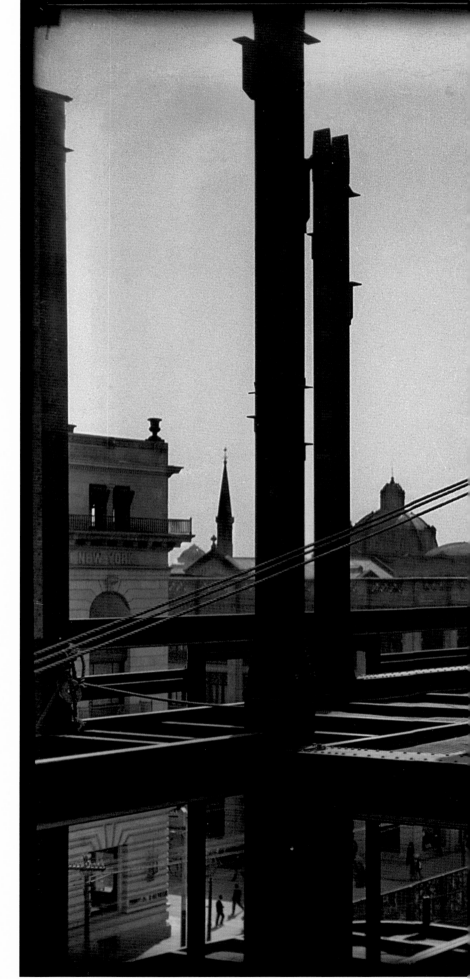

After changing the name of the Teatro Nacional to the Palacio de Bellas Artes (Fine Arts Palace), the great work was finished in 1934. Today it is one of the most emblematic buildings in Mexico City. Its construction was initiated during the Porfirio Díaz regime. *Ca.* 1920. [85467]

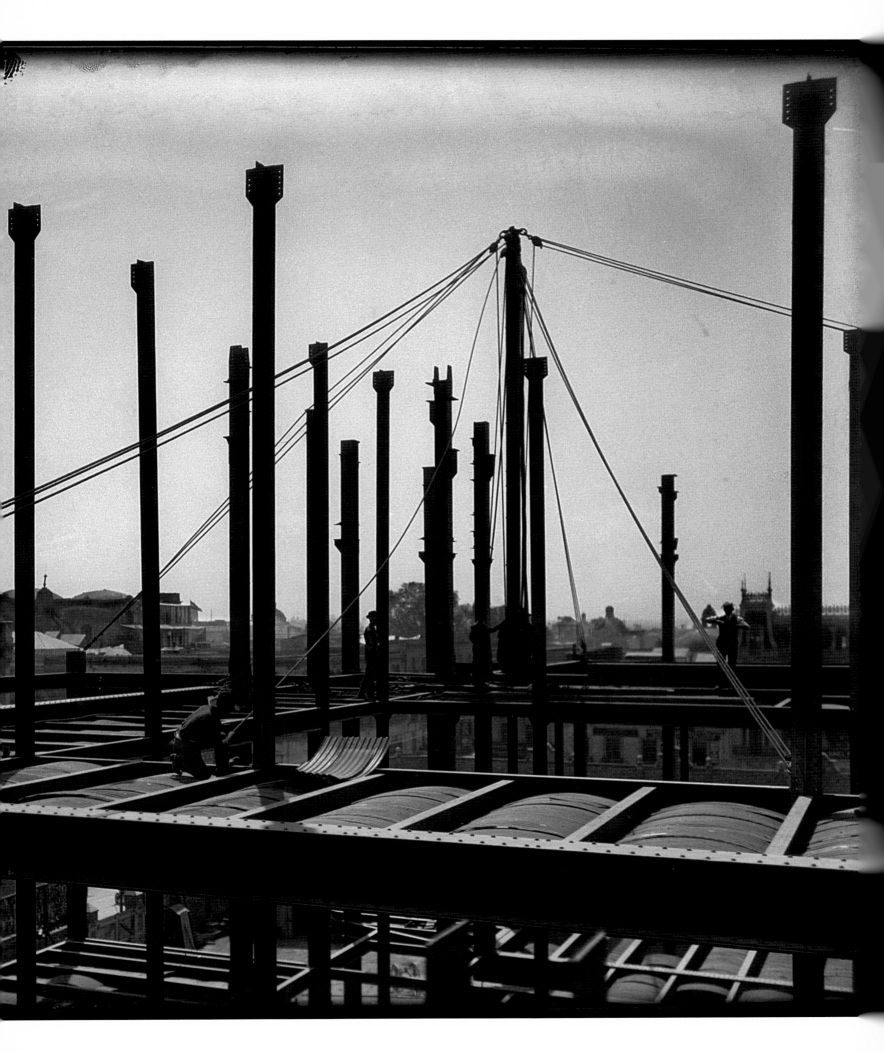

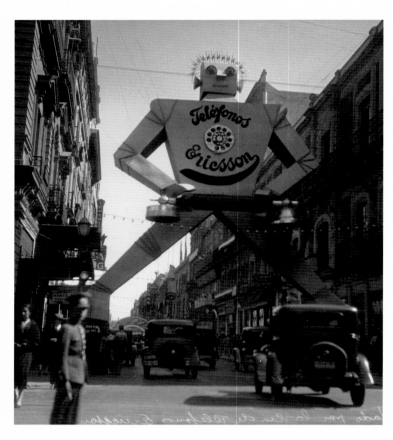

The promotion of new foreign investment had good results. In the photograph, we see a spectacular advertisement for the Ericsson Telephone Company. Mexico City, *ca.* 1932. [1764]

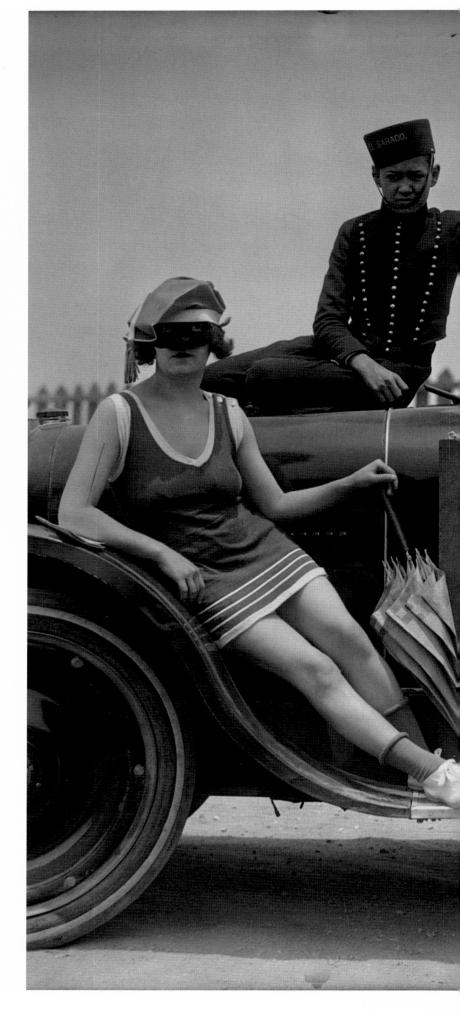

The arrival of new foreign investment also led to other new forms of advertisement, such as that featuring these masked girls. Mexico City, *ca.* 1926. [163976]

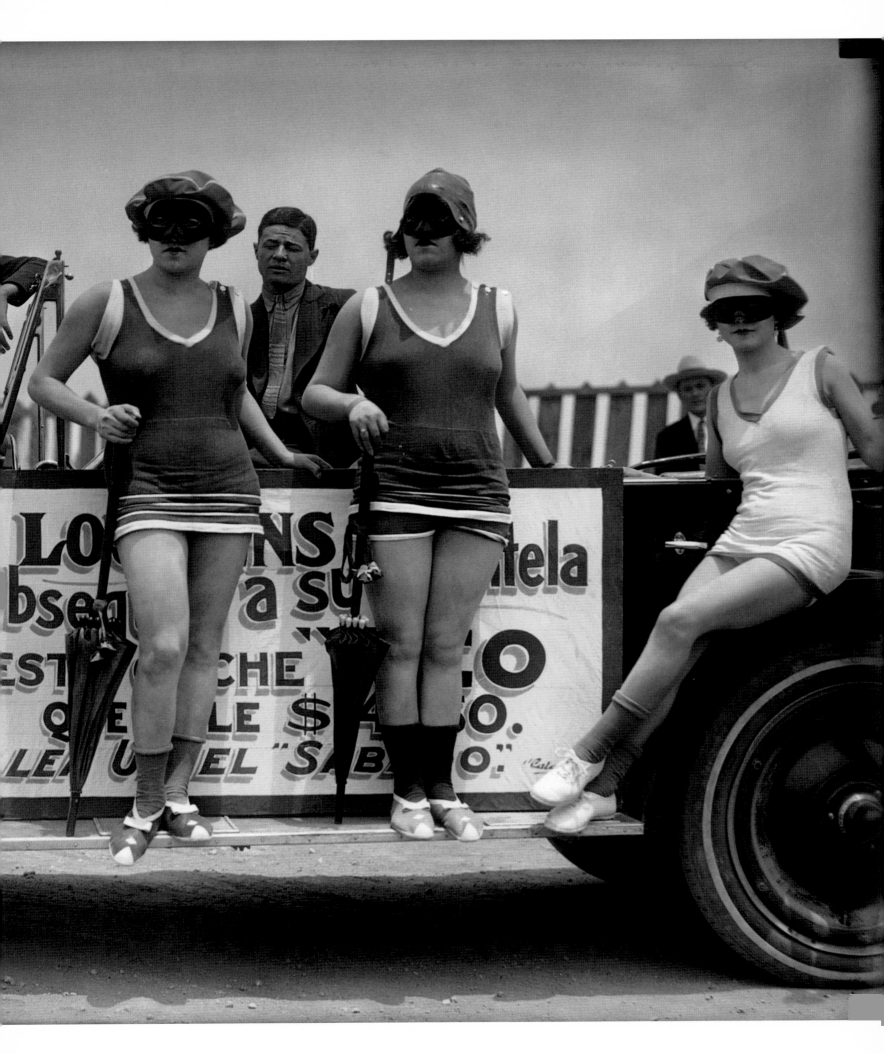

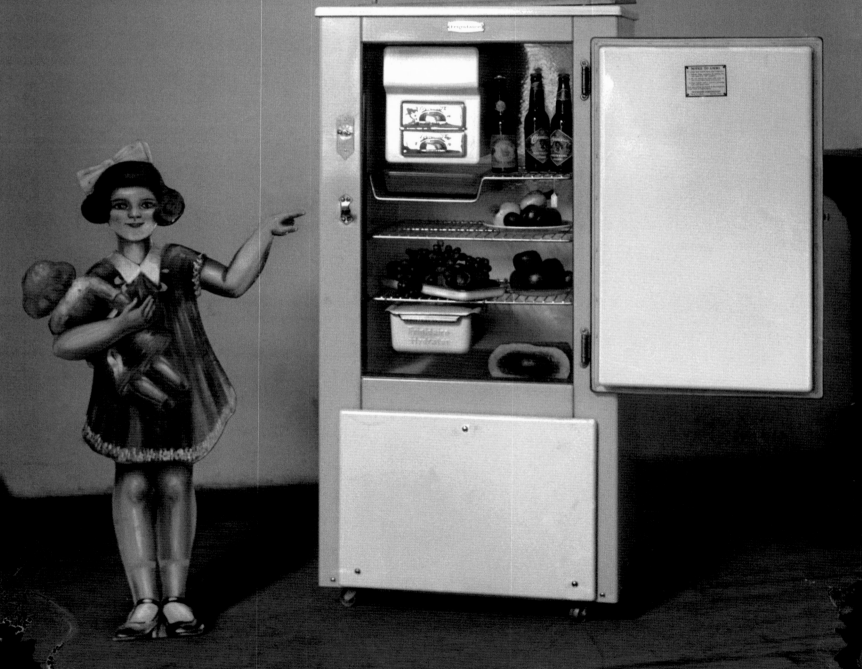

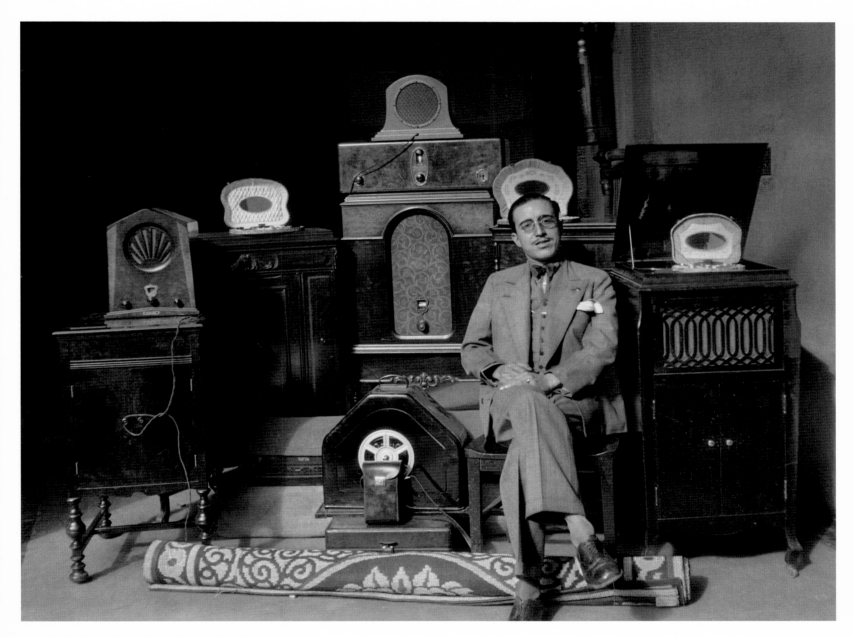

In 1921, the first radio transmissions were heard in the country.
One year later, the businessman Emilio Azcárraga Vidaurreta
founded the broadcasting station called Casa del Radio.
The photograph shows a proud radio salesman.
Mexico City, *ca.* 1925. [73138]

The lifestyle of the middle and upper classes was modified
with the purchase and use of the first Frigidaire electrical
home appliances. Mexico City, *ca.* 1940. [163838]

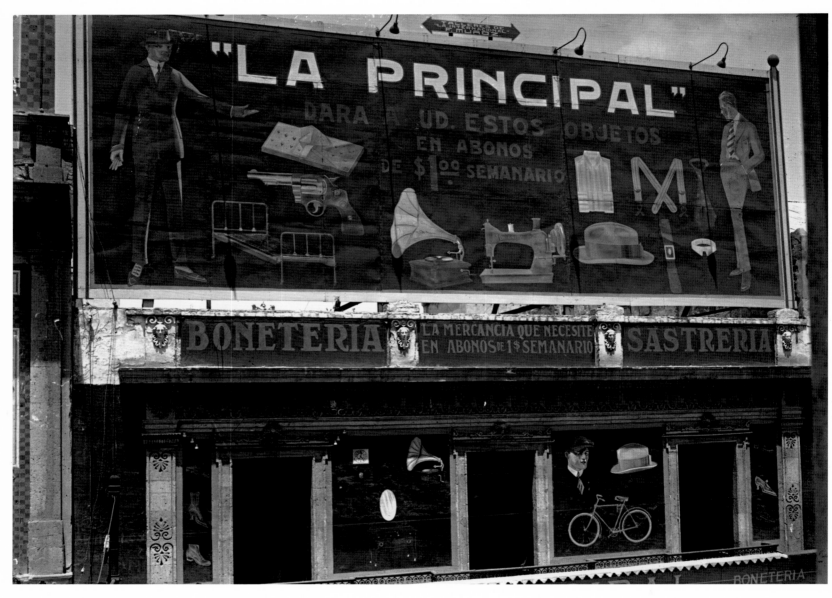

Mexico City was the major commercial center, and a large percent of the merchandise, products, and fashionable clothing sold here went to smaller cities in the country. In this photograph, we see one of the new department stores named La Principal. Mexico City, *ca.* 1926. [163973]

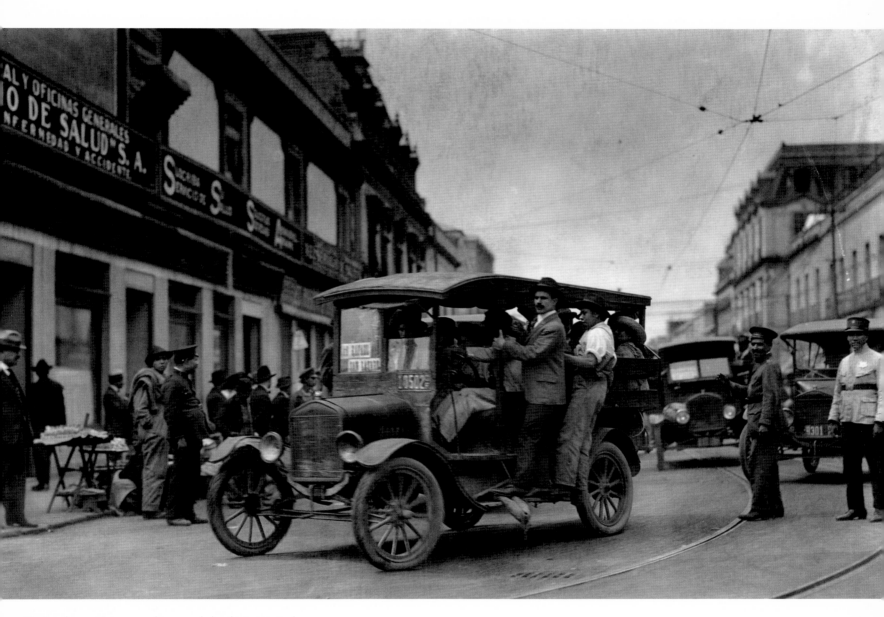

During the 1920s passenger buses tended to be improvised
vehicles; they traveled along five routes connecting outlying
areas with downtown Mexico City. 1923-1924. [131714]

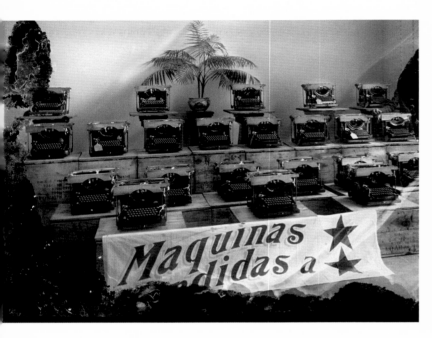

In this store window, typewriters are featured as a novelty—a fantastic new product that would become a formidable instrument for making out invoices, bills of exchange, and all kinds of documents. Mexico City, *ca.* 1913. [164518]

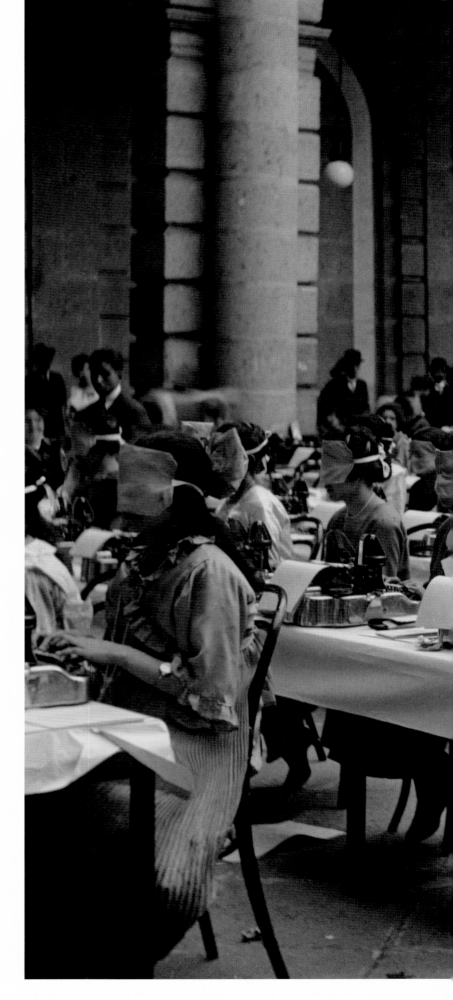

Young women, blinfolded, undertake a public typewriting test. The expansion in trade, services, industry, and public offices paved the way for young women to become secretaries after completing their studies in schools or academies. Mexico City, *ca.* 1920. [164445]

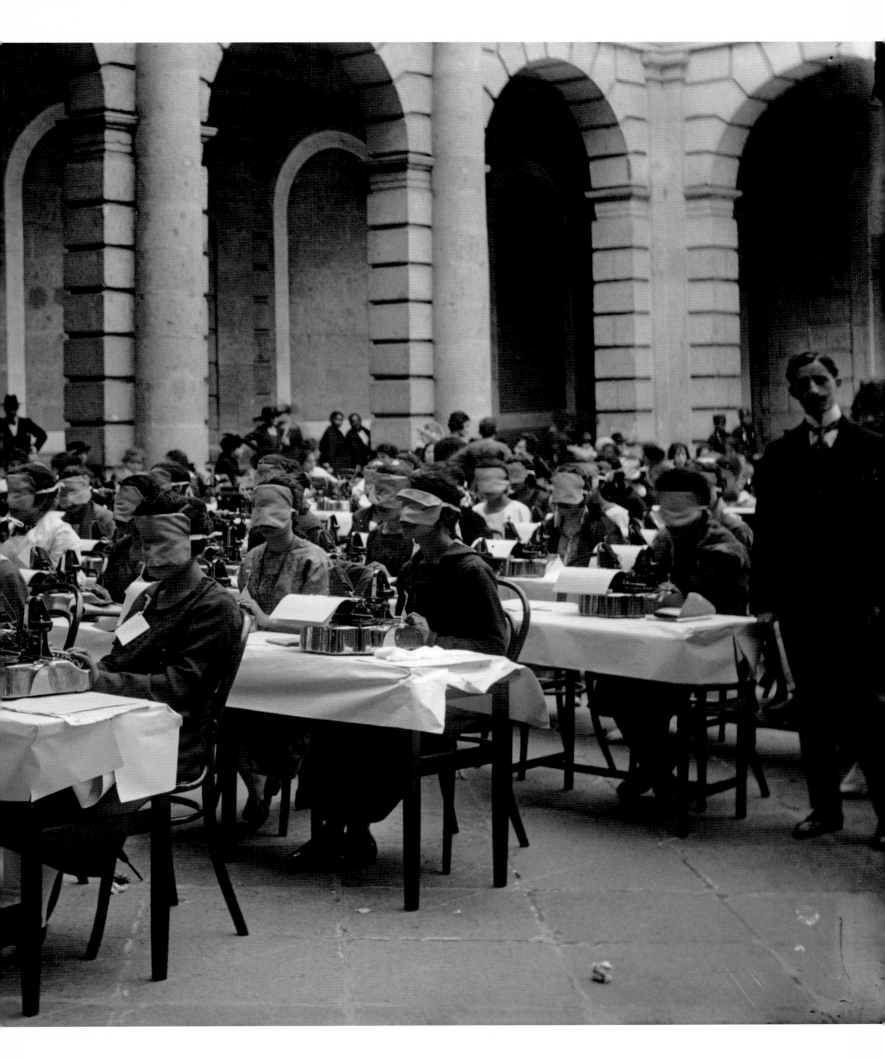

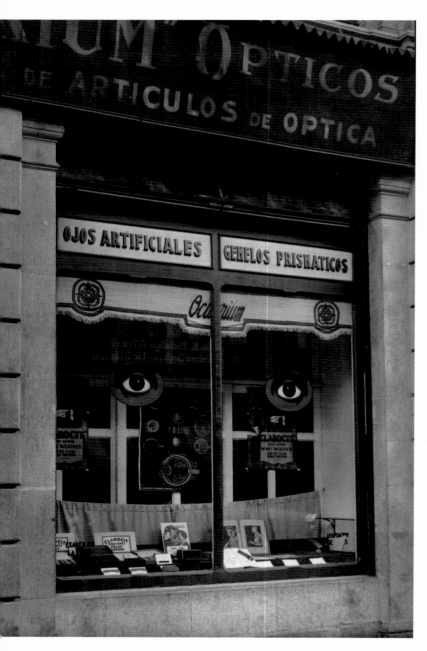

Modern optics delighted city dwellers with other novelties, billed here as "artificial eyes" and "prismatic twins" (binoculars). Mexico City, *ca.* 1935. [4826]

Blind girl in anatomy class. Post-revolutionary governments undertook the educational transformation of the country, devising courses of study for children, young people, and adults, as well as for blind and other handicapped people. Mexico City, *ca.* 1924. [208611]

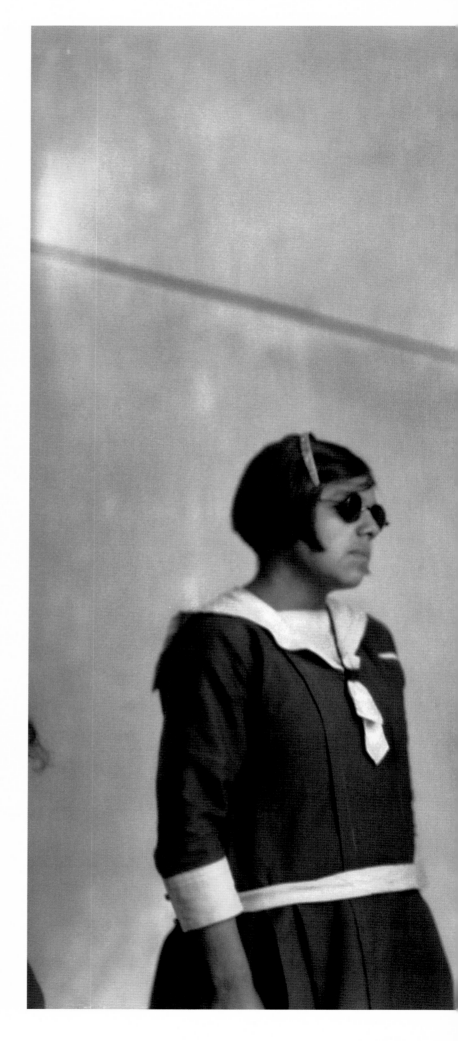

THE EAGLE AND THE SERPENT

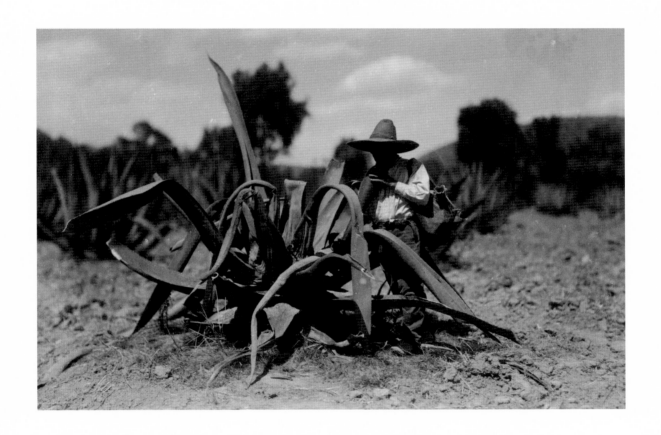

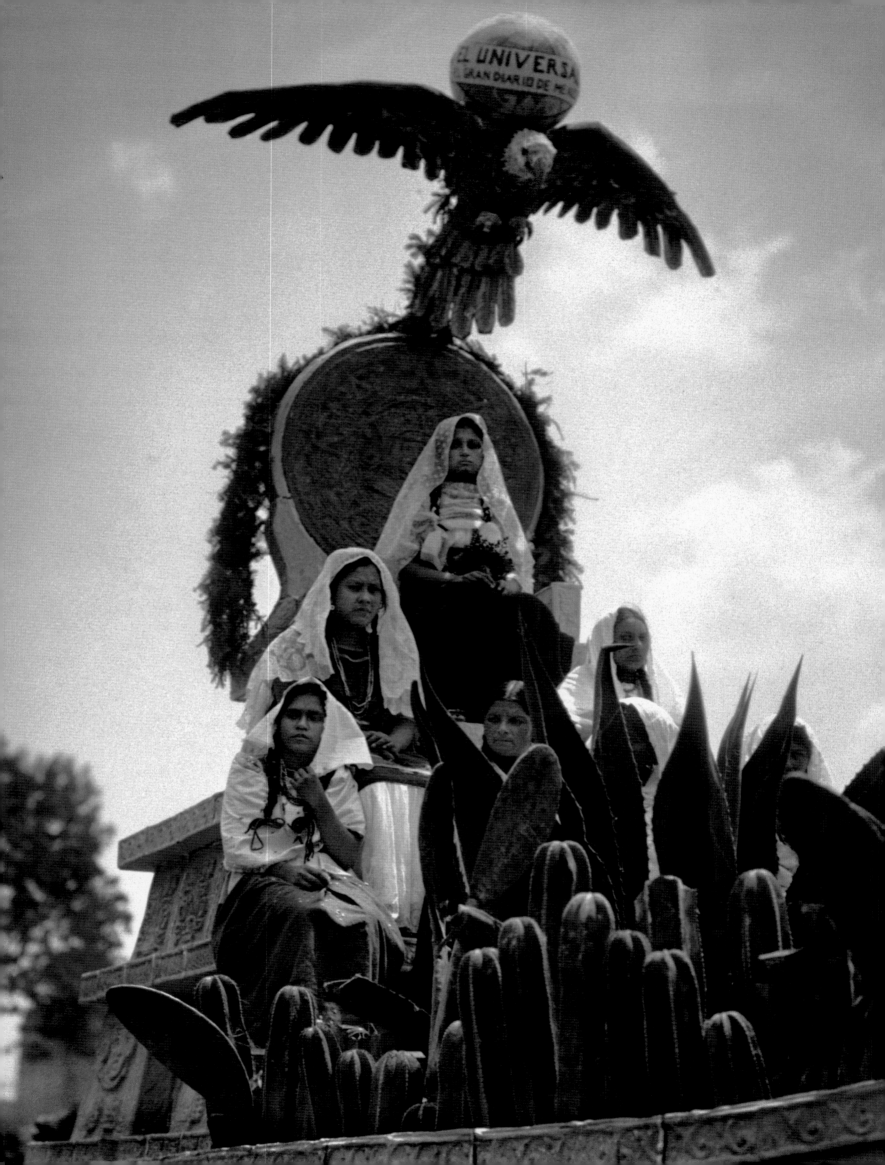

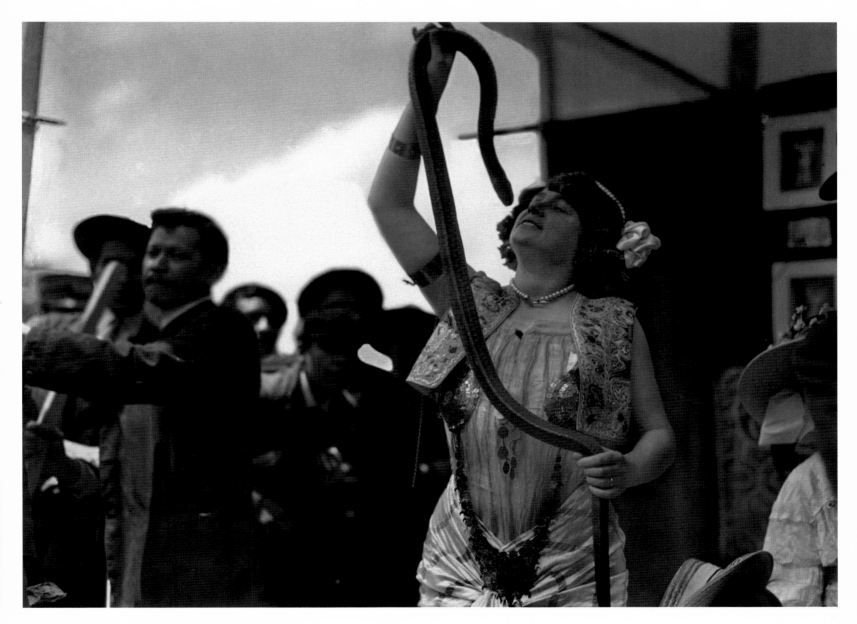

Mexico City's residents never ceased to be fascinated by street musicians or small circus acts, such as the performance put on by this snake charmer. *Ca.* 1912. [89082]

Float in a Mexico City parade. The pacification of the country and the institutionalization of power by revolutionary leaders was accompanied by the formation of cultural nationalism, based in popular traditions and the Pre-Hispanic past. As seen in this photograph, this trend was often exploited by big business. 1928. [10899]

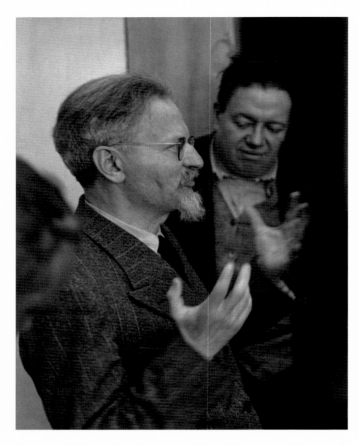

The painter Diego Rivera was part of a group that promoted political asylum for Leon Trotsky. The Russian revolutionary leader and his wife Natalia Ivanovna lived in Diego Rivera and Frida Kahlo's house, located in the Coyoacán residential area in the southern part of Mexico City. 1937. [49750]

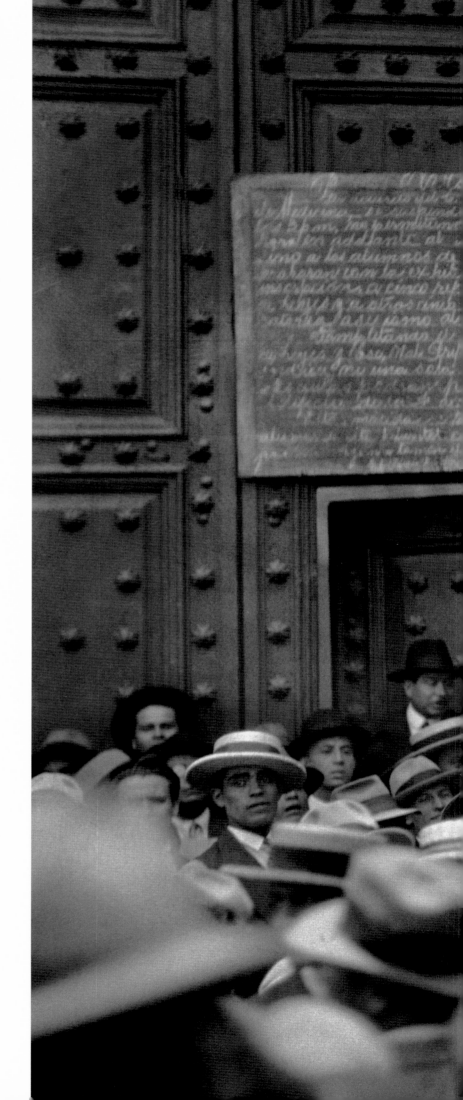

Students achieved an autonomous university in the year 1929 by means of mobilizations and protests. This photograph portrays a demonstration called by Law School students. [5193]

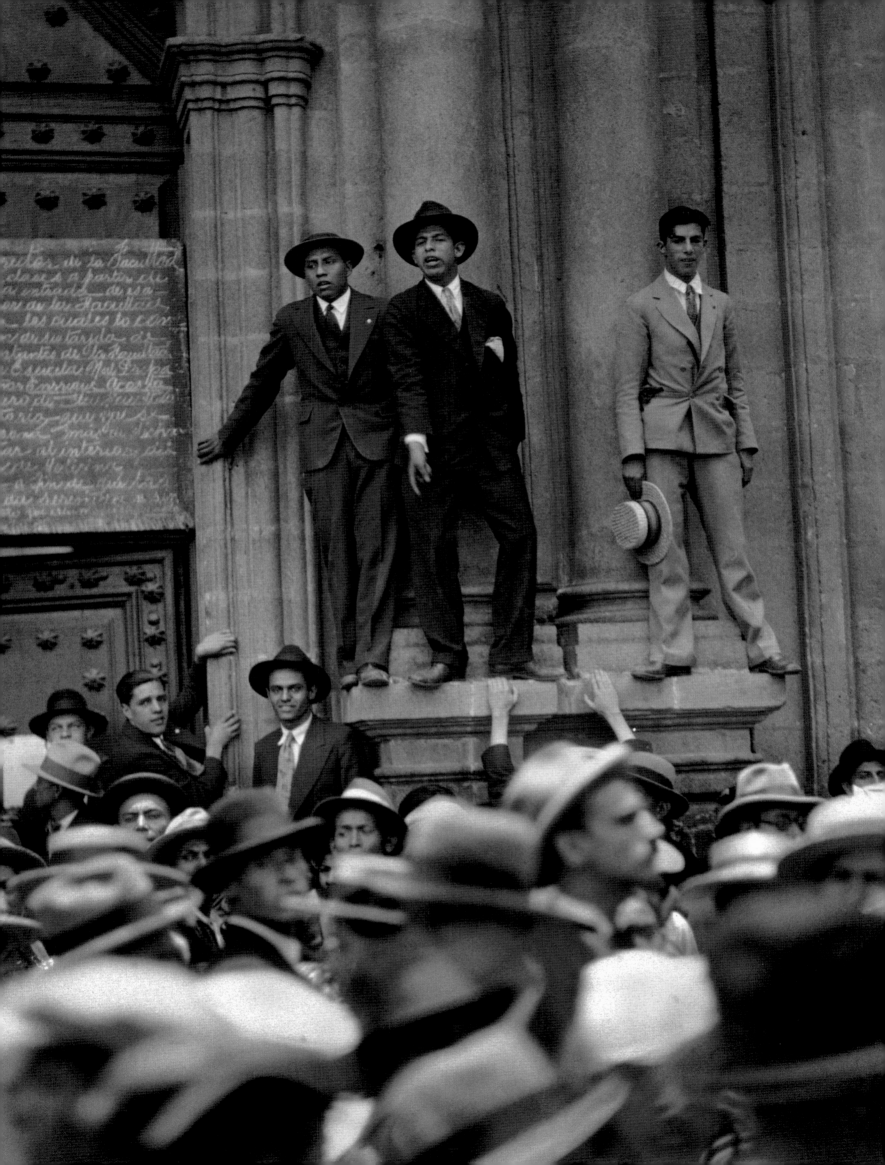

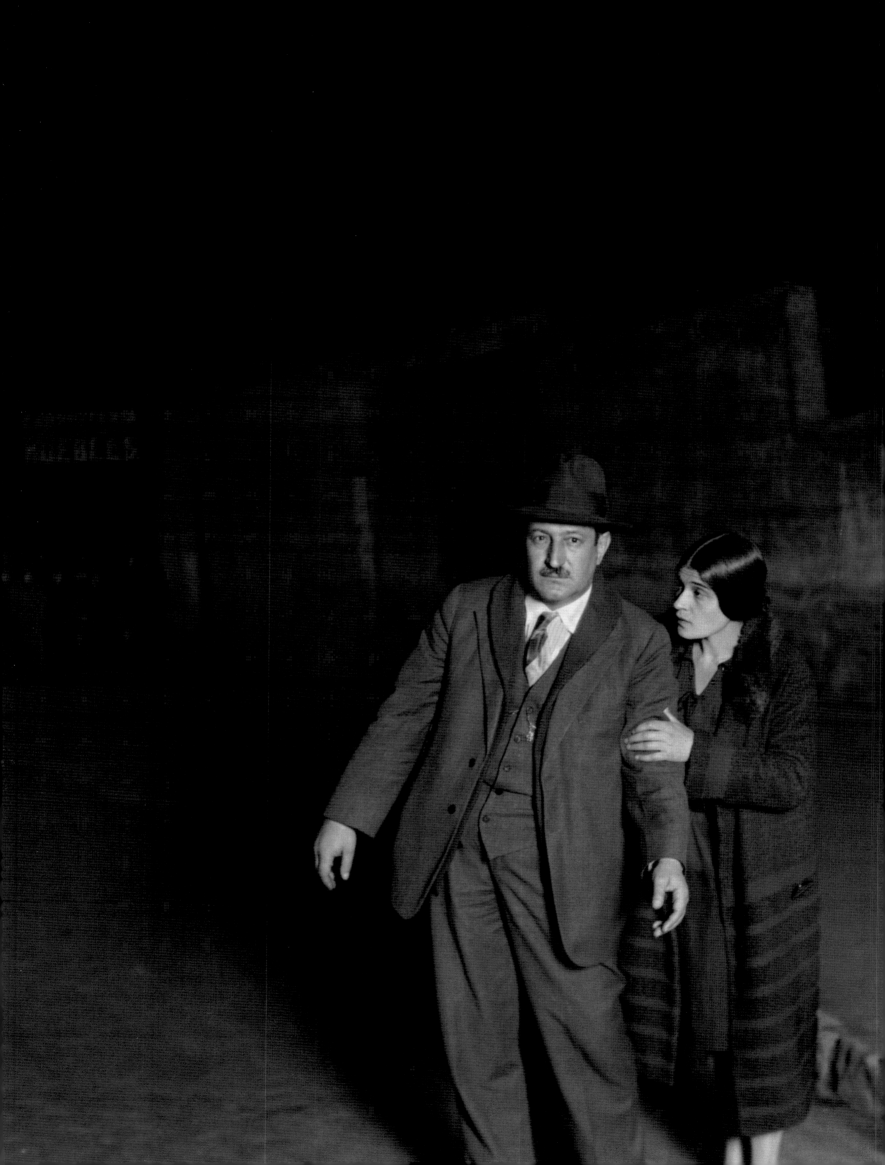

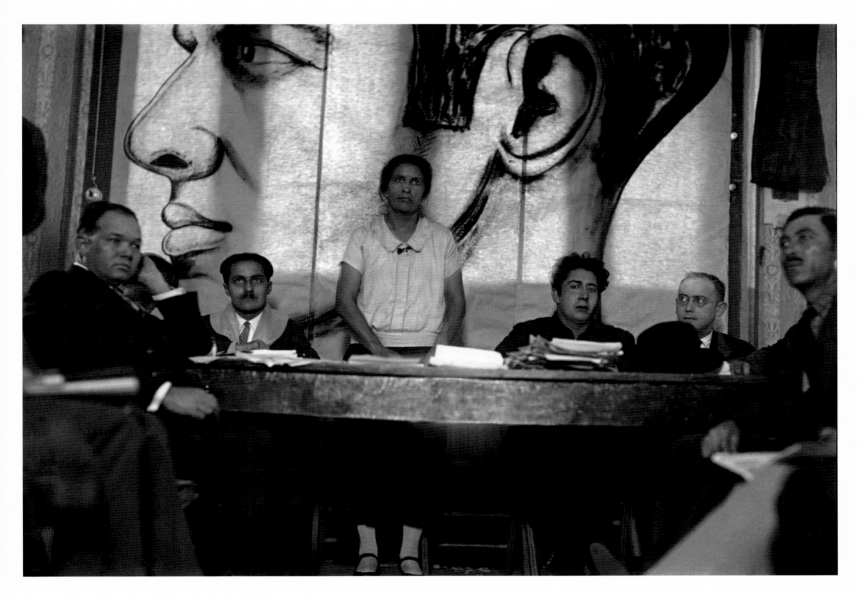

On the night of May 6, 1929, Tina Modotti and Julio Antonio
Mella were walking towards the home of the Italian-born
photographer and activist when unknown assailants opened
fire, killing Mella on the spot. The picture shows Mexican
Communist Party militants paying homage to him. One of
those present is the painter David Alfaro Siqueiros, seated to
the left of the woman standing in the center. [5857]

Mexico City was the scene of two brutal political crimes:
the assassination of the Cuban communist Julio Antonio
Mella in 1929, and that of the legendary Leon Trotsky in 1940.
This photograph shows Tina Modotti reconstructing the crime
with police authorities. 1929. [46373]

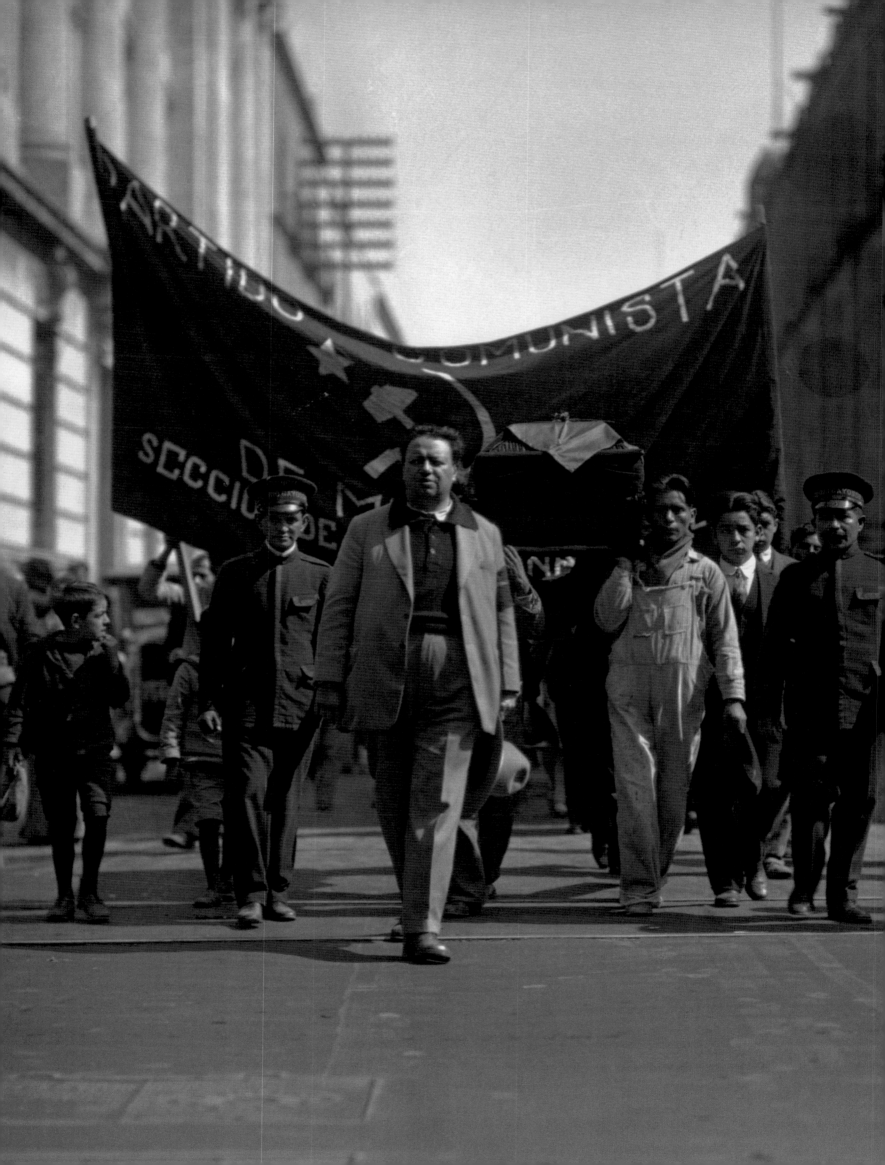

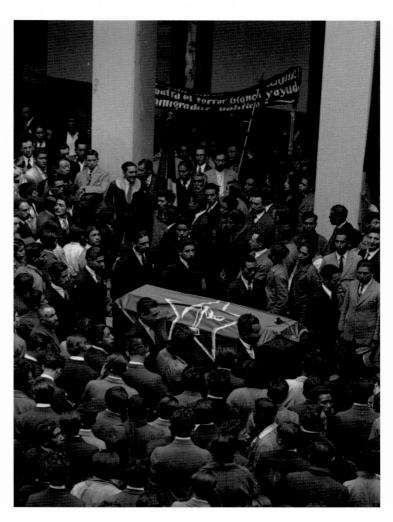

Mella's funeral turned into an act of repudiation against the Cuban dictatorship of Gerardo Machado, who is believed to be the intellectual author of the crime. 1929.[6351]

The painter Diego Rivera led Julio Antonio Mella's funeral procession and also protested against the police harassment of Tina Modotti and other fellow communists. 1929. [46385]

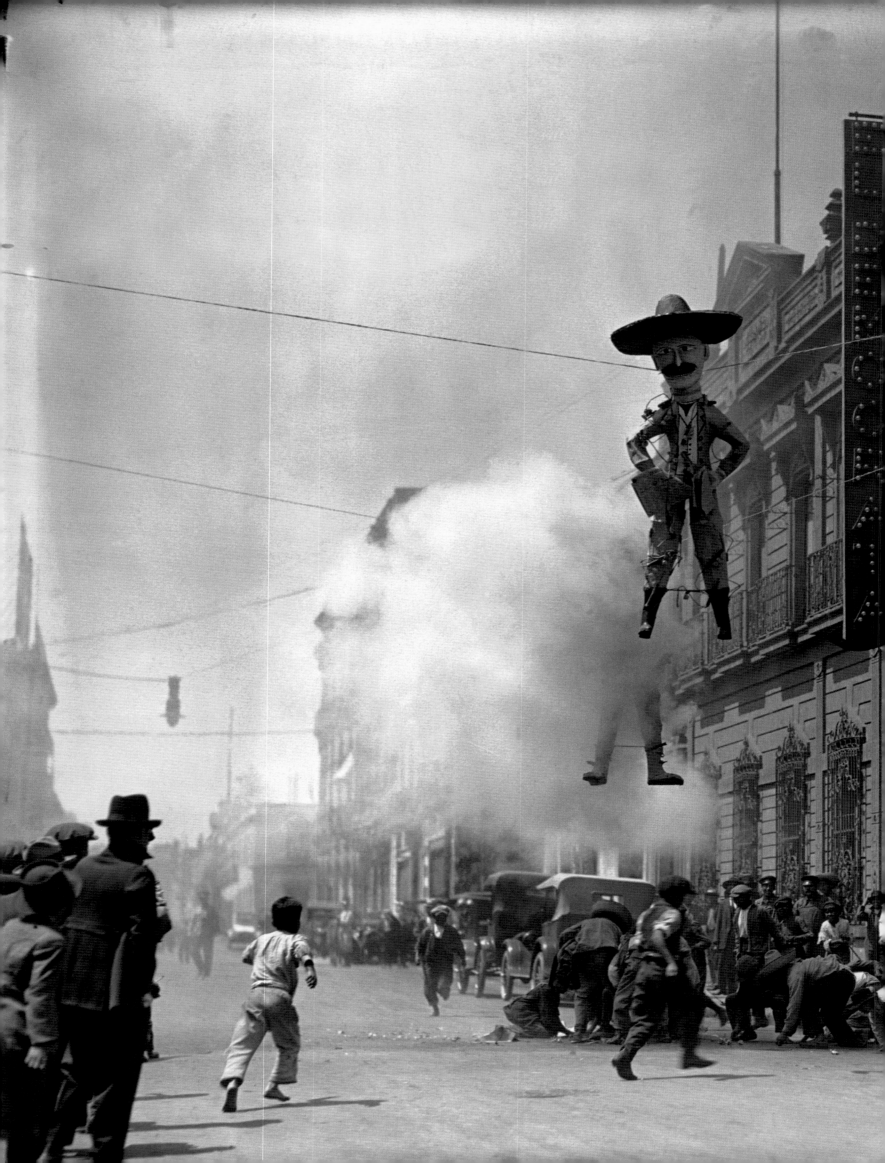

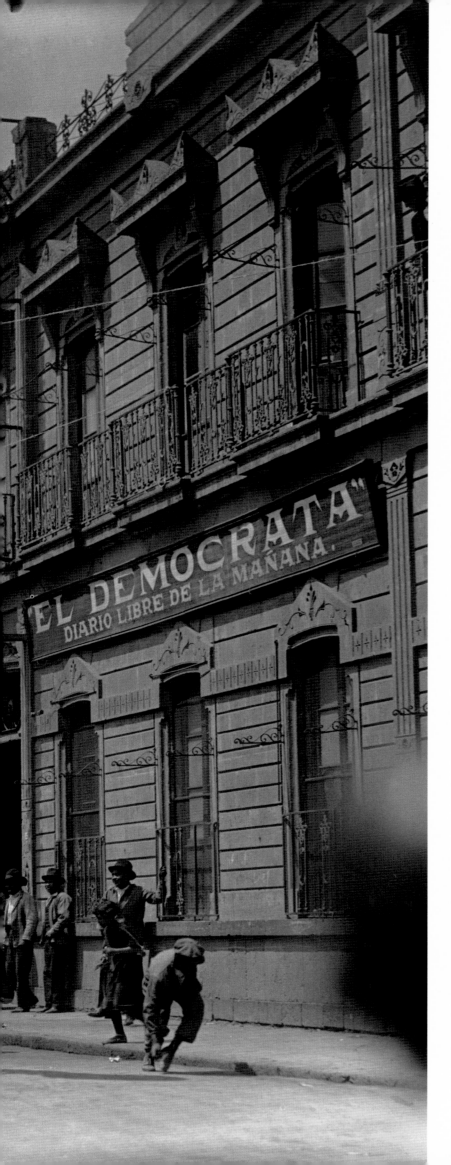

Every year on December 12 at the Basilica of Guadalupe, musical groups and pilgrims pay tribute and sing songs in praise of the Virgin of Guadalupe, the patron saint of Mexico. *Ca.* 1935. [128688]

On Easter Saturday, at the end of Holy Week, it was the custom for an enthusiastic crowd to "burn" Judas, a grotesque papier-mâché figure full of gun-powder and firecrackers. The photograph depicts this festivity outside the offices of the newspaper *El Demócrata. Ca.* 1920. [288018]

Pages 128-129
Streetcars empowered by electric energy came to replace streetcars drawn by mules. Mexico City, *ca.* 1920. [5812]

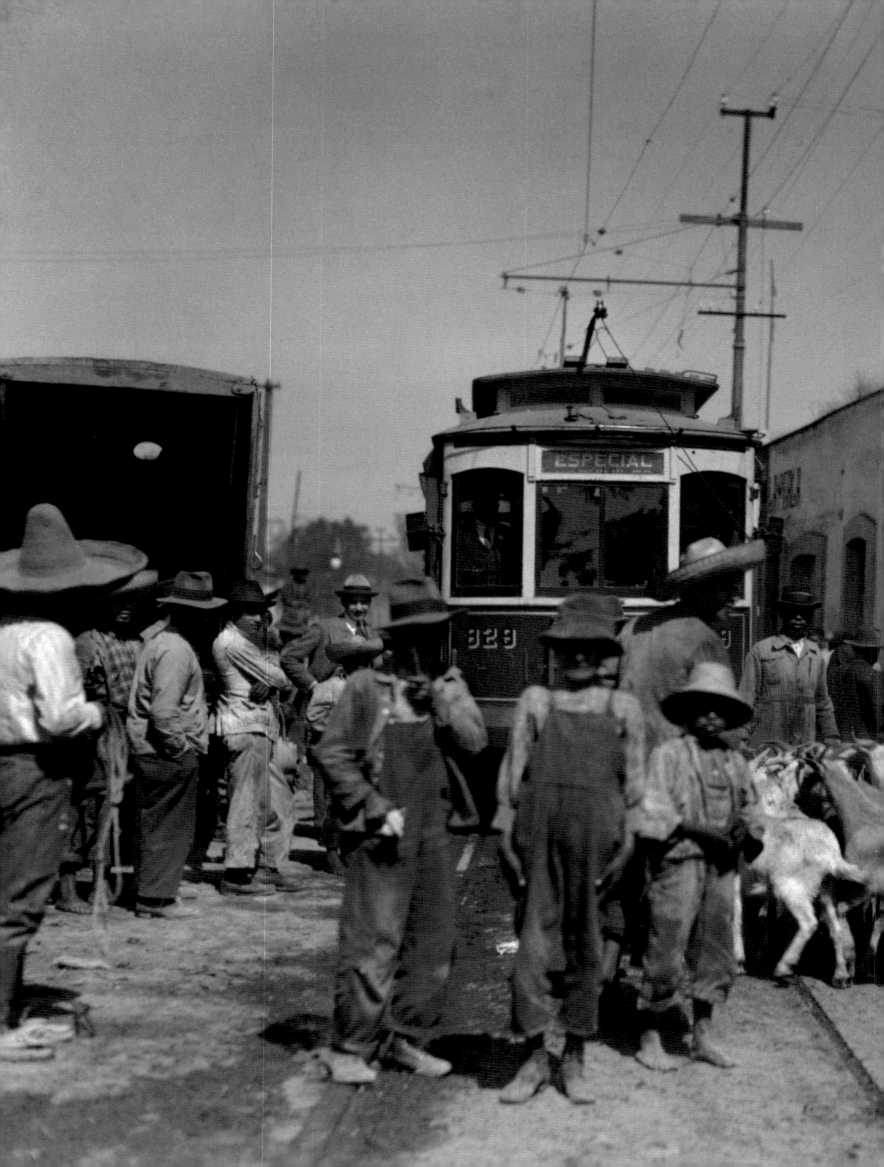

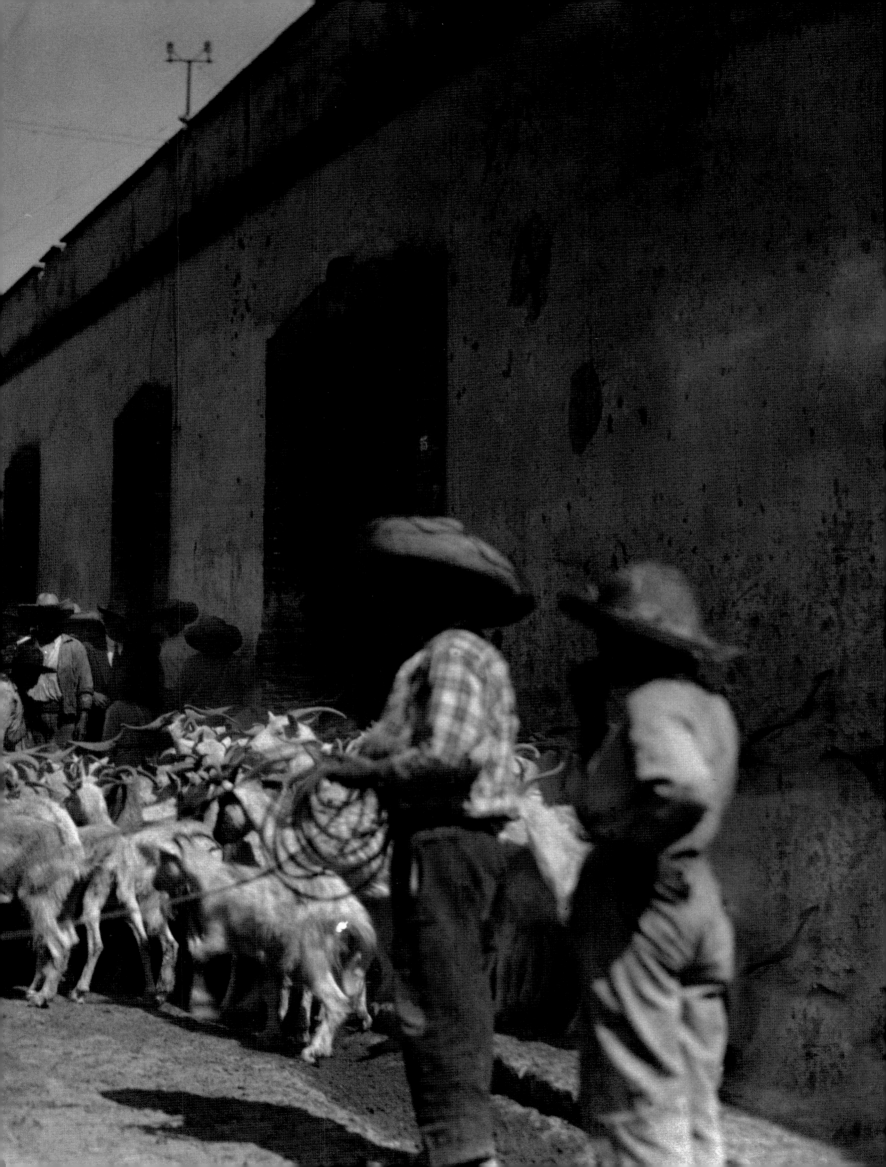

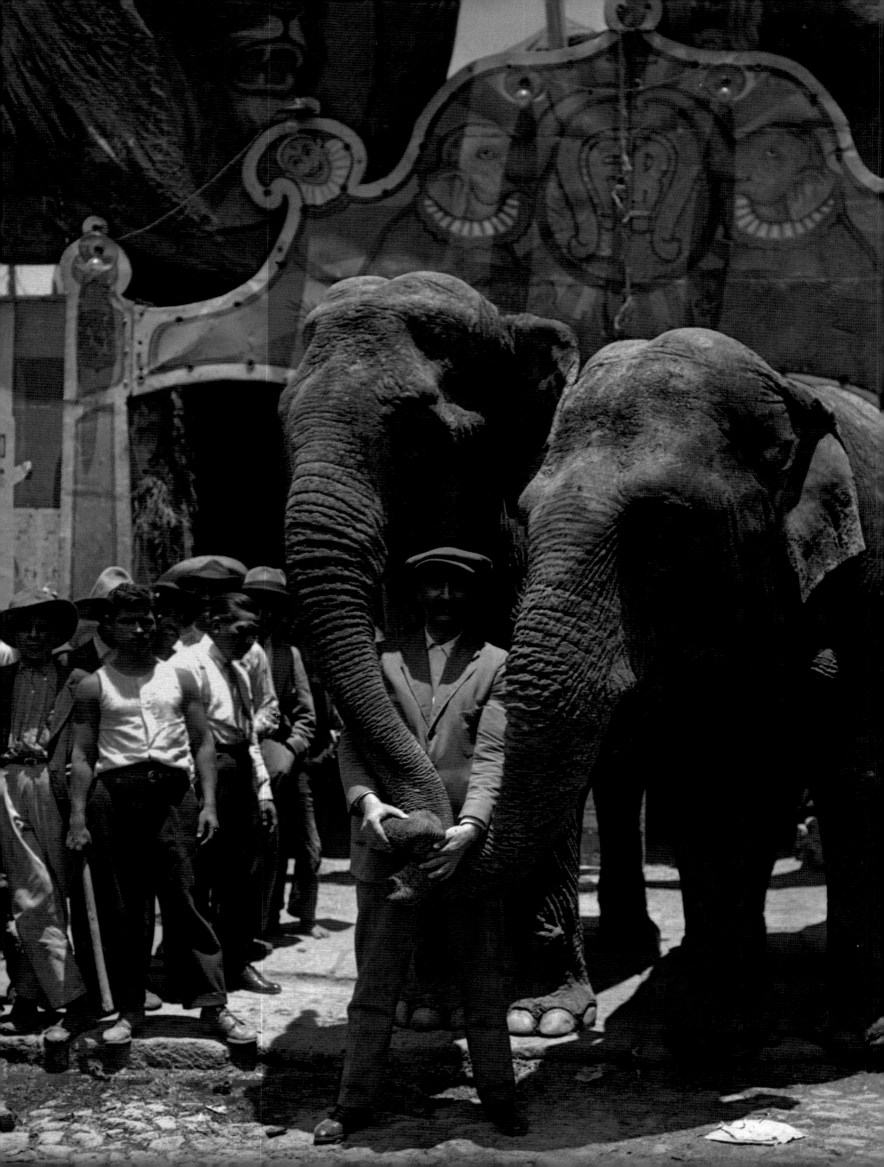

Circus entrepreneurs satisfied the public's zest for a good time. This photograph shows an elephant trainer from the Gran Circo Teatro Modelo. Mexico City, *ca.* 1918. [202670]

Pages 132-133
On the Day of San Juan, the popular classes thronged to public baths and swimming pools. This photograph shows the crowd of bathers at the Alberca Pane pool. Mexico City, *ca.* 1924. [108764]

Thanks to cinematographers, Charles Chaplin's films were appreciated, and it wasn't long before local imitators followed his lead. Mexico City, *ca.* 1920. [98698]

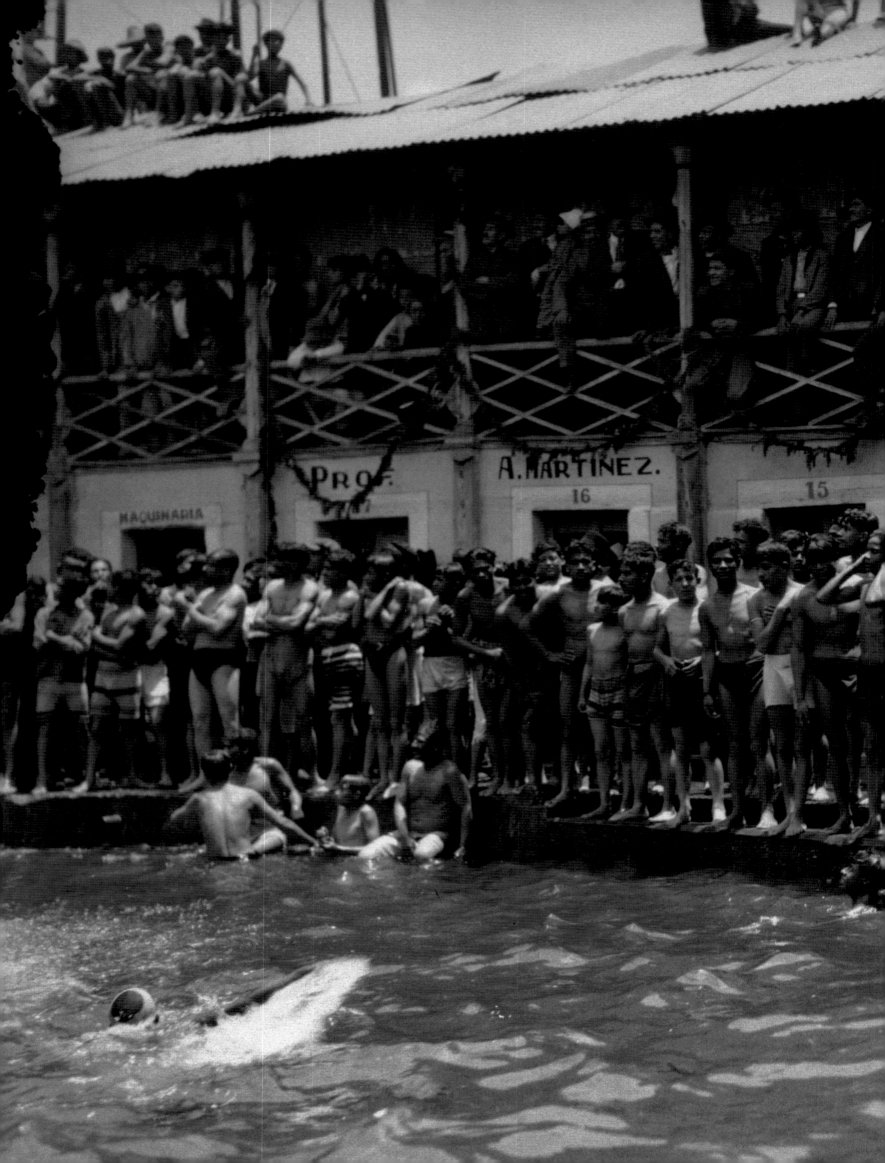

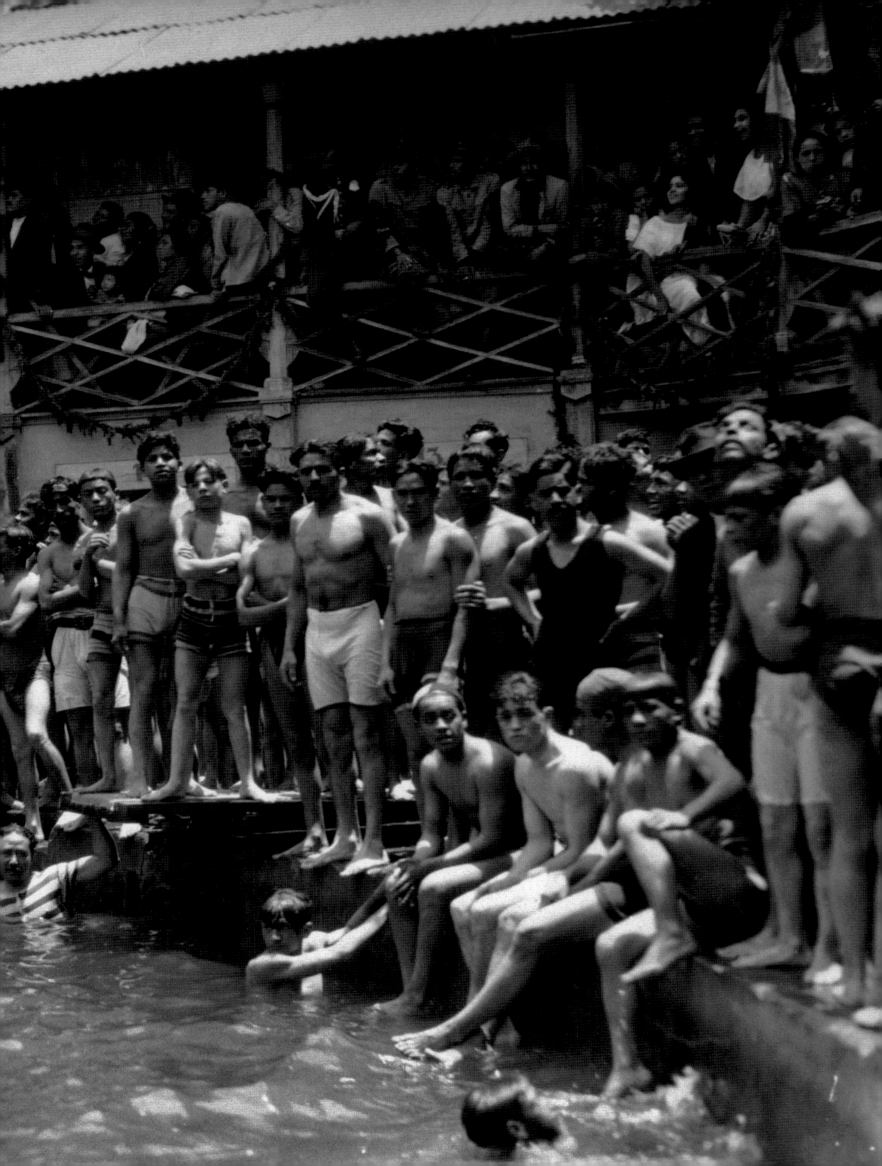

THE NIGHT

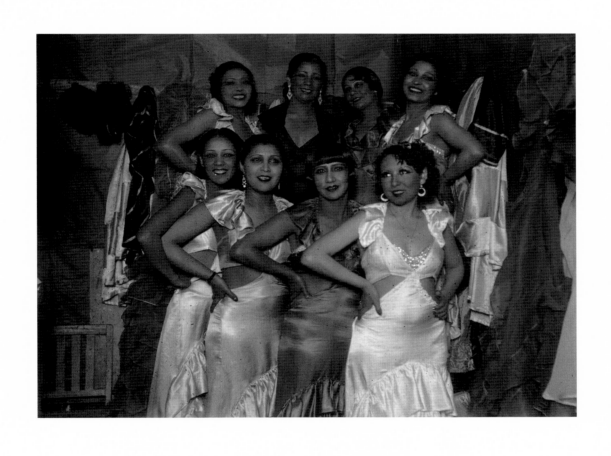

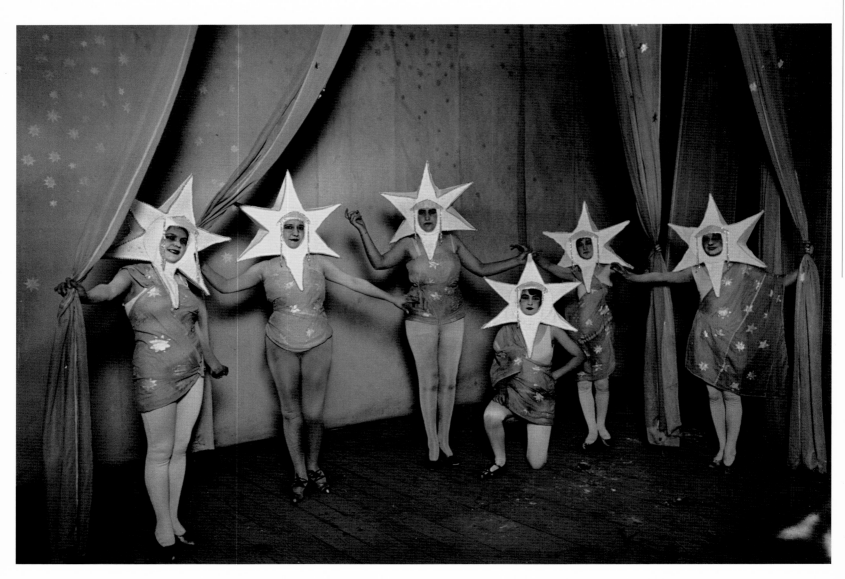

The city's vibrant night life catered to diverse audiences, who enjoyed reviews, operettas, dramas, comedies, and Spanish comic operas known as *zarzuelas*. Both national and international companies put on extravaganzas for packed houses at theaters such as the Colón, Principal, Arbeu, María Guerrero, and Esperanza Iris. Mexico City, *ca.* 1925. [197113]

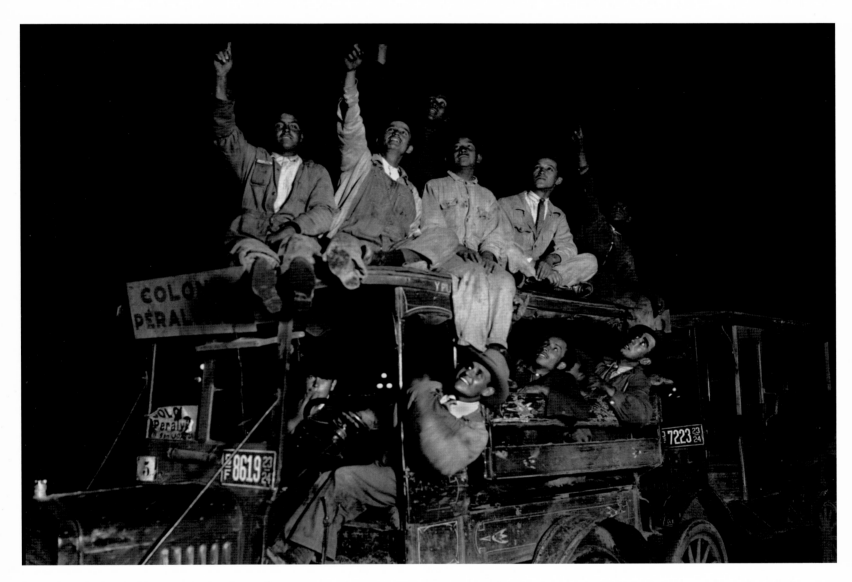

In another vein, breathtaking events such as lunar eclipses were
attentively viewed and celebrated by thousands of avid
spectators in the capital city. Mexico City, 1923-1924. [218430]

Tent shows were favorite hangouts for night owls. This is a photograph of the famous vaudeville hall, the Salón Rojo, the home of many comedians and comic actors. Mexico City, *ca.* 1935. [73158]

Page 140
This was probably the best of all times for circus performers, such as the trio shown in this photograph. Mexico City, *ca.* 1915. [197085]

Page 141
Between 1922 and 1929, comedies once again focused on themes from the days of Madero and the Revolution and did not hesitate to make direct references to politicians. In this photograph, Isabel Blanch and another actor are seen on stage. Mexico City, *ca.* 1926. [10967]

Pages 142-143
Sopranos and chorus girls elicited fervent shouts and applause when they appeared on stage. Mexico City, *ca.* 1925. [97988]

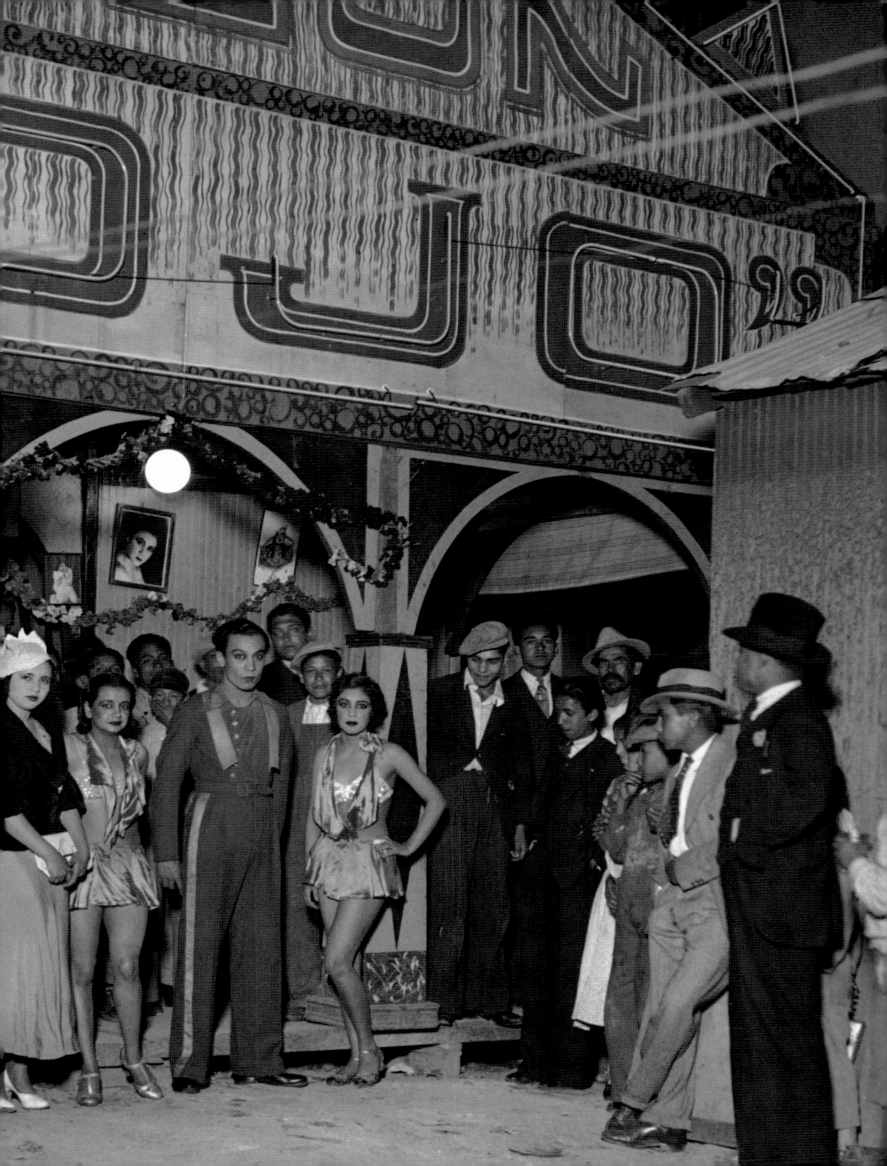

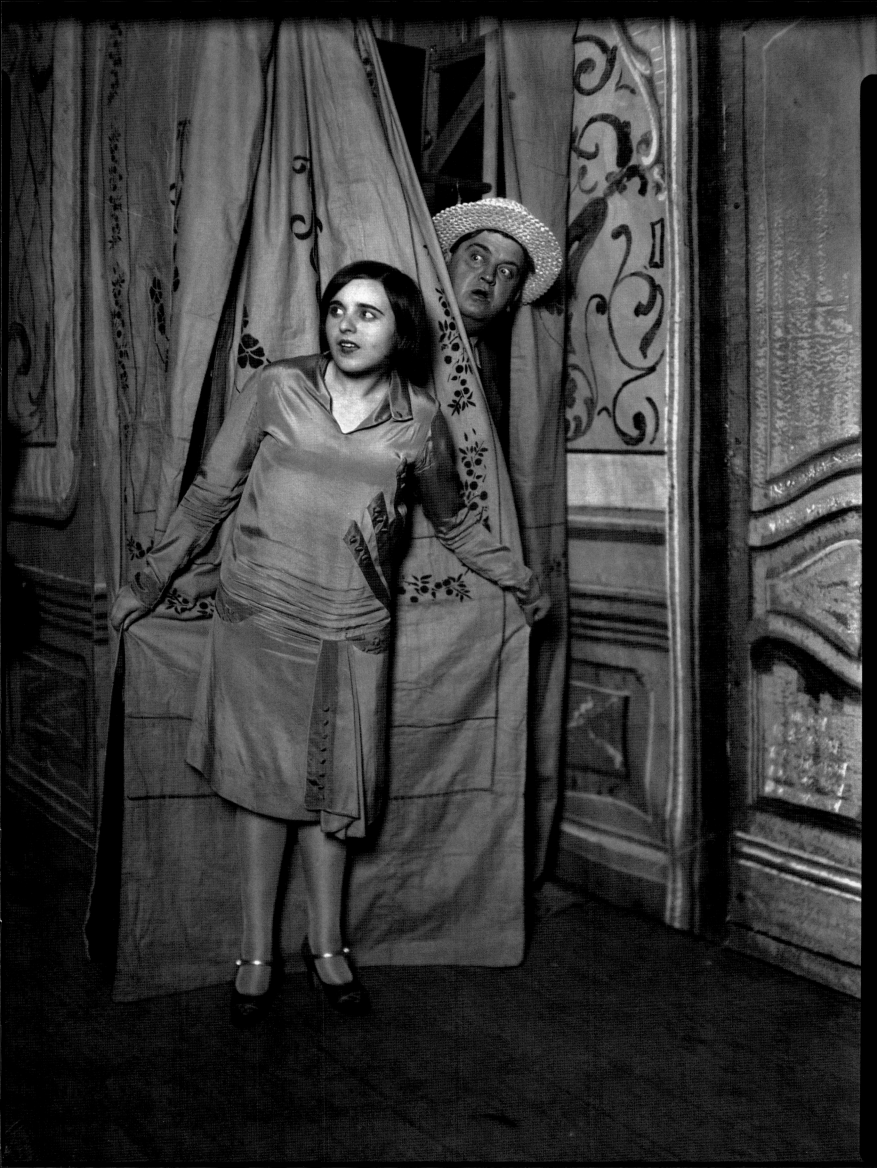

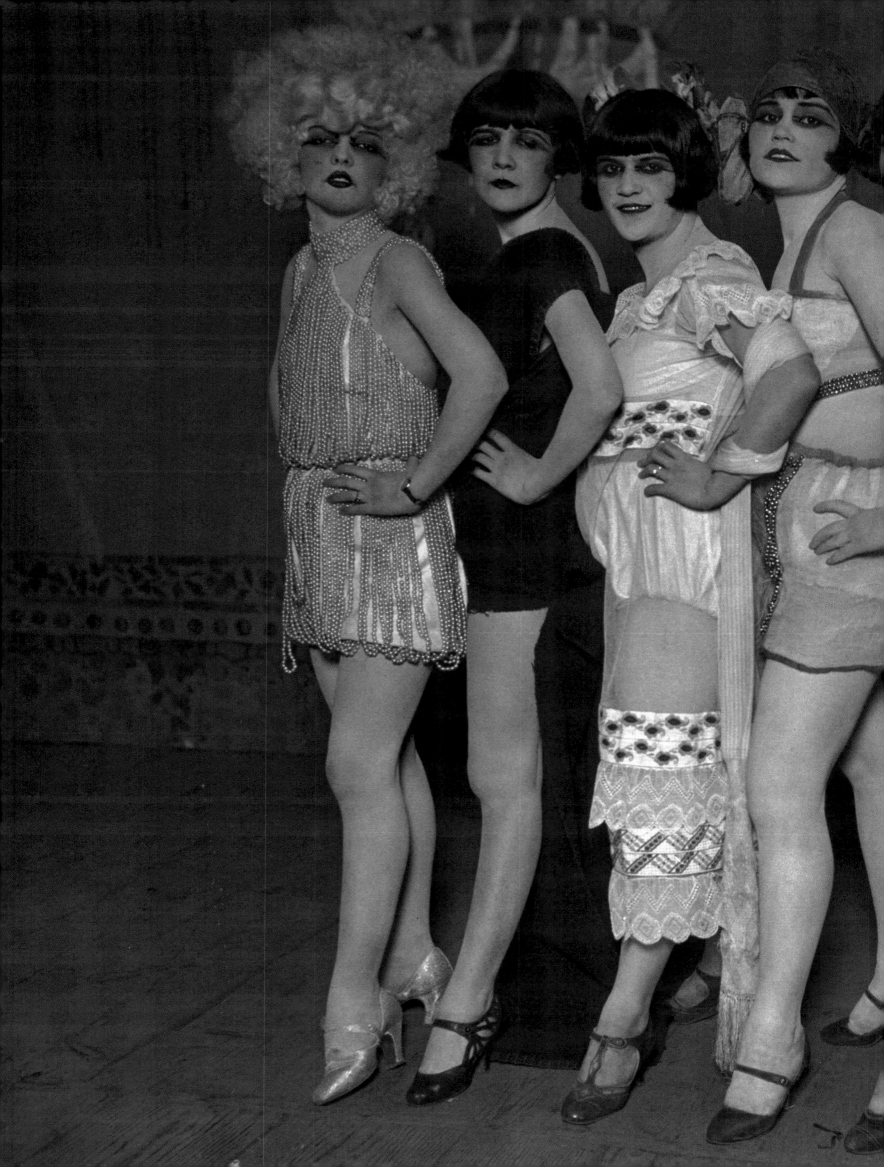

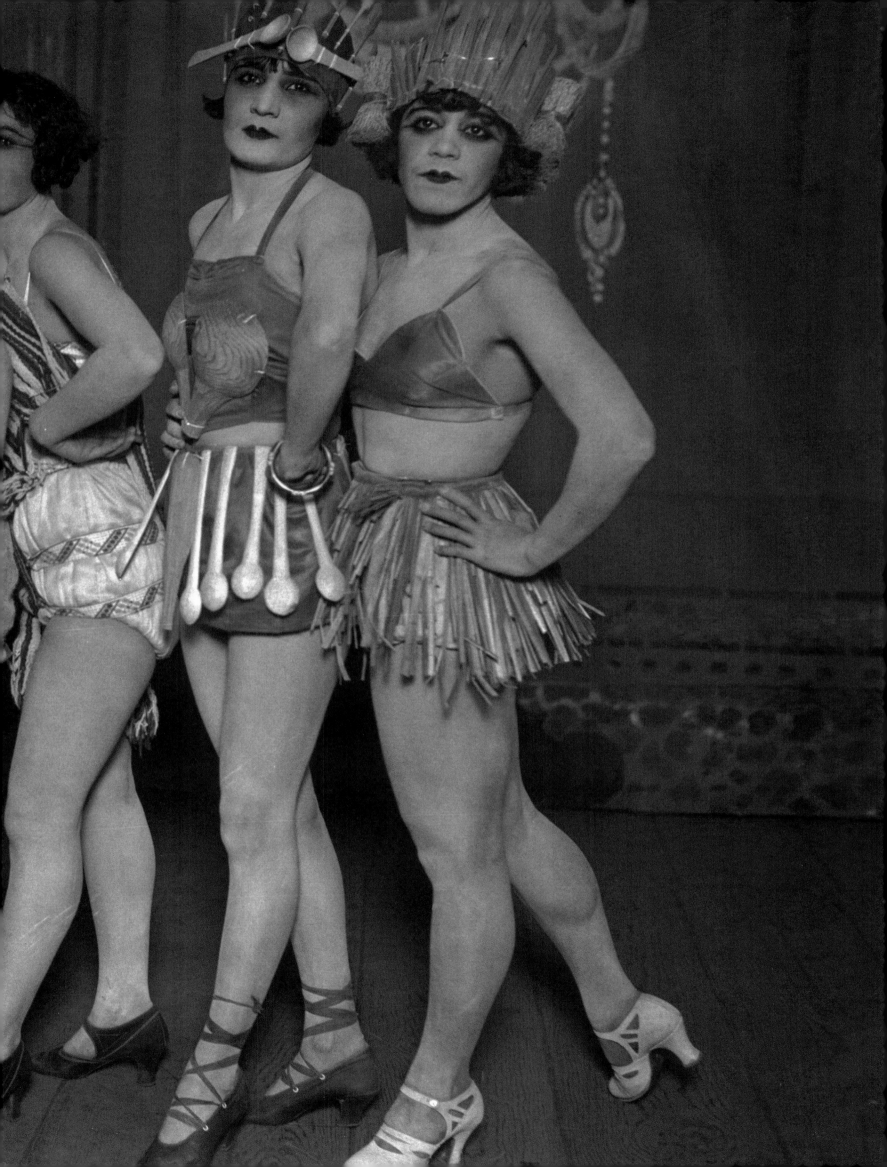

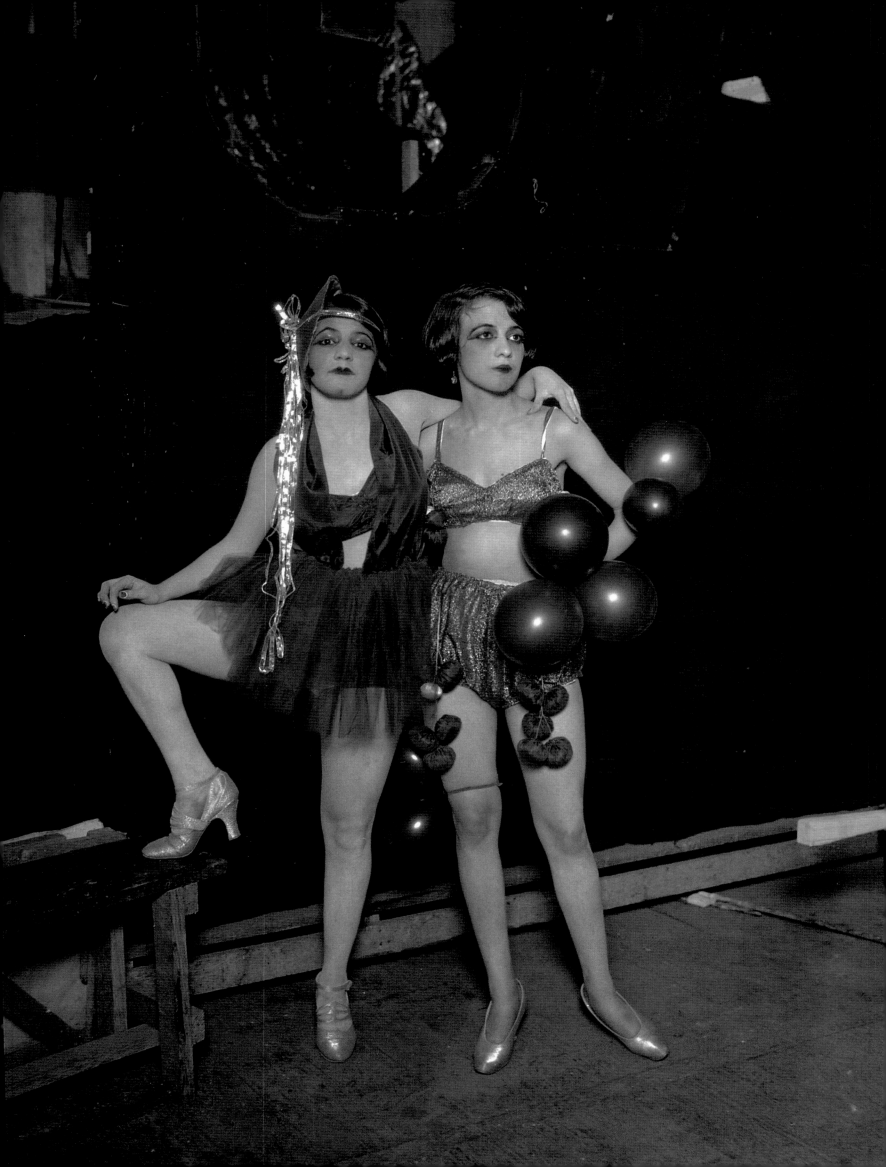

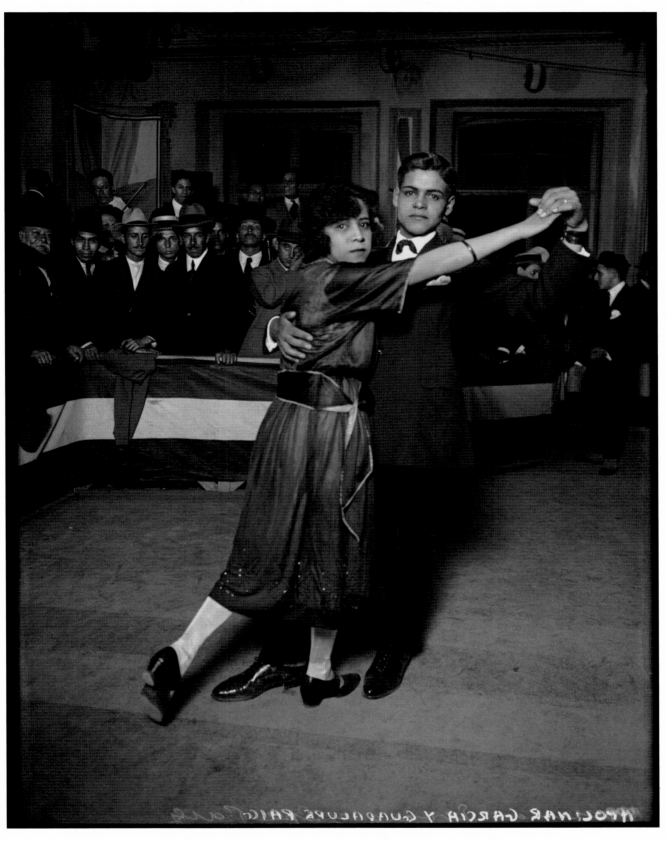

Diverse sponsors organized dance contests: fox-trot, tango, and *danzón*. In the photograph, Apolinar García and Guadalupe Paig take the floor in a dance contest organized by the newspaper *El Demócrata. Ca.* 1920. [73005]

In 1925, there was a full house every night at the Teatro Iris to enjoy Madame Berthe Rosini's BA-TA-CLAN French Review. Two chorus girls from the dance company appear in the photograph. Mexico City, *ca.* 1925. [97995]

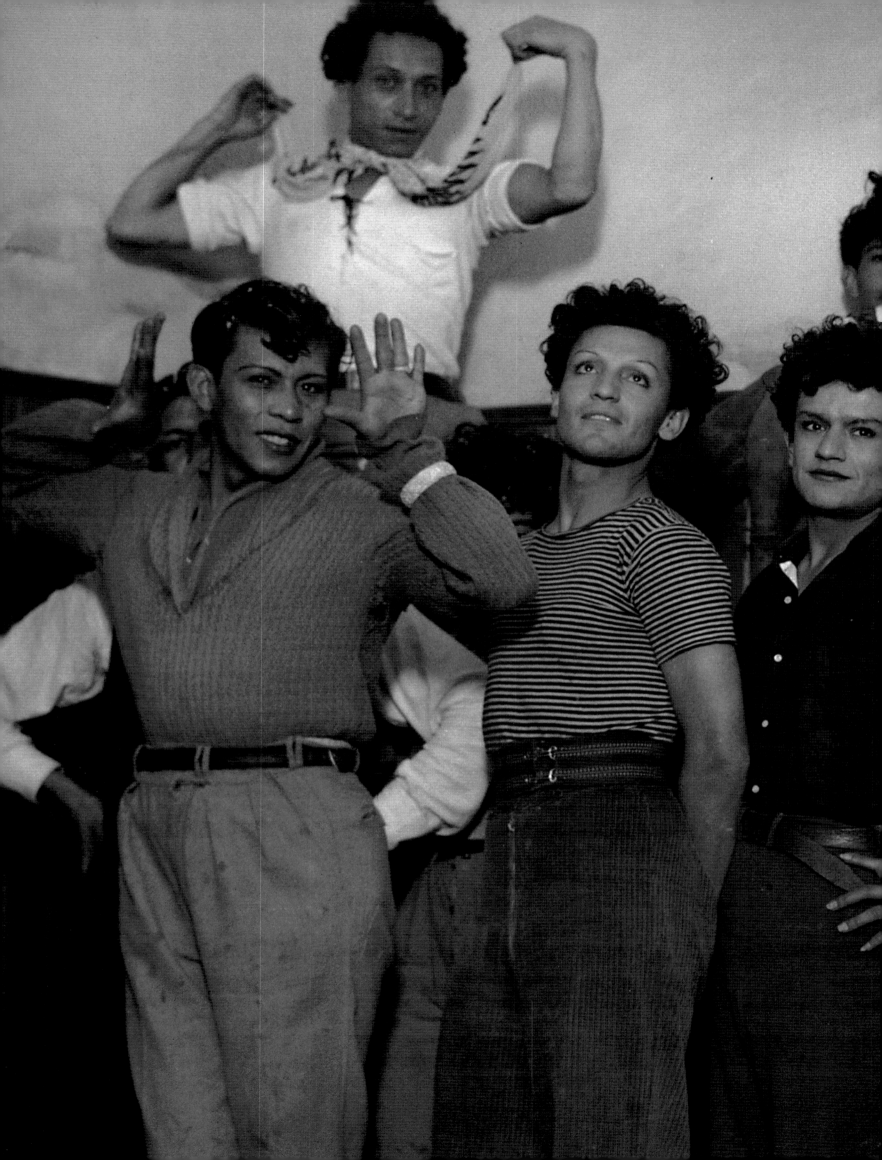

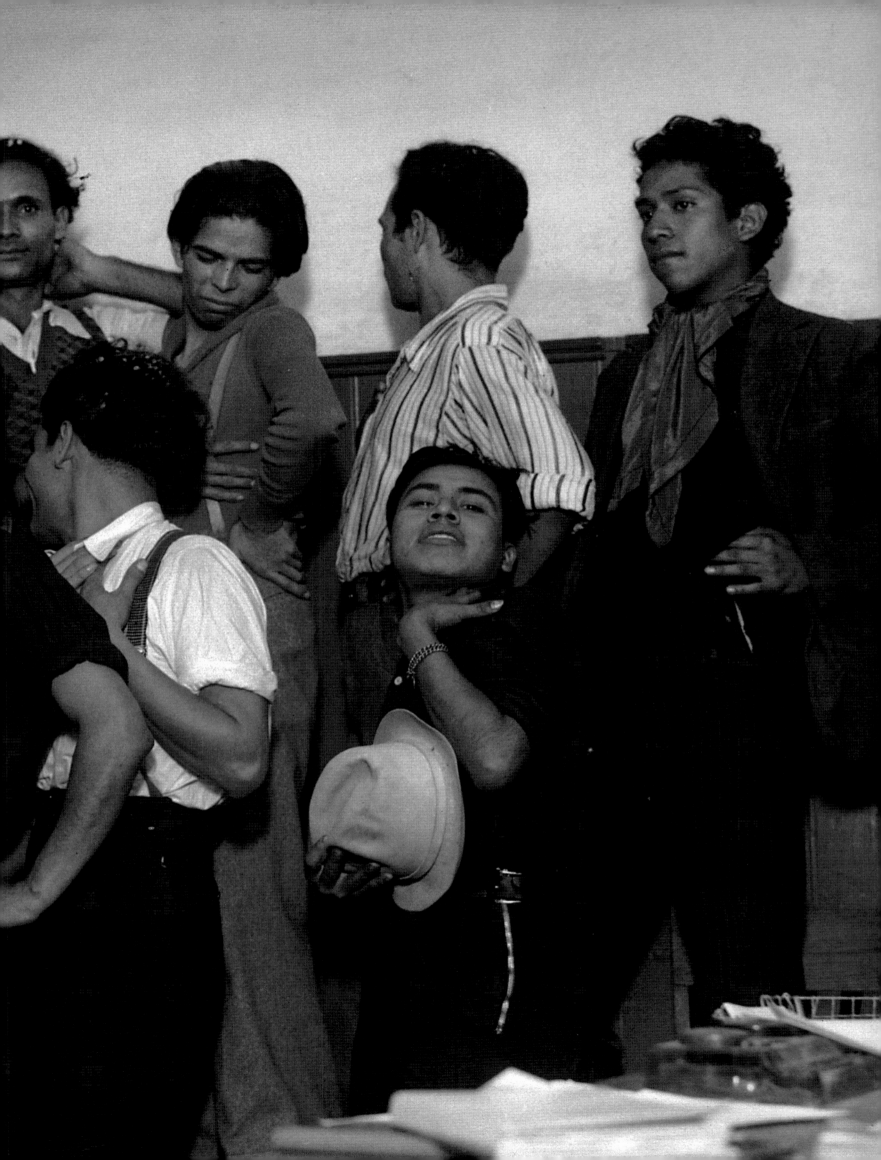

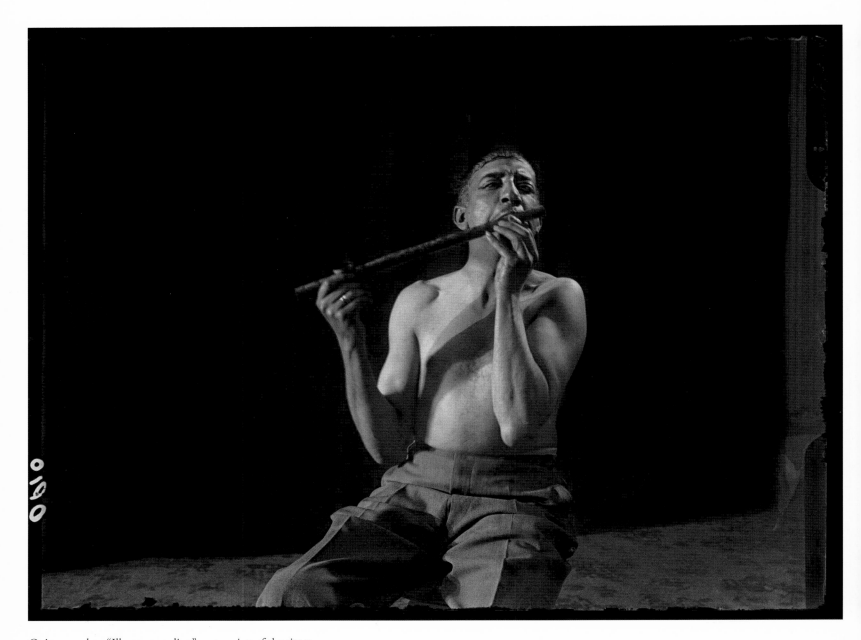

Opium smoker. "Illusory paradises" were a sign of the times.
Mexico City, *ca.* 1935. [6665]

Pages 146-147
Homosexuals, viewed as degenerate and unwholesome by
the police, were targets of constant repressions. Here, some
of those arrested pose for the camera at the police station.
Mexico City, *ca.* 1935. [6631]

In Mexico City, elegant, clandestine opium dens existed for
the rich, while soldiers and proletarians smoked marijuana.
Ca. 1935. [6263]

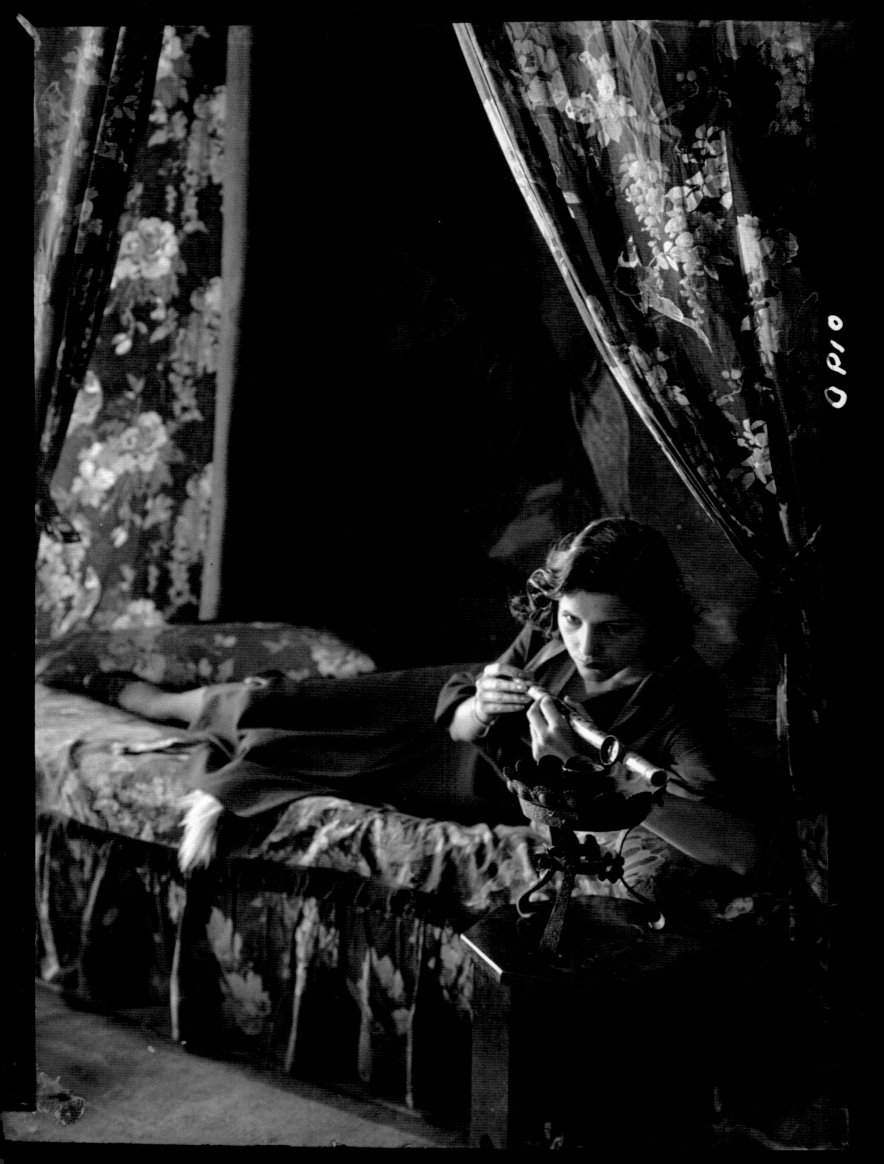

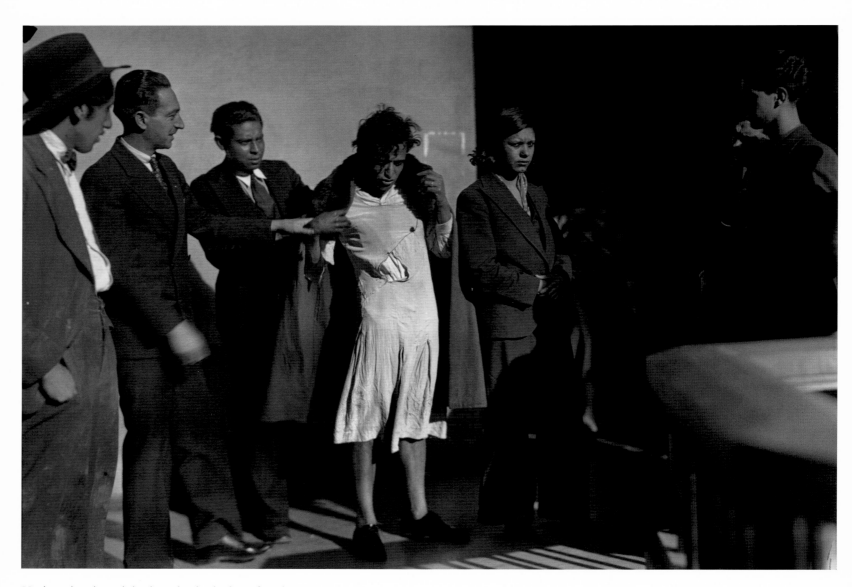

He dressed as she and she dressed as he, both are forced to
endure jeers at the police station. Homosexuals and prostitutes
were preferred targets of police and societal intolerance.
Mexico City, *ca.* 1935. [6626]

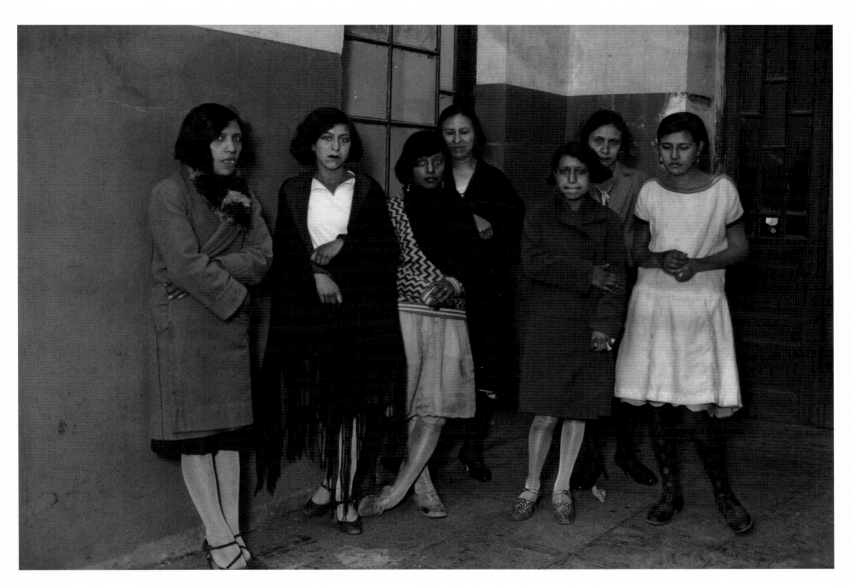

Prostitution was scorned and outlawed in the name of respect for moral standards and respectability, but it was tolerated if and when the women abided by "sanitation control," as documented by this photographer. Mexico City, *ca.* 1926. [6647]

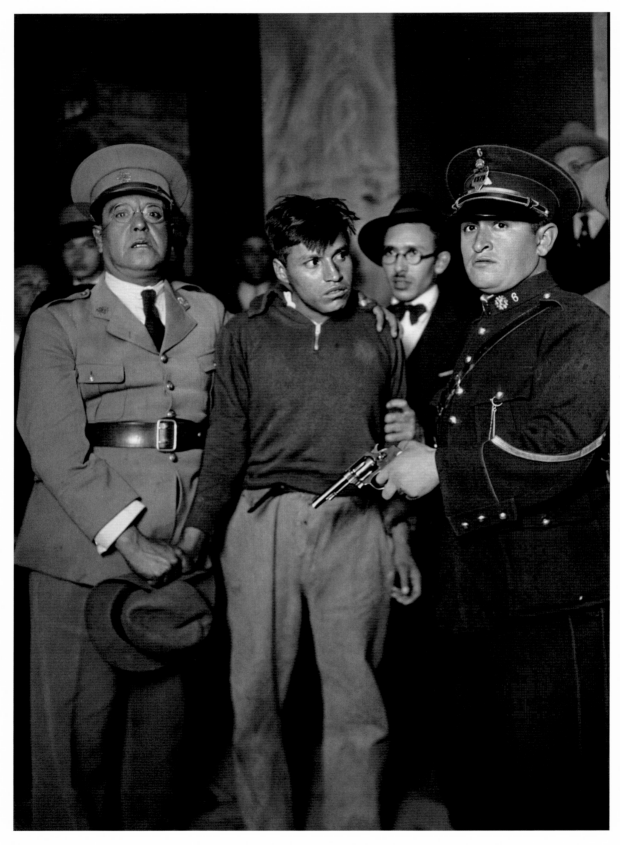

This "crime story" photograph established the image
of the delinquent with his weapon, under the watchful
gaze of his arresting officers and jailers.
Mexico City, *ca.* 1935. [68995]

Notwithstanding prohibition and persecution, "the
world's oldest profession" was practiced in specific
neighborhoods recognized as tolerance zones in
Mexico City. *Ca.* 1935. [68981]

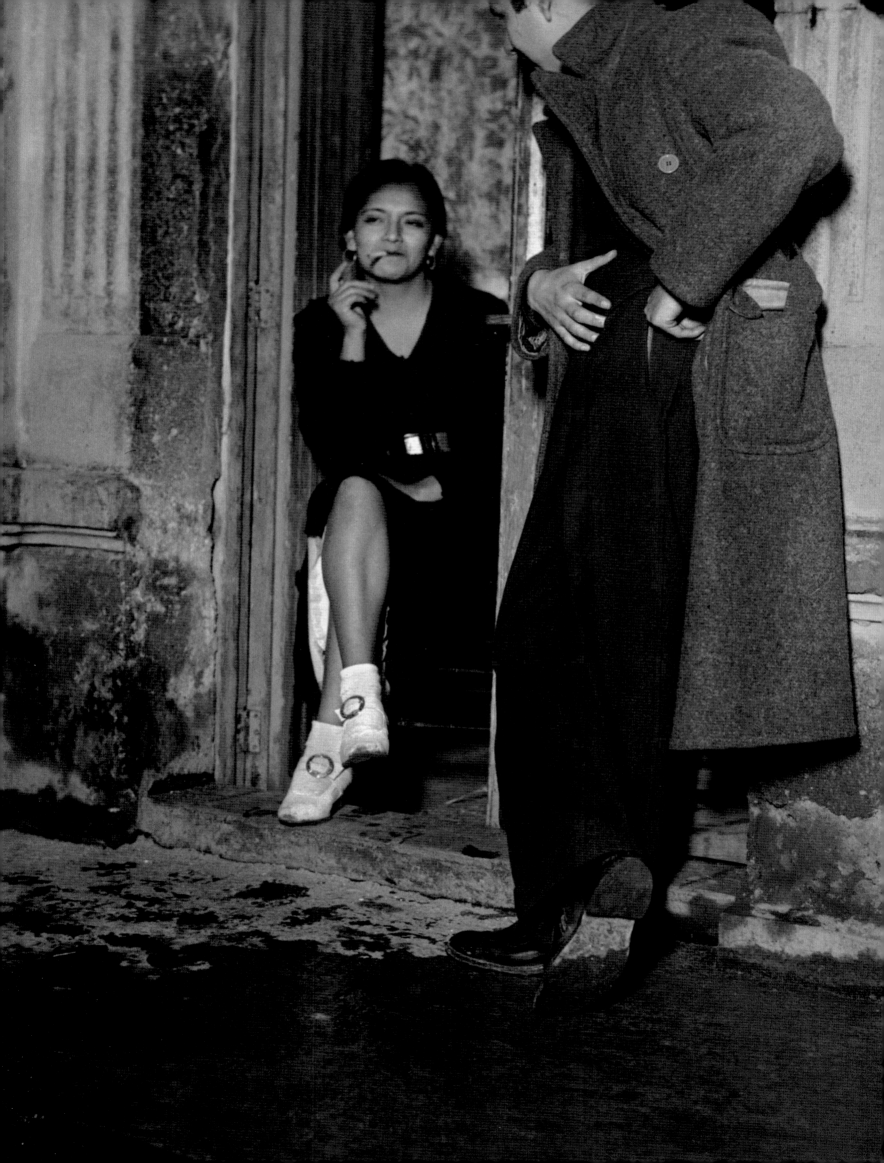

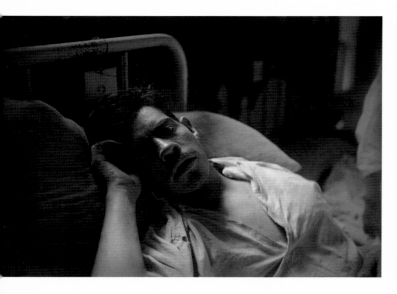

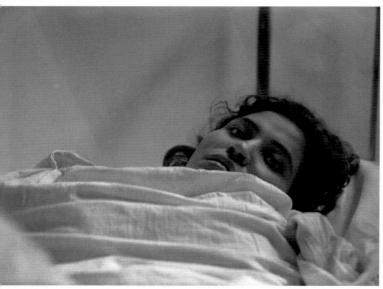

In 1910, medicine in Mexico was on par with most advanced countries; nevertheless, during the Revolution many hospitals were lost. Among the successes of public medicine were campaigns against endemic diseases such as yellow fever. Mexico City, *ca.* 1930. [74945/73733]

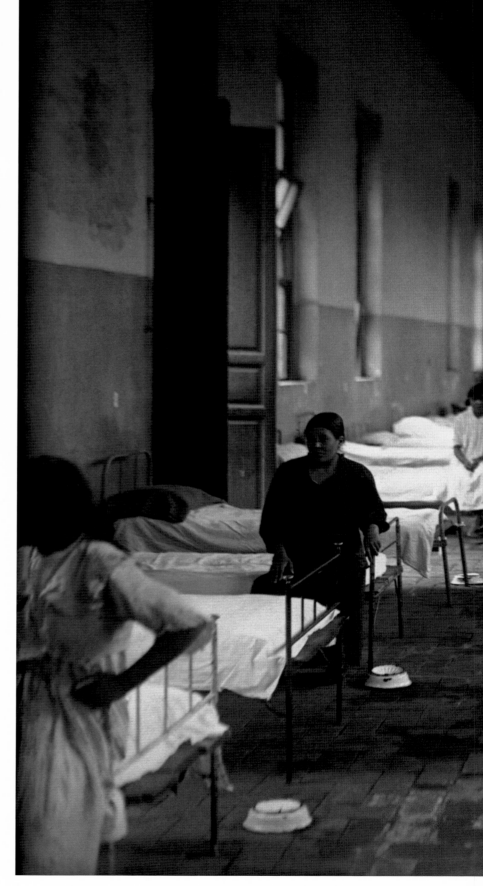

An inside view of the women's ward in a public hospital. During the pacification period after the Revolution, the Office of Public Welfare was renovated and reinforced. It was charged with the administration, construction, and functioning of new hospitals. Mexico City, *ca.* 1914. [186986]

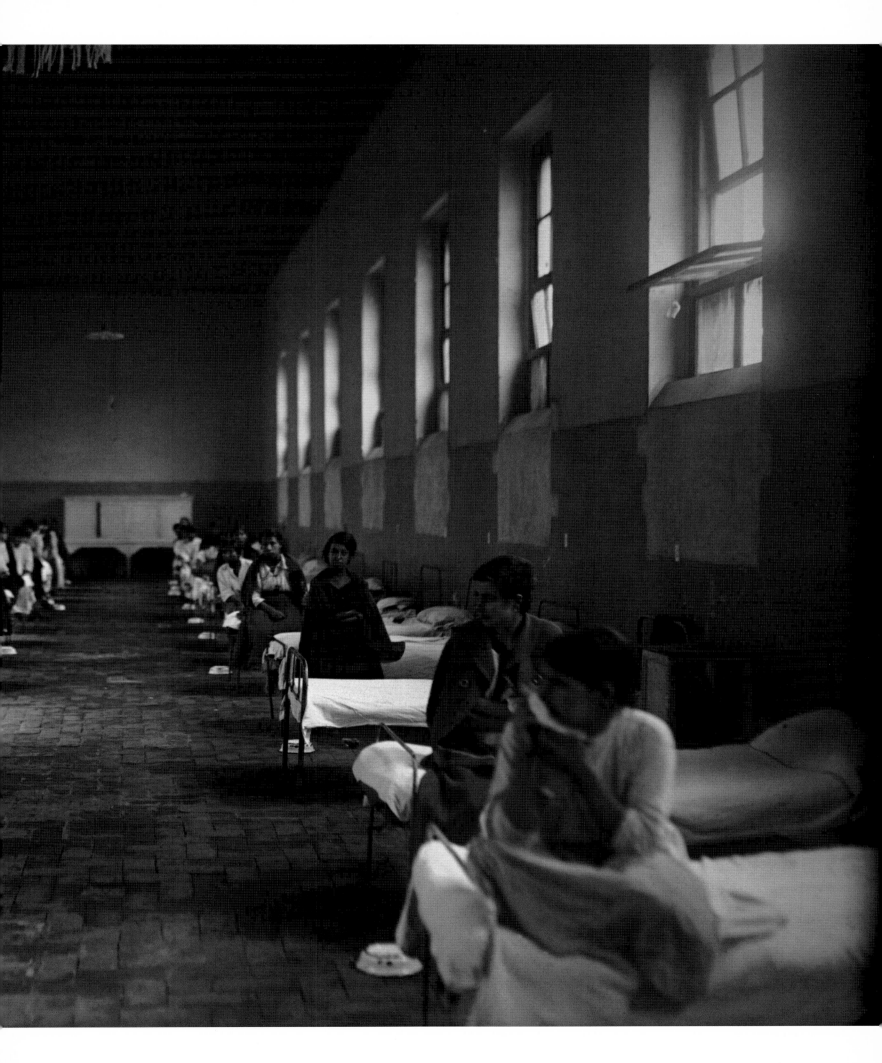

HALLS OF JUSTICE

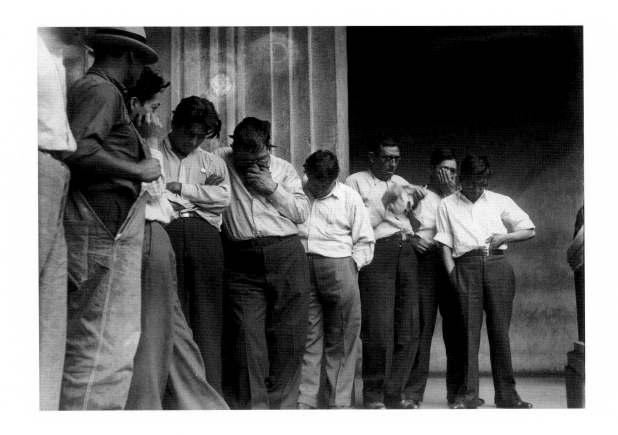

Since Porfirian days, one of the main injustices suffered by the people was inequality in the administration of justice. It was believed that the problem would be solved with the reform of criminal codes and the adoption of professional methods of criminal investigation. The photograph here is of an unknown woman. Mexico City, *ca.* 1935. [6045]

Pages 160-161
Modernized police investigators began to score heavily publicized victories, such as solving the mystery of a child's kidnapping. Mexico City, *ca.* 1915. [23702]

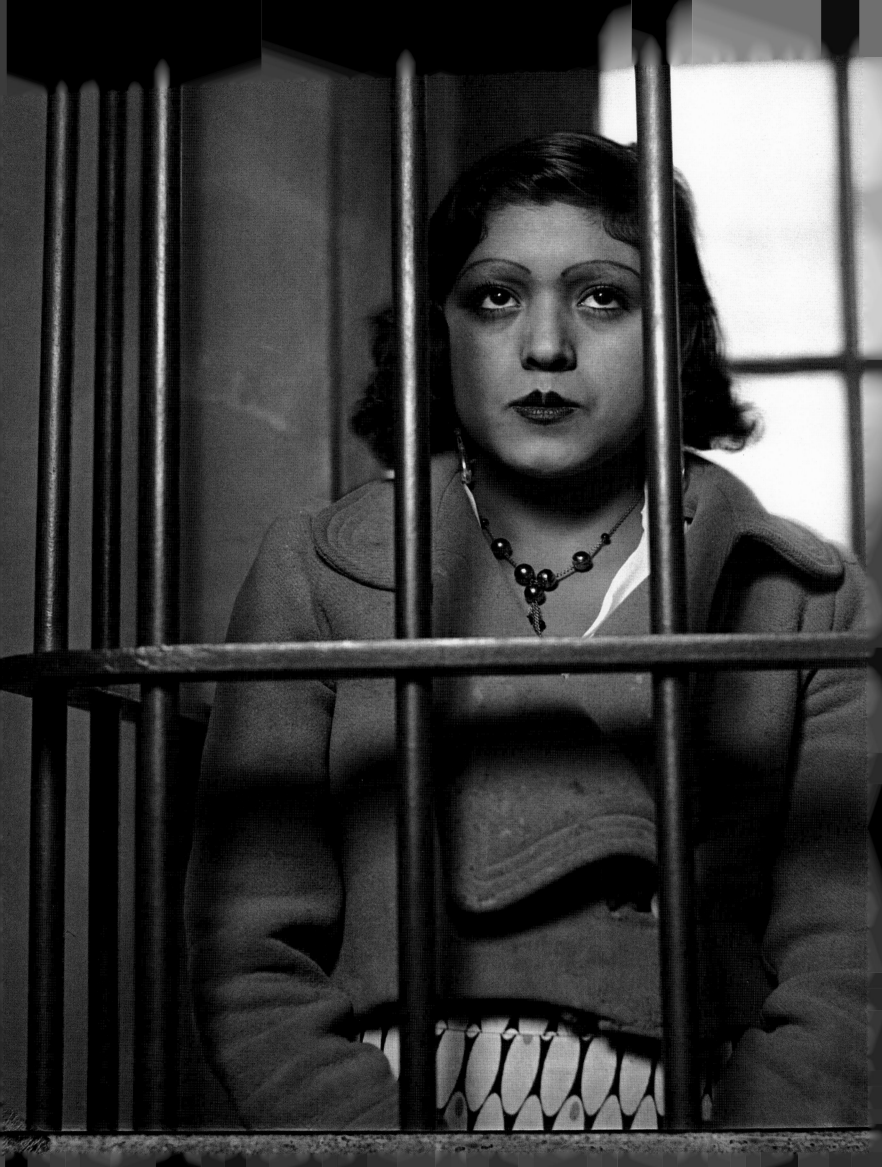

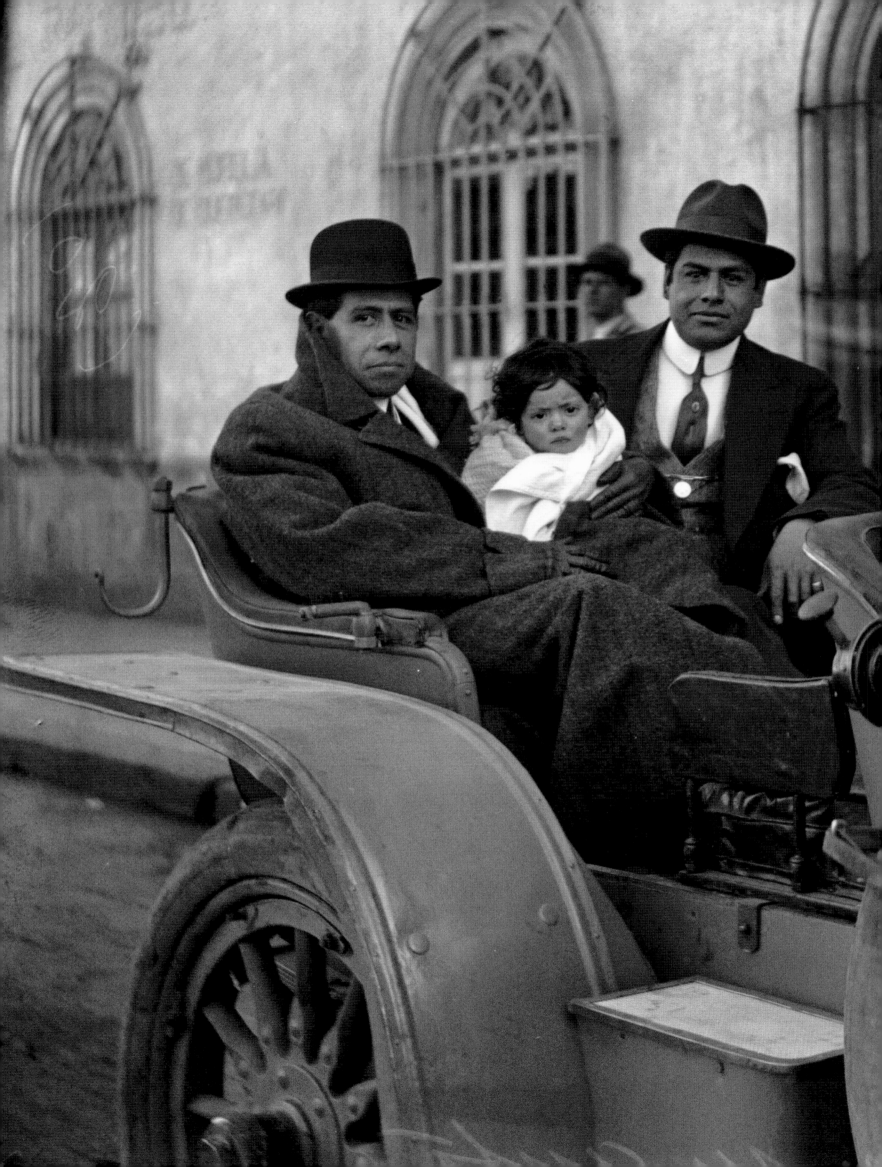

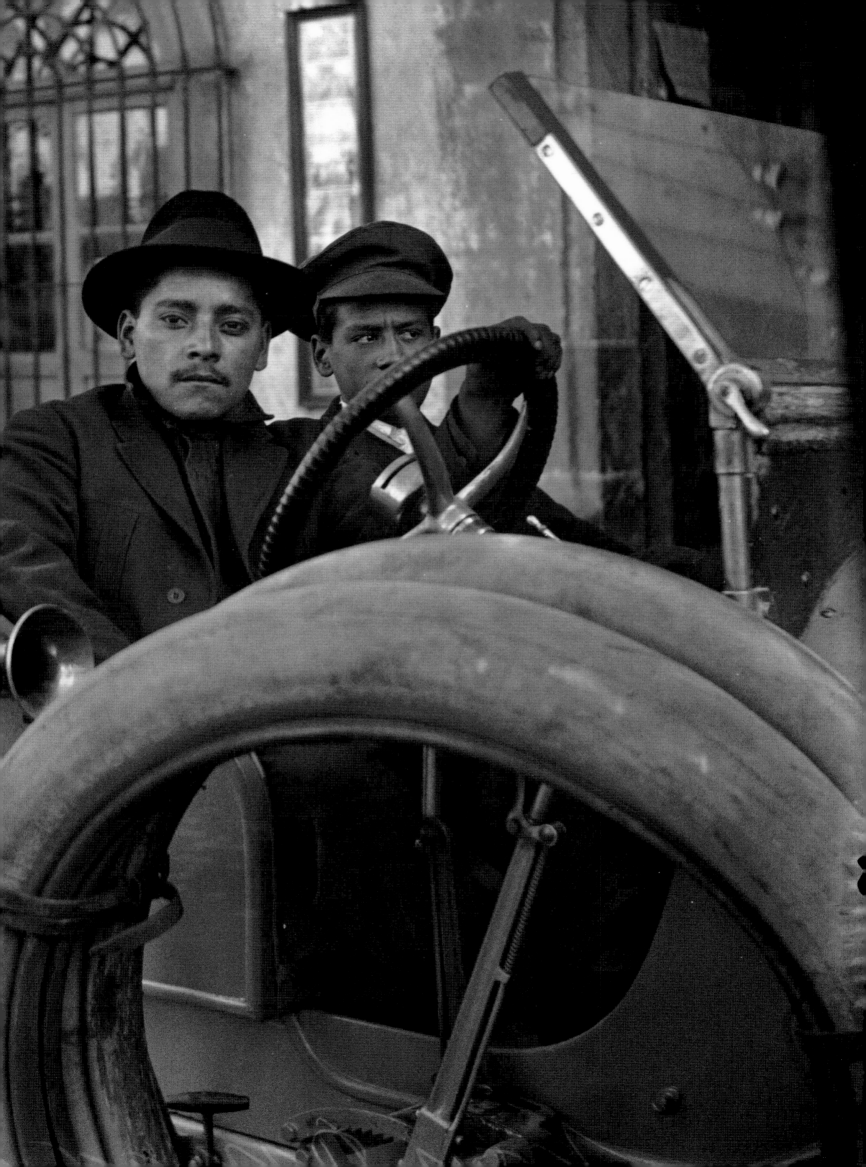

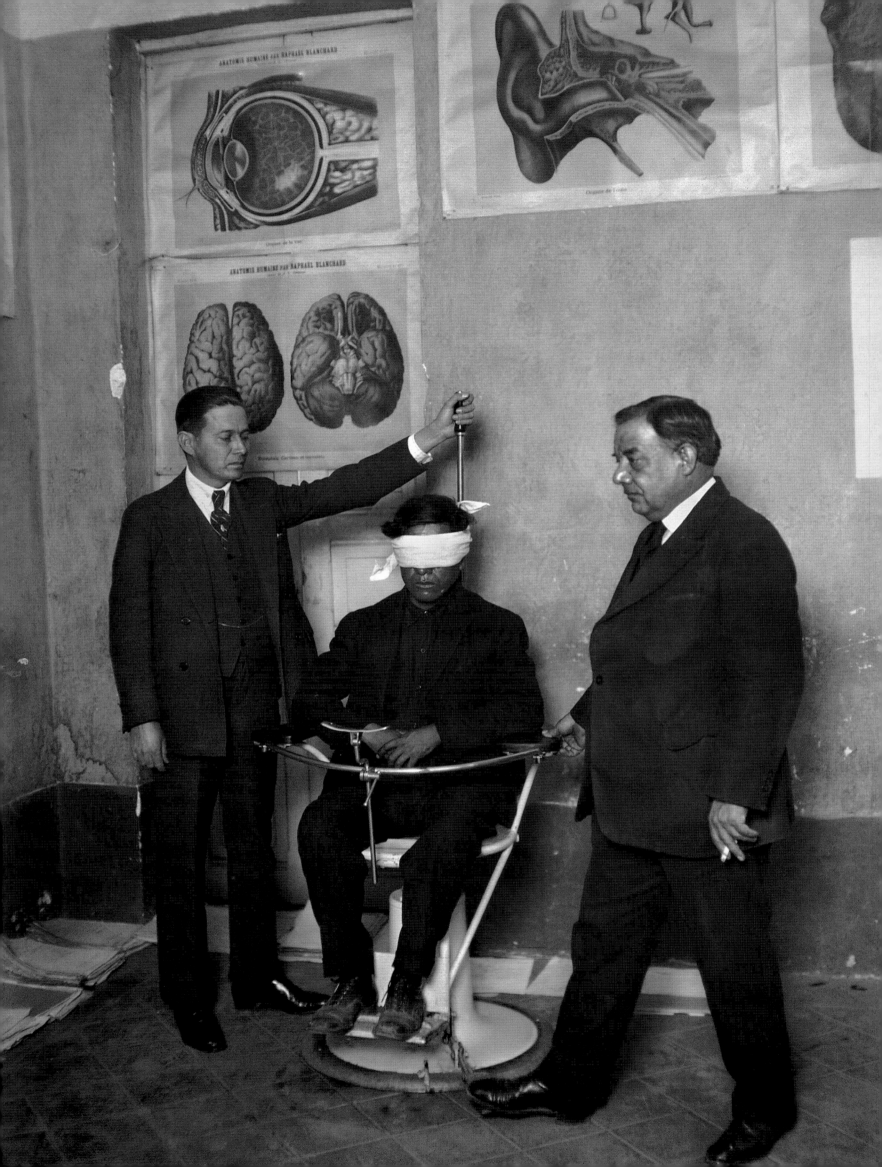

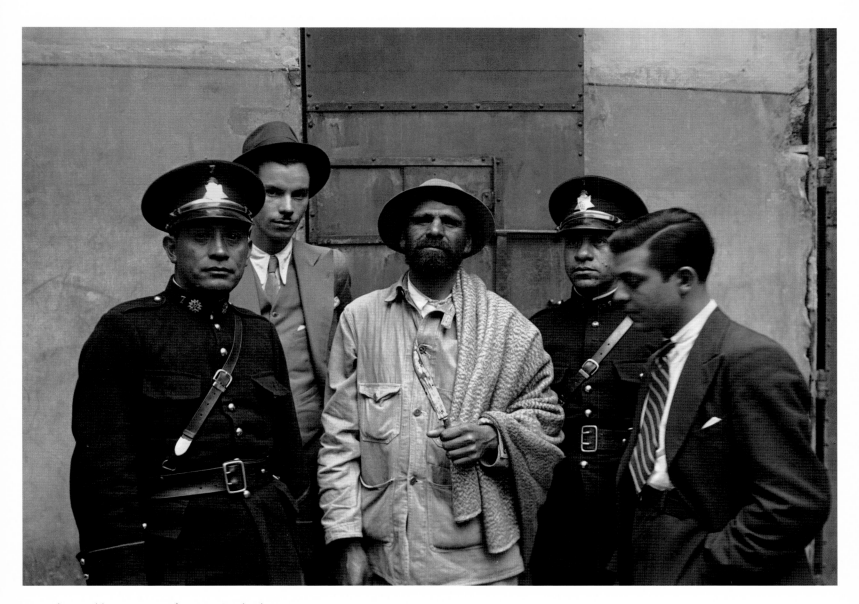

A murderer and his weapon are frozen in time by the camera. Many of the most notorious criminals were locked up in the cells of the Belén Prison, a building that had formerly functioned as a convent and hospital. Mexico City, *ca.* 1935. [69134]

Delinquents were studied according to common techniques in use at the time. In 1920, the Criminology and Identification Laboratory was inaugurated, as shown in the photograph. This lab initiated the fingerprint identification system under the administration of Benjamín A. Martínez. Mexico City, *ca.* 1935. [69118]

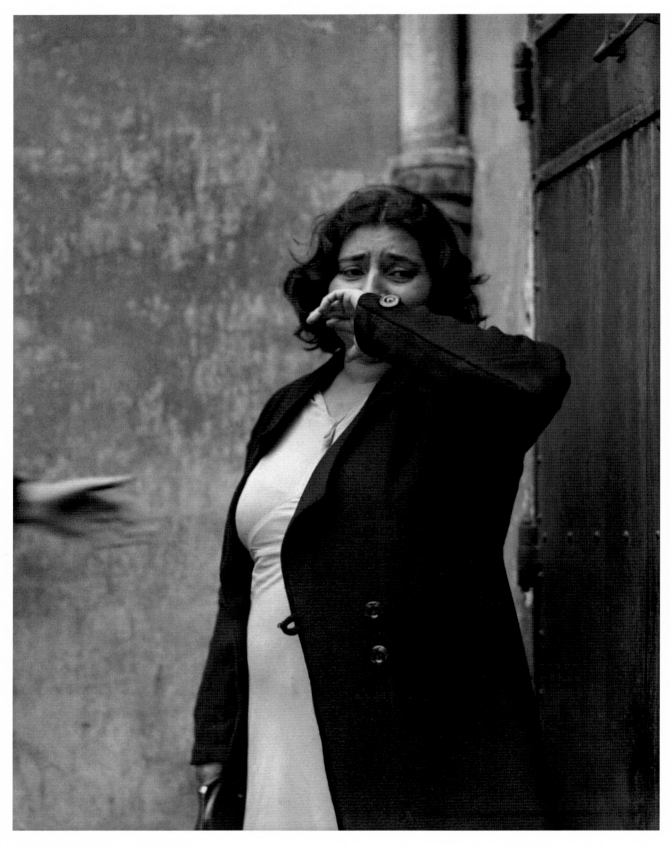

A woman accused of prostitution.
Mexico City, *ca.* 1935. [69056]

The murder of La Cinta Aznar by the notorious assailant
Gallegos was one of the most highly publicized crimes.
Investigators dug up evidence in the victim's house that
enabled them to solve the crime. Mexico City,
ca. 1920. [69109]

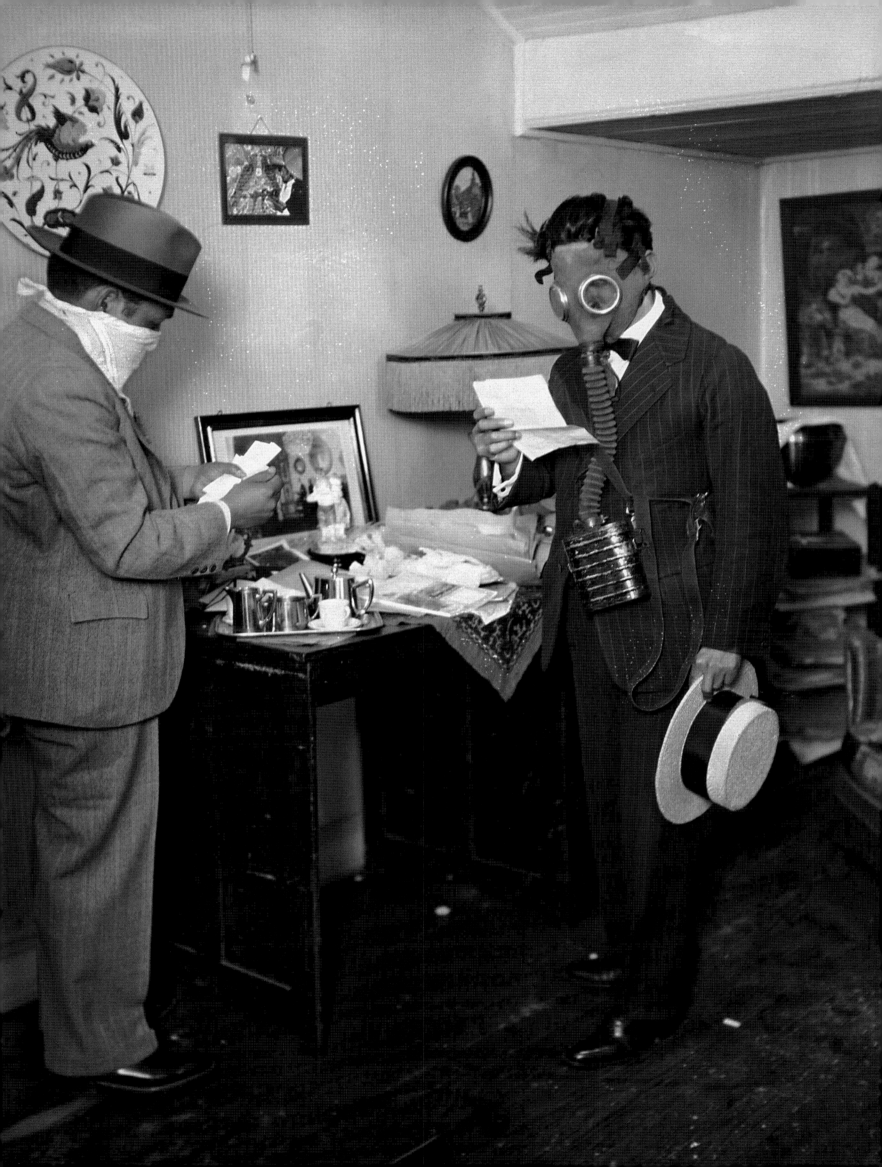

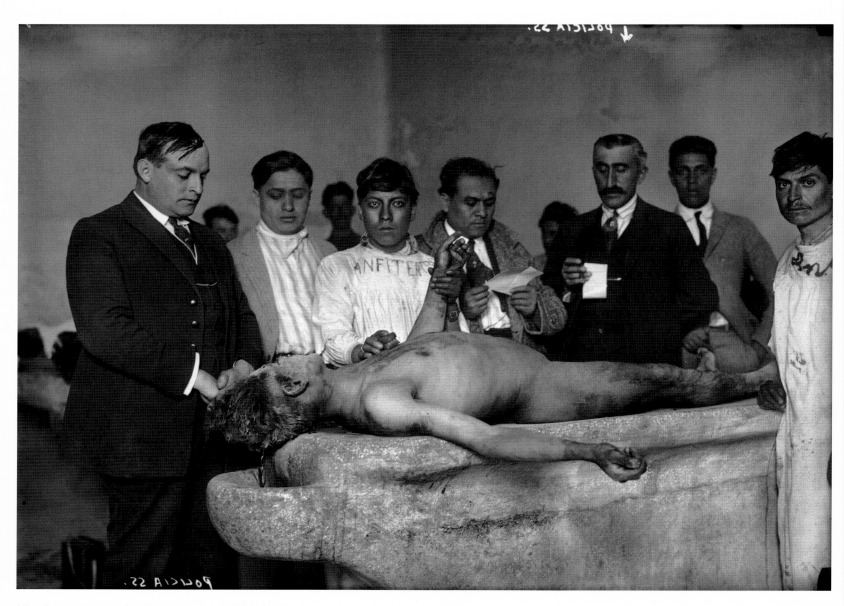

The photographer recorded the moment in which forensic doctors
informed the authorities and the press of the results of analyses
performed on the cadaver. Mexico City, *ca.* 1935. [186897]

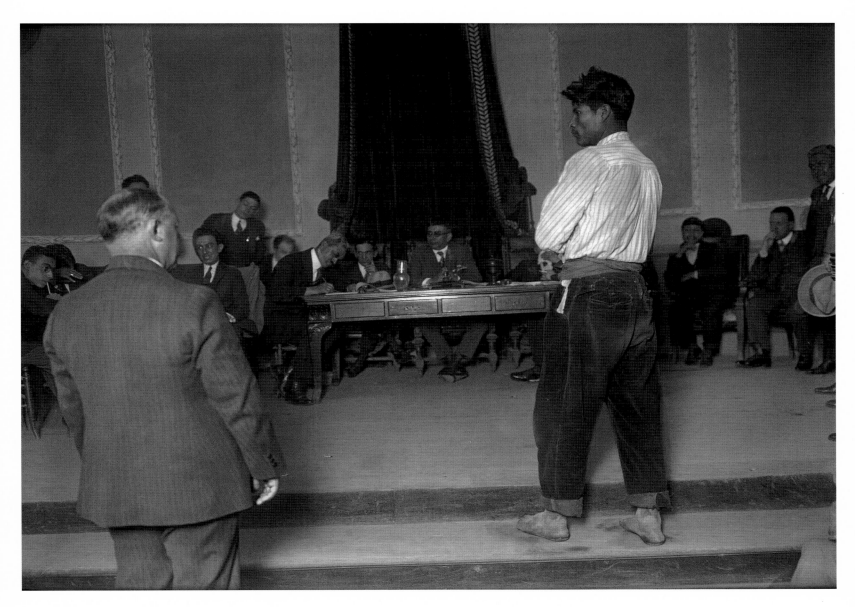

Among the most famous criminal lawyers of those years were
José María Lozano, Querido Moheno, Agustín Barrios Gómez,
Castro López, Telésforo Ocampo, Ramón Pedrueza, Víctor
Velázquez, and Luis Chico Goerne. In the photograph, the
prosecuting attorney presents the man accused of the crime.
Mexico City, *ca.* 1930. [69013]

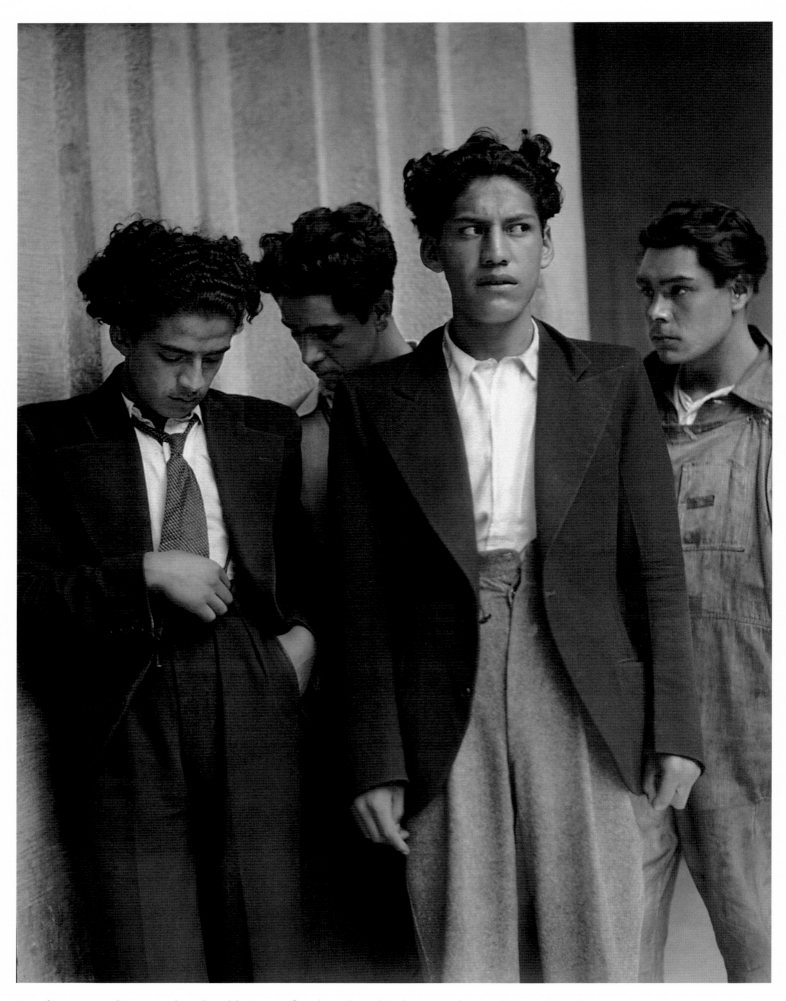

According to criminal science in those days, delinquents reflected an inherited tendency towards savage behavior although, in truth, many of them were simply young people who had gone astray. Mexico City, *ca.* 1935. [141633]

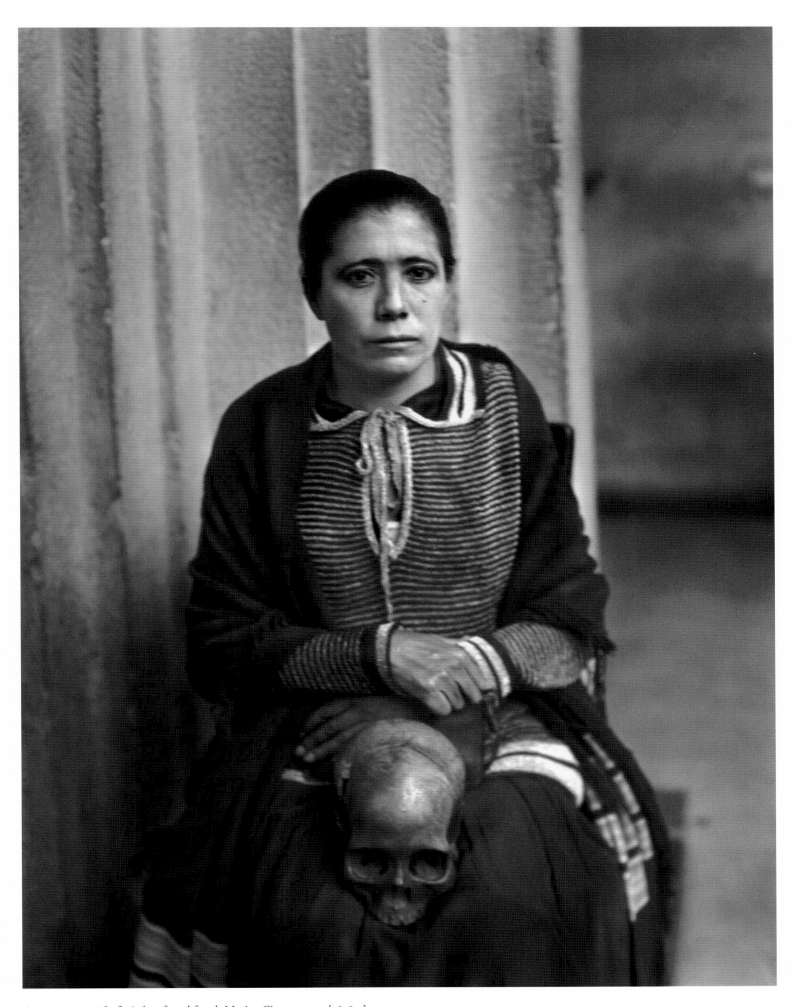

A woman accused of witchcraft and fraud. Mexico City, *ca.* 1935. [162639]

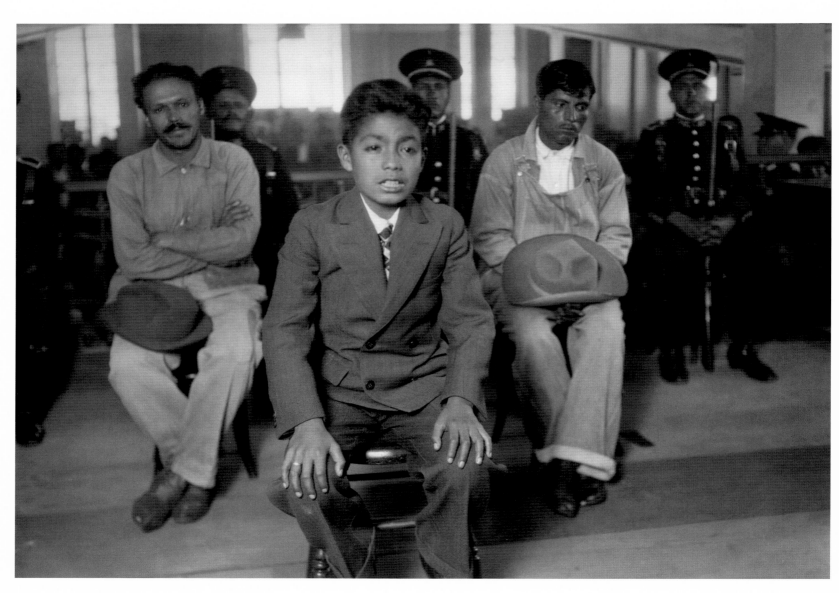

This photograph captures the moment in which a child
participates as a witness in a trial. Mexico City, *ca.* 1930. [6372]

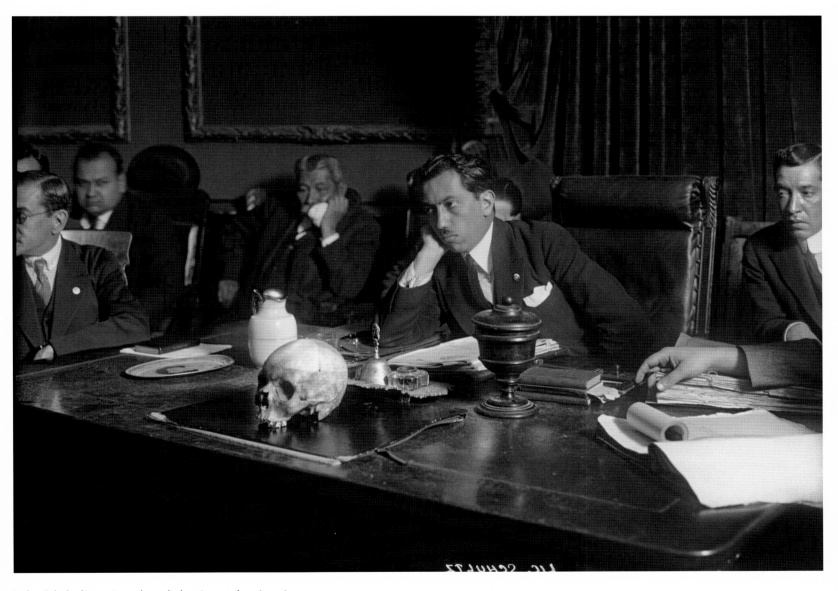

Judge Schultz listens intently to declarations and testimonies.
Mexico City, *ca.* 1935. [69006]

Pages 172-173
The Revolution brought about the formation of popular juries
convoked to pronounce sentences in famous cases.
These judicial structures were in step with the mood of the
times. A number of verdicts that caused a public stir were
issued in the courtroom at the Belén Prison.
Mexico City, *ca.* 1926. [292538]

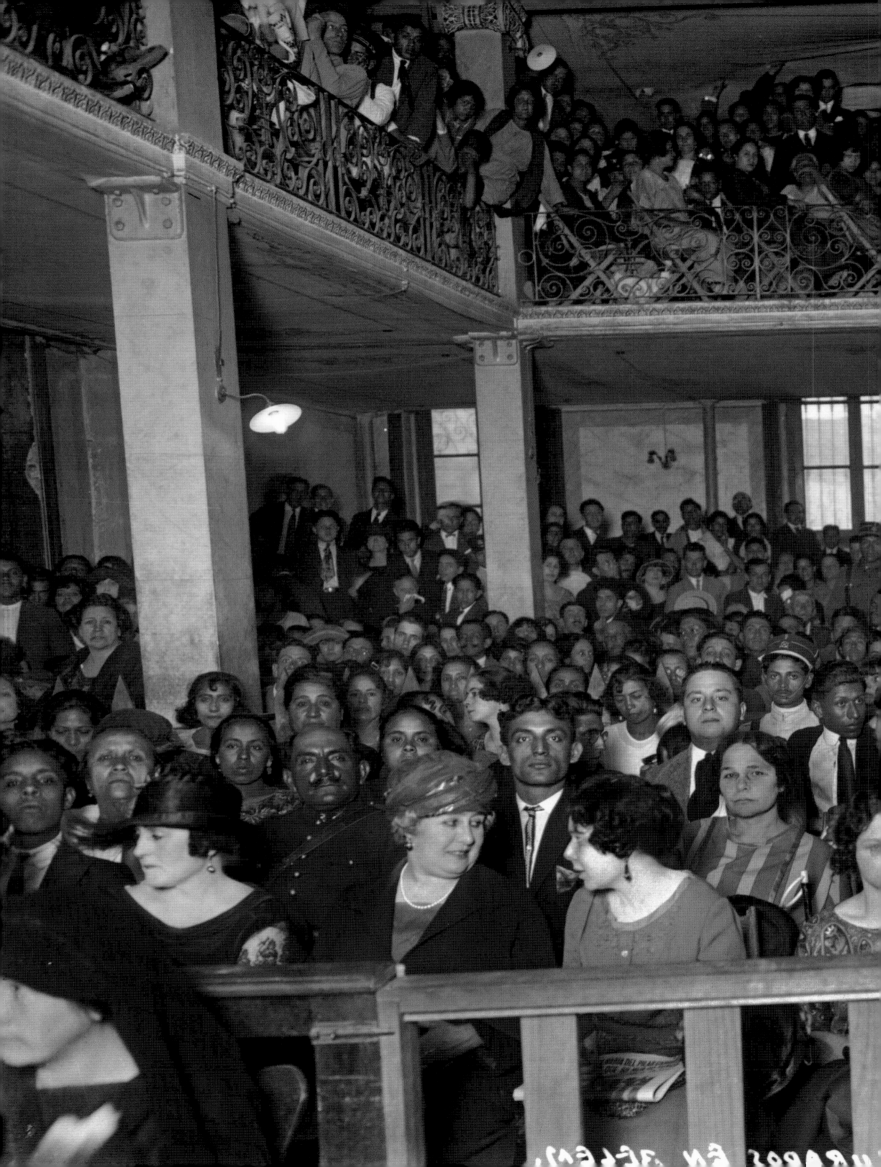

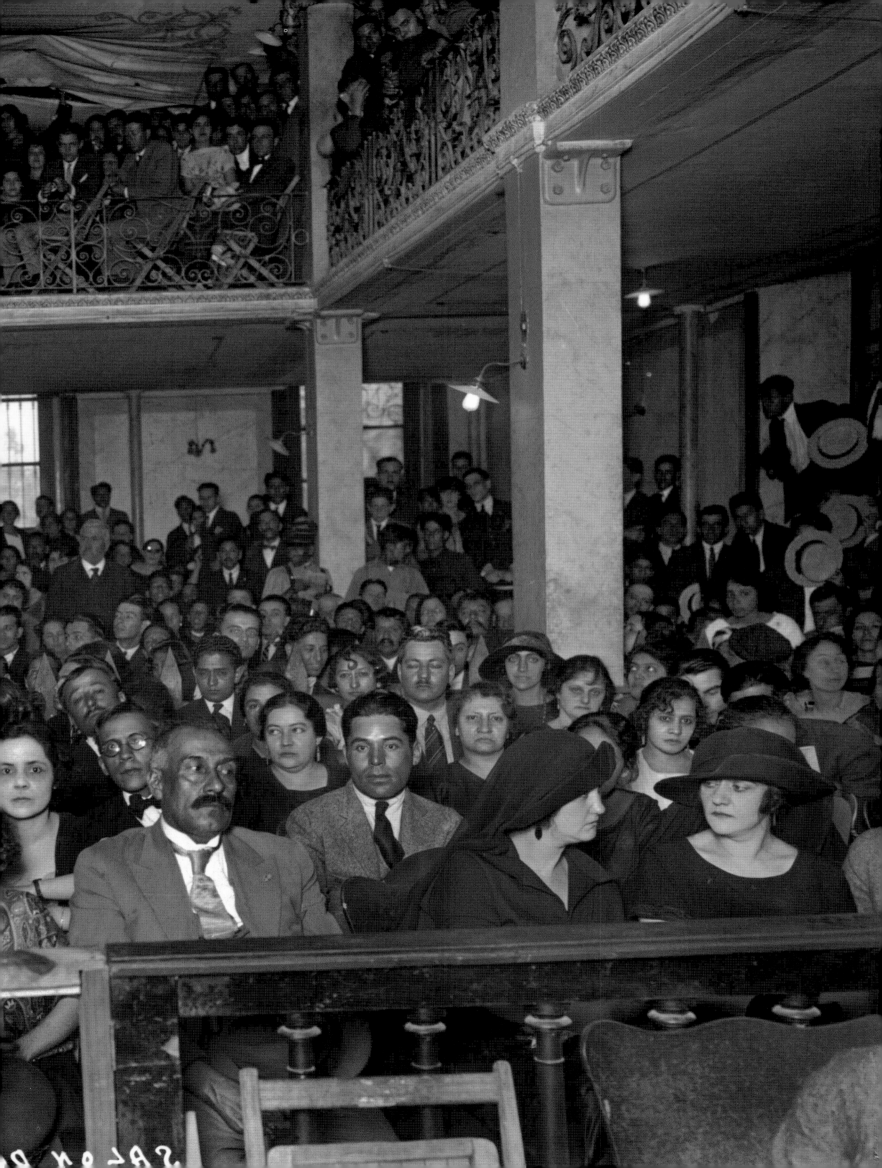

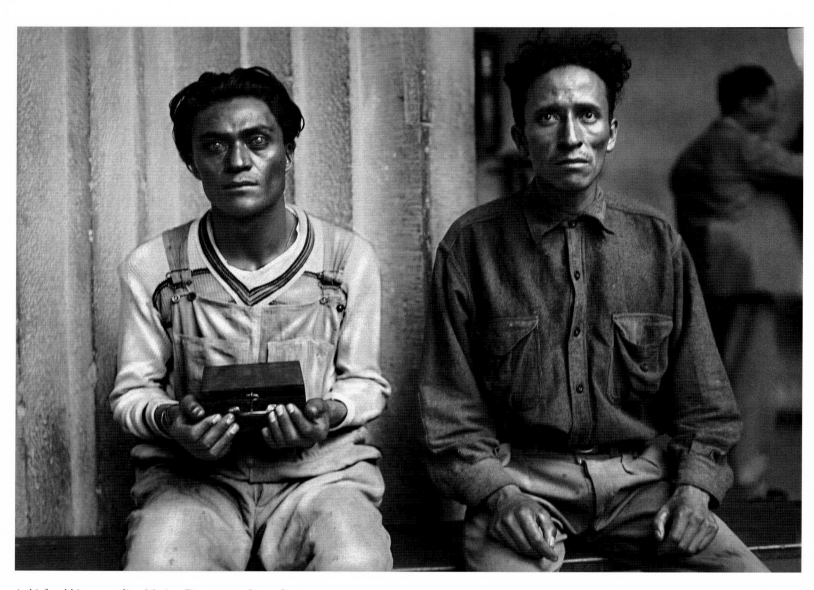

A thief and his accomplice. Mexico City, *ca.* 1935. [145295]

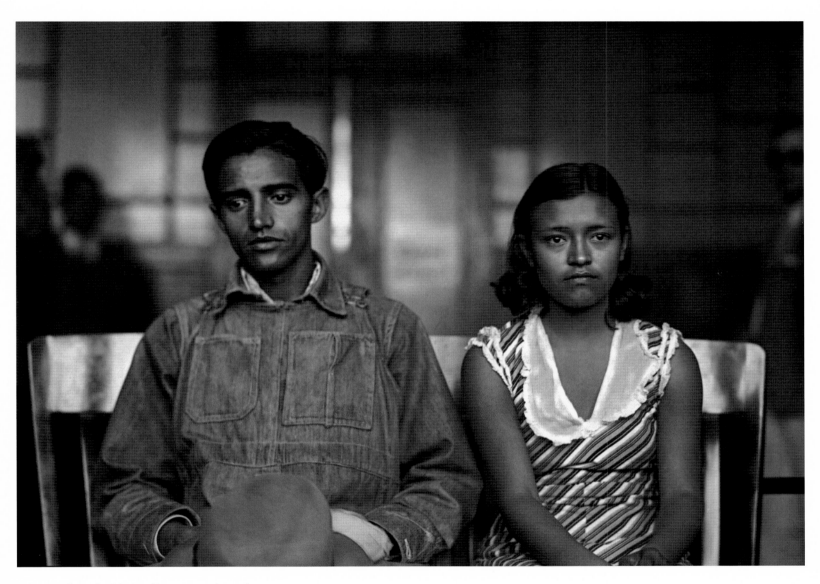

An accused couple. Mexico City, *ca.* 1935. [145381]

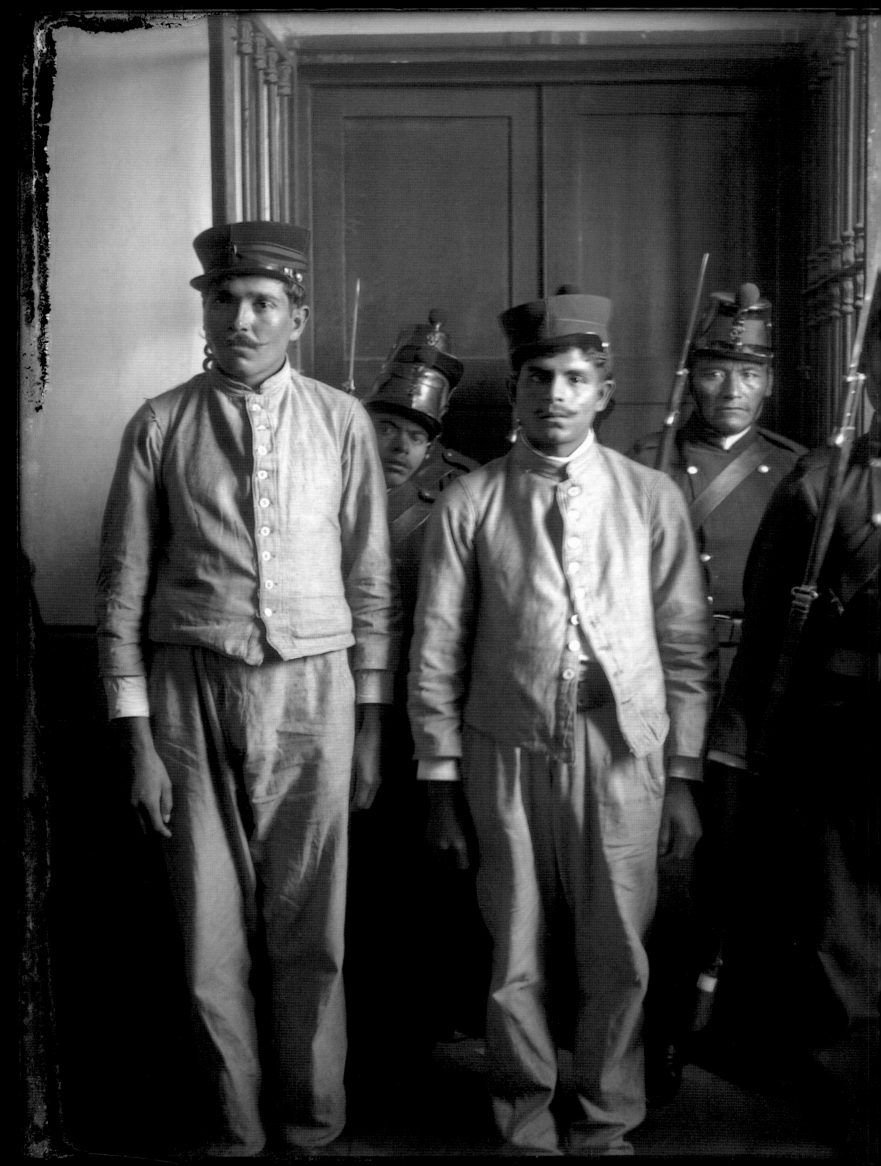

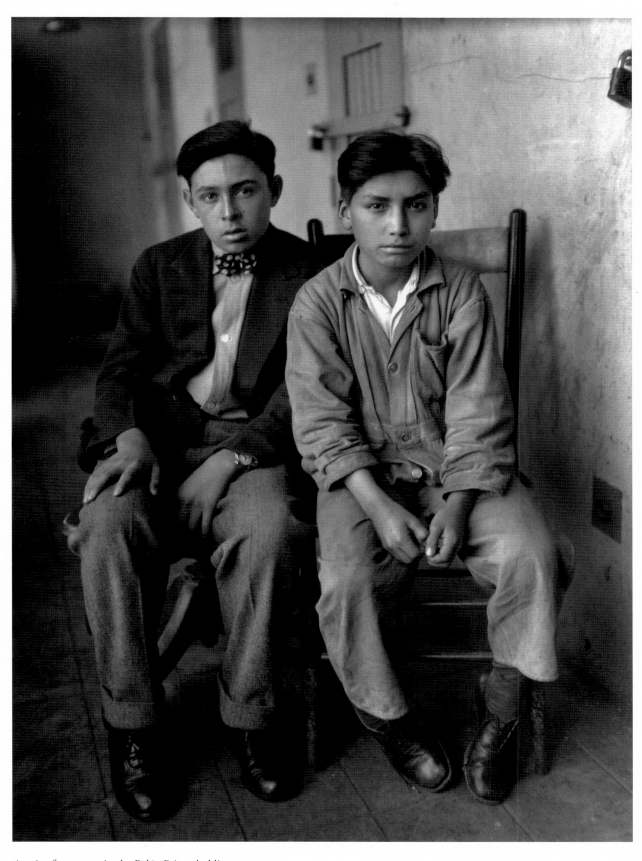

A pair of teenagers in the Belén Prison holding area.
Mexico City, *ca.* 1935. [14704]

Police offenders in the hands of justice.
Mexico City, *ca.* 1928. [64575]

Pages 178-179. Women prisoners in the penitentiary. *Ca.* 1920. [5598]

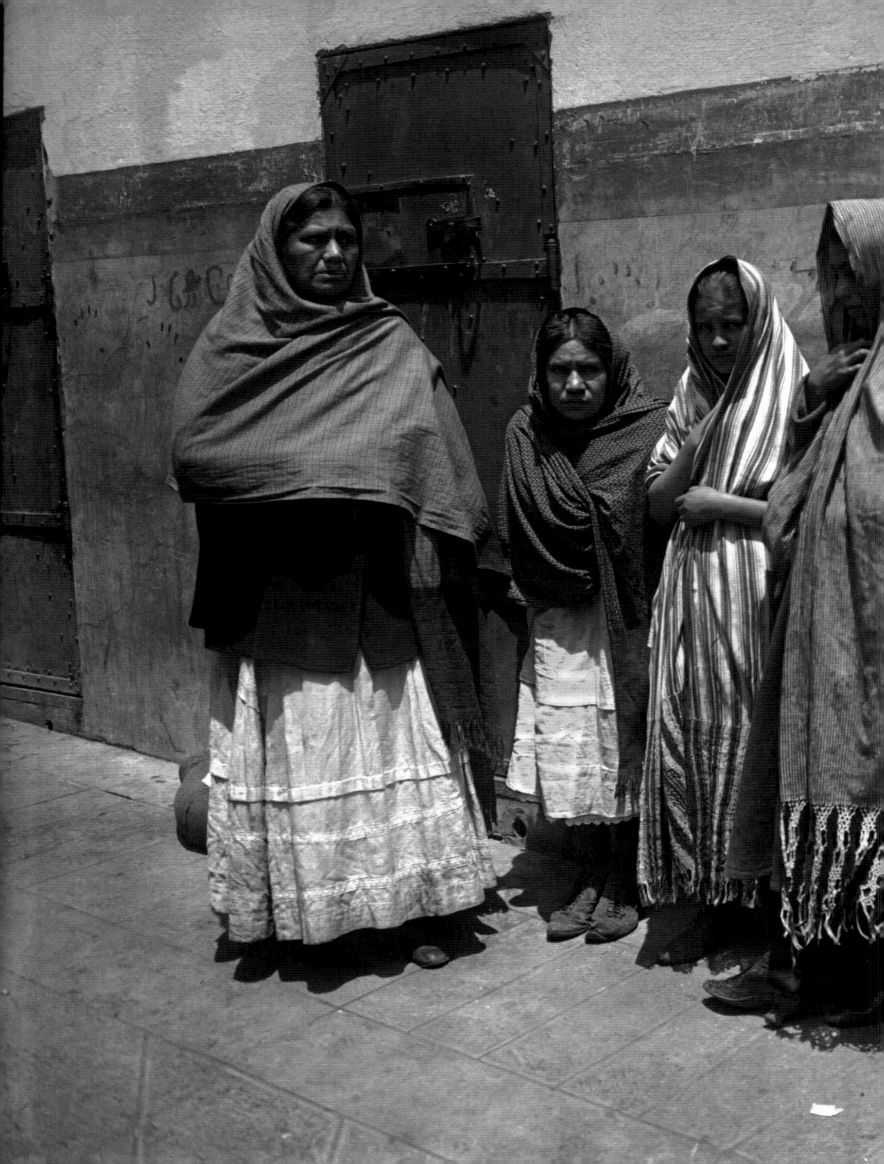

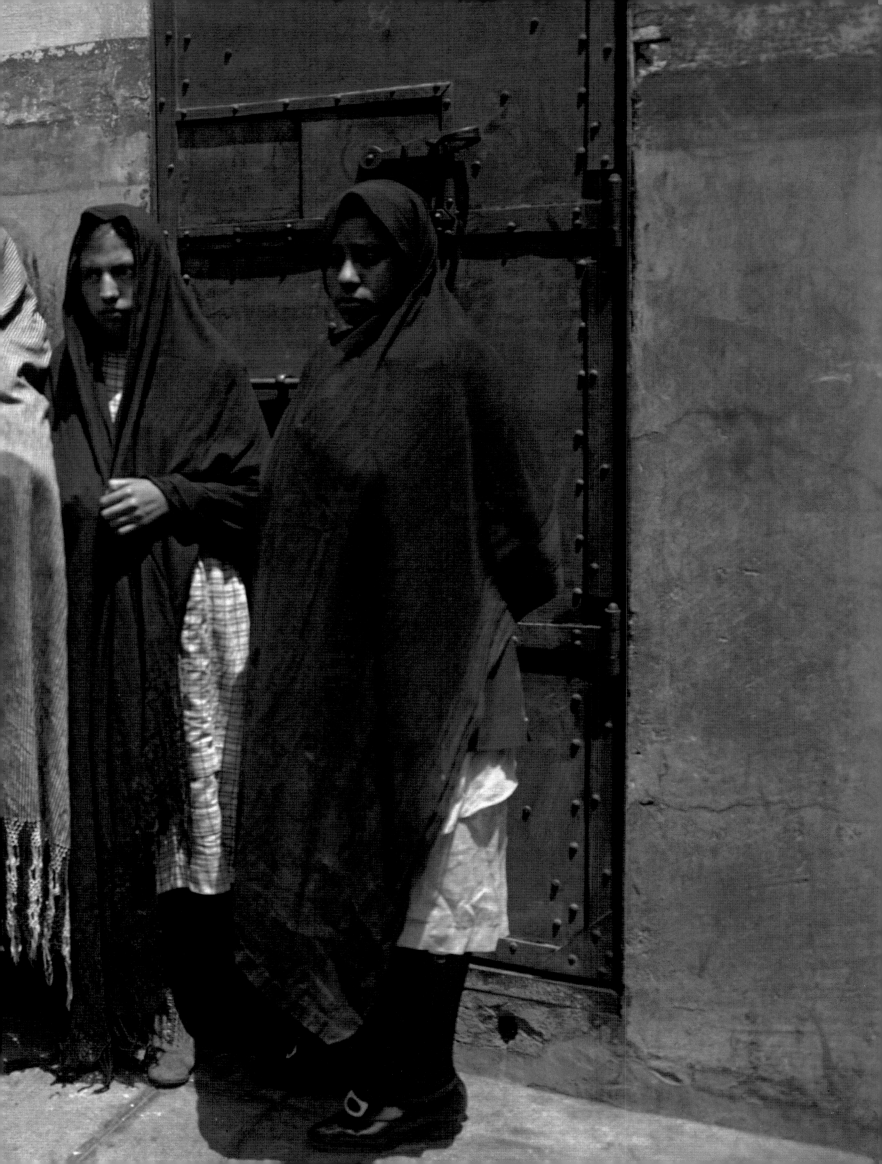

FAMOUS PEOPLE

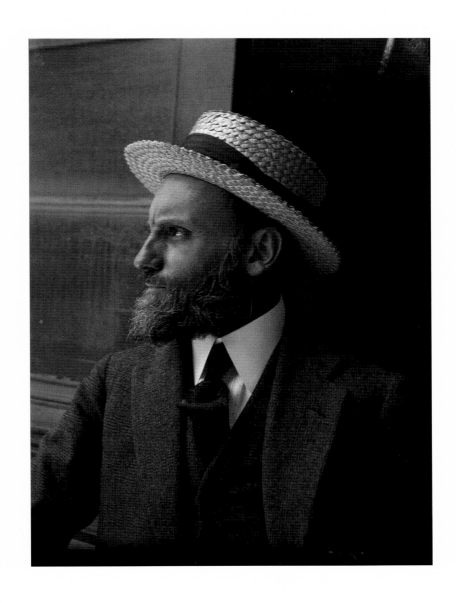

Page 181
Gerardo Murillo, better known as "Dr. Atl," volcano
specialist and renowned Mexican landscape painter.
Ca. 1918. [22537]

The revolutionary leader Emiliano Zapata was born August 8, 1879,
in Anenecuilco, a town in the southern state of Morelos. His goals
were best encapsulated in the slogan, "Land and Liberty."
Mexico City, *ca.* 1915. [6341]

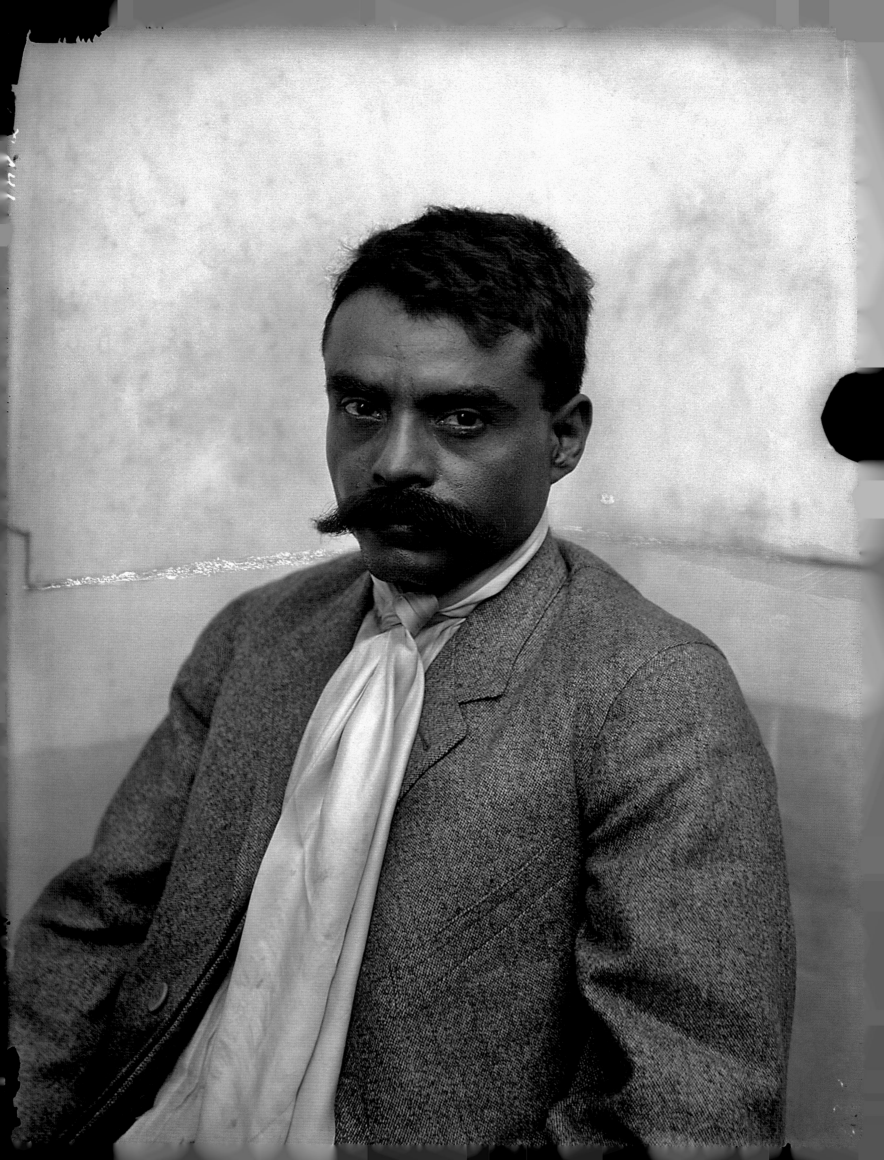

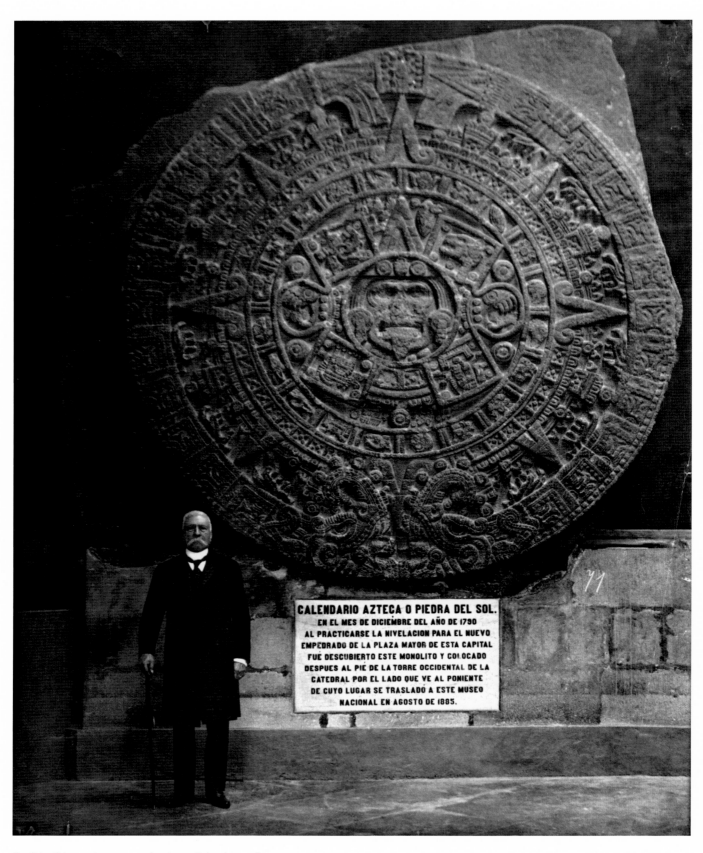

Porfirio Díaz posing next to the Aztec Calendar, at the
National Museum of History which was an important project
of the Porfirian period. Mexico City, *ca.* 1910. [243480]

A woman drinking *pulque*. *Ca.* 1910. [162995]

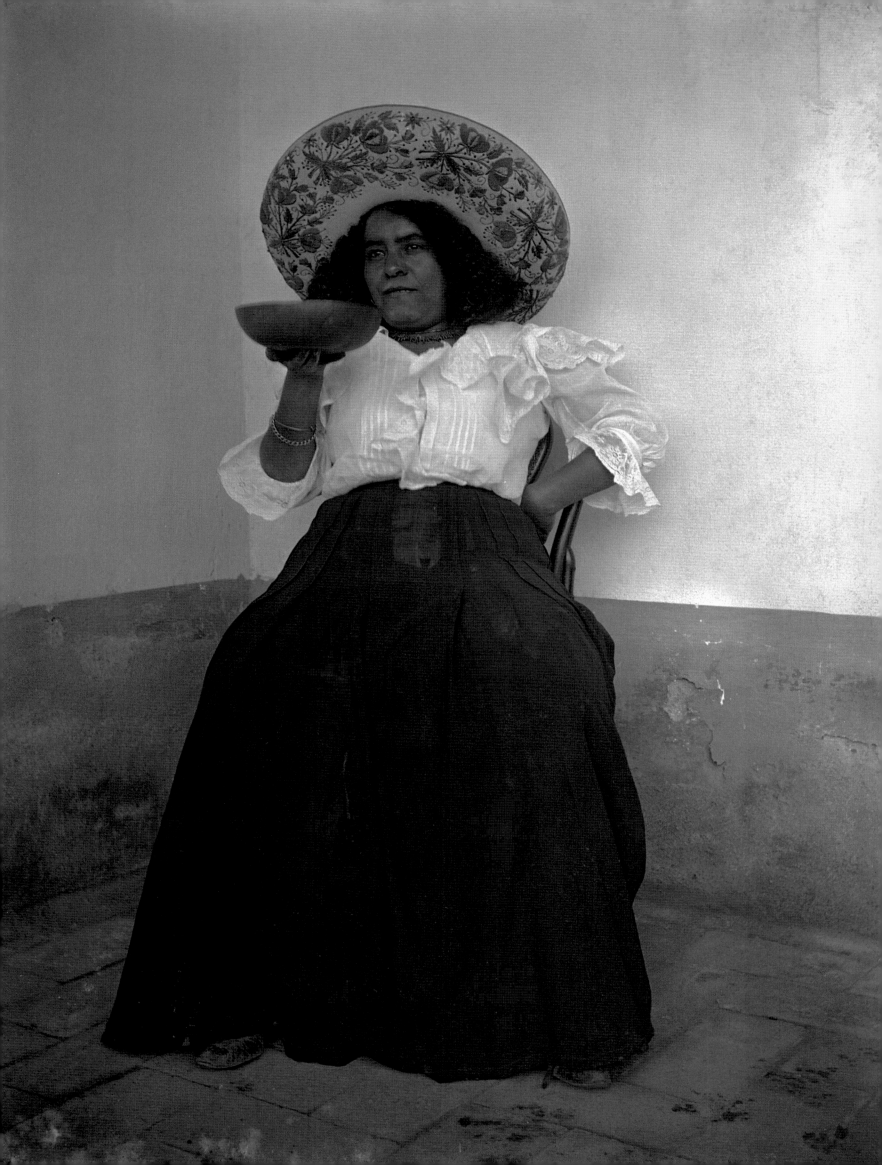

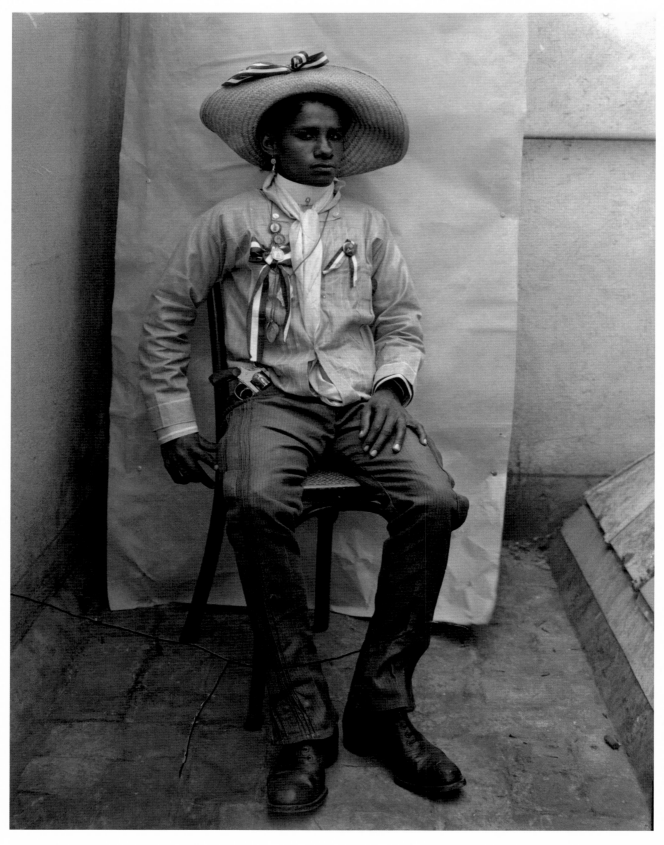

More than just an image in a popular song, the *soldadera* was a warrior and a woman who acted in solidarity with the revolutionary troops. *Ca.* 1915. [186387]

Venustiano Carranza was the Commander in Chief of the Constitutionalist Forces and a prime mover of the Constitution of 1917. Elected president in 1917, he stayed in office three years. In May 1920 he was killed by a group of military insurrectionists. Querétaro, *ca.* 1914. [287596]

Pages 188-189. In southeastern Mexico, the Chamula indigenous people joined the revolutionary struggle in 1910. In these two photographs, Doctor Policarpo Pruneda appears with two dwarfs and a giant who formed part of the Chamula contingent. Chiapas, *ca.* 1912. [34264/34260]

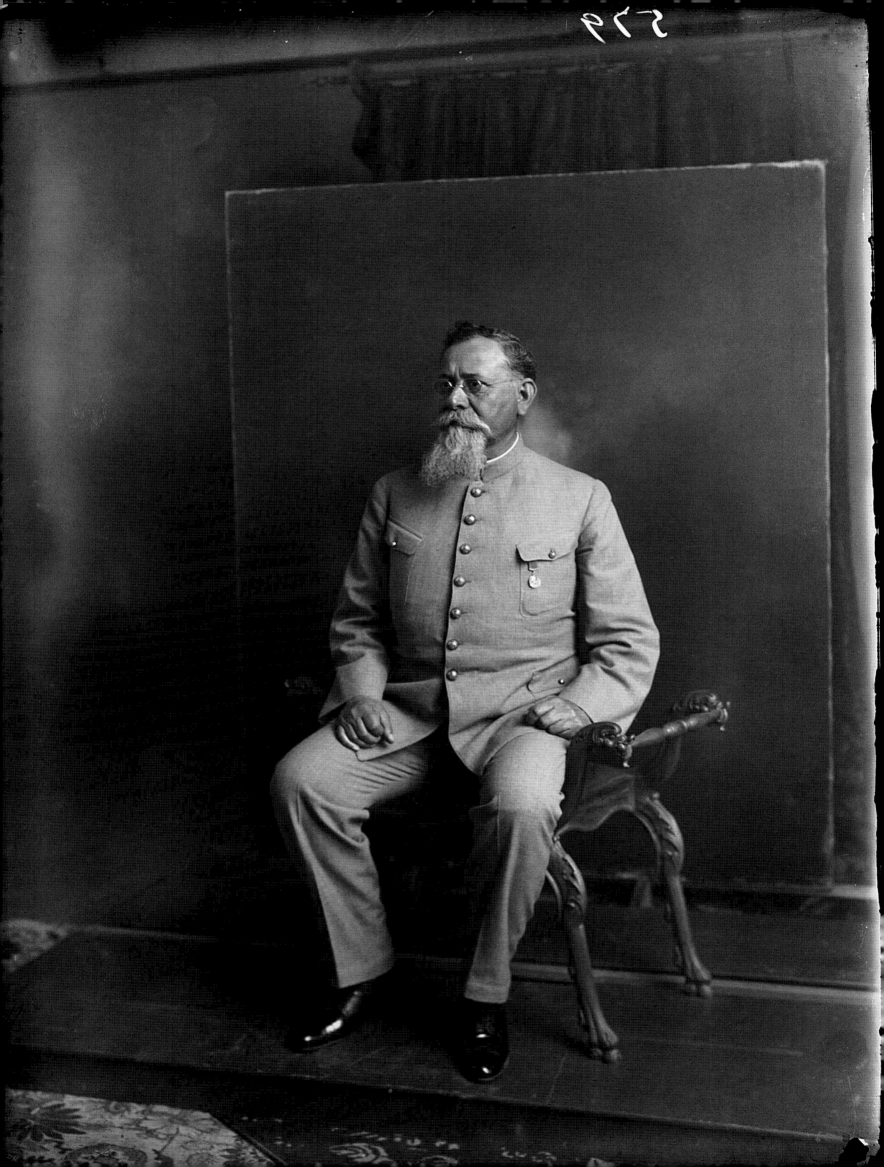

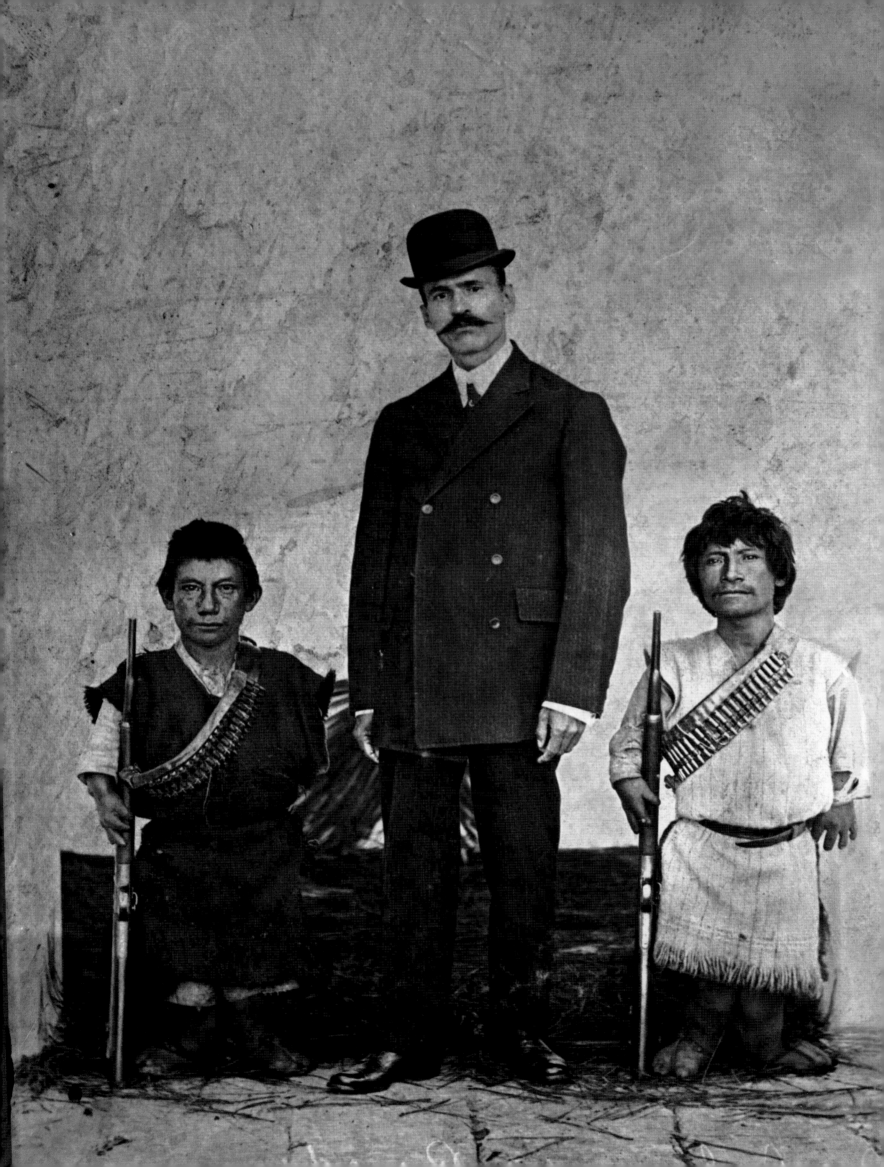

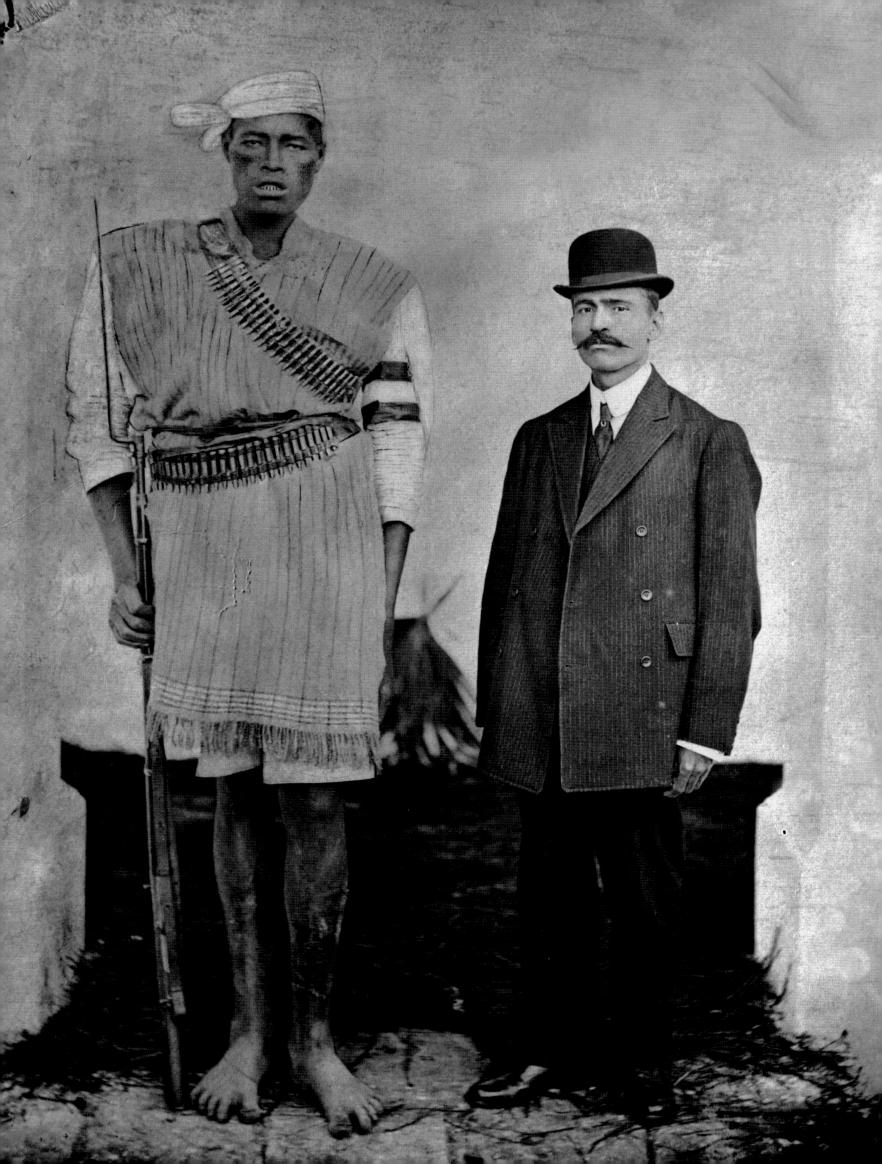

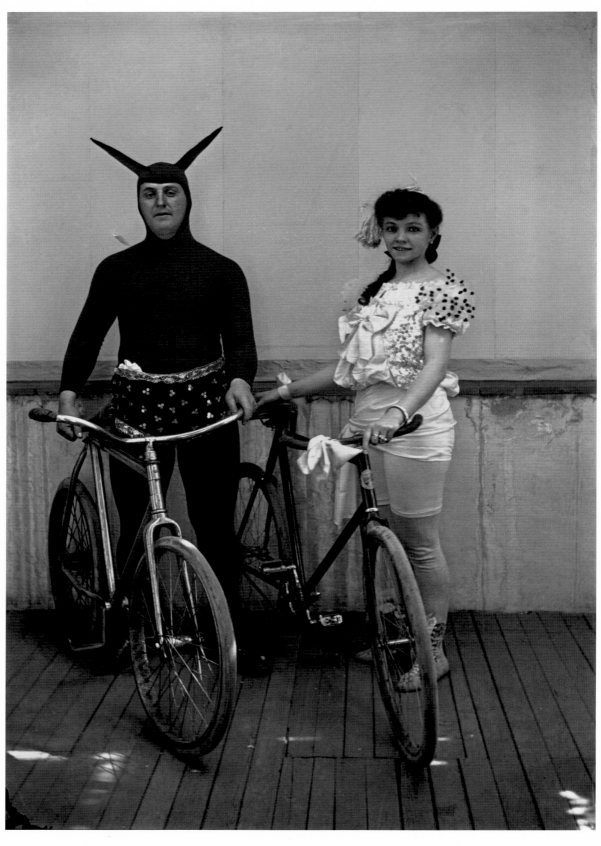

Diverse circus companies, both national and
international, were sensational attractions in
post-revolutionary Mexico. Mexico City,
ca. 1918. [202668]

Jesús Urueta, eminent diplomat, lawyer, and
writer, was born in the state of Chihuahua in 1867
and died in Buenos Aires, Argentina, in 1920.
Mexico City, *ca.* 1914. [31037]

Merced Gómez, a brave and unflinching bullfighter.
Mexico City, *ca.* 1922. [17070]

Agustín Lara, pianist and composer, was born in Mexico City in 1897 and
died there in 1970. He was the author of many songs known around the
world. Lara appears here with Ana María Fernández, one of the singers in
his first orchestra, Son Marabú. Mexico City, *ca.* 1930. [19348]

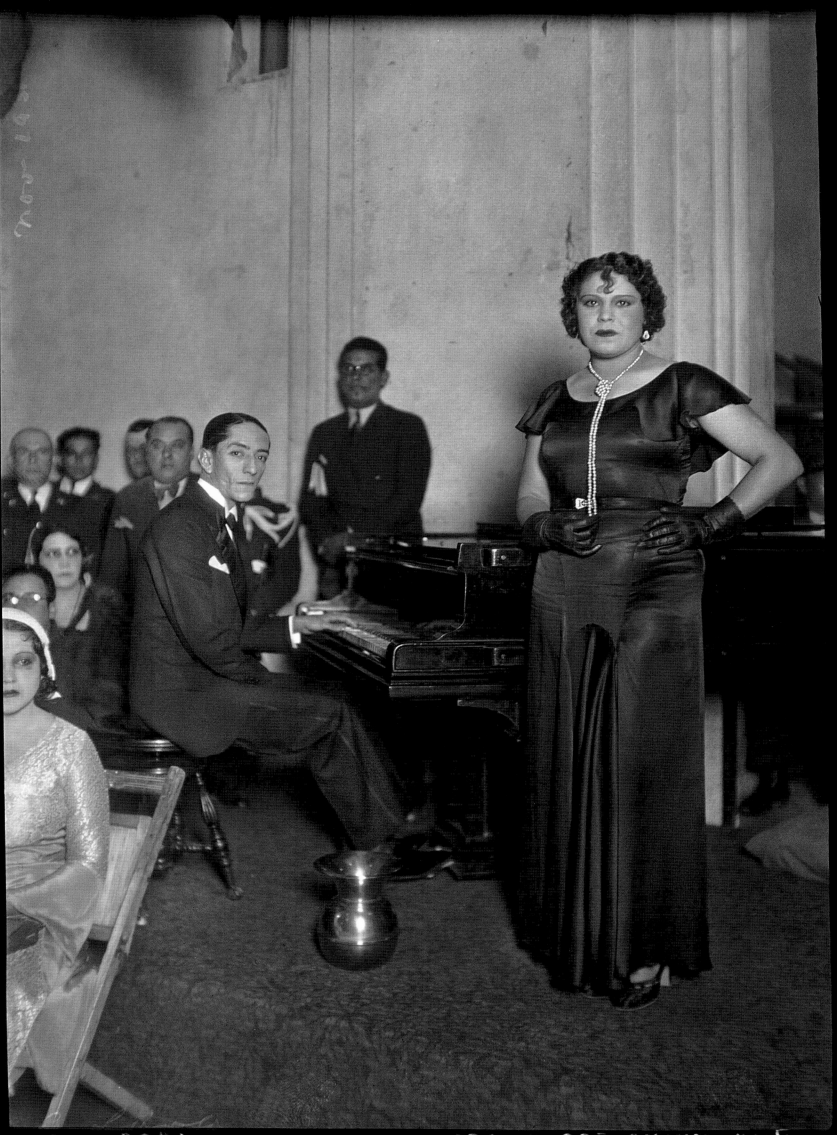

Graciela de Lara, one of many women in show business.
Mexico City, *ca.* 1928. [19377]

Nicaraguan revolutionary César Augusto Sandino
took temporary refuge in Mexico in 1929, the year
of this photograph. [31030]

194 |

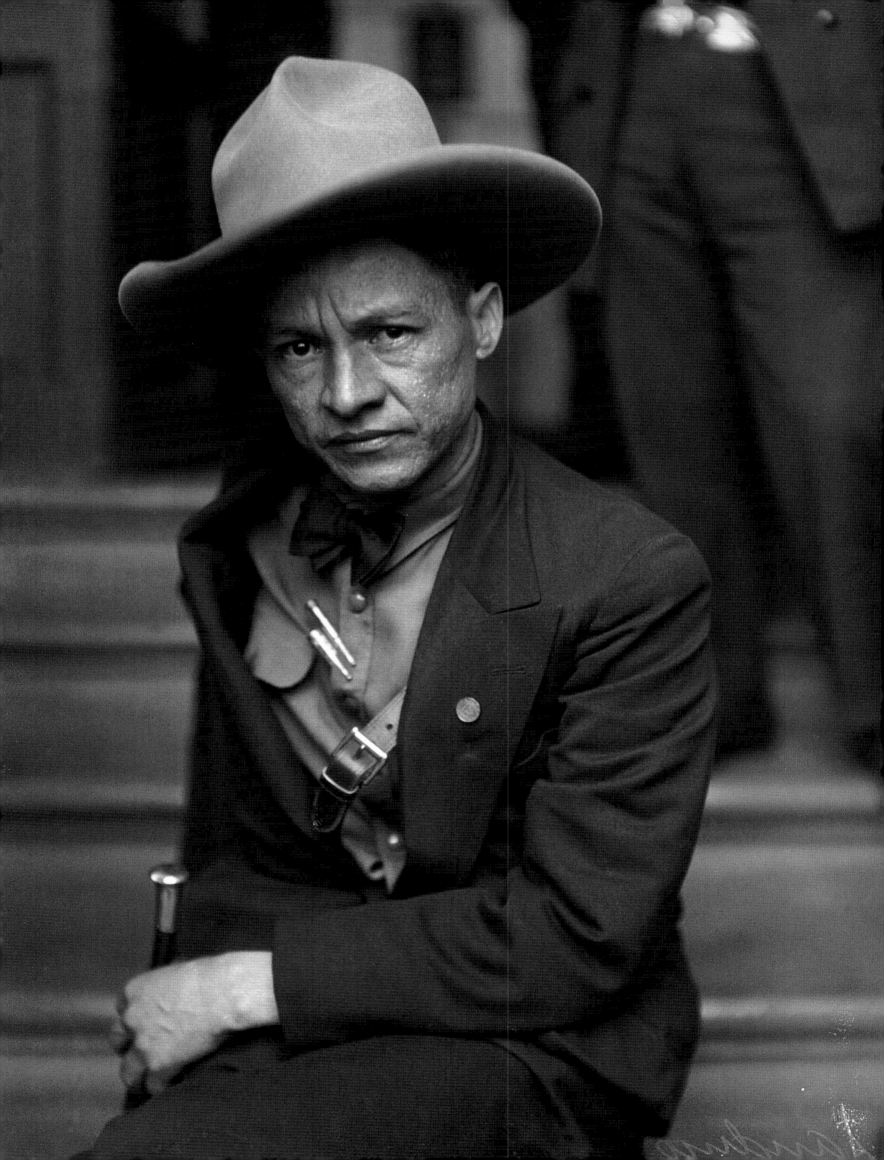

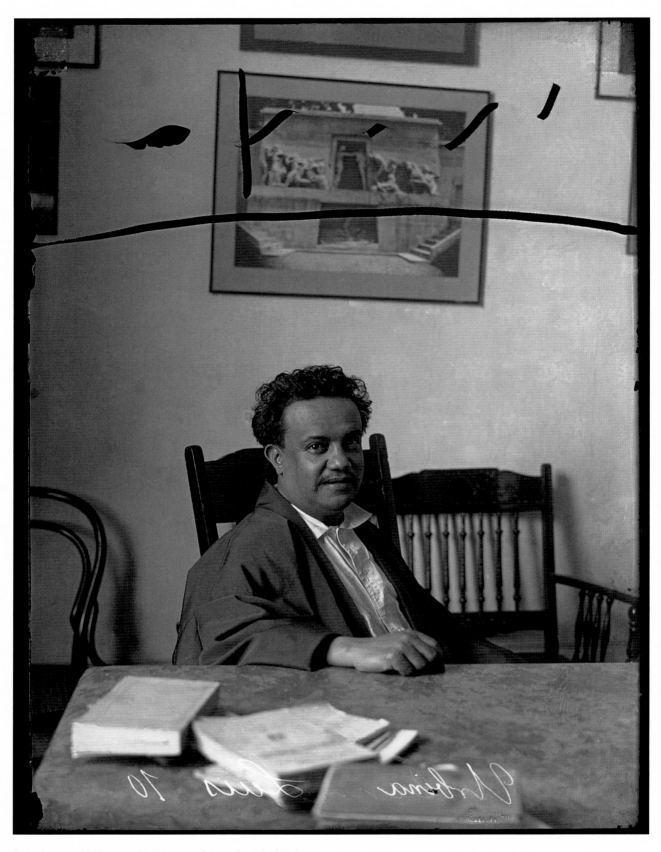

Luis Gonzaga Urbina, modernist poet who was born in Mexico
City in 1864 and died in Madrid in 1934. Urbina was the
author of more than ten books of poetry and prose.
Mexico City, *ca.* 1920. [29351]

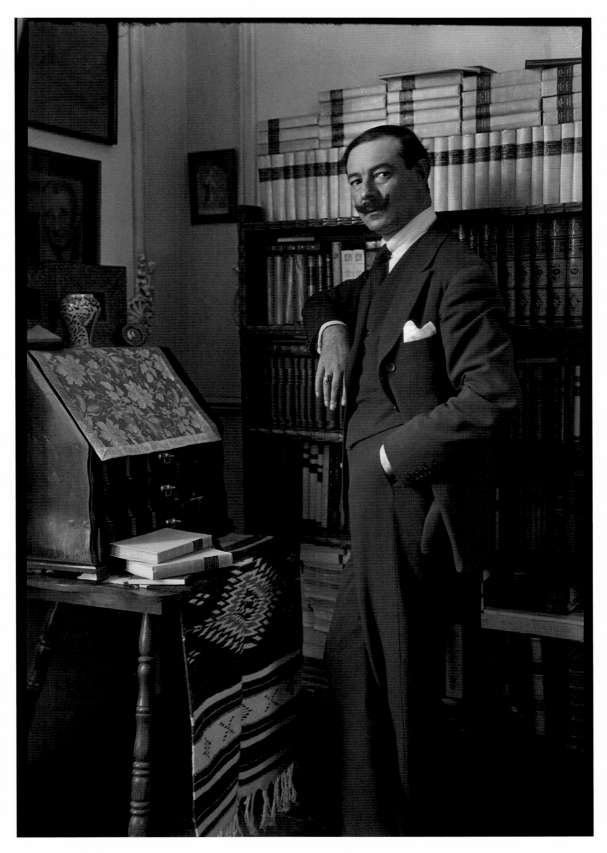

Artemio de Valle Arizpe, diplomat, legislator, and writer, was born in the state of Coahuila in 1884 and died in Mexico City in 1961. He was the author of a prodigious body of literature including chronicles, tales, and essays. He is remembered as the originator of the colonial novel. Mexico City, *ca.* 1938. [29738]

Page 198. The distinguished, scholarly writer Alfonso Reyes (1889-1959), author of a copious body of literature. Mexico City, *ca.* 1928. [26254]

Page 199. Blanca Calveti, acclaimed dancer and singer in the *zarzuelas*. Mexico City, *ca.* 1928. [165927]

Pages 200-201. María Conesa, of Spanish origin, famous for her variety songs called *cuplés* and for the passions that she unleashed in politicians and revolutionary officers. The diva gets into her car. Mexico City, *ca.* 1920. [73041]

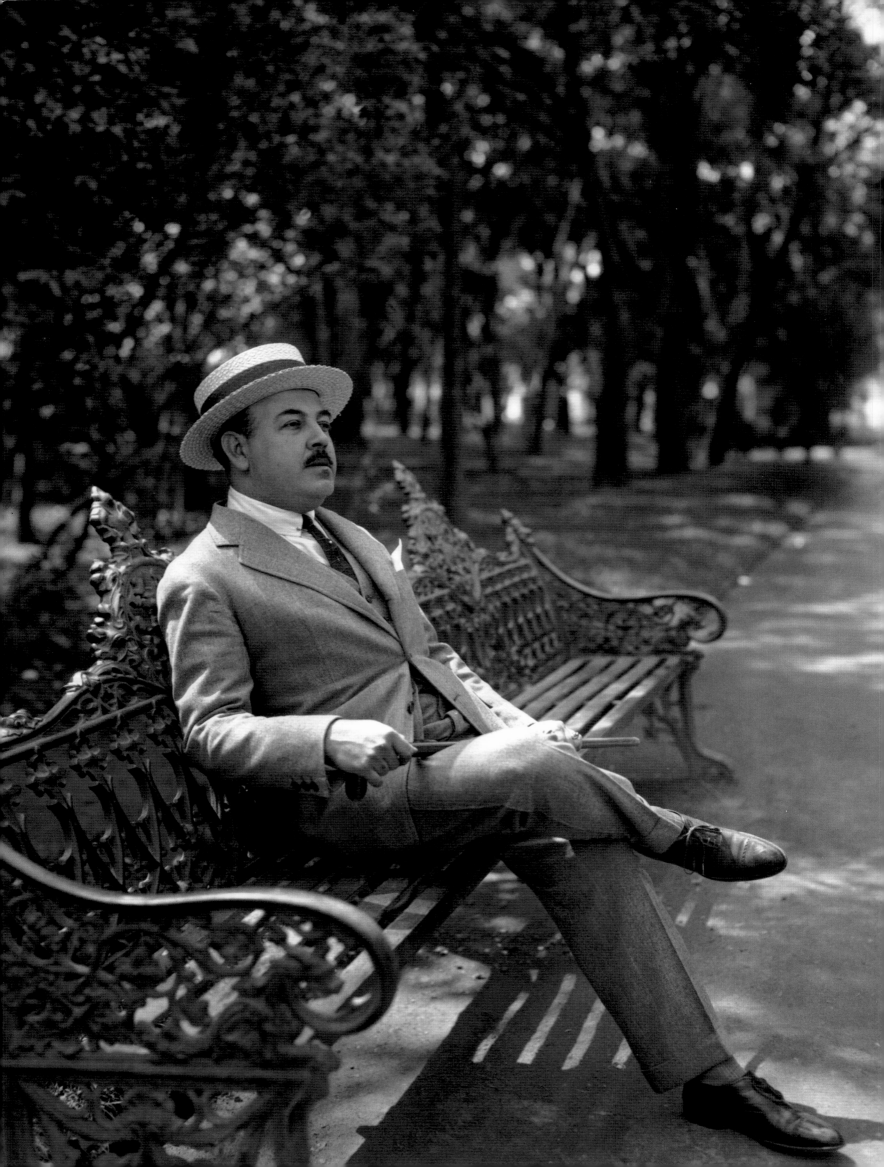

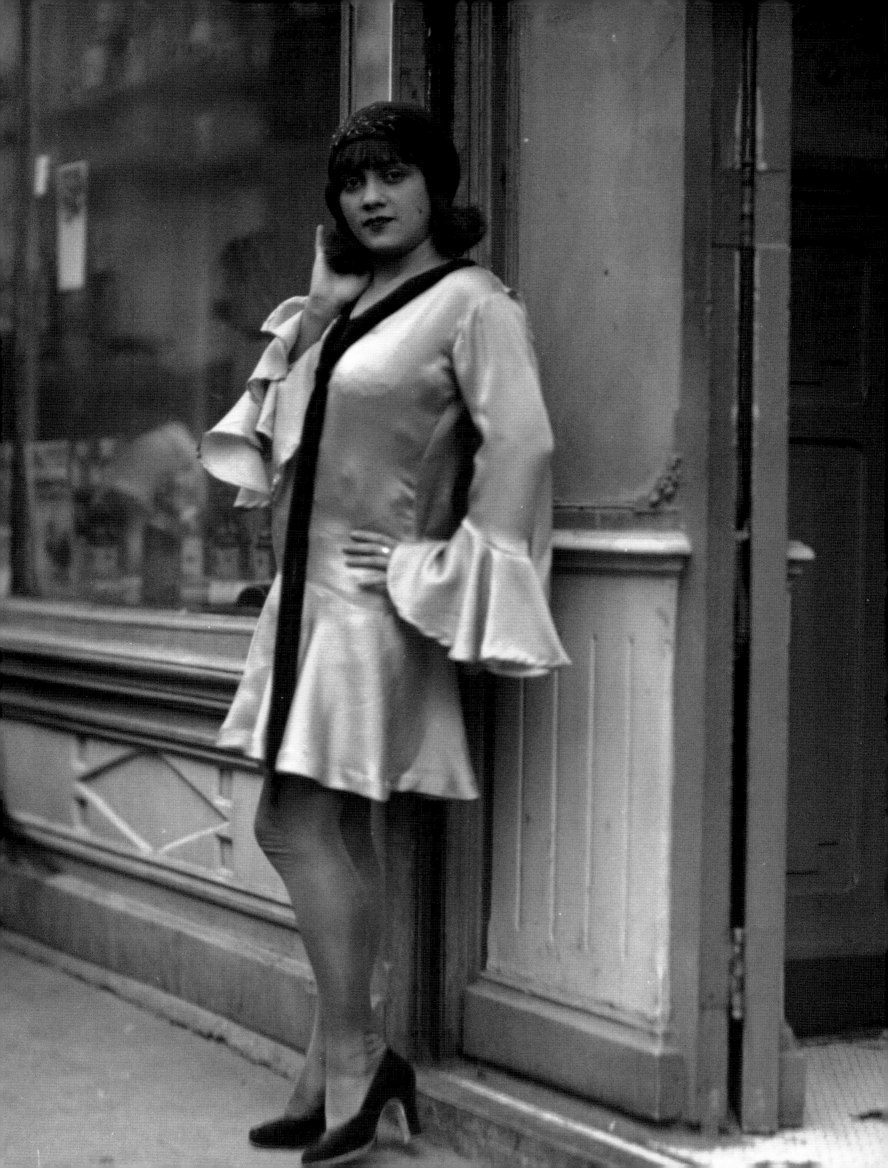

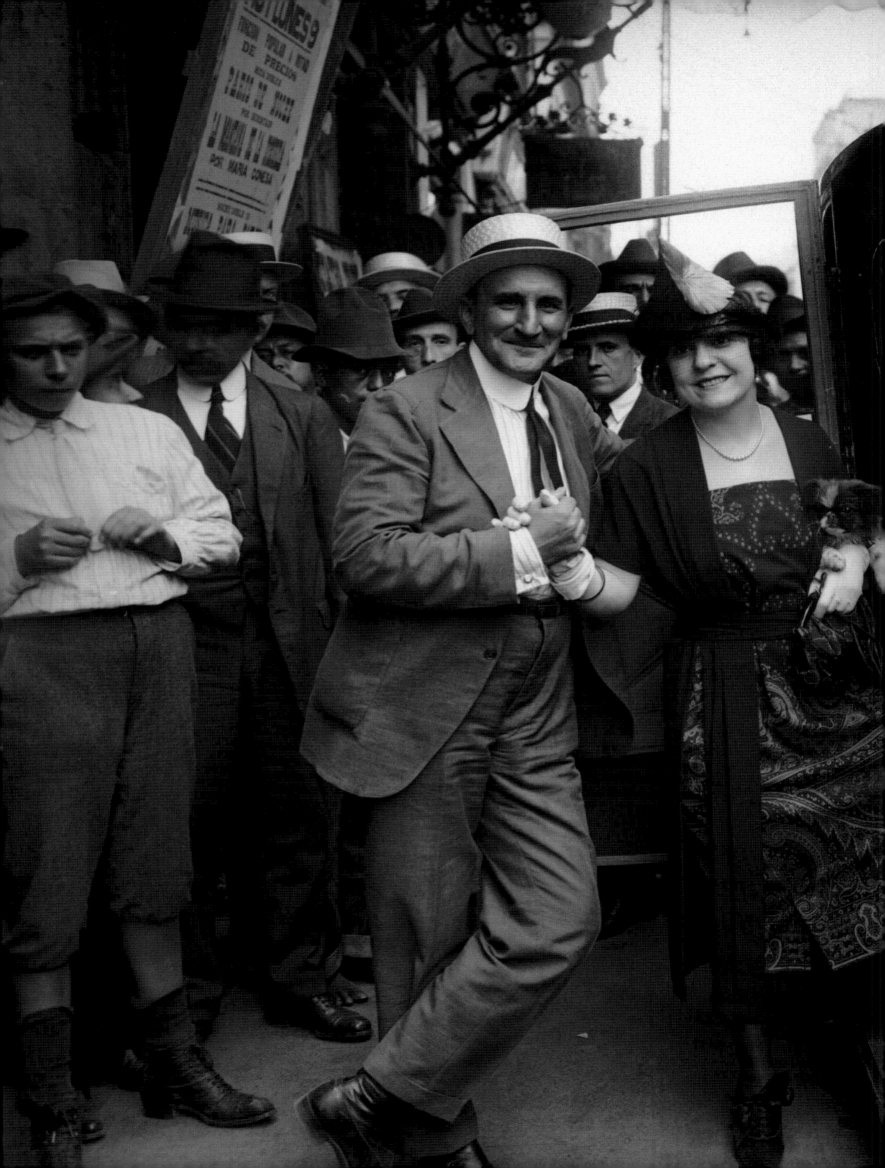

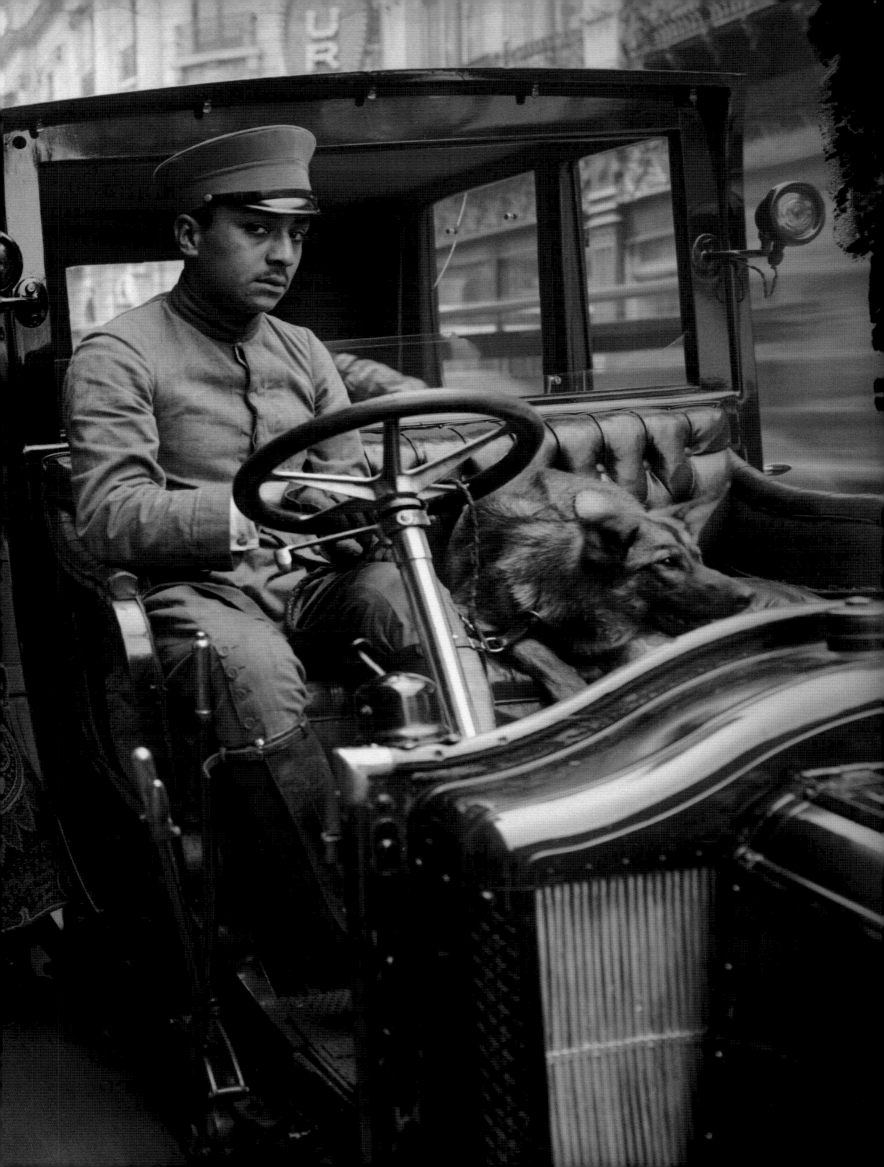

LA SEMANA ILUSTRADA

Director general y gerente
EDUARDO I. AGUILAR.

México, 2 de junio de 1914

Jefe de redacción
MANUEL DE LA TORRE.

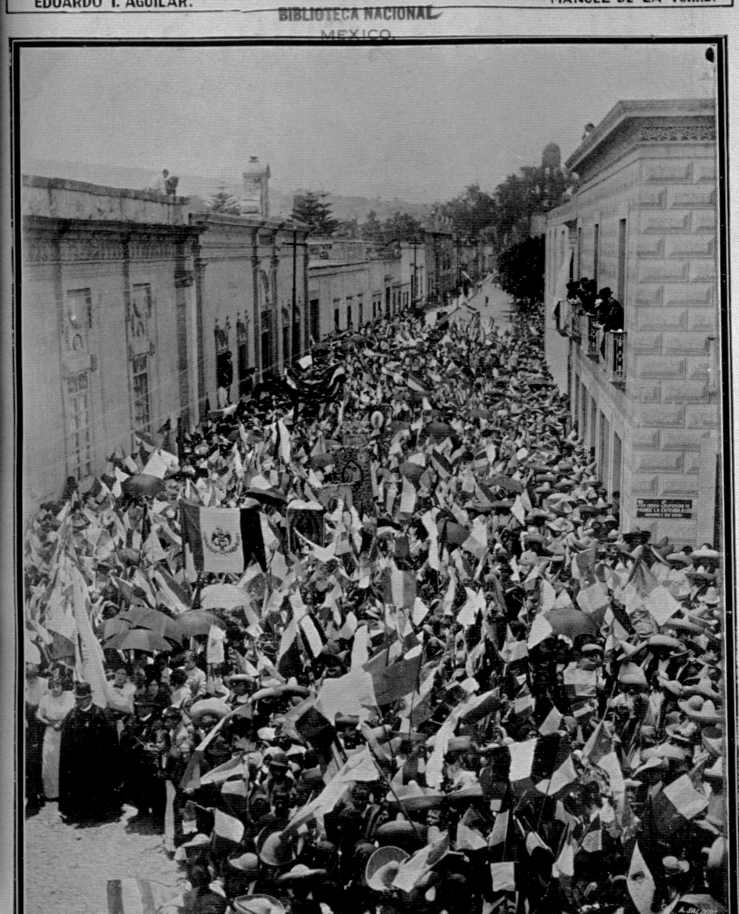

THE CASASOLAS: AN EVERYDAY EPIC

SERGIO RAÚL ARROYO
ROSA CASANOVA

Each image that forms part of the enormous photographic network of the Casasola Collection can be understood as a kind of time travel that reveals, with bare simplicity, the ancestral human need to keep certain moments alive. Out beyond the tempests of history and the great or small deaths of the people that lived in a particular era, these moments of different densities defined the course of Mexican time; they oscillated between the territories and salons where political rituals and revolutionary war were played out, and the scenes that encompassed the vertiginous geography of everyday life.

History religiously written with capital letters and divided into chapters, as well as that which slowly records identity and evocation, brings multiple lines of communication into the network of references among which we seek orientation in order to approach the Casasola chronicle.

The analysis of this vast collection, this immense river of time that flows through seventy years, has been anything but easy for the specialists, especially considering its dimension, thematic diversity, and political and social ubiquity. Upon dipping into Mexico's collective reserve of images or producing concrete reflections on the exercise of power, thorny issues have been opened up, ruffling sensitive political fibers on more than one occasion. The critics and historians involved in this project are few; they come from university backgrounds as well as from the photographic milieu and the technical teams of the Fototeca Nacional of the National Institute of Anthropology and History. With a healthy pragmatism, they have catalogued and digitalized a large part of the reserve, even while running the risk of becoming ensnared by their own fascination with the images, whose cumulative force can indeed be overwhelming.

The crux of the matter is representation, or that which is represented by the Casasola photographs. This is ambiguous terrain which, as Carlo Ginzburg has pointed out in relationship to the humanistic sciences, moves between the conception of represent-ed reality, which refers to absence, and the act of making reality visible, suggesting presence; it's a game of mirrors between substitution and mimetic evocation.[1] The images captured by this indefatigable tribe of photographers, upon being published, are transformed into a rite that seems to make acts eternal, rescuing them from oblivion. They are there, suspended and exhibited for the public in a kind of time vacuum. The photographs they did not publish, but which have been rescued over the years, are momentaneous records; we view them today as living representations of the reality of Mexico City.

The forging of the instantaneous

Agustín Víctor Casasola Velasco, the dynasty's emblematic founder, peers out at us, tall and distinguished, in numerous shots that catch him in the course of his various activities: photojournalist, association leader, agency director, bureaucrat, and collector.

How did this apparently timid man embark upon the project of compiling an archive that began with a limited vision of the sale of photographic materials to a few newspapers and commercial enterprises and evolved into a group of icons that seeped into the center of the collective whirlpool of images? Agustín Víctor was born in 1874, during the consolidation of the project now referred to as the *Porfiriato*. He came from that part of nine-teenth- century society that could only get ahead through work.[2]

[1] See Carlo Ginzburg, *Occhiacci di legno*, Milan, Feltrinelli, 1998, chapter "Rappresentazione. La parola, l'idea, la cosa," pp. 82-99. Here he makes reference to the studies of Roger Chartier and Ernest Gombrich.

[2] In addition to the editions produced by the family itself, numerous publications provide basic information about the dynasty from diverse perspectives. Some of the most important are: *Agustín Victor Casasola: El hombre que retrató una época, 1900-1938*, Mexico, Ed. Gustavo Casasola, 1988, a commemorative edition that contains texts by Mario Luis Altúzar, Carlos Monsiváis, Alejandra Noriega, Mario Orozco Rivera, Jacobo Zabludowsky, and Gustavo Casasola Zapata, as well as numerous photographs by Agustín Víctor. The studies of Flora Lara Klahr are of particular importance, including: "Agustín

When he entered the field of journalism, the press was assuming an increasingly important role in the process of conceiving and divulging the country's modernization, the most perennial of all goals in succeeding regimes. Although he learned his trade in small shops, he became a truly modern man. Throughout his work as a bookbinder's apprentice, typographer, reporter, and photographer, he was wise enough to gradually construct a network of friendships and professional relationships that helped him conceive of, refine, and compose his broad journalistic horizon.

His brother Miguel, "Miquis," is considered by many to have been the best photographer in the family. Legend has it that he was a bold young man, a picturesque cameraman who used rough language and excelled in various trades. Miguel Casasola actively participated in the revolutionary struggle as a militant in Álvaro Obregón's ranks and was wounded during the violence of the *Decena Trágica* following President Madero's assassination. His legend was further embellished by the image of him working in the laboratory with a pistol on his hip. His stubborn, combative presence as he carried out assignments for various dailies, especially in the House of Representatives, together with his propensity for making friends, earned him the persistent support of politicians in high places as well as that of countless fellow journalists.[3]

The 1900-1930 period is key to an understanding of Agustín Víctor Casasola's project because the nucleus of the collection was formed at that time and work patterns were established. Around 1900, when he "felt the need to illustrate his newspaper articles," he began to take pictures with a camera.[4] Just a few years before, photographs had begun to appear in newspapers and magazines, thanks to the photomechanical reproduction process that made the news more convincing and realistic to readers who were often flabbergasted at this new development. Up until that time, photographs had mainly served as an inspiration for engravings, woodcuts, and lithographs that illustrated publications and also authenticated the veracity of information.

By that time, Casasola had already worked as a "reporter" (an English word often inserted into Spanish language conversations in those days as a symbol of modernity) at *El Liberal, El Correo Español, El Popular, El Universal* and *El Globo*, whose director was the poet Amado Nervo.[5] As the new century began, he was working at *El Tiempo*, a Victoriano Agüeros publication, and remained on the editorial staff until 1904. This notable Catholic daily brought together distinguished intellectuals like Luis G. Urbina, José María Vigil, José María Roa Bárcenas, Joaquín García Icazbalceta, and Carlos Pereyra, and published the weekly *El Tiempo Ilustrado*, an extraordinary vehicle of propagation of the possibilities inherent in the photographic image. As a staff member of that daily newspaper, he participated in the founding of the Asociación Mexicana de Periodistas (Mexican Association of Journalists) around October 1903; this was his first experience in a guild, which was dominated by reporters working at *El Imparcial*. In March 1904, he went over to that newspaper, owned by Rafael Reyes Spíndola, recognized as the originator of modern journalism in the country. Reyes had purchased all the newest machinery in order to assure high visual quality in the production of the daily paper.

In those years, the concept of the illustrated family magazine was forged. With up-to-date images, it would cater to the urban public now touched by an incipient educational system, even if primarily for males. *El Imparcial* was supported by *Los Científicos*, a group of powerful politicians united around a positivistic, progressive, technocratic vision, and led by Treasury Secretary José Yves Limantour. The newspaper was aware of the increasing value now assigned to the image and gradually conceded more space to photographs, despite the scant credit given to photojournalists.[6] At that time they were considered mere participants in a trade in which individual differences were negligible. This experience may have affected the concept of authorship displayed by Casasola in his archive, in which he did not even record the names of members of his own family. Whoever published or commercialized the images became their owner; in many cases, the public knew who had taken the pictures and was conscious of the way in which the authors were exploited. [7]

Casasola continued to work at *El Imparcial* until 1912. Legend has it that when the paper closed in 1914, he saved the photo archive and retained control over it. If this is true, it reflects a sense of vision on his part due to his recognition of the potential uses of the images that broadened his collection. It also explains why the archive contains a large number of plates by Manuel Ramos, another outstanding photographer who had been part of

Víctor Casasola, fotógrafo, coleccionista y editor," in Pablo Ortiz Monasterio (selec. and ed.), *Jefes, héroes y caudillos*, Mexico, Fondo de Cultura Económica (Colección Río de Luz), 1986, pp. 99-109; and *Fotografía y prisión, 1900-1935*, Mexico/Santa Cruz de Tenerife, Conaculta/Secretaría de Relaciones Exteriores/Fotonoviembre, 1991. Likewise, Ignacio Gutiérrez Ruvalcaba has written about the Casasolas on a number of occasions: "A Fresh Look at the Casasola Archive," in *History of Photography*, vol. 20, no. 3, Autumn 1996, pp. 191-195; and "Los Casasola durante la posrevolución," in *Alquimia*, no. 1, Sep.-Dec. 1997, pp. 37-40.

³ Luis Jorge Gallegos generously offered us access to his research on the genealogy of some families of photographers, which will soon be published. It is known that Miguel Casasola contributed to numerous newspapers, especially *La Prensa* towards the end of his life. Arellano Martínez evokes his personality so full of contrasts at the time of his death: "Don Miguel with his serious face, a man of few friends, tended to lose himself in the laboratory, but he was a good man, a great photographer, and had the heart of a spoiled child," in "Miguel Casasola", *El Nacional*, September 3, 1952.

⁴ So says Gustavo Casasola Zapata in *Agustín Victor...*, p. 97.

⁵ In a 1979 interview, Gustavo Casasola Zapata says that Carlos Roumagnac, of *El Popular*, was the person who gave Agustín his first opportunity as a journalist. See Cristina Pacheco, *La luz de México*, Mexico, Fondo de Cultura Económica, 1996, p. 119.

⁶ With respect to the complex relationships between Limantour and the rest of the Porfirian cabinet, see Alfonso de María y Campos, *José Yves Limantour*, Mexico, Grupo Condumex, 1998.

⁷ At least since the decade of the 1890s the General Archive of the Nation has registered photographic series under the category Literary and Artistic Property. The manner in which the Agency hired photographers or acquired their images is yet to be researched.

Reyes Spíndola's staff. While working at *El Imparcial*, Casasola attained recognition in the journalistic field, especially due to his 1907 scoop: images of the firing squad execution of the assassins of General Manuel Lisandro Barillas, the former president of Guatemala residing in Mexico, after coverage of the execution by reporters had been prohibited.[8]

With time, his name appeared in the headlines. He covered the most important political events, especially those involving the aging dictator Porfirio Díaz in Mexico City. He was present at the meeting between Díaz and North American President William H. Taft in El Paso, Texas, in 1909, and covered the festivities for the Mexican Independence Centennial in 1910. These events amounted to a trial by fire for photographers due to the excessive number of stages for official acts. Organization and heroic endurance were necessary in the face of long working hours, as was effective planning for taking pictures amidst throngs of people. It would not be long before daily newspapers would be covering the portentous events put in motion by Francisco I. Madero's anti-reelection campaign in northern Mexico.

As a press photographer associated with Porfirian society, Agustín Casasola accompanied the defeated Díaz to the port city of Veracruz in June 1911; amidst white suits, flowers, and waving handkerchiefs, the ship departed, carrying the dictator to exile in Europe. In one of the photographs, Agustín is seated on a dock at the port, which the dictator had inaugurated just a few years before, looking nostalgically out to sea; he is accompanied by Manuel Ramos, the photographer he admired so much. On these occasions, Agustín Víctor had not acquired sufficient prestige to gain entry to ceremonies held behind closed doors. He would have to wait for a change in government in order to cross that threshold, experiencing for himself the transformations in attitudes towards journalists.

Slaves of the moment

At the beginning of the twentieth century, photojournalism was thought to be a chronicle of the comings and goings of powerful people, the record of civic events, governmental acts, Independence Day festivities, entertainment, works of charity, social events, factory employment and production, school activities, and some crimes and accidents. With the outbreak of the armed movement, the happenings that became mandatory subjects for news stories suddenly took on different nuances. Any number of bloody uprisings erupted throughout the national ter-

ritory without regard for Porfirian order. Photographers had to become part of battles and of dizzying changes in alliances and power groups, compounding the unstable, precarious nature of their work. The period was framed by blood-drenched garments and a dramatic, unceasing stream of cadavers, ranging from presidents (Madero, Carranza, and Obregón) to recruits and inexorably anonymous civilians.

According to Olivier Debroise, the photographers who worked in the seventy-four photographic studios in the capital and perhaps three hundred more in the rest of the country in 1900, were propelled into activity by the events of those years. They alternated between carefully arranged studio takes and the literal pursuit of the astounding happenings that were moving the entire society.[9] Years later, in 1919, there were at least forty-eight photographers registered in Mexico City, some in elegant studios like those of Lange or Clarke, or the more modest establishments of H. J. Gutiérrez, Agustín Jiménez, or Eduardo Melhado, who would play a more transcendent role in the history of Mexican photography. Others worked in studios catering to the broad masses of people, like those of Elvira Escudero or Albino Mendoza.[10]

The year 1911 was pivotal for the country, as well as for Agustín Víctor. He showed a high degree of professionalism in his coverage of the brief interim government of Francisco León de la Barra, which guaranteed presidential elections. In the same year he founded the Asociación Mexicana de Fotógrafos de Prensa (Mexican Association of Press Photographers), in which he was elected president of the Board of Directors at a time when the Ministry of the Interior decided to withhold subsidies to the press. As association president, he headed the delegation that visited León de la Barra in his official residence in Chapultepec Castle to thank him for "a new stage of freedom in journalistic photography," in virtue of the fact that he allowed photographers to take close-up shots, establishing a precedent of unquestionable importance for other officials. On the other hand, Casasola used the rhetoric of mutuality, so common in Porfirian days, to justify the Association. He clearly distinguished the organization from the feared unions, which at that time were demanding a just minimum wage and ten-hour workdays. He declared that the photographers were joining together "to protect themselves from the vicissitudes of everyday life ..." and defined the Association as a "cordial grouping of respectable men, of honorable people," who sought to pursue their "duty of leaving impressions of instants, of becoming slaves of the moment ..."[11]

[9] See Olivier Debroise, *Fuga mexicana*, Mexico, Conaculta, 1994, p. 144.

[10] Historic Archive of the Federal District (AHDF), City Hall, Mexico City, Infractions, Photography Section, vol. 2380, t. 1, expedients 1-17.

[11] In the *Álbum histórico gráfico*, Mexico, Agustín V. Casasola editor, 1921, Notebook no. 4 (page numbers unknown), it is noted that those in attendance include Agustín V. Casasola and Abraham Lupercio, from *El Imparcial*; Antonio Garduño, from *El Diario*; Isaac Moreno, from *El Demócrata*; Samuel Tinoco, from *La Semana Ilustrada*; Ezequiel Álvarez Tostado, from *El Mundo Ilustrado*; Gerónimo Hernández, from *Nueva Era*; Víctor León, Rodolfo Toquero, Miguel Casasola, Eduardo Melhado, and Ezequiel Carrasco. The *Álbum*, Agustín's work, devotes several pages to the journalists' activities, emphasizing his

[8] In order to obtain these images, Agustín Víctor conceived of this ephemeral construction of a platform supported by a telephone pole, which allowed him to take the pictures above the wall that surrounded the Belén Prison. The photos (of the execution and of him on the platform) were published on the front page of *El Imparcial*, without his name, on September 10, 1907 and they won him a special award. Reproductions of that issue of the daily newspaper are found in the Fondo Casasola.

Casasola inaugurated a new relationship between the journalist, especially the photojournalist, and power. During Porfirio Díaz's regime, countless banquets and festivities were held for journalists aligned with the regime, among whom the photographer was always last on the list. In the new scheme of things, the Head of State received photographers personally, in recognition of the value accorded to the image in guaranteeing and disseminating the governmental project. This was, perhaps, the first time in Mexican history that a ruler posed with press photographers. A lesson had been learned, never to be forgotten: power—regardless of political tendency—would always have to generate more space so that photographers could perform their tasks and thus venerate and validate government actions.

The Asociación Mexicana de Periodistas Metropolitanos (Mexican Association of Metropolitan Journalists) was also founded at that time. It was headed by Agustín Víctor's cousin, Ignacio Herrerías.[12] In December of the same year the Association of Press Photographers put on its first and, as far as we know, only exposition in a salon on elegant Plateros Street (now Madero Avenue). It was inaugurated by Alberto Pani, Undersecretary of Public Instruction, and "sponsored by Luis García Pimentel, Alberto Braniff, Jorge Crump, the Islas brothers, and the directors of the newspapers to whom the exhibitors belonged."[13] In his *Álbum histórico gráfico* (Graphic Historic Album), Casasola transcribed the account that appeared in one newspaper: "Truly, Carrasco's gorgeous landscapes; the artistic studies by Garduño, Uribe, Lupercio, Carrillo, and Tinoco; Hernández's popular figures; Tostado's informative pieces; and Casasola's instantaneous photos formed an exceptionally beautiful ensemble that was duly admired by the public." "... One beautiful attribute of these pressmen was having ceded part of the exposition's proceeds to public welfare."[14] The exposition's closing ceremony was marked by the presence of none other than the recently elected President Francisco I. Madero, who had initiated the anti-reelection movement that led to the defeat of the dictatorship. Madero carefully observed a photograph of himself beside General Bernardo Reyes, his former opponent, taken by Tostado, as well as the "batch of historic photographs by Casasola." Before taking his leave, the president posed for a photo with the exhibitors "Tinoco, Casasola Agustín, Tostado, Esperón, Ramírez de Aguilar, Lupercio Abraham, Moreno, Hernández, Melhado, Casasola Miguel, Uribe, Pérez Taylor, etc."[15] The Association seems to have dissolved after these

events, perhaps because, among other reasons, it had already achieved its objectives.

Certain characteristics of the exposition are worth emphasizing: the predominance of traditional genres commonly used in the illustrated family magazines, which only Tostado and Casasola appeared to contravene; the sponsorship of politicians and newspaper directors, underlying Agustín Víctor's administrative ability; the benevolent gesture in favor of public welfare, reiterating old practices of power-holders and coinciding with Madero's programs; and, above all, the fact that the new President was captivated by the photographs. Significantly, Agustín Víctor would not know how to or would not be able to establish the same relationship with the succession of revolutionary leaders who began to take over the weary streets of the nation's capital for brief periods of time. The lack of images of Casasola at the side of Zapata or Villa, for example, is no mere coincidence.

During those convulsive years, the August 1912 Zapatista execution of some journalists, including Ignacio Herrerías, left an indelible mark on Agustín Víctor.[16] As a protest against the killings, he actively participated in a demonstration organized in the capital; he was, in fact the leader of the protest and sought to bring a new sensibility to the political mobilizations that characterized daily life in Mexico City. This event, along with the invitation of the Argentinian publication *Caras y caretas* to be their graphic correspondent in Mexico, motivated him to leave *El Imparcial*, which had undergone a change of ownership, and to found the Agencia Mexicana de Información Gráfica (Mexican Graphic Information Agency) along with another member of his family, his cousin Gonzalo Herrerías.[17] Another project gradually materialized. In December of that year Gerónimo Hernández, about whom no further information is available, began to send him postcards from San Luis Potosí containing images of the city. Surely the same practice was followed with contacts and acquaintances throughout the country as a way of augmenting his reserve of images.[18] It is known that Agustín Víctor, in addition to being obsessed with amassing photos, had also been a collector of "illustrations, documents, books, etc." since his days as a reporter.[19]

The association with his cousin was dissolved the following year because Herrerías took on the position of editor of *Excélsior*, but the Agency continued to be successful. Because of work demands, Agustín found it necessary to bring his thirteen year old son

own presence and pointing out that of his brother Miguel, who apparently was a contributor to *El Ahuizote*. Eduardo Ancira provided access to his research on the Association, the theme of his university thesis in progress.

[12] All seems to indicate that Agustín Víctor was also a member of this Association, whose local branch was inaugurated in January 1912.

[13] García Pimentel and Braniff were distinguished members of the Porfirian elite, and the Islas brothers were, above all, distributors of photographic equipment and material.

[14] The reference to profits leads us to believe that there was an entrance fee. In the *Álbum histórico gráfico*, Notebook No. 5. As far as we know, this is the only occasion upon which Agustín Victor exhibited his work.

[15] *Ibid.*

[16] We know through a telegram that he was in the city of Toluca when he was notified of the "death of Nacho," who affirmed that his journalism teacher had been Agustín Casasola. In CD-SINAFO.

[17] In February 1912, he still had a letter of presentation from *El Imparcial*, stating that "he is authorized to take photographs." Later, his press card would include *L'Ylustration Francaise* [*sic*] and the American Press Ass. In CD-SINAFO.

[18] A postcard in the Fototeca Nacional, with Inventory No. 652597. Here Mr. Hernández expresses regret for having written on the photograph, in response to Agustín Víctor's reproach. Evidently the writing made it more difficult to copy and reuse the images. The same problem frequently occurred with images from newspapers and magazines, which is reflected in the quality and texture of the negatives. Moreover, in the CD-SINAFO, clippings are conserved with the word *Hecho* (Done) written on them.

[19] In *Historia gráfica de la Revolución mexicana*, Mexico, Editorial Trillas, 1960, I, p. VII.

Gustavo into the Agency. Other photographers such as Antonio Garduño also worked with him.[20] An image taken outside the Agency, possibly in the mid-1920s, shows fourteen people who are said to have worked there.[21] Gustavo would be followed by all the members of the family formed with María del Refugio Zapata, whom Agustín married in 1899. Ismael, Agustín, Dolores, Piedad, and Mario took pictures and worked in the laboratory and the archive, with a clear division of labor between masculine and feminine members, the latter working only inside the business. An Agency business card identifies Agustín as artistic director with a frequently used photograph, that of a young man in a suit with a trace of a confidence inspiring smile. It describes the Agency's activities in much the same way that the pioneers in photography advertised themselves:

"This Agency
–is concerned with taking daytime and nighttime photographs
–inside and outside the capital
–promoting their publication in newspapers
–providing portraits and snapshots of one and all
–buying, selling, and renting cameras and lenses".[22]

Thanks to Agustín's prestige and probably to the intervention of Gonzalo Herrerías, in December 1916, Rafael Alducín, of *Excélsior* and *Revista de Revistas*, asked him to cover the debates in the Fifth Constitutional Congress in Querétaro, convoked by Venustiano Carranza, the president who had ruthlessly eliminated his political rivals. The paradigmatic Constitution of 1917 was the fruit of this Congress. It was adopted in February of that year, with notable advances in certain central themes involving the redress of social grievances, particularly the strengthening of public education and the recognition of the rights of workers and peasants. Agustín Víctor Casasola left for Querétaro with his sons and other photographers.

We know that the Agency was still functioning in 1918, because there is a record of a fifteen peso fine paid to the city government for not having a license required by the Health Department.[23] In 1919 Agustín Víctor sent his son Gustavo to photograph the controversial revolutionary leader Francisco Villa in his veiled exile at the Canutillo Hacienda, in Durango; the General expressed his pleasure with the photos in a letter sent in March 1921.[24]

We cannot be sure about what moved Agustín Víctor Casasola to found a photographic agency, which was certainly a novelty in those years in practically all parts of the globe. The national and international media's demand for images that recorded the happenings of the Mexican Revolution must have been fundamental for the Agency, as were the experience and recognition won by its director, not to mention the connections he had with politicians and newspaper editors. On the other hand, his undeniable vision, which we can certainly describe as intuitive, opened up horizons that allowed him to record diverse faces of history and to feel that he himself was in no small part a prime mover in that process. His own personal trajectory may be taken as the saga of all photojournalists.

Ignacio Gutiérrez Ruvalcaba found that on June 4, 1920, Agustín Víctor and Miguel signed a contract with the Mexico City government to document interiors and exteriors of commercial establishments and infrastructure projects, photograph people involved in cases at the police station, and make a record of those imprisoned at Lecumberri and Belén.[25] That contract also involved Gustavo Casasola, Francisco Ramírez, and Rafael López Ortega, who were replaced by Ismael Casasola and Adolfo Vera Solís in 1925. On August 23, 1929, Agustín Víctor signed another agreement naming him as the director of photography in the city government, a post he occupied until his death in 1938.[26]

With these contracts, the Casasola family began to work steadily for the government in power. That way they were assured of a fixed income, which in 1929 was nine pesos a day, a little higher than the salary paid to a draftsman's assistant (eight pesos), but significantly lower than the amount paid to an engineer's assistant (10.66 pesos), not to mention the salary of the Director of Public Works (35 pesos).[27] Their earnings were complemented by work taken in at the Agency, which continued to function, with family members working at a feverish pace. On May 27, 1922, for example, Miguel was in charge of six assignments, finishing a total of eighty-three glass plates in a 5 x 7 inch format and throwing out twenty. On that day he took pictures of President Calles arriving at the capital from Monterrey, a breakfast with the labor leader Luis N. Morones, the prisoners at the Belén Prison, a football game, and the society wedding of an important lady in capital city society; at night, he photographed prostitutes, drug-dealers, and drunks at the police station.[28] Only thirty plates were turned into the city government: all those taken at Belén and part of those

[20] In an interview with Adriana Malvido, Gustavo Casasola Salamanca said that his father was studying in an "English school" when he had to leave it "to dedicate himself to photography, he was the first-born and my grandfather needed him." In the article, "Relata la familia Casasola el devenir de su archivo de fotos," *La Jornada*, November 21, 1991. Likewise, on March 4, 1913, some of his photographs were published with this caption: "Fots, Casasola and Garduño para *El Semanario Ilustrado*".

[21] The exact date is unknown; in *Agustín Víctor…*, p. 78.

[22] The address is Niño Perdido 44, which at least since August 1912, was his home. In CD-SINAFO. A card, "Agustín V. Casasola and Hijos", carries the address República de Chile 4. Later there are references to Ayuntamiento 4, in 1921, Nuevo Mexico 76 (now Artículo 123) and the known location at Victoria 37C, immortalized in a photograph. In the first presentation of *Álbum histórico gráfico* the Ayuntamiento address is reported, and in the last, Victoria 18 appears. At times, a home address at Mixcoac and Holbein St. (formerly Córdoba) is given.

[23] It is described as "a photography shop providing graphic information services to capital city newspapers," and located at República de Chile 4. In AHDF, City Hall, Mexico City, Infractions, Photography Section, vol. 2380, t. 1, expedients 3-4.

[24] Letter reproduced in *Agustín Víctor…*, p. 82.

[25] I. Gutiérrez Ruvalcaba, "Los Casasola durante…," pp. 37-38. The author found the documentation in the City Hall Archive.

[26] Gutiérrez Ruvalcaba maintains that his son Gustavo took charge in 1930, but in the CD-SINAFO, a 1936 identification card is conserved identifying him as Head Photographer in the Public Works Department of Mexico City.

[27] AHDF, City Hall, Mexico City, Box 577, Package 2, Public Works, Personal.

[28] I. Gutiérrez Ruvalcaba, *op. cit.*, p. 38.

from the police station. Others went to *Noticioso mexicano*, a newspaper for which Miguel worked, and the rest went to his brother's archive.

The type of contracts signed by the Casasolas points to a modern conception of the photographer and also of the city government commissioning the work. In an undoubtedly impoverished city, where the ravages of the war were still evident, it was considered important to maintain a register and relative control over the manner in which commercial establishments displayed and distributed their merchandise. It was a capital city that brought immanence to the eternal contradiction between the fashionable stores that attracted a well-to-do clientele and the pauperized urban masses. The Casasolas, as a matter of fact, also recorded the stream of beggars that came mainly from the countryside, from a peasant culture that was foreign to the government's plans for modernization.

Images for the public at large

The year 1921 was another milestone. President Álvaro Obregón took advantage of relatively peaceful times to put on a series of festivities designed to compete with the pompous image of the celebrations staged by Díaz in 1910. Now it was the Centennial of the Consummation of Independence that was being commemorated. Obregón intended to make sure that the nation and the world had no doubt about the legitimacy of his government, which was following a new route of progress, according to the president. Casasola went a step further; in this political climate he initiated the publication of the *Álbum histórico gráfico*, which came out in installments. The credits announced "texts of Luis González Obregón and Nicolás Rangel…. Photographs and compilation by Agustín Víctor Casasola and sons." This was the only edition complete with texts and images that the photographer was able to publish; all the rest were published posthumously by Gustavo and Piedad, as obligatory homage to the father and founder. With the title of the album, rooted in nineteenth-century tradition, Agustín laid the foundations for the subsequent series; the script, texts, and images of the period in question are basically the same, but the publications exhibit significant differences.

Casasola announced the publication of fifteen notebooks, installments of the Album that would extend coverage to the period of Álvaro Obregón's Presidency. Nevertheless, the project was a commercial failure and he was only able to publish the first issue, which covered the end of the *Porfiriato* and the beginning of Madero's government, but did not go as far as the president's assassination and the succeeding *La Decena Trágica*.[29] Understandably,

the parameters were established by the countless albums printed for the inaugurations, festivities, and dramatic works performed for the Independence Centennial. The choice of contributors to the publications was no accident; for the most part they were prestigious members of the late Porfirian cultural elite, experts in commemorative publications.[30]

The cover design of the first installation of the Album, as well as the ornamental drawings around the texts and images are clearly inspired by *art nouveau* (harking back to the past once again), which along with the quality and care in printing, establish a clear difference with succeeding editions. But the graphic effusiveness is a counterpoint to the violence that unfolds in the photographs, whose incipiently manipulated negatives reveal an extraordinary sharpness.[31] The photo dimensions, 22.5 x 15.5 centimeters, favor the publication of an image on the right hand page; the text, necessarily brief, is on the left in Spanish and English. It is clear that gaining access to the North-American market was the intention of the author, who was conscious of the interest aroused by the armed struggle in certain circles in the United States even if that country had still not extended diplomatic recognition to Mexico. (This would not happen until 1923, when economic agreements were reached with regards to the debt contracted by the Mexican government). Upon displaying the Revolution's bloodiest episodes, Agustín Víctor found it necessary to give longer explanations and reproduce more documents. For this reason, he gave notice in the fifth notebook that, "With the aim of devoting more space to the texts that refer to the pictures that illustrate this Album, we have decided to publish separate Spanish and English editions."

Significantly enough, Agustín Víctor Casasola speaks of "pictures that illustrate", once again opening up the thorny issue of his idea of photography–illustration. Nevertheless, he considers the images insufficient to explain all the occurrences that have forged the country's contemporary history, and for this reason the photographs must be based on other documents. The incessant pursuit of images, his own and those of other photographers, is basically geared towards confirming and evoking the narration of events. In the issues of the Album later published by Gustavo, this search for substantiating images would become obsessive, to the point that the quality and legibility of the image ceased to be important; the

[29] The fifth notebook does not give notice that publication will be suspended. Gustavo Casasola confirms that it only went as far as the Madero government in *Seis siglos de historia gráfica de México, 1325-1976* (Mexico, Editorial Gustavo Casasola, 1978). The number of copies published is not known either although we know that few exist in public libraries. The notebooks had an Italian format and a periodicity that was impossible to determine; each one had around 200 unnumbered pages and cost 2.50 pesos, undoubtedly a price that

was not exactly economical. The aim was commercial, judging by the advertising that appeared in the fourth installment, but the only ad was that of the famous cigar factory El Buen Tono, an old client for whom Casasola had taken photographs for advertisements. A postcard conserved in the CD-SINAFO is dedicated to "Ygnacio Arroyo, El Buen Tono, S.A. With gratitude, I affirm our long-time friendship and affection. A.V. Casasola".

[30] González Obregón gained prestige as a chronicler and historian and is best known for *México viejo*, an anecdotal compilation about the capital city's past. Rangel was one of the few editors of the *Antología del Centenario*, a review of literature in Mexico in the nineteenth century, compiled under the direction of Justo Sierra and produced in conjunction with Luis G. Urbina and Pedro Henríquez Ureña.

[31] At times, the image shows clumsy retouching in an effort to display features that were lost in the general shot, or traditional photographic montages; likewise, there are examples of compositions with several photos on one page. Generally speaking, it can be said that the quality is good; unfortunately, the name of the printing house is unknown, although the address appears as Revillagigedo 65.

primary task became reconstructing the fundamental universe (not a photographic one) of events deemed worthy of recording for posterity.[32]

"Accomplishing a historic work free from all partisanship and stripped of all political passion ..." is the central goal enunciated in the preface, to be reached through "a careful compilation of the most important events of the last ten years ... whose historical value is incalculable, given that it contains facts that will clarify any number of errors hidden or invented by the agitation of the moment." An attached flyer reiterated: "We beseech you to recommend our work to your friends and like-minded people as an example of patriotic propaganda." The civic and ethical virtues of Agustín Víctor's work are based in the author's objectivity, sustained in images, facts, and historical value; he manages to penetrate patriotic sentiment without ever abandoning it. His endeavor is accomplished in the framework of a chronicle with a journalistic tone, which apparently does not pass judgment but simply enumerates, something like the innocuous prose of the social page. Flora Lara explains: "In those days objectivity was a dogma and an imperative for press photographers and cameramen. Objectivity was synonymous with realism, of uncontrived visual reproduction ... In time, this practice of 'objective' journalism adopted registry patterns that gradually became rigid and conventional."[33]

The irremediable sensation produced by the texts is that they are taken directly from the newspaper, a simple spatial repositioning in an immutable present tense. The permanence and force of the images diverge from the colloquial tone of the texts, which makes it difficult to follow the events in their inevitable sequential development towards a country that was, to some extent, pacified. In Agustín's work, contradictory statements are made about some public figures, as in the case of José María Pino Suárez, who is criticized for the control that he tries to reestablish over the press, only to be praised later on for his openness and amiability in dealing with the media. The journalistic tendency is reinforced by constant references to the activities and achievements of photojournalists, especially Casasola's closest associates. As a matter of fact, the press photographer's work gained a new status with the publication of his Album. Despite certain contradictions, however, Agustín Víctor had an eye for giving priority to the most forceful photographs, structuring an autonomous discourse that was independent of the text and facilitated by the graphic solution. It is there, in the life of the images themselves, that the nucleus of their power and transcendence resides.

So then, why was the Album not successful in commercial terms? Perhaps the images were too modern with regards to theme and form, but the overriding issue was this: it was too soon to view the bloody events of the preceding decade with distance or nostalgia. Hugo Brehme knew this; in 1923 he published *México pintoresco* (Picturesque Mexico), a programmatic title, in which he willfully ignored the development of the Zapatista movement. Brehme focused on natural and urban scenes and on the inhabitants of the country, leaving out any photograph that was the least bit perturbing. His orientation could be termed a "photography of manners." It appeared that a period of peace was being consolidated and that the public neither desired to recognize nor revive a drowsy chaos. Perhaps the only yearning possible was for the Porfirian Peace, to which the first notebook was dedicated. This publication was well received by the public, a response that was heartening to the editor. By 1926, Agustín Víctor clearly showed his inclination towards nostalgia: He contributed to the magazine *Rotográfico*, in a weekly section entitled, "What Mexico Has Seen in the Last Thirty Years," in which traditions, customs, and important public figures were reclaimed. [34]

In 1929 a credential from the Mexico City Entertainment Office identified Agustín Víctor as director of the Mundial Photo Agency. It is likely that he used this to gain access to the nightlife of the metropolitan world. On another identification card from the same governmental department, he is listed as a "qualified photographer," apparently to allow him to record a crime of forgery. In 1934, at the beginning of the Cardenista mass movement (made up of followers of Lázaro Cárdenas), he had his National Revolutionary Party card.[35] In this way, he sealed his relationship with the world of politics and consolidated a vision of journalism that permeated an entire era. He looks tired as he gazes at us from his 1936 identification card as head photographer of the Public Works Department; he died a year and a half later, on March 15, 1938.

New editions of his work would follow, with increasing success. In 1942, Gustavo, Piedad, and Miguel launched the publication of the *Historia gráfica de la Revolución mexicana* (Graphic History of the Mexican Revolution). The title conveys the impressive nature of the project, which would eventually bring the iconography of the revolutionary struggle and contemporary history to the public eye, gradually incorporating episodes from each presidential regime.[36] In those publications, the documentary function of the photographs was reinforced. They became the evidence of what the Casasolas had seen and intuited. [37]

In the 1942 work, José de J. Núñez y Domínguez dedicates a note to the founder of the dynasty:

[32] The classic example is *Seis siglos...*

[33] F. Lara Klahr, "*Agustín Víctor Casasola...*", p. 103.

[34] No. 7, March 24, 1926, explains that the editor met with Casasola to look at negatives that they observed "with the light of a naked bulb"; in this way they chose "images extracted from dust and time."

[35] In CD-SINAFO.

[36] Miguel Casasola participated as manager as of Notebook 4, but Gustavo says that he "directed and finished" it and that Piedad took charge of the archive. Once Piedad appeared as archive director. Since the notebooks were sold in installments and few changes were made, it is difficult to determine the year of publication, except for the last issue that explicitly includes the new presidents. The way in which edition numbers were handled is also unclear.

[37] In all the editions of this history, the same credit is given to the founder: "Compilation and photographs: Agustín V. Casasola, Archivo Casasola."

He had ... the clear perception of the historic sense of his profession. He realized precisely that photography, over and above its primordial function, which had been seen for many years as that of a utilitarian and purely artistic medium, could be of enormous use as a documentary testimony of history. And he got down to work, fulfilling his aspiration of forming an archive of the utmost importance ... [with which] the name of Agustín Víctor Casasola would forever remain in the catalogue of those meritorious men who accomplished a laudable work for the sake of the country.[38]

He reiterates several of the myths that would dominate the archive.

The chronology elaborated by Gustavo Casasola is more coherent; entitled *Efemérides ilustradas del México de ayer* (Illustrated Ephemeris of the Mexico of Yesterday), it was published in the 1950s.[39] In these later editions, the selection of the image is governed by its capacity to illustrate the essential event included in his historic reconstruction: the technical and formal quality, according to Lara Klahr, is "an admirable element, but not indispensable."[40]

National family albums

The Casasola Collection is not only made up of images that the family considered illustrative of Mexican history, but also those photos commissioned by public agencies and private businesses, which are a reflection of the authors' contact with everyday life in the capital city and of their own express curiosity. As a matter of fact, the classification system they devised for locating negatives reveals the breadth of themes, the circumstances, and the use assigned to each. Organized by series, themes, and dates, the material encompasses multiple affairs, including economic activity, entertainment and sports, advertising, prototypes and customs, ceremonies and fiestas (both public and private), transportation, the world of courtrooms and jails, factories, and social mobilizations; the minute details of these themes form bridges that permit us to enter into different moments in the life of Mexico with a certain feeling of empathy.[41] The depth and brilliance of the treasure enclosed in the collection has been a ceaseless motivation for the search for images, for the yet undiscovered icon. And it is true that many rough jewels still lie untouched among the countless negatives; someday they will surely be revisited and brought to light as witnesses to the peculiar sensibility of a historic moment, of an irreducible instant.

The genre of the social portrait yielded some of Agustín Víctor Casasola's best photos, especially those depicting rituals of commerce, industry, and public administration. These are not shots of prototypal figures or social customs of the day, although an awareness of such visual traditions is evident in the photos. They are open shots, in which the subjects pose with their work instruments; the people, the objects, and space itself are observed in an integrated atmosphere, immersed in a complex luminosity. They do not display the heroic intention occasionally seen in the work of August Sander or the denunciation of social ills in the style of Lewis Hine. The portraits of expectant multitudes or crowds in motion, on the other hand, record the action (and reaction) of the urban masses to political events that affect their daily lives. It is somewhat amusing that a physical characteristic may have allowed Agustín to dominate the scenes of uncontainable throngs of people. We simply can't ignore the fact that he was very tall—over six feet; this allowed him to attain an all-encompassing view, which was translated into a clear sense of order in his compositions.

The Casasola Collection presents a cross-section of Mexican society; its subjects appear with all the force of their anonymous individuality, and naturally, as a collective presence, too. In these photographs we cross the line that defines the masses as protagonists.

Far from the vision of history shared by Agustín Víctor Casasola and his family, we contemplate the dynasty's vital pragmatism from a distance and are continually fascinated by the powerful images that allow us to gaze at the complex unfolding of Mexican time. The Casasolas are responsible for a good part of the graphic universe that profiles the contemporary country. In their pioneering work there is a certain convergence that marks the course of photography—themes that surged or resurged from wartime ruptures of vital rhythms. Each photo is transformed into a particle of the immense adventure that Mexico has struggled to imagine and comprehend. Thanks to the Casasolas, many of us have been able to develop a certain insight, a mirror-like ability to grasp objects, events, panoramas, and corporeality—an insight that brilliantly synthesizes the political and social passions of an age.

[38] Núñez worked with Casasola at *El Imparcial*, directed the well-known magazine *Revista de Revistas* for twenty years, and was secretary of the National Museum. Notebook 1.

[39] There is no year on the editions and they were published in installments, with a total of fifty notebooks in five parts, according to an advertisement in "Ediciones Archivo Casasola ... A profusely illustrated work, printed at Rotograbado, with extensive texts and expressive covers". In CD-SINAFO. Gustavo says that he produced it "with material left over from the *Historia gráfica....*" In C. Pacheco, *op. cit.*, p. 124.

[40] F. Lara Klahr, "*Agustín Víctor Casasola...*," pp. 106-107.

[41] There are approximately twelve thousand series, and in the registers it is possible to perceive that the references became increasingly complex and specific: the initial entries are typewritten with additions in pencil or ink. According to Gustavo Casasola, his father had the material in a state of disorder and he and Piedad put it in order. In C. Pacheco, *op. cit.*, p. 122.

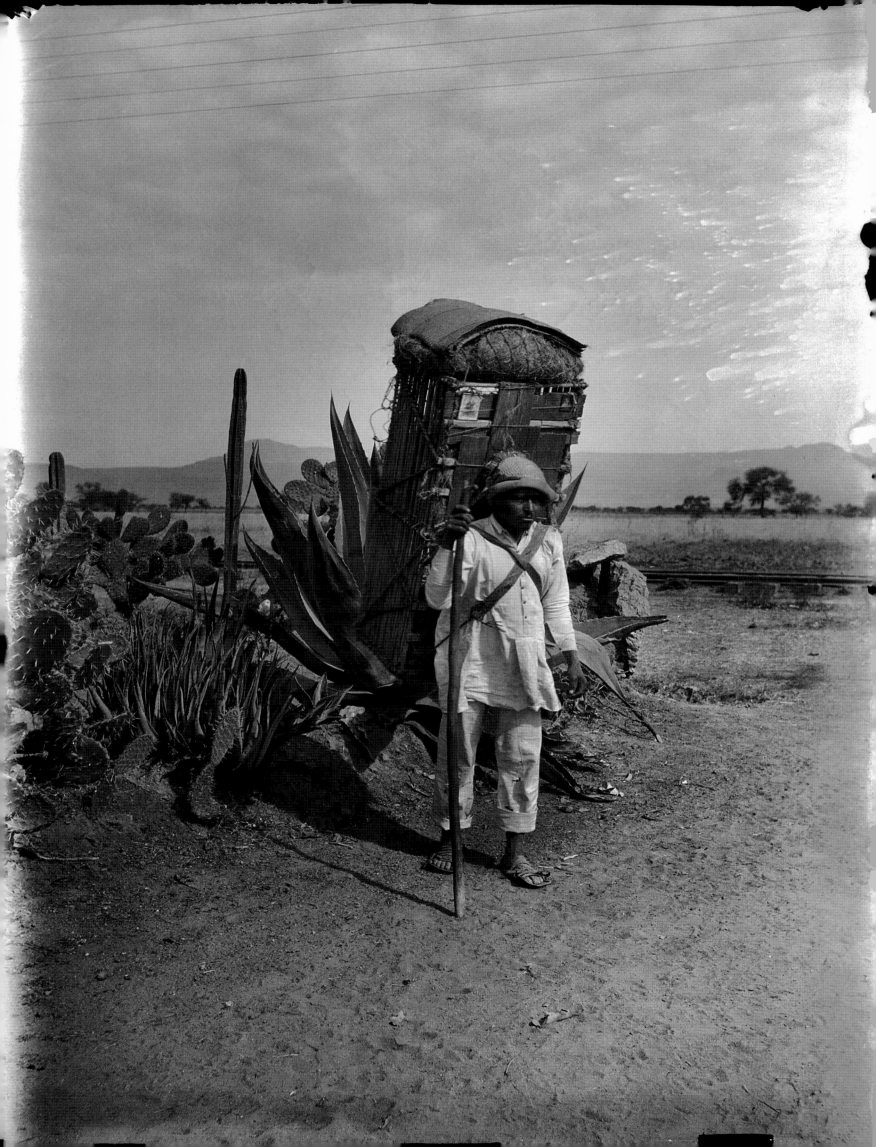

LO QUE HA VISTO MEXICO EN LOS ULTIMOS 30 AÑOS

ANECDOTARIO GRAFICO NACIONAL

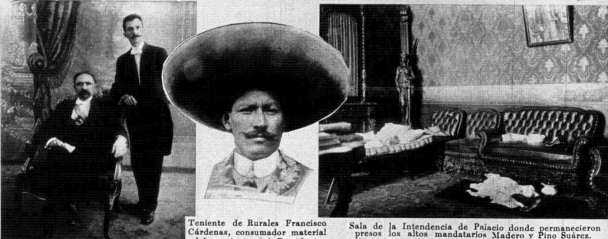

Teniente de Rurales Francisco Cárdenas, consumador material del asesinato del Presidente Madero.

Don Francisco I. Madero y don José María Pino Suárez, a fines de 1912, en el Palacio Nacional.

Sala de la Intendencia de Palacio donde permanecieron presos los altos mandatarios Madero y Pino Suárez.

ROPAS del Presidente Madero: Pantalón mostrando huellas de fango en las rodillas.

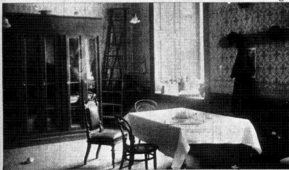

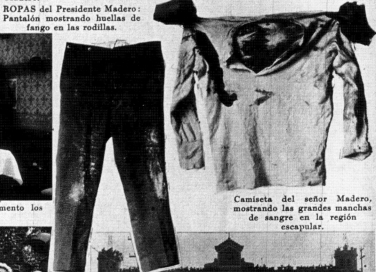

Mesa donde por última vez tomaron un frugal alimento los prisioneros mandatarios

Camiseta del señor Madero, mostrando las grandes manchas de sangre en la región escapular.

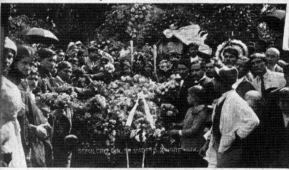

Tumba del señor Madero en la primera manifestación pública de duelo en el año de 1914.

Aspecto de los alrrededores de la Penitenciaría al ser sacados los cadáveres del Presidente y Vicepresidente.

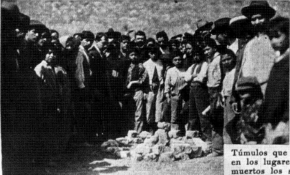

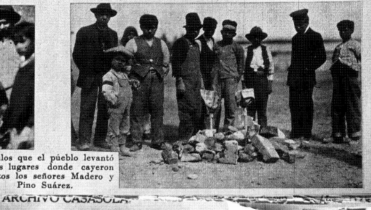

Túmulos que el pueblo levantó en los lugares donde cayeron muertos los señores Madero y Pino Suárez.

NOTES AT THE END OF AN ODYSSEY

PABLO ORTIZ MONASTERIO

I

Agustín Víctor Casasola was born July 28, 1874. His father died at the age of six, and while he was still very young he began to work in typographical shops. At the age of twenty he held a job as a reporter, and by the end of the century, he was an established photographer in Mexico City with an aptitude for accurate reporting. Fully conscious of the power of the photographic image, he initiated a project he would never abandon, one that would become a vital obsession: the formation of a photographic archive that would help to document the history of Mexico.

The photographic collection that the Casasola family amassed and conserved for decades has been safeguarded since 1976 in the air-conditioned vaults of the Fototeca Nacional, the National Photo Library of the INAH. Hundreds of thousands of negatives are lodged in an old Franciscan convent in the city of Pachuca, Hidalgo; this rich compilation is, without a doubt, the finest one available for getting a grasp of Mexican history and society throughout the upheavals of the first half of the twentieth century. The usefulness of the repository is due not only to the inherent ability of the photograph to record reality, but also to Agustín Víctor Casasola's determination to assemble an archive that would illustrate the history of Mexico.

In 1912 Agustín Víctor founded a photo agency epitomized by the slogan: "I have or will make any photo you need." He offered his services to newspapers, magazines, and the general public. He brought his brother Miguel into the agency and, eventually, his sons and grandsons, as well. For years he engaged the services of other professional photographers and bought photos and plates that he deemed important.

By the 1920s, the historic mission of the Casasola Archive was evident. The magazine *Rotográfico* regularly published an entire page containing articles on themes related to the past: important political events, nostalgic views of everyday life, fiestas, and social or religious occasions. The editors used his photographs, not as news but as references to the past.

The bibliography that emerges from the Casasola Collection is extensive. Agustín Víctor Casasola made the first entry in 1921, when he began to publish installments of the *Álbum histórico gráfico* about the Mexican Revolution. Upon his death in 1938, his sons continued the editorial project and published a number of revised and augmented editions of the album. It was amplified to include material on the post-revolutionary civilian governments, and a high point was reached with the ambitious project, *Seis siglos de historia gráfica de México* (Six Centuries of the Graphic History of Mexico), published in 1960 with more than twelve thousand photographs. In 1943, Anita Brenner published *The Wind that Swept Mexico*, an interesting text that would become a classic about the Mexican Revolution, illustrated with 184 photographs, some of which came from the Casasola Archive.

When the Mexican government acquired the Casasolas' photographic collection and converted it into a public archive, a new cycle of publications was initiated. Researchers of diverse origins have taken an interest in the archive and produced books on special themes: children, commerce, trains, prominent figures, and specific periods of Mexican history. The Revolution continues to be a highly attractive theme; over the years, several volumes have been published on this subject. One outstanding publication is *Tierra y libertad: Photographs of Mexico, 1900-1935, from the Casasola Archive*, published by the Oxford Museum of Modern Art as a catalogue of the exposition presented in England in 1985. The famous Photo Poche Collection, published by the French Centre Nationale de la Photographie, devotes volume 52 to Agustín Víctor Casasola. These publications are undoubtedly a recognition of the photographic quality of the Casasolas' work, above and beyond the historic importance of the events that were recorded. In 1997, the Casa de las Imágenes in Mexico published *Los inicios del México contemporáneo* (The Onset of Contemporary

Mexico), a stupendous selection compiled by David Maawad about Mexico City in the 1920s and 1930s.

Our project covers the period from the last years of the nineteenth century at the height of the *Porfiriato*, when Agustín Víctor Casasola initiated his photographic career, up until the end of the 1930s, when our protagonist died. Better still, the conclusion could be marked with that dramatic date that shook the world: August 1940, when Ramón Mercader assassinated the leader of the Soviet Revolution, Leon Trotsky, with a blow from a pick-axe in Coyoacán. With this publication, we aspire to be a stitch in the tapestry of our visual memory, at the same time celebrating one of the most potent and original gazes of the twentieth century.

II

At the beginning of the summer of 2001, Manuel Arroyo, Juan García de Oteyza, Santiago Fernández de Caleya, and the author of these lines met in Madrid, to formalize the commitment we had spoken of months before: that of creating a book and an exhibition based on the collection amassed over several decades by the Mexican photographer and publisher, Agustín Víctor Casasola.

The opportunity to immerse myself once more in the Casasola family's photographic archive definitely aroused my enthusiasm. My first serious contact with that prodigious reserve of photographic plates dated back fifteen years, when we composed the book about the political bosses, heroes, and charismatic leaders of the Mexican Revolution for the Fondo de Cultura Económica, entitled *Jefes, héroes y caudillos*. Years later, I collaborated with Flora Lara and marco Antonio Hernández on *Fotografía y prisión*, an exposition and catalogue published by the Cabildo de Tenerife in 1991. It was about a specific branch of the archive entitled Judicial Affairs, a revealing set of images that documents the post-revolutionary criminal justice system, from police headquarters to mental hospitals, complete with shots of courtrooms an jails. In 1997, to celebrate the second decade of the archive as a public resource, we published an entire issue of the magazine *Luna Córnea*, with material that came from various collections of the Fototeca Nacional. It is true that I had worked on the archive on several occasions, but given its proportions, it continued to be a huge enigma, a kind of iceberg with one part visible and known and the other submerged, enormous, yet to be discovered.

In the editorial conversations aimed at defining the project more precisely, the word "definitive" constantly came up; it was a question of publishing a "definitive" Casasola, of marshalling the best and most significant pieces from the archive. That was what prompted my terror. How was it possible to construct a definitive version of an archive that was so immense and so important to the history of Mexico? Aren't all versions ultimately a product of the historic moment and always perfectible?

With these anxieties, we embarked upon the project. We were clear that the book should offer a vision of the archive as a whole.

The most unique characteristic of the collection is its indisputable historic mission; for this reason, we wanted to start the book with two chapters that dealt with key periods of our recent history: the *Porfiriato*—a period of peace and stability, with its French-influenced, positivistic modernity imposed by force—and the Revolution, that fratricidal war that shook the country for almost two decades and claimed nearly a million lives.

Instead of aiming at a precise description of the *Porfiriato* and the Revolution, we tried to construct atmospheres that would allow us to approach each era and its history from the perspective of the participants themselves, before they became official heroes who would be resuscitated in monuments of stone and bronze.

In spite of the terrible reality of the war, a romantic vision of the Mexican Revolution has been constructed over the years, one which adorns the walls of cantinas and restaurants: *Adelitas* embracing their men or picturesque revolutionaries posing with their carbines. We wanted to construct a cruder vision, in which death itself and the railroad tracks were the backdrop, in which belligerent masses (known as "la bola" in those times) joined forces behind the great charismatic leaders: Zapata in the South, Villa in the North, and so many others. Then too, there were the politicians who joined the war only to develop factions that grew more and more antagonistic to each other, and the common people, who swelled the ranks of the dead and suffered more than anyone.

We decided to include some photographs that are relevant for historic reasons, such as those portraying famous people, but we were even more interested in featuring those that stand out because of their photographic quality and their original perspective. The chapters entitled "Modernity," "Halls of Justice," and "The Night," reveal the undeniable talent of the photographers who documented the new reality surging forth from the revolutionary war, in which the impetuous advancement of modernity was proclaimed as a formula for national development, one that would rescue the entire country from poverty and backwardness. Not only did they photograph movement, machines, construction, and other motifs of modernity. They did it by applying a series of modernistic strategies to their settings, including low-angle shots, overhead takes, and vanishing perspectives, in order to re-create the palpitating movement and rhythm of the metropolis through a still image.

It is often said that one of the basic reasons for the invention, or perhaps the discovery, of the photograph in the first half of the nineteenth century was the social pressure to produce portraits more quickly and economically than it was possible to do through painting or drawing. So it happened that photography became the ideal technique for the portrait, a faithful testimony of what people were like and how they looked. At first, it was common to use strategies and codes for portrait painting that had

been developed down through the centuries. By the end of the nineteenth century though, the photograph succeeded in constructing its own portrait-making aesthetics through the work of several great authors: Nadar in France and Julia Margaret Cameron in England, to mention two of the most famous. By the time Víctor Agustín Casasola began to take photographs, the medium already had a history and tradition of its own, from which the young photographer took what he needed; he added to it over time, thereby forging his own unmistakable personal trademark.

A good part of the plates in the archive are portraits, especially of groups; in these the Casasolas developed great skill and displayed outstanding artistry. In the chapter "Trades," the refined handling of spaces, poses, interpersonal relationships, and luminous qualities can be perceived, clearly demonstrating the Casasolas' strength and precision as portrait makers. I dare to say that their portraits are comparable in quality, originality, and richness, to the work exhibited by their contemporary, August Sander, after the First World War in Germany. Fundamentally, both of these polar opposites record the state of affairs in a nation through a portrait.

III

I have used the first person plural to write these lines, not as a rhetorical figure, but as a reflection of the work process. Editorial production in general, and this type of project in particular, always imply a goodly number of people. Since those luminous afternoons in Madrid when we defined the general plan of action, together with Manuel Arroyo, many people have joined us. Juan García de Oteyza originated the project and was present throughout the entire endeavor. In Mexico, Rosa Casanova, director of the Fototeca Nacional, played a key role in discussions that defined the content of the book as well as the exposition and also resolved any number of logistical issues, always with graciousness and cordiality.

As of now, approximately 50 percent of the Casasola Collection is digitalized. Almost 250,000 plates! I personally spent hours navigating through the digital archives. Without the help of Gabriela Núñez and Marcelo Silva in the reference module in the Photo Library in Mexico City, this labor would have been much more difficult and considerably less enjoyable. Paula Barra's knowledge of the archive as a whole was essential for making specific searches and writing the photo captions. The universe of digitalized plates is enormous and difficult to approach in a comprehensive manner, and more than 250,000 photographs are yet to be explored; in my worst nightmares, I imagined all those precious gems that could have enhanced our project. Nevertheless, we were able to gain at least partial access to that territory and discover some of those envisaged jewels, thanks to Heladio Vera's discriminating eye, patience, and knowledge of the archive, and to Rogelia Laguna's support.

Rolando Fuentes re-photographed the original plates that would be reproduced in this book with great precision and also helped to resolve other technical problems. The support of Alejandro Castellanos and Eva Calderón at the Centro de la Imagen was fundamental to our research among newspaper photos.

Once the sequence was arranged and the layout accomplished, Daniela Rocha, a keen, discerning graphic designer, contributed her expertise to help us fine tune the project and arrive at this final version of the publication, which will be circulated in Spain, Mexico, and the United States.

It takes a tremendous effort on the part of many people to orchestrate an exhibition. Rosa Casanova, a key person, knew how to avoid stormy seas, enabling us to keep on course. Juan Carlos Valdez, assistant director of the Fototeca Nacional, was exceptionally helpful from the beginning, his considerations and proposals were always right on target. María Ignacia Ortiz, a photographer and printer at the photo library, shared her work space and smoothed the way for the project to advance full steam ahead. Juan Manuel and Paco worked for three weeks with the new enlarger in the Fototeca laboratories, alongside the photographers and printers who are there on a daily basis. The rigor, expertise, and generosity of our guests made it possible for us to learn more about the arts of photographic printing. Above all, however, these attributes ensured that the copies were truly excellent products, worthy of the incredible photographs that make up the Casasola Archive. I can certainly affirm that I have never seen Casasola copies as powerful as those produced by this pair of dear friends in that old Franciscan convent in the city of Pachuca.

Gerardo Jaramillo, circulation director of the INAH, understood the project from the first moment on. His boundless enthusiasm for overcoming difficulties was heartening. Finally, Sergio Raúl Arroyo, director general of the INAH, an in-depth expert on the Fototeca Nacional, supported and accompanied us throughout the entire experience, always willing to take time out from the numerous tasks that constantly require his attention.

Above all, we are grateful to the Casasola clan and the rest of the "slaves of the moment," as Agustín Víctor referred to photographers, for bequeathing this archive to us. They have made it possible for us to navigate in the waters of the past and re-create, with amazing richness and precision, the yesterdays that make up the today we are now living.

CATALOGUE

Note: The listings below are for the convenience of those who wish to consult the Casasola Archive.

Page 64
Inventory No.: 32955
Author: Casasola
Title: *Soldados en una locomotora*
Place: Mexico Date: *ca.* 1915
Ref.: DGP/B

Page 65
Inventory No.: 19694
Author: Casasola
Title: *"Corl. León Román"*
Place: Mexico City Date: *ca.* 1924
Ref.: DGP/B

Page 66
Inventory No.: 63674
Author: Casasola
Title: *Felipe Acevedo se despide de un compañero antes de ser fusilado*
Place: Mexico City Date: *ca.* 1920
Ref.: SF/C

Pages 66-67
Inventory No.: 69107
Author: Casasola
Title: *Fusilamiento de falsificadores de dinero*
Place: Mexico City Date: 01-10-1915
Ref.: SF/B

Pages 68-69
Inventory No.: 6259
Author: Casasola
Title: *Soldaderas acompañan a columna de revolucionarios*
Place: Mexico Date: *ca.* 1914
Ref.: DGP/C

Page 70
Inventory No.: 45539
Author: Casasola
Title: *José León Toral y Concepción Acevedo de la Llata durante su juicio*
Place: Mexico City Date: 1928
Ref.: NF/B

Page 71
Inventory No.: 187125
Author: Casasola
Title: *Álvaro Obregón, su esposa María Tapia y sus hijos en el Castillo de Chapultepec*
Place: Mexico City Date: *ca.* 1921
Ref.: DGP/B

Page 72
Inventory No.: 687569
Author: Casasola
Title: *Soldados heridos junto a vagón de ferrocarril*
Place: Mexico City Date: *ca.* 1918
Ref.: VP/B

Page 73
Inventory No.: 687560
Author: Casasola
Title: *María Zavala que ayudó a bien morir a los soldados*
Place: Mexico Date: *ca.* 1915
Ref.: VP/B

Page 75
Inventory No.: 5032
Author: Casasola
Title: *Vendedores de Judas*
Place: Mexico City Date: *ca.* 1915
Ref.: DGP/B

Pages 76-77
Inventory No.: 90683
Author: Casasola
Title: *Vida cotidiana en el Zócalo de la Ciudad de México*
Place: Mexico City Date: *ca.* 1920
Ref.: DGP/B

Page 78
Inventory No.: 5031
Author: Casasola
Title: *Ejecutivos y empleados en la armadora de Ford*
Place: Mexico City Date: *ca.* 1927
Ref.: DGP/B

Page 79
Inventory No.: 5765
Author: Casasola
Title: *"Fábrica de Vidrio"*
Place: Mexico City Date: *ca.* 1912
Ref.: DGP/B

Page 80
Inventory No.: 342
Author: Casasola
Title: *Obreras y maestro zapatero en una fábrica*
Place: Mexico City Date: *ca.* 1918
Ref.: NF/B

Page 81
Inventory No.: 33255
Author: Casasola
Title: *Ferrocarrileros trabajando*
Place: Mexico City Date: *ca.* 1922
Ref.: DGP/B

Pages 82-83
Inventory No.: 292398
Author: Casasola
Title: *Orquesta de la "Escuela Nacional de Ciegos"*
Place: Mexico City Date: *ca.* 1910
Ref.: DGP/B

Page 84
Inventory No.: 186891
Author: Casasola
Title: *Empleados de un laboratorio*
Place: Mexico City Date: *ca.* 1920
Ref.: DGP/B

Page 85
Inventory No.: 292491
Author: Casasola
Title: *Clientes y dependientes de una carnicería*
Place: Mexico City Date: *ca.* 1928
Ref.: DGP/B

Page 86
Inventory No.: 5626
Author: Casasola
Title: *Mujeres aprenden a hacer vendas*
Place: Mexico City Date: *ca.* 1913
Ref.: DGP/B

Page 87
Inventory No.: 5756
Author: Casasola
Title: *Luchadores*
Place: Mexico City Date: 1925
Ref.: DGP/B

Page 88
Inventory No.: 196376
Author: Casasola
Title: *Empleados de un juzgado civil*
Place: Mexico City Date: *ca.* 1920
Ref.: DGP/B

Page 89
Inventory No.: 5033
Author: Casasola
Title: *Voceadores acomodando ejemplares de* El Demócrata
Place: Mexico City Date: *ca.* 1925
Ref.: DGP/B

Page 90
Inventory No.: 72967
Author: Casasola
Title: *Payasos callejeros durante una función*
Place: Mexico City Date: *ca.* 1928
Ref.: NF/C

Page 91
Inventory No.: 161508
Author: Casasola
Title: *Niño cargador de un mercado*
Place: Mexico City Date: *ca.* 1930
Ref.: NF/B

Page 93
Inventory No.: 73109
Author: Casasola
Title: *"Place donde fue instalada la 1a. Imprenta en América"*
Place: Mexico City Date: *ca.* 1920
Ref.: NF/B

Pages 94-95
Inventory No.: 196262
Author: Casasola
Title: *Gente camina cerca del Centro Mercantil*
Place: Mexico City Date: *ca.* 1924
Ref.: NF/B

Page 96
Inventory No.: 196219
Author: Casasola
Title: *Tránsito en la calle de "Tacuba"*
Place: Mexico City Date: *ca.* 1927
Ref.: NF/B

Page 97
Inventory No.: 72983
Author: Casasola
Title: *Mujeres en un tranvía*
Place: Mexico City Date: *ca.* 1928
Ref.: NF/B

Pages 98-99
Inventory No.: 196308
Author: Casasola
Title: *Congestionamiento vial ocasionado por una huelga de transportistas*
Place: Mexico City Date: *ca.* 1932
Ref.: NF/B

Page 100
Inventory No.: 165987
Author: Casasola
Title: *Vitrina del Almacen Fal de Moda*
Place: Mexico City Date: *ca.* 1925
Ref.: DGP/B

Page 101
Inventory No.: 96436
Author: Casasola
Title: *Muchachas modelando sombreros*
Place: Mexico City Date: *ca.* 1920
Ref.: DGP/B

Page 102
Inventory No.: 276136
Author: Manuel Ramos
Title: *Feria*
Place: Mexico City Date: 15-11-1934
Ref.: NF/B

Pages 102-103
Inventory No.: 136464
Author: Casasola
Title: *Hombre cruzando una calle*
Place: Mexico City Date: 1922
Ref.: NF/B

Page 104
Inventory No.: 196265
Author: Casasola
Title: *Obreros trabajando en la construcción del Palacio de Bellas Artes*
Place: Mexico City Date: *ca.* 1925
Ref.: NF/B

Pages 104-105
Inventory No.: 85467
Author: Casasola
Title: *Obrero tensando tirante de acero durante la construcción del Palacio de Bellas Artes*
Place: Mexico City Date: *ca.* 1920
Ref.: DGP/B

Page 106
Inventory No.: 1764
Author: Casasola
Title: *"Arco presentado por la Cía. De Teléfonos Ericsson"*
Place: Mexico City Date: *ca.* 1926
Ref.: NF/B

Pages 106-107
Inventory No.: 163976
Author: Casasola
Title: *Mujeres con traje de baño y antifaz, hacen publicidad para que la gente lea* El Sábado
Place: Mexico City Date: *ca.* 1926
Ref.: DGP/B

Page 108
Inventory No.: 163838
Author: Casasola
Title: *Publicidad de Frigidaire*
Place: Mexico City Date: *ca.* 1940
Ref.: NF/B

Page 109
Inventory No.: 73138
Author: Casasola
Title: *Vendedor de radios*
Place: Mexico City Date: *ca.* 1925
Ref.: NF/B

Page 110
Inventory No.: 163973
Author: Casasola
Title: *Bonetería y sastrería La Principal, fachada*
Place: Mexico City Date: *ca.* 1926
Ref.: NF/B

Page 111
Inventory No.: 131714
Author: Casasola
Title: *Hombres viajan en el estribo de un taxi*
Place: Mexico City Date: 1923-1924
Ref.: NF/B

Page 112
Inventory No.: 164518
Author: Casasola
Title: *Lote de máquinas de escribir*
Place: Mexico City Date: *ca.* 1913
Ref.: DGP/B

Pages 112-113
Inventory No.: 164445
Author: Casasola
Title: *Examen de mecanógrafas*
Place: Mexico City Date: *ca.* 1920
Ref.: DGP/B

Page 114
Inventory No.: 4826
Author: Casasola
Title: *Aparador de una óptica*
Place: Mexico City Date: *ca.* 1935
Ref.: NF/B

Pages 114-115
Inventory No.: 196265
Author: Casasola
Title: *Muchacha ciega en clase de anatomía*
Place: Mexico City Date: *ca.* 1924
Ref.: NF/B

Page 117
Inventory No.: 5828
Author: Casasola
Title: *Tlachiquero extrayendo aguamiel*
Place: Mexico City Date: *ca.* 1910
Ref.: NF/B

Page 118
Inventory No.: 10899
Author: Casasola
Title: *Carro alegórico de* El Universal
Place: Mexico City Date: *ca.* 1928
Ref.: NF/B

Page 119
Inventory No.: 89082
Author: Casasola
Title: *Mujer encantadora de serpientes*
Place: Mexico City Date: *ca.* 1912
Ref.: NF/B

Page 120
Inventory No.: 49750
Author: Casasola
Title: *León Trotski con Diego Rivera*
Place: Mexico City Date: 1937
Ref.: NF/C

Pages 120-121
Inventory No.: 5193
Author: Casasola
Title: *Estudiantes de medicina durante suspensión de clases en su facultad*
Place: Mexico City Date: 05-1929
Ref.: NF/B

Page 122
Inventory No.: 46373
Author: Casasola
Title: *Tina Modotti y policía durante la reconstrucción del asesinato de Julio Antonio Mella*
Place: Mexico City Date: 1929
Ref.: NF/B

Page 123
Inventory No.: 5857
Author: Casasola
Title: *David Alfaro Siqueiros y otras personas presiden homenaje a Julio Antonio Mella*
Place: Mexico City Date: *ca.* 1930
Ref.: NF/B

Pages 124-125
Inventory No.: 6351
Author: Casasola
Title: *Diego Rivera encabeza cortejo fúne-bre de Julio Antonio Mella*
Place: Mexico City Date: 1929
Ref.: DGP/B

Page 125
Inventory No.: 46385
Author: Casasola
Title: *Funeral de Julio Antonio Mella*
Place: Mexico City Date: 1929
Ref.: DGP/C

Pages 126-127
Inventory No.: 288018
Author: Casasola
Title: *Quema de Judas*
Place: Mexico City Date: *ca.* 1920
Ref.: DGP/B

Page 127
Inventory No.: 128688
Author: Casasola
Title: *Músicos callejeros*
Place: Mexico City Date: *ca.* 1935
Ref.: NF/B

Pages 128-129
Inventory No.: 5812
Author: Casasola
Title: *Rebaño de cabras obstruyen el paso a un tranvía*
Place: Mexico City Date: *ca.* 1920
Ref.: NF/B

Pages 130-131
Inventory No.: 202670
Author: Casasola
Title: *Empleados y elefantes del Circo Teatro Modelo*
Place: Mexico City Date: *ca.* 1918
Ref.: DGP/B

Pages 131
Inventory No.: 98698
Author: Casasola
Title: *Imitador de Chaplin*
Place: Mexico City Date: *ca.* 1920
Ref.: NF/B

Pages 132-133
Inventory No.: 108764
Author: Casasola
Title: *Bañistas en la Alberca Pane durante el día de San Juan*
Place: Mexico City Date: *ca.* 1924
Ref.: NF/B

Page 135
Inventory No.: 6363
Author: Casasola
Title: *Coristas*
Place: Mexico City Date: *ca.* 1925
Ref.: NF/B

Page 136
Inventory No.: 197113
Author: Casasola
Title: *Coristas del Bataclán*
Place: Mexico City Date: *ca.* 1925
Ref.: NF/B

Page 137
Inventory No.: 218430
Author: Casasola
Title: *Hombres observan un eclipse*
Place: Mexico City Date: 1923-1924
Ref.: NF/B

Pages 138-139
Inventory No.: 73158
Author: Casasola
Title: *Artistas y espectadores fuera de la Carpa Salón Rojo*
Place: Mexico City Date: *ca.* 1935
Ref.: NF/C

Page 140
Inventory No.: 197085
Author: Casasola
Title: *Artistas*
Place: Mexico City Date: *ca.* 1915
Ref.: DGP/B

Page 141
Inventory No.: 10967
Author: Casasola
Title: *Isabel Blanch oculta a otro actor tras una cortina durante escena teatral*
Place: Mexico City Date: *ca.* 1925
Ref.: NF/B

Pages 142-143
Inventory No.: 97988
Author: Casasola
Title: *Tiples con su vestuario de fantasía*
Place: Mexico City Date: *ca.* 1925
Ref.: NF/B

Page 144
Inventory No.: 97995
Author: Casasola
Title: *Coristas con globos*
Place: Mexico City Date: *ca.* 1925
Ref.: NF/B

Page 145
Inventory No.: 73005
Author: Casasola
Title: *"Apolinar García y Guadalupe Paig", durante baile organizado por el diario* El Demócrata
Place: Mexico City Date: *ca.* 1920
Ref.: DGP/B

Pages 146-147
Inventory No.: 6631
Author: Miguel Víctor Casasola
Title: *Homosexuales detenidos*
Place: Mexico City Date: *ca.* 1935
Ref.: NF/C

Page 148
Inventory No.: 6665
Author: Miguel Víctor Casasola
Title: *Fumador de opio*
Place: Mexico City Date: *ca.* 1935
Ref.: DGP/C

Page 149
Inventory No.: 6263
Author: Miguel Víctor Casasola
Title: *Mujer fumando opio*
Place: Mexico City Date: *ca.* 1935
Ref.: DGP/B

Page 150
Inventory No.: 6626
Author: Miguel Víctor Casasola
Title: *Homosexuales detenidos en la Cárcel de Belén*
Place: Mexico City Date: *ca.* 1935
Ref.: NF/B

Page 151
Inventory No.: 6647
Author: Miguel Víctor Casasola
Title: *Prostitutas detenidas*
Place: Mexico City Date: *ca.* 1926
Ref.: SF/D

Page 152
Inventory No.: 68995
Author: Miguel Víctor Casasola
Title: *Detenido custodiado por policías*
Place: Mexico City Date: *ca.* 1935
Ref.: NF/B

Page 153
Inventory No.: 68981
Author: Miguel Víctor Casasola
Title: *Prostituta conversando con un hombre*
Place: Mexico City Date: *ca.* 1935
Ref.: NF/C

Page 154
Inventory No.: 74945
Author: Miguel Víctor Casasola
Title: *Enfermo en un hospital*
Place: Mexico City Date: *ca.* 1930
Ref.: DGP/B

Page 154
Inventory No.: 73733
Author: Miguel Víctor Casasola
Title: *Enferma en un hospital*
Place: Mexico City Date: *ca.* 1930
Ref.: NF/C

Pages 154 y 155
Inventory No.: 186986
Author: Miguel Víctor Casasola
Title: *Mujeres convalecientes en una sala de hospital*
Place: Mexico City Date: *ca.* 1914
Ref.: SF/D

Page 157
Inventory No.: 143557
Author: Miguel Víctor Casasola
Title: *Hombres detenidos en la Cárcel de Belén*
Place: Mexico City Date: *ca.* 1935
Ref.: NF/B

Page 159
Inventory No.: 6045
Author: Miguel Víctor Casasola
Title: *Mujer detenida*
Place: Mexico City Date: ca. 1935
Ref.: NF/C

Pages 160-161
Inventory No.: 23702
Author: Miguel Víctor Casasola
Title: *Investigadores de la policía en su automóvil*
Place: Mexico City Date: ca. 1915
Ref.: DGP/B

Page 162
Inventory No.: 69118
Author: Miguel Víctor Casasola
Title: *Especialistas hacen pruebas a un hombre en el laboratorio de criminalística*
Place: Mexico City Date: ca. 1935
Ref.: NF/B

Page 163
Inventory No.: 69134
Author: Miguel Víctor Casasola
Title: *Detenido custodiado por policías y agentes del ministerio público*
Place: Mexico City Date: ca. 1935
Ref.: NF/B

Page 164
Inventory No.: 69056
Author: Miguel Víctor Casasola
Title: *Detenida cubriéndose el rostro*
Place: Mexico City Date: ca. 1935
Ref.: NF/C

Page 165
Inventory No.: 69109
Author: Miguel Víctor Casasola
Title: *Agentes revisan la casa de Jacinta Aznar después de su asesinato*
Place: Mexico City Date: 1932
Ref.: NF/B

Page 166
Inventory No.: 186897
Author: Miguel Víctor Casasola
Title: *Policías del Servicio Secreto examinan un cadáver*
Place: Mexico City Date: ca. 1935
Ref.: DGP/B

Page 167
Inventory No.: 69013
Author: Miguel Víctor Casasola
Title: *Hombre declarando ante un juzgado*
Place: Mexico City Date: ca. 1930
Ref.: DGP/B

Page 168
Inventory No.: 141633
Author: Miguel Víctor Casasola
Title: *Muchachos detenidos en los separos de la Cárcel de Belén*
Place: Mexico City Date: ca. 1935
Ref.: SF/C

Page 169
Inventory No.: 162639
Author: Miguel Víctor Casasola
Title: *Adivinadora detenida en los separos de la Cárcel de Belén*
Place: Mexico City Date: ca. 1935
Ref.: NF/B

Page 170
Inventory No.: 6372
Author: Miguel Víctor Casasola
Title: *Niño declara ante un juzgado*
Place: Mexico City Date: ca. 1930
Ref.: NF/B

Page 171
Inventory No.: 69006
Author: Miguel Víctor Casasola
Title: *Lic. Schultz preside un juicio*
Place: Mexico City Date: ca. 1935
Ref.: DGP/B

Pages 172-173
Inventory No.: 292538
Author: Miguel Víctor Casasola
Title: *Público presente en un juicio*
Place: Mexico City Date: ca. 1926
Ref.: DGP/B

Page 174
Inventory No.: 145295
Author: Miguel Víctor Casasola
Title: *Hombres detenidos en los separos de la Cárcel de Belén*
Place: Mexico City Date: ca. 1935
Ref.: NF/B

Page 175
Inventory No.: 145381
Author: Miguel Víctor Casasola
Title: *Pareja detenida en una comisaría*
Place: Mexico City Date: ca. 1935
Ref.: NF/B

Page 176
Inventory No.: 64575
Author: Miguel Víctor Casasola
Title: *Policías detenidos*
Place: Mexico City Date: ca. 1928
Ref.: DGP/B

Page 177
Inventory No.: 162639
Author: Miguel Víctor Casasola
Title: *Adolescentes detenidos en los separos de la Cárcel de Belén*
Place: Mexico City Date: ca. 1935
Ref.: NF/B

Pages 178-179
Inventory No.: 5598
Author: Miguel Víctor Casasola
Title: *Mujeres detenidas en la Cárcel de Belén*
Place: Mexico City Date: ca. 1920
Ref.: DGP/B

Page 181
Inventory No.: 22537
Author: Casasola
Title: *Gerardo Murillo (Dr. Atl)*
Place: Mexico City Date: ca. 1918
Ref.: NF/B

Page 183
Inventory No.: 6341
Author: Casasola
Title: *Emiliano Zapata*
Place: Mexico City Date: ca. 1915
Ref.: DGP/B

Page 184
Inventory No.: 243480
Author: Casasola
Title: *Porfirio Díaz junto a la Piedra del Sol en el Museo Nacional*
Place: Mexico City Date: ca. 1910
Ref.: SF/D

Page 185
Inventory No.: 162995
Author: Casasola
Title: *Mujer bebedora de pulque*
Place: Mexico Date: ca. 1910
Ref.: DGP/B

Page 186
Inventory No.: 186387
Author: Casasola
Title: *Soldadera*
Place: Mexico Date: ca. 1915
Ref.: NF/B

Page 187
Inventory No.: 287596
Author: Casasola
Title: *Venustiano Carranza*
Place: Querétaro Date: ca. 1914
Ref.: NF/B

Page 188
Inventory No.: 34264
Author: Casasola
Title: *Policarpo Pruneda acompañado de soldados chamulas enanos*
Place: Chiapas Date: ca. 1912
Ref.: NF/B

Page 189
Inventory No.: 34260
Author: Casasola
Title: *Policarpo Pruneda acompañado de soldado chamula gigante*
Place: Chiapas Date: ca. 1912
Ref.: NF/B

Page 190
Inventory No.: 202668
Author: Casasola
Title: *Pareja con bicicletas*
Place: Mexico City Date: ca. 1918
Ref.: DGP/B

Page 191
Inventory No.: 31037
Author: Casasola
Title: *Jesús Urueta*
Place: Mexico City Date: ca. 1914
Ref.: DGP/B

Page 192
Inventory No.: 17070
Author: Casasola
Title: *Merced Gómez, torero*
Place: Mexico City Date: ca. 1922
Ref.: NF/B

Page 193
Inventory No.: 19348
Author: Casasola
Title: *Ana María Fernández acompañada por Agustín Lara*
Place: Mexico City Date: ca. 1930
Ref.: NF/B

Page 194
Inventory No.: 19377
Author: Casasola
Title: *Graciela Lara bañándose*
Place: Mexico City Date: ca. 1928
Ref.: DGP/B

Page 195
Inventory No.: 31030
Author: Casasola
Title: *César Augusto Sandino*
Place: Mexico City Date: 1929
Ref.: NF/B

Page 196
Inventory No.: 29351
Author: Casasola
Title: *"Luis Urbina"*
Place: Mexico City Date: ca. 1920
Ref.: DGP/B

Page 197
Inventory No.: 29738
Author: Casasola
Title: *Artemio del Valle Arizpe en su casa*
Place: Mexico City Date: ca. 1940
Ref.: NF/B

Page 198
Inventory No.: 26254
Author: Casasola
Title: *Alfonso Reyes, escritor*
Place: Mexico City Date: ca. 1928
Ref.: NF/B

Page 199
Inventory No.: 165927
Author: Casasola
Title: *Blanca Calveti, actriz*
Place: Mexico City Date: ca. 1928
Ref.: NF/B

Pages 200-201
Inventory No.: 73041
Author: Casasola
Title: *María Conesa acompañada de otras personas*
Place: Mexico City Date: ca. 1920
Ref.: DGP/B

Page 211
Inventory No.: 543544
Author: Casasola
Title: *Mecapalero con su carga en el campo*
Place: Mexico Date: ca. 1908
Ref.: DGP/B

Page 216
Inventory No.: 182416
Author: Casasola
Title: *Coatlicue en la Sala de Monolitos del Museo Nacional*
Place: Mexico City Date: ca. 1910
Ref.: DGP/B

Note 1: All the photographs belong to the Casasola Archive.

Note 2: All the photographs were reproduced from original prints.

Note 3: In the "Author" field the first name is specified only when the authorship is exactly known. In all other cases the generic Casasola is used.

Note 4: The titles that appear in quotes are the original titles.

DGP Dry Gelatin Plate
NF Nitrocelulose Film
SF Security Film
VP Vintage Print
/A 8 x 10 inches
/B 5 x 7 inches
/C 4 x 5 inches
/D 2 x 3 inches

Coatlicue, "Woman with a skirt made of serpents." *Ca.* 1910. [182416]